Sister Arts

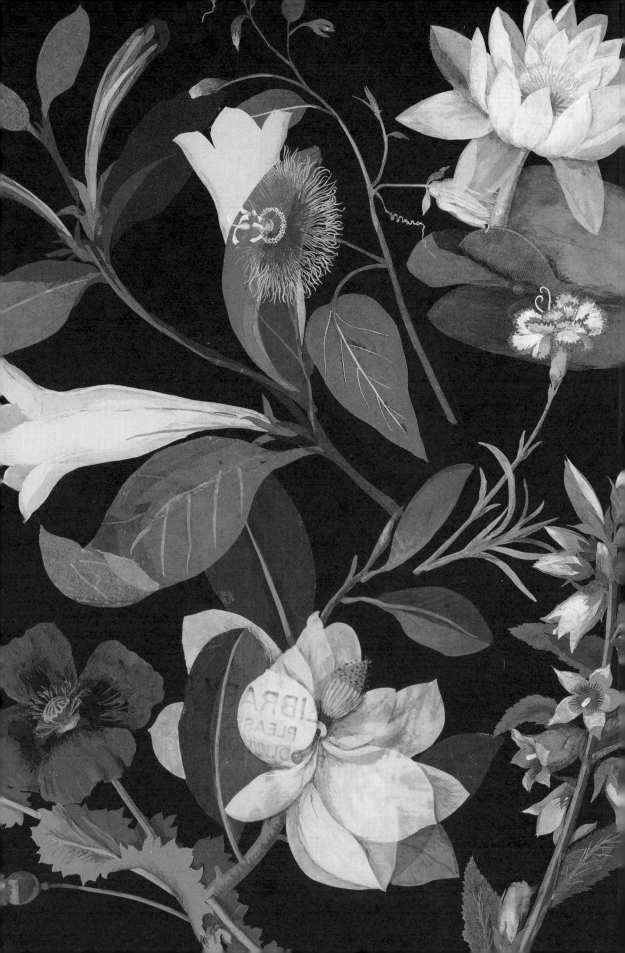

Sister Arts

THE EROTICS OF LESBIAN LANDSCAPES

..

Lisa L. Moore

University of Minnesota Press MINNEAPOLIS LONDON

The publication of this book has been aided by a College of Liberal Arts subvention grant awarded by the University of Texas at Austin.

An earlier version of chapter 1 was published as "Queer Gardens: Mary Delany's Flowers and Friendships," *Eighteenth-Century Studies* 39, no. 1 (Fall 2005): 49–70; copyright 2005 by The Johns Hopkins University Press. An earlier version of chapter 4 was published as "The Swan of Litchfield: Sarah Pierce and the Lesbian Pastoral Poem," in *Long before Stonewall: Histories of Same-Sex Sexuality in Early America*, ed. Thomas A. Foster (New York: New York University Press, 2007); copyright 2007 by New York University Press.

Published by the University of Minnesota Press
111 Third Avenue South, Suite 290
Minneapolis, MN 55401-2520
http://www.upress.umn.edu

Library of Congress Cataloging-in-Publication Data

Moore, Lisa L. (Lisa Lynne)
Sister arts : the erotics of lesbian landscapes / Lisa L. Moore.
 p. cm.
Includes bibliographical references and index.
ISBN 978-0-8166-7013-0 (hardcover : alk. paper) — ISBN 978-0-8166-7014-7
(pbk. : alk. paper)
1. Lesbianism in art. 2. Nature (Aesthetics). 3. Arts, Modern—18th century—Themes, motives. I. Title. II. Title: Erotics of lesbian landscapes.
NX650.H6M66 2011
704′.086643—dc22
 2011001280

Printed in the United States of America on acid-free paper

The University of Minnesota is an equal-opportunity educator and employer.

18 17 16 15 14 13 12 11 10 9 8 7 6 5 4 3 2 1

Contents

Listening to Gossip in the Queer Archives

IN SEPTEMBER 2009, a spectacular new exhibition of the work of the eighteenth-century diarist and gardenist Mary Granville Pendarves Delany opened at the Yale Center for British Art. Although I have spent years researching Mary Delany, there was much in the Yale exhibition that I had read about but never seen: for example, the breathtaking embroidered court dress that had been unpieced and distributed to family members after Delany's death and never publicly exhibited since. In addition, the show's curators, Mark Laird and Alicia Weisberg-Roberts, had commissioned the artist Jane Wildgoose to create an installation entitled "Promiscuous Assemblage, Friendship, and the Order of Things" to commemorate the decades-long friendship between Delany and the naturalist and collector Margaret Bentinck, the Duchess of Portland. In a small replica of an eighteenth-century drawing room, Wildgoose assembled luminous, sugary-white versions of items in the Duchess's collection, as well as of the gifts the two women made for each other over the years. On crowded rows of shelves, behind glass and before mirrors, Wildgoose conjured an intimate, feminine space that not only spoke to the scientific and intellectual interests shared by the two women but also subtly evoked their domestic and affective bonds. As I browsed through the exquisite installation, I heard a willowy young man behind me murmur to his equally soigné companion, "Yeah, right, they were just friends."

That visitor to the exhibition picked up on an aspect of Mary Delany's life and work that neither the curators nor Wildgoose directly name yet is palpable throughout: the erotic intensity of the same-sex bonds that characterized Delany's life and legacy. That is the side of Mary Delany's story, and those of the Duchess of Portland, the Romantic landscape poet Anna Seward, and the Connecticut poet and educator Sarah Pierce, that I tell in this book. We tend to bewail the invisibility of lesbian sexuality in history; here, I want to say also that our history is always hiding in plain sight among canonical visual and literary traditions.

To write this book I had to find, visit, and create many different kinds of archives. Despite their relative obscurity in literary and art history, Mary Delany and Margaret Bentinck belonged to a metropolitan aristocratic culture that polished its own sense of consequence like a mirror. These lives—even women's lives—have always been regarded as important enough that their letters, documents, and objects have been saved. That's

why, after all, in 2009 Mary Delany could be the subject of a touring exhibition jointly sponsored by the Yale Center for British Art and Sir John Soane's Museum in London. That her works have been passed down in private families as heirlooms and thus can be gathered and reconstructed for the purpose of museum exhibition attests to her cultural capital. A 2006 exhibition of portions of the Duchess of Portland's famous collection, displayed at the Harley Gallery on the Welbeck Estate, Margaret Cavendish Bentinck's childhood home, was a similar reconstructive project aided not only by the historical importance of the objects, which allowed their status as part of the famous Portland Museum to remain part of their provenance through the generations, but also the preciousness of the objects and materials themselves: many of the Duchess's jewels, artworks, and rare fossils and gemstones have remained expensive treasures since the Duchess herself paid small fortunes for them. For her part, Anna Seward comes down to us edited by her now much better-known contemporary, Sir Walter Scott. Scott's three-volume 1810 *Poetical Works of Anna Seward* and his illustrated six-volume 1811 collection of her letters remain the only editions in print. These lovely Edinburgh editions, as well as Scott's own bona fides, have ensured that despite the fluctuations in Seward's poetic reputation, she has never completely disappeared from view. By contrast, those who wished to remember the early Anglo-American intellectual Sarah Pierce's life and work—both at the time and subsequently—faced more formidable material and cultural obstacles. Institutions with the capacities of the English, Welsh, and Irish regional and national repositories that acquired Delany's, Bentinck's, and Seward's materials on their deaths or shortly afterward were only beginning to come into existence in the new United States at the time of Pierce's death. Even the houses of the wealthy in the early Republic were not as commodiously supplied with storage space as the stately homes of England; Sarah Pierce's house in Litchfield, Connecticut, is a modest two-story wooden dwelling that housed several family members and servants. When in the late nineteenth century Emily Vanderpoel sought out former students from the Litchfield Female Academy and asked them to write down reminiscences of their school days and contribute documents and objects they made in Litchfield, few of those items directly concerned Sarah Pierce. But Pierce's best-known poem, "Verses . . . to Abigail Smith," was preserved when her friend Elihu Hubbard Smith wrote it down in his journal. Smith was a founding member of the American Philosophical Society, so there was an institutional destination for his journals. The poem made it into print at last when the Smith diaries were published by the society in 1973.

This project required not only archival but methodological invention. As a feminist psychoanalytic critic once told me, "Researchers always find what they're looking for, because they put it there." Researchers in the history of sexuality may experience this epistemological insight as a rather excruciating triple bind. In the first place, sexual events that are not legal marriages are unlikely to make it to the public record unless prosecuted as crimes; where records of same-sex love exist in personal papers or

other evidently nonfictional sources, they are likely to be destroyed by lovers needing secrecy during life or by family members seeking to avoid scandal themselves or protect loved ones from censure after death. So our archive is slim to begin with. A second problem is that there is more evidence of same-sex love than the canons of scholarship have been willing to acknowledge, especially in the case of women. Making use of this material requires a willingness not just to find new sources but to read beloved, seemingly familiar classics in new ways that may be threatening to some. Third, our interpretations of the sexual meanings, especially the homosexual meanings, of that archive must meet a standard of proof that is never demanded of sex and love between men and women. Even when we do find something, or put something, into our archive, the meanings that seem plain to us may seem overstrained, unlikely, or even insulting to others. We are the ones always seen to be "reading too much into" the evidence. What research practice develops in response to these triple pressures?

Let's gossip.

In 2006, I traveled to the National Library of Wales to read Delany's voluminous correspondence. The National Library, despite its official-sounding name, is an endearingly populist institution. Located not in glamorous Cardiff but in Newport, a small provincial town about a thirty-minute train ride outside the capital, it is really just a collection of materials inside the regional public library, housed in a small strip mall above a fish and chips shop. In the library, I seated myself between a teenager surfing the Web on a library computer and an elderly gentleman reading a newspaper on a long wooden spindle. In response to my request, the librarian eventually rolled out a cart stacked high with boxes, and I nervously spread the precious papers in front of me, trying to avoid the teenager's soiled and soggy backpack.

The letters in the library's collection have only been published once, in 1861–1862, in a set of volumes edited by a great-niece with an eye to the family name. In reading her edition, one letter in particular had always intrigued me. In 1732, Delany writes to her sister from Dublin, saying that she is not going to bore her correspondent with accounts of the men she meets, but rather give her a detailed account of her new women friends. In the published version, one sentence reads: "Letty Bushe is [a] very good humored agreeable Girl with abundance of fancy." In the manuscript, however, the sentence is longer: "Letty Bushe is [a] very good humored agreeable Girl with abundance of fancy makes violent Love to me so we never meet without giving the company a great deal of entertainment."[1]

I found this exciting. I looked to my left . . . the old man was not interested. I looked to my right . . . the teenage boy was likely to be only too interested. I stepped outside and made a very expensive phone call home to share the news.

But what had I discovered? A piece of gossip, at least. Of course, the phrase "make love" as a euphemism for "have sex" dates only from 1950.[2] The sense "pay amorous attention to," however, dates from 1580 and is clearly the sense meant here.

Letty Bushe is engaging in amorous behavior toward Mary Pendarves when they are with their friends. Their friends find this not shocking or disgusting but entertaining. Such is the world of the cosmopolitan eighteenth-century bluestocking. When I've quoted this letter in talks, though, I've sometimes been asked, "But doesn't she really just mean romantic friendship?" As someone who wrote an entire book attempting to refute the idea that eighteenth-century romantic friendship has somehow nothing to do with lesbian sexuality—hoping never to be asked this question again—I find this frustrating. Nonetheless, that's the voice that gets in my head, the one that makes me look up the etymology of "to make love," the one that generates several sentences of careful explanation and elaboration before I allow myself to conclude that, yes, this is a moment in lesbian history I found in the archives and not something I just put there because I wanted to find it.

What troubles me about this experience is that in previous work I have proceeded on the assumption that we can perform queer readings regardless of the intention or biography of the author. If we have queer texts, what in particular do we need from historically queer people? For it seems that we, or at least I, do tend to find such people. How can I let discoveries such as this be significant without being determinative or setting a standard of literalness to which I don't want my own readings to be held?

In this book, I offer a method—mixed, promiscuous, interdisciplinary, feminist, and queer—to tell the stories of four fascinating eighteenth-century women and the art, science, gardens, love, and friendship they made. In each chapter, I offer some biographical context focused through the lens of my subject's relationships with other women, including the links between the four women themselves, which encompass three different but overlapping eighteenth-century generations and two continents. Readings of their work form the heart of the chapters, however: the argument here is about creative rather than sexual practice. I'm especially interested in how formal choices—images, lines, curves, shapes, quotations, displays, arrangements, structure, rhetoric—both draw on and build a landscape idiom in which these women notice, celebrate, and desire other women. Each chapter is an experiment in looking, an opportunity to see the histories of genres we think we know as a mysterious, sometimes unconscious or unintended, evanescent but nonetheless readable record of a landscape of lesbian desire.

I offer the concluding essay in the spirit of an eighteenth-century circuit garden. Also known as "emblematic" or "poetic" gardens, famous circuit gardens such as Stowe and Stourhead invite the visitor to ramble for hours along a carefully chosen route strung with specially constructed views meant to impart a moral lesson, retell a myth, or commemorate a historical event. Walking the circuit implicates the viewer's body in the point of view created by the designer, recruiting breath, blood, and muscle in its service. My idiosyncratic survey of more than two hundred years of women's art is just as coercive, directing the reader's attention to the aspects of each artist's life and work

that seems to me to continue, echo, or re-create the mixed landscape genres I'm calling "sister arts." I hope that, like an unexpected view at the end of a long climb, this essay will both reorient the reader's sense of what has come before and perhaps startle her or him into a new perspective on the world beyond the garden.

Listening to gossip means believing what you hear, see, touch, and feel; being unapologetic about what you love; and paying attention to what you're scared of. It means trusting hunches, intuitions, gaydar. It means using the discipline, rigor, and patience of a dedicated scholar, a besotted fan, and an obsessed lover. It means believing in the importance of the act and process of telling a story as much as in the literal and historical facts the story contains. It means making those stories available without necessarily knowing to what use they can and will be put in the present. In writing this book, I came to believe in the value of gossip precisely as a denigrated practice, one associated with teenage girls, gay men, and dyke drama. Of course our archival "recovery" projects are not meant to serve the long-dead objects of our research. What we are recovering is a usable past for ourselves, based on rumors, fragments, secrets, and secretions. These are the stories I want to listen to as well as tell.[3] ✪

Lesbian Genres and
Eighteenth-Century Landscapes

A SEXY LONG POEM published anonymously in 1789 provides an intriguing link
among the four women artists I discuss in this book: the garden designer, botanist,
and botanical illustrator Mary Granville Pendarves Delany; the naturalist and collector
Margaret Cavendish Bentinck, Duchess of Portland; the Romantic poet Anna Seward,
and the Connecticut educator and writer Sarah Pierce. The poem "The Loves of
the Plants" describes Mary Delany's botanical illustrations in detail, calling them
"wonderful";[1] it acknowledges the chief treasure of the Duchess of Portland's Museum,
the Portland Vase, as "Portland's mystic urn";[2] its first fifty lines were written by Anna
Seward, who is also quoted in its notes; and its first American publisher was Sarah
Pierce's correspondent and transcriber Elihu Hubbard Smith, who wrote to Pierce
about his enthusiasm for the new world of egalitarian same-sex relationships that
he thought it augured. It is less the author, soon revealed to be Erasmus Darwin, the
physician, botanist, poet, and English popularizer of the work of Carl Linnaeus, that
links the chapters in this study than the poem itself, which circulated in fragments in
manuscript form and then in various editions on both sides of the Atlantic.[3] "The Loves
of the Plants," in which Darwin referred to himself modestly as "only a flower-painter,"
was published as the second half of a longer work, *The Botanic Garden,* an ambitious
volume that also included Darwin's georgic poem "The Economy of Vegetation" as
well as several prose "interludes" on diverse subjects, including one on the qualities
of poetry that make it "a sister-art" to music and painting.[4] "The Loves of the Plants"
is nothing less than a botanical catalogue in verse organized, according to the new
Linnaean fashion, in terms of "the sexual system of botany."[5] Darwin's conceit is to
vividly personify plants as lovers in a desire-drenched world in which "beaux and
beauties crowd the gaudy groves, / And woo and win their vegetable loves."[6] Not only
do chaste nymphs and besotted swains populate the poem, there are also secret lovers
in "clandestine marriages," "feminine males," "eunuchs," "hybrid plants . . . between
male and female," "sister-wives," and "masculine ladies" involved in a polymorphous
variety of families, relationships, and desires.[7] Darwin sees these without judgment; for
this rational dissenting scientist-poet the "natural" is not the normal, far from it. In
Darwin's landscape both plant and human eroticism are multiple, profuse, and perverse,
both source and demonstration of nature's beauty, power, and irrefutable quiddity.

While it may seem odd on the face of it to begin a book with the word "lesbian" in the title by talking about a poem by a man, it emphasizes the queer take on lesbian cultural history that I attempt here. In this study, cultural and aesthetic objects and categories are a method for exploring the history of sexuality. I am more interested in what people made than in whom they may have had sex with or how their self-fashioning might line up with current categories of sexual identity. In this spirit, then, I would argue that "The Loves of the Plants" helped create and circulate a tradition of lesbian landscape arts; it is also, given Seward's contribution, itself an artifact of that tradition. It may have been through this poem that Anna Seward learned of the work of Mary Delany and the Duchess of Portland. Seward sought out a friendship with Delany's surviving family that enabled her to view for herself Delany's tribute to the Duchess and her collection: the *Flora Delanica*, a magnificent group of nearly a thousand botanical illustrations composed so as to emphasize, in Linnaean fashion, their sex organs. After viewing the works for herself, Seward wrote an angry critique of Darwin's account of them, accusing him of having minimized the work of a great artist by casting her as a lady amateur. Seward's own representations of the natural world in her love poems to Honora Sneyd traveled across the Atlantic and joined Darwin's text in the intellectual milieu surrounding Sarah Pierce, an early American writer and educator. In Litchfield, Connecticut, Pierce's position could be said to be comparable to Seward's in Lichfield, England. Both women were prominent figures among the heterosocial literary circles of their time and place. Both had close male friends who were physician-botanist-poets (Darwin and Smith), and who were appreciative enough of the women's writings to record them among their own. (In Darwin's case this amounted to plagiarism; in Smith's, the creation of a valuable and unique archive.) In reading Sarah Pierce we see how the discursive and visual tradition of women's landscape arts as what I call "lesbian genres" leaped across the Atlantic and became an international movement.

This book is a study of four eighteenth-century women practitioners of the landscape arts, and it focuses primarily on garden design, pastoral poetry, botanical collecting, shellwork, and botanical illustration. It shows how these artists engaged with three significant philosophical and aesthetic movements in the period that have hitherto been assumed to exclude them: eighteenth-century sister arts debates, the classical friendship tradition, and the tradition of the erotic garden. At the nexus of these three rhetorics lies a newly visible lesbian sister arts tradition.

LESBIAN GENRES AND THE LANDSCAPE ARTS

In this book, I use the terms "lesbian" and "genre" in intentionally loose and suggestive ways to indicate works in many media that use representations of the natural world to create or express relationships between and among women, including erotic relationships. As the example of Darwin suggests, "lesbian" is not understood here as

a kind of person but as an art-making practice, a form of relationship or community, and sometimes as a kind of art object. "Genre" too is (mis)appropriated to indicate categories that might in other circumstances be called modes, media, or kinds of art. In the pages that follow I argue that the landscape arts offered some eighteenth-century writers, illustrators, and designers a language in several media with which they could express intimacy and desire for other women. Each chapter focuses on the exchange of writings, plants, pictures, and garden designs between and among a particular group of women artists by looking at how collaboration and community shaped the genres they chose. Thus the kinds of intimacy that supported the acts of making examined in this book ranged from the erotic and interpersonal to the collective and communal (though perhaps no less erotic). The circulation of these works created a sense of a sympathetic audience of women who could be addressed, wooed, and impressed through the exchange of art and literature. These lesbian genres are literary and visual forms of expression that were meaningful in their own time and form a hitherto unrecognized chapter in the history of sexuality as well as in literary and art history.

The lesbian genres I address harvest the many traditional connections between nature and landscape on the one hand and nature and feminine eroticism on the other, and they do so in a variety of media that mix high and popular forms and are aimed sometimes at intimate audiences and sometimes at more public ones. In taking advantage of their perceived amateur status, eighteenth-century women artists could cultivate a ferocious degree of virtuosity in more than one genre and exploit the expressive potential of traditional women's media such as shellwork, embroidery, and paper collage. The feminine associations of these genres could speak for themselves about a "female world of love and ritual,"[8] but also engage with seemingly masculine scientific discourses such as natural history. This promiscuous, pillaging, mixed-art practice with its messy and differential relationship to female eroticism, rather than any one artist or work, is what I mean by the category "lesbian" here. These genres are "lesbian" not because of the sexual practices of the women who adopt them but because of their resonances with central features of lesbian history and culture that are still meaningful: the female body imagined by a woman as an object of desire; the creation of works of art as gifts or forms of exchange that create and/or intensify women's intimate relationships; the unapologetic use of craft, popular, ephemeral, and decorative forms by the same artist who might also be working in a recognized high-art tradition; and an unmarked mobility between audience—intimate and public, amateur and professional, literary and visual.[9] Thus, even though in this book I use the term "lesbian" to refer to a present-day point of view or practice, such as lesbian history or lesbian criticism, I may refer to an eighteenth-century phenomenon as "queer" in the sense defined above: queer in its violation of both categories of sexual identity and those of artistic genre. When I refer, for example, to Seward's "lesbian landscape poems" in chapter 3 I mean to denote how my own critical practice puts these particular poems in a group

not hitherto or otherwise identified, either by critics or by the poet herself. This is not to suggest that either term was being used in the eighteenth century the way I now use them to describe eighteenth-century phenomena, but rather quite the contrary: I wish to emphasize how a lesbian point of view might productively queer our understanding of objects, practices, and people in the past. To employ Eve Kosofsky Sedgwick's useful terms, mine is a reparative rather than paranoid reading of the literary and artistic tradition as well as of the public world for women: a reading for connection and creativity rather than skepticism and critique.[10]

Along with "lesbian genres," I have invented the term "landscape arts" to collect a wide range of artistic and literary practices that engage either with the direct manipulation of the lived environment as medium, that represent the natural world directly, or that use landscape imagery as a central motif or metaphor.[11] Because each of the artists that center my chapters worked in several media, and some crossed the boundaries between visual and literary art, my analysis is mobile and interdisciplinary in an attempt to match the suppleness of the oeuvres under discussion. These media all have distinct critical traditions to which I have attempted to be responsible, but ultimately these visual and literary analyses must cross disciplinary boundaries in order to illuminate a little-known aspect of women's art and literature that is not well captured using traditional disciplinary methods.

What are the landscape arts as employed by the women in this volume? Mary Delany and Margaret Bentinck, Duchess of Portland, engaged in long-term, well-documented works of landscape design that have gone understudied in histories of the great age of English landscape gardening, so those works are discussed in chapters 1 and 2. Chapter 1 also examines Delany's accomplishments as a botanical illustrator who developed a unique medium—paper collage—in which to represent plants and flowers with startling power. Delany's landscape drawings and paintings have yet to be fully catalogued and analyzed by art historians, and this chapter does not do justice to that large group of works, which now lies in the National Gallery, Dublin, and in private collections, but a brief analysis of one drawing of a Delville landscape feature gestures toward their importance. Delany's shell collages also fall under the landscape arts rubric because of their implementation of natural materials and their botanical designs. Delany's extensive and important writings are quoted in this chapter, but they are not themselves landscape texts as are some of the literary materials in later chapters. Chapter 2 surveys a similar cornucopia of objects and texts associated with Margaret Bentinck, who rivaled her friend Mary Delany in ambition and accomplishment. Primarily known in her own day as a natural philosopher and collector, Bentinck was also, as noted above, a landscape designer as well as a carver in wood, minerals, and gemstones. Chapter 2 takes seriously the work of natural history collecting as a landscape art, and it examines Bentinck's garden designs, carvings, and two special items in her Portland Museum. The chapter also discusses her creation of networks of exchange among women as a form of art practice.

Chapters 3 and 4 narrow quite dramatically the range of genres discussed. Although Anna Seward is known in local Staffordshire lore as the designer of a Lichfield landscape feature (the Minster Pool), the main focus of chapter 3 is her pastoral poetry and the landscape imagery in her elegies and sonnets. There are scores of poems from which to choose in Seward's oeuvre, and I have attempted to offer the reader a rich selection without being repetitive or overwhelming. The final chapter narrows even further to focus on just one poem by Sarah Pierce, a georgic elegy that has been called the earliest lesbian poem in American literature.[12] As the range of genres discussed diminishes throughout the book, the context for each work discussed deepens, so that the full range of landscape arts echoes through the reading of Pierce's single text to place it within the lesbian sister arts tradition.

Landscape attracted practitioners of the lesbian sister arts for the same reasons it attracted canonical garden designers like Lancelot "Capability" Brown, Humphrey Repton, and Horace Walpole, or landscape poets like Alexander Pope and Thomas Grey, or artist-scientists like Mark Catesby and Georg Dionysius Ehret: it was a powerful idiom in eighteenth-century Anglo-American culture. The Elizabethan era saw the establishment of the pleasure garden as an essential feature of any country house, and the building boom of the early seventeenth century allowed for the creation of many new estate gardens. At the same time, an outpouring of vernacular garden literature began to inform English letters.[13] Elizabeth I and Anne of Denmark were notable female patrons of garden art, and Anne in particular is noted for her design contributions to Somerset House, Greenwich Palace, and Richmond Palace in the Jacobean period. In Renaissance ideology the pleasure garden came to signify a complex of ideas: the human ability to subject and tame nature; regal and aristocratic status; a living encyclopedia of God's creation; a setting for alfresco entertainment; and a symbolic vehicle for allusions and allegorical meanings drawn from classical, biblical, and literary sources. Further, as an aspect of regal power, gardens came to symbolize imperial dominion and the "taming" of colonial possessions both in the installation of English-style gardens in colonial settings and in the importation of colonial plants and animals to English pleasure gardens. In the later seventeenth century, English gardens participated in the European trend for the French formal gardens associated with André Le Nôtre and André Mollet; the latter was made royal gardener at St. James's Park in 1661. It was this French and foreign influence that eighteenth-century gardenists such as Joseph Addison, Pope, and Stephen Switzer were to reject in the early eighteenth century. Their writings advocated English designs inspired by the model of pastoral poetry: in Addison's words, "my Compositions in Gardening are altogether after the Pindarick manner, and run into the beautiful Wildness of Nature."[14] Landscape gardening was flowing down the social scale, so that, to quote Addison again, "a man might make a pretty Landscape of his own possessions" even without a royal park.[15] The "natural" garden exemplified the Popeian neoclassical aphorism of "nature

to Advantage drest."[16] Beyond these literary influences, however, the eighteenth century saw the material transformation of the English landscape through new technologies of land fertility and reclamation as well as agricultural enclosure. New possibilities for pleasure travel opened up with road improvement and the development of lighter vehicles. Technological advances were so integral to the new explosion of English landscape design that the word "improvements" came to signify the installation of new gardens or garden features. Trend-setting ideas developed by the elite members of the Kit-Kat Club, a select coterie of tastemakers that included Sir Robert Walpole, Addison, and Sir Richard Steele, were disseminated through an explosion of writing about gardens. Switzer, a writer and professional gardener often hired by wealthy "improvers," advocated a new openness in design with unlimited views instead of the boxy parterres and hedges of the French and Dutch formal gardens of the previous century. Switzer's contemporary, Charles Bridgeman, introduced the "capital stroke, the leading step" in this new aesthetic, according to Horace Walpole, when he invented the ha-ha, or sunken fence. From this preference for a prospect or view uninterrupted by fencing developed more new features including leveling, mowing, and rolling, and the famous English lawn was established in the national vernacular. In the next generation, Lancelot "Capability" Brown came to dominate the profession of landscape gardening. He went further than Bridgeman (and Bridgeman's contemporary William Kent) in imagining landscapes in bold sweeps punctuated by the water features for which he was so well known. In creating dams, reversing the flow of rivers, and planting trees by the thousands Brown was called "Capability" because he recognized virtually no material hindrance in the landscape itself to realizing his painterly visions. As Walpole wrote, at the height of Brown's thirty-five-year hurricane of a career, "How rich, how gay, how picturesque the face of the country. The demolition of walls laying open each improvement, every journey is made through a succession of pictures . . . what landscapes will dignify every corner of our island when the daily plantations that are making have attained venerable maturity."[17] Brown was succeeded in fame, after his death in 1783, by Humphrey Repton, who was not a plantsman from an agricultural or trade background like Bridgeman and Brown but rather a gentleman gardener, a man of culture who brought his literary and artistic tastes to bear on the beautiful watercolor designs he created for clients in his famous Red Books. Repton is associated with the late-century craze for the picturesque that is satirized in Jane Austen's *Mansfield Park:* the preference for the blasted stump over the healthy tree, the ruin over the neat and useful laborer's cottage. The picturesque interest in irregularity, roughness, and sublimity became important sources for the emergence of Romanticism. Repton lived long enough to see the devolution of landscape gardening that the industrial revolution of the nineteenth century was to usher in: "The riches of individuals have changed the face of the country" he mourned; "the ancient hereditary gentleman . . . gives up beauty for gain, and prospect for the produce of his acres."[18]

And it is indeed the differential access of men and women to property that determined the participation of women in the great age of English landscape gardening. Where women had both money and land, as did Margaret Bentinck and (on a smaller scale) Mary Delany, they showed themselves to be as much people of their era as their male contemporaries by improving, destroying, planting, and writing about it all with relish. Like Anne of Denmark nearly two hundred years before her, Queen Charlotte, who reigned for an extraordinary sixty years beginning in 1761, was an important royal woman patron of the English garden; both Charlotte and her mother-in-law Princess Augusta, the mother of King George III, participated significantly in the design of the gardens at Kew. The material of which the work of garden art is composed is of a transitory nature; the canonical eighteenth-century gardens that have survived, such as Stowe, Painshill, and Stourhead, were seen not just as expressions of the taste of their male owners and designers, but also as national treasures into which first family and then public resources should be poured to preserve England's patrimony for future generations. Women's gardens have not generally been regarded in the same light. Mary Delany's Delville, probably the best-known eighteenth-century woman's garden, did not survive the century; even the great fortune of the Duchess of Portland could not keep her garden at Bulstrode, which Mary Delany also worked on, intact past the 1840s when the estate was sold.[19]

Because this study concerns landscape, it necessarily also encounters the questions of indigeneity, nationalism, and colonialism that shaped landscape practices in the eighteenth century. The "sister arts" contest, as so much else in this period, fueled a rivalry among European nations, especially between England and France but later also between England and the new United States. The new "English style" of landscape design associated with Capability Brown was said to connote English liberty and openness, as against French formal rigidity in either its ancien régime oligarchical guise or its Revolutionary rationality-gone-mad character. English imperialism pillaged the world not just for objects and resources—including botanical specimens and other objects like those collected by Margaret Bentinck and illustrated by Mary Delany—but also for aesthetics and styles, such as the Moorish paradise garden, the Mediterranean grotto, the Chinese house, and the North American sylvan grove. Relations between the sister arts and the landscape traditions of England and British North America were of course centrally shaped by these transatlantic exchanges. The imperialist land grab on the one hand and the nationalist claim to territory on the other put issues of landscape at the center of the politics of settler colonialism. Throughout the period the violent appropriation of American territory was represented as, among other things, an aesthetic, a shaping of the so-called New World from chaos into a garden of Eden. While these issues are not at the center of my analysis of eighteenth-century lesbian landscapes in this book, they must be understood as the conditions of possibility of the existence of the tradition being excavated here.

In these pages I speak of a *tradition* of landscape art genres used to express desire between women. By this I mean several things. Mary Delany and the Duchess of Portland were collaborators and intimates. Their relationship models one way that lesbian landscape genres were created and influenced one another. In this case, each woman brought her own training and interests to the work they did together as well as to the work they made for one another. Mary Delany's botanical illustrations, emphasizing as they do sexual function and formal boldness, were shaped by her exposure to the Duchess's botanical collections and scientific education. Similarly, the collecting practices that formed the Portland Museum were underwritten by Mary Delany's writing and illustration, which not only documented the collection but maintained the relationships that brought new objects into its purview. The long, deep intimacy between the two women, widely admired in their community of Sapphic and bluestocking eighteenth-century women, shapes my reading of the content as well as the form and influence of these works and practices. But the dissemination of the lesbian sister arts tradition institutionalized at Bulstrode also took place through less direct means. The fame of Delany's illustrations meant that although they remained in private hands until 1897, when Delany's great-niece donated them to the British Museum, they were well known and sought out by connoisseurs. As detailed in chapter 3, Anna Seward saw them at the home of Delany's nephew Court Dewes in 1792. Darwin's representation of Delany's work in his widely circulated poem *The Botanic Garden* also popularized it. And as I argue in chapter 2, the practices of collaboration and exchange among women artists developed at Bulstrode were also disseminated through letters and personal relationships. The Duchess and Mary Delany used correspondence and the exchange of collectibles as means for passing on, to younger women and girls in their circle, the art of using landscape genres to express love for other women. Such practices are of course harder to document than are artworks, letters, and poems, but part of the task of this book is to tell their story. As I argue in chapter 4, the circles within which women's landscape art circulated in late eighteenth-century America benefited directly from sources such as manuscript circulation and publication, garden description and design, botanical illustration and landscape painting, and the sexualized language of Linnaean classification, but they also produced practices and relationships that were more publicly engaged and self-consciously revolutionary than the tradition in England. Lesbian landscape arts were a mode of erotic expression, identity formation, and artistic innovation in eighteenth-century Anglo-American culture that shaped transatlantic art, land, and letters in hitherto unexplored ways.

SISTER ARTS HISTORY AND THEORY

Horace's famous dictum, *ut pictura poesis* (as in poetry, so in painting), was the basis for classical and Renaissance studies of the rhetorical power of the image. This classical

tradition of visual and verbal rhetoric aimed at a philosophical understanding of the nature of art itself. The metaphor of different art forms as "sisters" refers to the nine Muses of classical myth. From this divine company, however, painting and sculpture were excluded. As "works of the hand," they were classified by medieval and Renaissance theoreticians as inferior to the liberal arts, considered "works of the mind." Leonardo da Vinci was the first to challenge this hierarchy with the notion of the *paragone,* or contest between the arts, in a bid to displace the primacy of poetry in favor of painting. Since the eye is the window to the soul, Leonardo argued, painting, which we apprehend through the eye, is actually superior to poetry and music, which stimulates only "the sound made by the movement of the percussed air, which is the least matter in the world."[20] In the late eighteenth century G. E. Lessing famously inverted Leonardo's hierarchy by arguing that poetry is a temporal art and painting a spatial one; as such, poetry is superior because it unfolds over time and requires intellectual understanding, whereas painting can be apprehended in an instant and merely through the senses.[21]

Although some commentators treated sculpture, the place of spatial forms in sister arts theory found its most powerful expression in the eighteenth century, at the height of the great age of the English landscape garden movement. Horace Walpole, the famous designer of the "English Gothic" estate at Strawberry Hill, placed himself in the Horatian tradition with an oft-quoted dictum that went one better than his classical predecessor: "Poetry, Painting, and Gardening, or the Science of Landscape, will forever by men of Taste be deemed Three Sisters, or The Three New Graces who dress and adorn Nature."[22] By the time Walpole coined his bon mot in 1770, the idea that the shaping of space in the landscape has the rhetorical force of painting and poetry, and thus deserves to be studied and practiced with similar seriousness, was taken for granted in England. Landscape design was considered a distinctively English contribution; while the French were often acknowledged to be superior as poets and the Italians as painters, landscape design was an art that required, as Anna Seward said of Humphrey Repton, "the poet's feeling and the painter's eye," and it reached its highest expression in the English tradition.[23]

Despite the metaphor of sisterhood, women's participation in eighteenth-century sister arts discourse as both theorists and practitioners has been virtually neglected.[24] Jean Hagstrum's important book *The Sister Arts: A History of Literary Pictorialism and English Poetry* (1958) was a major work whose legacy has been taken up in two recent collections of essays (Richard Wendorf's *Articulate Images* and Ann Hurley and Kate Greenspan's *So Rich a Tapestry*). In this history of distinguished scholarship, however, there is neither a book-length study of women working in the sister arts traditions nor a fully interdisciplinary treatment of the topic that looks at visual, literary, and landscape art in the eighteenth century. W. J. T. Mitchell was among the first to notice the deeply gendered assumptions structuring much sister arts rhetoric, thus locating "the *ut pictura*

poesis controversy" in "the battle of the sexes, nations, and religious traditions since the Enlightenment."[25] In his analysis of the status of pictorial and verbal images in Lessing and Edmund Burke, Mitchell argues that "the most fundamental ideological basis for the laws of genre" in these texts are "the laws of gender. The decorum of the arts at bottom has to do with proper sex roles" (109). Both Lessing and Burke argued for the primacy of poetry over painting in gendered terms, making a "connection between poetry, sublimity, and masculinity on the one hand, and painting, beauty, and femininity on the other" (111). Yet these provocative remarks, scattered throughout Mitchell's stimulating work, do not in themselves add up to a feminist theory of the sister arts, neither do they give us a way to understand (nor even in themselves seem to notice) the way women artists interacted with these assumptions.

Mitchell's work also hints at the role of sexuality in understanding the relationships between genres:

> Genres are not technical definitions but acts of exclusion and appropriation which tend to reify some "significant other." The "kind" and its "nature" is inevitably grounded in a contrast with an "unkind" and its propensity for "unnatural" behavior. The relations of the arts are like those of countries, of clans, of neighbors, of members of the same family. They are thus related by sister- and brother-hood, maternity and paternity, marriage, incest and adultery; thus subject to versions of the laws, taboos, and rituals that regulate social forms of life. (112)

The fundamentally agonistic nature of any genre is true of lesbian genres as well. These forms of expression battle to be read and understood on a variety of fronts, including the sexual. In translating Lessing's German, Mitchell uses "kind" in its originary sense to mean something like "kin" or "creature," God's creation, as opposed to "unkind," that which is unrelated, unnatural, monstrous—frequent metaphors for queer sexuality. Mitchell uses sexual metaphors ("significant other," "incest and adultery") to describe the relations between genres in the "protracted struggle for dominance between pictorial and linguistic signs" that he characterizes as "the history of culture"(43). Mitchell writes that

> the sexual basis of the text-image difference is simultaneously disguised and revealed by the traditional trope of "sisterhood" . . . The association of painting with cosmetics and the lure of the "painted woman" was never far from the surface of Sister Arts rhetoric.[26]

Eighteenth-century theories of the relations between the arts, then, were embedded in an implicit and explicit language of gender and sexuality in which the status of women's practice—both sociosexual and artistic—bore a special responsibility for "all political and cosmic order."[27] And marking the boundaries between proper marital sexuality and unauthorized "other" forms was one of the dynamic features of this discourse.

Given the specific contours of eighteenth-century life—imperialism, the decline of patronage, the emergence at the end of the century of the role of professional artist, and the invention of new genres such as the novel—the sister arts rhetoric of the period mobilized sexuality, in ways both stated and unacknowledged, to manage the anxieties produced by these changes.[28]

How then did women understand their participation in the theory and practice of rival genres? In one of the few published sources to take up this question, an article on the ekphrastic verse of Victorian women poets, Michelle Martinez argues that the "network of sister artists living abroad in Rome and Florence" during the nineteenth century created an "interart poetry and aesthetic criticism rich with conflict and interest."[29] One aspect of women's increasing participation in art practices of all kinds from the end of the Renaissance onward seems to be the creation of such networks. Women who in many cases were denied formal training and professional opportunities shared resources—everything from drawing masters to recipes for paste[30]—and exchanged the products of their artistic labors, thereby creating a new mixed-genre practice related to the ability of "amateurs" to move easily from medium to medium as well as producing a new audience for this interdisciplinary work: other women. Communities such as the ones Martinez mentions and the ones studied in this book give us the opportunity to consider women as viewers, readers, and collaborators in relation to one another's work. But the networks of exchange identified in the chapters that follow are less sites in which women struggle for recognition in a male-dominated literary and artistic marketplace as they are opportunities for the circulation of texts and objects among women with varying and differential access to professional and public prestige. Thus, the lesbian sister arts tradition I sketch here has less to do with hierarchy than with promiscuity among genres: practitioners move easily among media in their representations of landscape by drawing on the resources of different artistic traditions—professional and amateur, feminized and masculinized, elite and popular—to create bonds with one another.

Why the special status of landscape here? This is not a study of the relations between painting and poetry, the traditional focus of sister arts studies. Rather, I argue that the concept of the sister arts gave these women landscape artists a way to understand their own interdisciplinary practice as part of a larger whole having to do with sexuality and community as expressed through representations of the natural world. Thus I do not single out ekphrastic verse and other explicit attempts to meld one genre with another. The works examined below mix genres in a less systematic and self-conscious way, a way that I argue is one of the defining features of the lesbian sister arts tradition. Specifically, these artists make use of a vast topos—the natural world—as it appears to represent or enable their relations with other women. Landscape design, because of its special place in eighteenth-century English artistic culture, had a prominence that drew women as well as men to the question of how art shapes nature.

In this book I also argue for the transatlantic status of women's adaptation of these landscape genres. In the study of early American literature it has been argued that there is very little that is distinctive about the writing of Anglo-American elites in the eighteenth century, including that of women. So many important early American writers, after all, were either born in England, spent significant portions of their adult lives there, or were acculturated in a tradition of Anglophilia that made little of the differences in the American setting.[31] More recently, however, scholars emphasizing American indigeneity as well as those emphasizing the impact of settler colonialism on eighteenth-century writers have critiqued earlier approaches that see English-language literatures on both sides of the Atlantic as more or less continuous.[32] In the final chapter of this book, I follow this direction in scholarship by demonstrating how the post-Revolutionary rhetoric of egalitarian same-sex relationships influenced Sarah Pierce's adoption of the sister arts transmitted through Darwin and Seward. This argument joins the growing body of work on material culture in early America. Susan Stabile's study of the way "women's preservation efforts" in the period focused on "the local, the particular, and the domestic"[33] is a productive context for understanding the nation- and world-building work of the poem by Pierce that I analyze in chapter 4 and the complex relation it enacts between literature and landscape. Susan Scott Parrish's valuable work on the relationships between colonial natural history, "candid friendship," and women's versions of the pastoral speak eloquently to early American women's landscape practice.[34] My study connects this cultural-studies-inflected work on material culture with sister arts criticism, usually focused on England and the continent and concerned primarily with high-culture forms.[35] I extend as well the emerging attention to gender in early American studies to encompass sexuality and erotic desire between women. Sarah Pierce emerges as an important practitioner of a transatlantic tradition at the nexus of these influences.

With the exception of Seward, none of the artists I treat in this volume was actively engaged in the philosophical and rhetorical debate over the status of artistic genres. I am deliberately playing with the connotations of the term "sister arts" in an attempt to broaden our understanding of the role of women and female sexuality in women's interartistic and multimedia landscape practice. The "sisterhood" of the arts in the following pages takes many forms. Sometimes I exploit the feminist connotation of the term in order to highlight relationships between women that ran the gamut from literal familial sisterhood and supportive friendship to rivalrous competition or erotic longing. Elsewhere, I use the sister arts to indicate the range of genres in which a particular artist worked. In some cases, women's amateur status meant that they more easily picked up and discarded different art forms in the search for expression. And there were some genres, such as shell decorating and embroidery, that were "sister arts" in that they were primarily practiced by women in the period and thus have their own virtually unexamined history.[36] Further, I sometimes use the metaphor of sisterhood to indicate the kinship of elements within a single work.

As the most important example of the latter, I identify the development of a synaesthetic vocabulary for the expression of sensory and emotional experiences as an aspect of a women's sister arts tradition. As a term used in psychology and linguistics as well as literature, synaesthesia refers to the apprehension of one sense experience in terms of another. In literary criticism, according to the *Oxford English Dictionary*, it refers to a metaphor in which "terms relating to one kind of sense-impression are used to describe sense-impressions of other kinds."[37] The poetry of both Seward and Pierce is marked by a characteristic use of such imagery. The layering of emotional and erotic expression, the visual aspects of landscape, and a body overwhelmed with sensation seems to require or produce such expressions. But the psychological meaning of synaesthesia as "agreement of the feelings or emotions of different individuals, as a stage in the development of sympathy," also applies here. As a term denoting the role of affect in the development of relationships, synaesthesia could be said to characterize the networks of friendship that undergird the women's artistic communities described in chapters 1 and 2.

SISTER ARTISTS AND THE FRIENDSHIP TRADITION

The exclusion of women from the classical friendship tradition emblematized by Plato, Aristotle, and Cicero in the classical era, Erasmus and Montaigne in the Renaissance, and Gray, Collins, Hume, and Smith in the eighteenth century is axiomatic in the field recently dubbed "friendship studies."[38] As Jody Greene writes categorically, "Women have no part in the friendship tradition; if anything, women are, by virtue of their constitutive shortcomings (of mind, of soul, of spirit), the reason there needs to be a masculine friendship tradition at all."[39] Scholars who, perhaps quixotically, persist in attempting to document, analyze, and historicize a tradition of women's friendship in literature have typically followed either a separatist strand by tracing a history of women's friendship without feeling constrained to compare or refer it to the masculine tradition, or have argued that particular women writers were aware of and engaged with the masculine tradition in order to make room for their own self-representations.[40] The separatist approach has the advantage of allowing the terms and conditions of women's friendships to arise from the literary evidence rather than being set in comparison to masculine and masculinist rhetoric, implicitly reminding us that what counts as "the friendship tradition" may be various and that alternative traditions (not only feminine but nonelite and non-European discourses of friendship circulated throughout the eighteenth century)[41] must be acknowledged as part of its history. Those studies that have focused on women's engagement with the masculine tradition have made it impossible to argue that its misogyny can be taken as any kind of historical fact; just as exceptional women found ways to educate themselves in Greek and Latin philosophy, so they talked back to a friendship tradition that claimed to exclude

them. Their own writings were evidence that such exclusion was impossible in fact if often reiterated in theory. For the most part, however, this critical approach has been represented by essay-length studies of individual writers; we have little sense of the history, across a particular period or from period to period, of women's engagement with the rhetoric of classical friendship.

Ivy Schweitzer, in a recent book on friendship in early American literature, takes a different approach by examining both men's and women's representations of friendship and considering them as a heterosocial as well as homosocial phenomena. Schweitzer argues that there are two strands in the friendship tradition. Ciceronian *amicitia* emphasizes the power of friendship to ennoble and strengthen not just the individual friends but philosophy and the *polis* as well. Thus friendship is best served when the friends are of equal, and elevated, social status. The roots of the tradition in Cicero's lament for a dead friend in *De amicitia* mean that this tradition is often concerned with mourning friendship's loss. Aristotelian *philia,* in which the friends is conceived as "another self," emphasizes the passionate pull of a love in which the friends would happily die for one another. Though for Aristotle, too, masculine friendship is an elite practice, its utopic and transcendent possibilities, Schweitzer argues, made it adaptable to the emphasis of Scottish enlightenment philosophers on the power of sympathy in human relations. According to David Hume, for example, the emergence of commercial society allowed for a distinction between "interested" transactions in the marketplace and "disinterested" relationships of sympathy and affection. Until the eighteenth century, friendship "could signify the relationship with a patron or sponsor, close or distant kin, or associates and advisors, as well as ties of warm affection." Samuel Johnson's *Dictionary* records a diminishment of this capacious notion of friendship to a relationship in which one may "cherish private virtues" only (52). Because "sympathetic friendship" was increasingly feminized in early nineteenth-century America, Schweitzer argues, "a version of the classical model of aristocratic dyadic friendship reserved for men persists in female culture, co-existing with neoclassical notions of sympathy, thus giving women at least a foothold in debates about equality, virtue, citizenship and national identity" (67). With this remark, Schweitzer seems to draw on both the separatist and engagement strands of historicizing female friendship, assuming there is such a thing as "female culture" while remaining interested in women's place in the classical tradition, even if that place is just a "foothold."

In this book I offer a robust version of this move to have our critical cake and eat it too. That is, I document an eighteenth-century discourse of women's friendship across time as a distinct tradition, and I notice the moments when my subjects explicitly or implicitly engage with the rhetoric of classical friendship, whether to extend, revise, reject, or ignore that rhetoric. If Anna Seward is the great sister arts theorist of this volume, Mary Delany is its philosopher of friendship. Delany leaves the most extended and continuous legacy of writings on the importance and meaning of friendship in the

lives of women. In Schweitzer's terms, Delany and the Duchess of Portland might be said to value a Ciceronian model of friendship. The power of friendship to inculcate personal and social virtue is what makes it superior to marriage for these women. By contrast, Seward and Pierce, though inheriting from this Georgian discourse the notion of friendship's superiority to marriage, understand it in the more privatized affective context of Romantic and post-Revolutionary ideas of sympathy. Yet it is Seward and Pierce who are the elegists in this story. Romantic melancholy and the violence of early American settler life bring the death of the friend to the forefront of each poet's mind. The distinctiveness of this heterogenous pillaging of a friendship discourse Schweitzer, too, calls "transatlantic" is the tradition traced in this book.

Denying the possibility that classical friendship is also a sexual relationship has a long history.[42] Even Schweitzer wants, "without denying the erotic and sexual potential of friendship," nonetheless to discard those terms in favor of an analysis of "social and political relations" implicitly understood as untouched by sexuality.[43] Yet the overlap between histories of friendship and those of sexuality has been made indisputably evident by recent work in queer studies. As Valerie Traub writes, for relationships between men "sodomy and friendship could be recognized at one moment as utterly distinct and at another moment as close to the same thing," while for women she denies the existence of any "a priori dividing line between female friendship and female homoeroticism."[44] While friendship and sexuality may sometimes operate as Other to one another, Laurie Shannon observes that "it will be noticed at once that friendship has served euphemistically to name aspects of what we would call 'sexuality,' and it has also (and often simultaneously) worked to name sexuality's remainder, whatever it is that sexuality is not."[45] The relative frankness of the eighteenth century in comparison to later Victorian strictures, according to S. J. Connolly, means that at least in London and Dublin "lesbian partnerships were referred to, with varying degrees of explicitness, both in fiction and in gossip. Yet it was also possible for close and highly emotional relationships to be taken wholly at face value, both by those involved and by a wider social circle."[46] My interest is in the ripples created in such circles by artistic exchange.

This study, then, aims neither to parse the terms "sexuality" and "friendship" nor to draw a hard distinction between them. For the most part, I have chosen to use the terms I find in the archive itself to characterize the identities, relationships, and images discussed. The method I have developed for analyzing these artists and their works is interdisciplinary, eclectic, mixed, and queer. I have pillaged the biographical record for accounts of these artists' relationships with other women, not to demonstrate that they are "lesbians" in some definitive way but to illuminate their representations of the natural world in the context of the lesbian sister arts. After the superb and thorough work in lesbian history that has characterized the last two decades, I need not rehearse here the debates over the historical appropriateness of various terms—tribade, tommy, Sapphist, lesbian, hermaphrodite—that in eighteenth-century culture may have pointed

to relationships we would now call lesbian.[47] I am agnostic on the issue of whether or not these women are what we would now call lesbians; what can be said, though, is that my methods derive from lesbian and queer cultural studies and that these women and their work belong in that tradition.[48]

THE EROTIC GARDEN

The rich history of associations between transgressive sexual knowledge and the garden goes back to the myth of Eden. In the eighteenth century, such associations were literalized in several ways. First, there was a tradition of literary satire in which landscape features were punningly and vulgarly compared to body parts, such as (to take just one of many risibly titled examples) the anonymous *Little Merlin's Cave, As It Was Lately Discovered, by a Gentleman's Gardener, in a Maiden-Head Thicket* (1737).[49] These did not seem to contribute to the sister arts tradition discussed here in any significant way. More relevant is the three-dimensional version of this approach, equally jokey but more labor intensive: the small group of English gardens, such as Sir Francis Dashwood's West Wycombe, discussed in chapter 1, in which hills and vales in actual landscape parks were designed to create what was essentially an earth sculpture of the female nude. Finally, the English adoption of the sexual taxonomy of Carl Linnaeus brought the vocabulary of sexual intercourse and gender inversion into eighteenth-century representations of plants, gardens, and landscape.

Sexual symbolism, what James Turner calls an "aesthetic of sexualized topography," is thus a persistent feature of eighteenth-century landscape design.[50] As Carol Fabricant argues, landscape in the eighteenth century was regarded by male designers and estate owners as a mistress: "The landscape's feminine allurements were highlighted but also kept in check by gentlemen gardeners who felt called upon to restrain the 'careless and loose Tresses of Nature.'"[51] Fabricant notes that botanical description in particular often gave way to a "gynecological spirit of inquiry" in which plant parts were described as "ovaries," the "vagina," and the "uterus."[52] The garden had the paradoxical status as both a space for the "private enjoyment of nature's charms," including "sexual stimulation and release," and as an opportunity for display, for showing off the fashionable "open prospects" that connoted liberty, wealth, and taste.[53]

Although every fashionable landscape needed to have an unrestricted view, Fabricant insists that almost all designs included places of enclosure and privacy such as grottoes. Turner gives us the example of Rousham, a place that "accommodated not only the garden parties which punctuate rural retirement, but lover's assignations."[54] Literature gives us other examples: one of the problems with the ha-ha and wilderness at Sotherton in Austen's *Mansfield Park* is that those within them were screened from view of the house, thus making Maria Bertram's adulterous liaison possible. The ha-ha can serve its function as the very figure of English liberty and unbounded prospects,

Austen shows, only from a distance. When strollers in the park cling close to the fence, they are as effectively concealed from scrutiny as the fence itself.

Women landscape artists brought explicit discussion of sexuality into the sister arts tradition not only through their interest in the bawdy garden but also through their engagement with Carl Linnaeus. Linnaeus famously proposed a sexual system for the classification of plants that organized them in terms of their reproductive patterns. Although his taxonomy has been superseded, many of the Latin names of plants still in use reflect Linnaean terminology; his was the first scientific taxonomy to see widespread global adoption. The reception of Linnaeus's ideas in Britain, popularized by Darwin's "The Loves of the Plants," anthropomorphized this notion into an allegory of human sexual relations. British Linnaeans drew on a long tradition that viewed flowers as strongly suggestive of human eroticism. The later eighteenth-century English reception of Linnaeus capitalized on this history of sexual connotation. The notion of plants as possessors of a sexual life comparable to that of humans was extensively, even obsessively, imagined in "The Loves of the Plants." Darwin describes the Ovidian metamorphosis of the flowers, with their floral "harems," and figures stamens and pistils as beaux and belles. Darwin's translations of Linnaeus's Latin terms are especially anthropomorphizing, and they take note of plants he calls "inverted."[55] They also note those who manifest "unallow'd desires": Darwin speaks of certain species as "eunuchs," others as "feminine males," and still others as "masculine ladies."[56] Clearly the idea that plants mimicked human sexuality, and even human homosexuality, was part of the British cultural adaptation of Linnaeus's system. Thus it was not only in literary and artistic discourses but also in emerging scientific approaches to landscape that women, like men, engaged with representations of feminine sexuality when they practiced the landscape arts.

THE PROBLEM OF THE ARCHIVE

The great challenge of the history of lesbian culture is the relative paucity and inaccessibility of sources. Not only were women less likely to have had their existences documented in official records such as court, Parliament, and publication, they were also less likely to have had the resources to write and keep private records such as letters, diaries, and journals. And even when such documents did exist in a woman's lifetime, after her death those materials were less likely to be preserved at all, much less seen as worthy of donation to a museum or library. And finally, material that might be of special interest to lesbian history is likely to have been destroyed either by the writer or her survivors in order to protect the woman's reputation and spare the family embarrassment. The material legacy of each of the artists discussed in this book has a different, complicated, and interesting relationship to the problem of the archive. The diversity of materials under consideration in these chapters is in part determined by

the multidisciplinary practice of the artists themselves as well as their innovative use of genre, but it is also determined by what survives and what has disappeared that can be reconstructed, and for which "open secrets" of the past we may never find evidence.[57]

Mary Delany, for example, was well known for her epistolary talents, and to some extent her letters were seen as a valuable family legacy. Not only do large numbers of Delany's manuscript letters survive in public collections in Great Britain and the United States, but many were published in the mid-nineteenth century in a six-volume series edited by her great-niece, Lady Augusta Llanover. Though Delany is a relatively obscure figure in canonical art and literary history, it would seem that for the intrepid lesbian cultural studies scholar, she left plenty of material. But there are also telling gaps in this archive. The nineteenth-century edition, for example, omits phrases such as "she made violent love to me" that can be found in surviving manuscript letters, thereby leaving us to wonder what may have been contained in letters that have not survived.[58] A key group of such vanished letters would be Delany's correspondence with Margaret Bentinck. We know they corresponded at least once a week (except when they were living together) from 1736 to Bentinck's death in 1785. Yet the vast majority of these letters have disappeared. In one surviving letter Mary Delany asks her sister Anne to destroy some of her letters. How often did such purges take place at Delany's behest? What about after her death, at the hands of a bowdlerizing Victorian descendant such as Augusta Llanover? Did the Delany-Bentinck correspondence fall victim to such a fate because it contained material seen as compromising? Such material is of course exactly what lesbian cultural critics could interpret with sensitivity and expertise, but we rarely get the chance.

Margaret Bentinck was a less skilful and less frequent writer than was Mary Delany, and as a wealthy aristocrat she also had access to others who sometimes carried on her correspondence for her, including Mary Delany. Because of the importance of both the Welbeck estate she was born into and the Portland lands she acquired by marriage, there is a considerable public record about her financial life. But there is shockingly little material in her own hand. Much of what we know about her comes by report in either the letters of Mary Delany or in accounts by other prominent literary friends such as Horace Walpole. We do not have access to any extended version of Bentinck's own account of her affective and psychic life. Thus contemporary accounts of her collecting and artistic practices must stand in both for her own words and for readings of objects that no longer exist, at least not as part of the same collection.

Anna Seward left a copious record of her inner life in both her literary compositions and her voluminous correspondence, and it is no accident that she is the figure discussed here that has been most often identified as belonging to lesbian literary history.[59] In part this is because her literary legacy is easier to read than the scattered objects, manuscripts, and old books that comprise Delany's and Bentinck's oeuvres. One aim of this introduction, then, is to allow us to read backward from a more established figure in lesbian history (Seward) to influences we may not otherwise

perceive as belonging in the archives of lesbian culture (Delany and Bentinck). In Seward's case what is missing is a good modern edition of her poems and letters. The early nineteenth-century editions that made her a household name as a Romantic poet in both Great Britain and the early United States have at best an obscure relationship to her manuscript poems, which have never been systematically analyzed. And while many letters have survived, they are scattered in small collections all over Great Britain that are difficult for many to access.

But the archive for even obscure women writers in Great Britain is rich compared to the available sources for many British North American women writers. Sarah Pierce, although a prominent early American intellectual and the founder of the famous school Litchfield Female Academy that educated Harriet and Catherine Beecher among other well-known figures, left only a handful of personal letters that survive today. For nearly thirty years Pierce made all of her pupils keep journals, but if she kept one herself it has been lost or destroyed. While materials written by her students as well as their personal recollections were collected by local historians in the early twentieth century, these materials tell us little of Pierce's affective life. Indeed, the poem that centers the analysis of U.S. lesbian landscape genres in chapter 4 survived only because it was copied into the journal of a man, Pierce's friend and correspondent Elihu Hubbard Smith. Smith's journals were published in the 1970s by the American Philosophical Society, of which he was one of the founders. By such slender threads does lesbian cultural history hang.

In order to meet the challenge of the archive, this book is organized as both an argument for a hidden tradition of lesbian landscape art and a series of essays that circle around recurring themes. Chapter 1, "Queer Gardens: Mary Delany's Flowers and Friendships," surveys a selection of Delany's prodigious artistic and epistolary production in order to illuminate its reliance on two distinct practices for their erotic power. Delany produced and circulated her work in the context of a network of intimacies with other women. She first collected shells for her shell collages while on a two-year sojourn in Ireland with Anne Donellan; later, she decorated the home she often shared with Margaret Bentinck, the Duchess of Portland, with such shellwork. Her garden designs at Bulstrode were collaborations with the Duchess, and at Delville she designed and dedicated a portico to her friend. Finally, her chef d'oeuvre, the *Flora Delanica,* was created at Bulstrode, illustrated the Duchess's world-famous botanical collection, and was dedicated to her after her nearly fifty years of intimacy with Mary Delany. The second tradition that Delany drew on was a masculine tradition of sexual representation in the landscape arts. The ribald garden, elements of which she reproduced at Delville, and the Linnaean sexually explicit botanical illustration that so distinguished her floral collages both point to a bold appropriation of sexual imagery and associations on the part of a woman artist.

Collaboration and community among women practitioners of the landscape arts is an even more prominent theme in chapter 2, "A Connoisseur in Friendship:

The Duchess of Portland's Collections and Communities." Just as Mary Delany appropriated and adapted the traditions of the ribald garden and the Linnaean botanical illustration for her own purposes, so Margaret Bentinck adapted and modified the history and theory of collecting, thereby creating a practice that hovered somewhere between feminine accomplishment and masculine scientific endeavor. This chapter also explores the status of Enlightenment collecting as a practice of imperialism and looks at the Duchess's role in financing the botanists Georg Dionysius Ehret and Daniel Solander on Captain Cook's voyages.

Chapter 3, "The Voice of Friendship, Torn from the Scene: Anna Seward's Landscapes of Lesbian Melancholy," documents the institutionalization of women's friendship as a trope of the landscape arts via an examination of Anna Seward's poetry, which became canonical for this tradition. Seward's adaptation of traditions of the elegy and pastoral in the service of the representation not just of women's love but of its loss and the poet's melancholic identification with that loss constitute a powerful and understudied aspect of Romantic verse in general and an especially influential example for other practitioners of the lesbian landscape tradition that Seward was both drawing on and canonizing. The chapter argues that Seward's poems inflect recent discussions of melancholia in queer theory with a lesbian specificity, a "lesbian death wish" that deserves further scrutiny.

The role of women poets as "sisters" to garden designers and visual artists is explored further in chapter 4, "The Landscape Which She Drew: Sarah Pierce and the Lesbian Georgic." In this chapter I show how women's friendship as a landscape trope and practice travels via circuits of transatlantic radical literary culture to land in the very different natural and built world of Litchfield, Connecticut. With the changed national context, the images and methods that characterize the tradition take on new political and material meanings. The status of Pierce's "Verses" in the more denuded landscape of early American literature, in which there are simply fewer examples of any kind of literary production from the period, especially by women, puts an even heavier burden of representation on this single text. Pierce's importance as an advocate of early American women's education helps us to understand how this tradition of lesbian landscape art took root in U.S. culture and literature. We also see Pierce's distinctively American take on the classical friendship tradition, one that emphasizes the egalitarian, radical, and revolutionary possibilities of horizontal same-sex bonds between women.

Finally, in the conclusion to this volume I speculate about places we might look for later examples of this tradition. Without arguing for hard-and-fast cases of direct literary and artistic influence, I offer a carefully shaped promenade through a landscape of rich examples for future research. I begin by assessing the book's argument in terms of the history of genre theory. I then offer brief readings of a wide range of art, literature, and garden design: Mary and Jane Parminter's early-Victorian shell house, Emily Dickinson's language of flowers, Edmonia Lewis's wilderness heroines and garden

sculpture, Vita Sackville-West's lesbian georgic, Georgia O'Keeffe's exploitation of both her woman lover and a Native American women's craft tradition in the creation of her powerful floral imagery, Frida Kahlo's gardens of sex and death, Judy Chicago's self-conscious construction of a new feminist history for her own sister arts practice, a lesbian reimagining of the iconic image of la Virgen de Guadalupe by Alma Lopez, Tee Corinne's literary and visual documentation of West Coast lesbian landscape art in the 1970s and 1980s, Alice Walker's iconic essay "In Search of Our Mother's Gardens," Faith Ringgold's quilt for Marlon Riggs, Kara Walker's biting satirical appropriations of eighteenth-century sister arts media and techniques, Mickalene Thomas's lush images of African-American lesbians, and the installation artist Allyson Mitchell's "lesbian feminist storybook gardens," which move easily between lesbian and transgender characters and representations. This dizzying array of works allows us to see more clearly how tensions around race, imperialism, and colonialism are intertwined with the lesbian sister arts tradition; women artists of color often adapt its conventions to critique these tensions. In particular, questions of land, property, and ownership have a much different history for African-American, Native American, and Latina artists than they do for the elite white women of the earlier chapters. The story this book tells allows us to see not just texts and objects but also place itself as a contested artifact of lesbian culture. ⊛

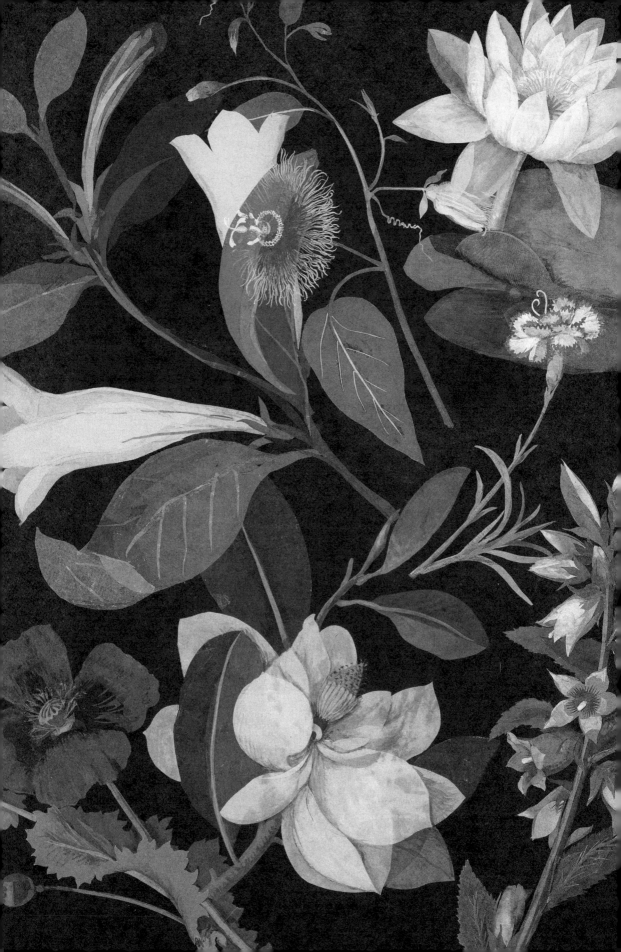

1

Queer Gardens

MARY DELANY'S FLOWERS AND FRIENDSHIPS

MARY GRANVILLE PENDARVES DELANY, born in 1700 to a family with court connections, was an aristocratic lady of leisure nonetheless possessed of a punishing work ethic and a truly fearsome ambition (see Plate 1). Delany left behind an impressive corpus of literary and visual art, but because she worked mainly in minor genres associated with women—such as the letter, the memoir, needlework, ceramics, shellwork, paper silhouettes, collage, landscape drawing, and the copying of famous paintings—her work has, until recently, been either overlooked or dismissed.[1] Even her famous *Flora Delanica,* the nearly one thousand botanical illustrations in cut-paper collage that now reside in the British Museum, is called by Wilfred Blunt in his canonical history of botanical illustration "'quaint' rather than beautiful," though "admittedly remarkable for a woman of her age."[2] More recently, Ann Bermingham has called for a reevaluation of women's amateur traditions, pointing out that the "accomplished woman" was a figure discursively constructed to manage anxieties about the increasing commodification of visual culture in the eighteenth and nineteenth centuries. For Bermingham, female accomplishments such as Delany's were commodities on the marriage market, "an occasion for women to display themselves . . . intended to arouse masculine desire."[3] Delany, who married twice, was certainly extremely accomplished in this sense. But her most important work was created in collaboration with and for an audience of other women. Thinking beyond the commodity allows us to ask what circuits of exchange outside the market created the material conditions out of which such work arose.[4] Further, it enables us to examine the hitherto unread social meaning and aesthetic traditions both drawn upon and exemplified by such work. What other histories of desire are embedded in Mary Delany's "quaint" productions?[5]

To address this question, I begin this chapter by demonstrating that Delany participated in a self-conscious community of intimate women friends in the cosmopolitan cultures of eighteenth-century London and Dublin. These women's friendships fell along a continuum from sexual intimacy to chaste mutual devotion, and Delany's writings about friendship, intimacy, and marriage document and theorize these distinctions.

Next, I turn to Delany's important work as one of the few known women garden designers from the great age of the English landscape garden. Comparing her "improvements" at Delville and Bulstrode with an eighteenth-century tradition of erotic garden design allows us to see Delany in the act of creating three-dimensional spaces for female eroticism and intimacy in her gardens. Finally, I offer a new interpretation of Delany's best-known work, the *Flora Delanica,* by suggesting that these images form part of a tradition, following Linnaeus, of seeing the heterogeneous and sometimes "homosexual" life of plants as analogous to and expressive of human sexuality and sexual variation.[6]

Mary Delany's Tory family suffered a reversal of fortune after the death of Queen Anne in 1714 that was to have a material effect on their daughter's sexual history. Mary was married off in 1718 to Alexander Pendarves, a wealthy fifty-seven-year-old member of Parliament, on the strong urging of her powerful uncle Lord Landsdowne. Pendarves died in 1725; ironically, he failed to leave Mary the fortune her family had anticipated by disinheriting her in favor of a nephew. After her husband's death, Mary Pendarves moved to London and lived on her widow's jointure, first with her aunt, Lady Stanley, and then with her friend Anne Donellan. During this period, as a relatively youngand affluent single woman living a cosmopolitan life with a woman friend and traveling widely, she wrote biting letters in which she overtly prefers female friendship to heterosexual marriage. On a trip to Dublin in 1731 with Anne Donellan, she met Dr. Patrick Delany, a leading figure in the Church of Ireland. There was no talk of marriage at that time, however, and Dr. Delany married a rich widow, Margaret Tenison, instead. When Margaret died in 1742, Patrick Delany proposed to Mary Pendarves, and the two were married in 1743 and lived near Dublin. Mary continued to travel back to England frequently, however, and she stayed especially close to Margaret Harley Bentinck, the Duchess of Portland, carrying out at least one project on the Duchess's estate at Bulstrode. After Patrick Delany's death in 1768, Mary Delany moved back to England and began living six months a year with Bentinck. At Bulstrode, Delany made the spectacular *Flora Delanica* discussed in the last part of this chapter. By the time Bentinck died in 1785, Delany had attracted the admiration of Queen Charlotte, who gave her a royal cottage and an income for the remainder of her life. Mary Delany died at Windsor in 1788.

"I COULD HUG THE OLD PHILOSOPHERS": MARY DELANY ON FRIENDSHIP AND MARRIAGE

Mary Delany's life story, recorded in six volumes of letters and an autobiographical memoir published only once, in the 1860s, reveals her to have been a lifelong proponent of women's friendship and, despite two husbands, one of the eighteenth century's sharpest critics of marriage. In her letters, Delany talks back to a classical friendship tradition that excludes women, and she adapts that tradition's elevation of disinterested

same-sex friendship over the material and moral constraints of the institution of marriage. In the wake of her first marriage she writes to her sister,

> I have read so much of Philosophy lately that I am convinced there is no real Happyness but in a Faithfull Friend, as Doctor Swift says in his Vanessa it is a Rational delight. It fills the mind with Generous thoughts, and I must have a mean opinion of those, that call it Romantick. It is the most improper name for it in the world for the foundation of a worthy Friendship is truth[.] People may fancy themselves in Love, and work up their imagination to such a Pitch as to really believe themselves posses'd of that Passion, but I never yet heard of any Body's carrying Friendship on by meer imagination.[7]

Mary's engagement with "Philosophy" here is telling; she unselfconsciously aligns herself with male writers on the friendship tradition ("Doctor Swift") but rejects the feminizing associations of Aristotelian *philia* by arguing that because friendship is not blinded by the "fancy" of heterosexual desire, it is a relationship that elevates the friends to a pursuit of "Rational delight" and "truth," the solid virtues of Ciceronian *amicitia*. On the virtues of friendship Mary aligns herself not only with contemporary writers but with classical ones:

> Epicurus declares it his opinion, that Wisdom among all the ingredients of Happyness has not a nobler, a Richer, or a more delicious one than Friendship.—

> I could hug the Old Philosophers notwithstanding their long dirty Beards whenever I meet with a Passage that speaks my sentiments.[8]

Friendship is here associated with "Wisdom" in Ciceronian fashion, but it is also a more "delicious" experience linked to Epicureanism. This sensual association is playfully extended in the subsequent image of the beautiful young bluestocking hugging the hoary old philosopher. This picture of informal intimacy speaks to Mary Granville's sense of entitlement to a place in the classical discourse of friendship. She neither apologizes for nor seems to notice that the "Old Philosophers" insisted that exalted same-sex friendship was for men only. She says dismissively, "I may venture to say where one person has a right notion of friendship, there are hundreds that never examined what the word meant."[9] Such examination marks her as not just a practitioner but a philosopher of friendship who sees herself as an authority.

Widowed at twenty-four, Mary Pendarves first went to live with an aunt, Lady Stanley. On Lady Stanley's death, rather than moving in with her sister or brother as would have been expected of an unmarried woman, she set up housekeeping with her friend Anne Donnellan, whom she nicknamed "Phillis" or "Phill." Marriage and men held few charms for Mary Pendarves in this period. As she wrote to her sister in 1728, three years after Alexander Pendarves's death:

Matrimony! I marry! Yes, there's a blessed Scene before my Eyes of the Comforts of that State. A Sick Husband and Squawking Bratts, a Cross Mother in Law, and a thousand unavoidable impertinences. No, No, sister it must be a Basilisk indeed that makes me doat on those wretched incumbrances. But Stop my rage, be not too fierce, I may be dash'd on the very Rock I endeavour to avoid and therefore I will say no more against a Station of Life which in the Opinion of some People is not in our power to prevent.[10]

The "Basilisk" was Mary's nickname for Lord Baltimore, a suitor she might have considered marrying, but who never proposed. Many of her letters to her sister concern her efforts to get over her attraction to a man whom she suspected of desiring an extramarital liaison with her. Such a suggestion made him unworthy in Mary Pendarves's eyes not only of marriage but also of friendship. Her wish to avoid another marriage was difficult to carry out against social pressures, she implies; she fears being "dash'd" on the "Rock" of marriage despite her objections. In another letter, she speaks of the shortcomings of men, even fantasizing about an Amazonian slaughter of them all:

Would it were so, that I went ravaging and slaying all the odious men, and that would go near to clear the world of that sort of animals, you know I never had a good opinion of them, every Day my dislike Strengthens, some few I will except, but very few. They have so despicable an opinion of women and treat them by their words and actions so ungenerously and inhumanly. By my manner of inveighing any body less acquainted with me than your Self would imagine I had lately receiv'd some very ill usage from the Men, no, this my observation on conversing a good deal with them, the minutest indiscretion in a woman (though occasion'd by the men) never fails of being enlarg'd into a notorious crime, but the Men are to Sin on without limitation or blame, a hard case! Not the restraint we are under for that I extremely approve of, but the unreasonable License tolerated in the Men. Phill and I were wishing this morning that there were two or three hundred women of consequence that had the same indifference towards men that we have, then their Pride might be a little mortified, how amiable![11]

This passage is remarkable not only for its violence but also for its desire for a female community of women (albeit only those "of consequence") sharing "the same indifference towards men" that Mary Pendarves treasured in her relationship with "Phill" (Anne Donnellan). We can imagine that the unsentimental writer of these words had felt mainly relief at the death of the odious older husband forced upon her by her family, which left her young and free to pursue her attachments to other women, including living and traveling with her friends for years at a time.

Even while happily married to Patrick Delany two decades later, Mary Delany argued that marriage was often nothing but an economic contract in which women were at a structural disadvantage:

Why must women be *driven to the necessity* of marrying? a state that should always be a matter of *choice!* and if a young woman has not fortune sufficient to maintain her in the station she has been bred to, what can she do, but marry? and to avoid living either very obscurely or running into debt, she accepts of a match with no other view than that of interest. Has not *this* made matrimony an irksome prison to many, and prevented its being that happy union of hearts where mutual choice and mutual obligation make it the most perfect state of friendship?[12]

Though this "perfect state of friendship" was theoretically available in her relationships with both men and women, in practice heterosocial intimacy could best take place within marriage, as Delany's experience with Lord Baltimore demonstrated. Yet for her, the situation of intimate friendship within a particular locale and landscape were definitional to its idealized difference from marriage. She called such a relationship

the greatest blessing that heaven has in store—a strong and faithfull friendship! That's the true zest of pleasure, the refinement of life, which mends the heart, and mitigates a thousand sorrows. A fairy spot of ground to be enjoyed with a friend is preferable to the whole world without that happiness.[13]

Mary Pendarves's first marriage served dynastic rather than affective or even moral purposes; she had no shaping creative power at Alexander Pendarves's Cornish castle. By contrast, she speaks in the lines cited above of female friendship as ideally taking place in a landscape—a "fairy spot of ground." Much of Mary's work at Delville and Bulstrode aimed to create such "fairy spots"—with all the queer connotations of magic, transformation, and mischief implied in the adjective—for her friends and friendships.

Mary Pendarves and Patrick Delany met in the 1730s when "Pen" (as Mary Pendarves often signed herself) and "Phill" (Anne Donellan) traveled to Dublin.[14] At that time Mary also met several Irish bluestockings, many of whom were to become her intimates during her marriage to Dr. Delany years later. One of these, a local "beauty and wit" named Miss Kelly, became Mary's rival for both men's and women's attentions.[15] Mary Pendarves writes to her sister that she has "given up the trial" for Patrick Delany's attention; Miss Kelly's "beauty and assiduity has distanced me." She does not seem particularly distraught about this, however, saying that "Dr. Delany will make a more desirable Friend he has all the Qualities requisite for Friendship."[16] Later in the same letter, however, she confided that Miss Kelly "has touch'd me in a tenderer part, for she has so intirely gain'd Mrs. Donellan, that without Joking she has made me uneasy." Popular and flirtatious, Mary Pendarves attracted and was attracted by both men and women, but her deepest jealousy and sincerest distress were reserved for her intimacy with "Phill."

During this trip Mary Pendarves also befriended the painter Letitia Bushe, of whom she wrote to her sister in 1732: "Letty Bushe is [a] very good humored agreeable Girl with abundance of fancy makes violent Love to me so we never meet without giving the company a great deal of entertainment."[17] This letter includes a catalogue of all of Mary Pendarves's women friends, in which she rates them for her sister according to her fondness for them. Anne Donnellan is placed "out of the question," as Mary states: "I have a Friendship for her far above any I can cultivate here." Later that same year, Mary reports on a trip from Dublin to Killala in the company of Donnellan, telling Anne Granville that "Phillis's love, and mine (that is Miss Kelly and Letty Bushe) played their parts very handsomely" when the time came to say goodbye.[18] S. J. Connolly has vividly documented Letitia Bushe's intimate relationship with Lady Anne Bligh, arguing that the relationship provided an "emotional and possibly sexual outlet" for the two women.[19] Anne Bligh and Mary Pendarves seem never to have met in Dublin, but when Anne visited London during Mary's residence there, Letitia Bushe endeavored to arrange a meeting between the two. As Bushe assured the reluctant Lady Anne (who wanted their intimacy to remain a secret): "You might have trusted me with preserving decorums . . . Pen is not a woman to make the remarks you imagine."[20] As a woman of the world, Bushe implies, Mrs. Pendarves would not be shocked to be introduced to someone whose relationship with another woman might be seen by some as contravening "decorums." The boundary between platonic friendship and erotic relations is porous in Mary Pendarves's world.

Given Mary's harsh words about men and marriage, and the fact that she no longer needed to marry out of economic duress, how might we read her decision to remarry? She defied her family's wishes in choosing Patrick Delany, a man of inferior birth and considerably less fortune than expected of a Granville suitor. But Patrick offered her two things she perhaps valued more: "The encouragement to persevere in her artistic works" and a garden.[21] In a letter pressing his suit, Patrick reminded her that his country house near Dublin included "a pleasant garden (better I believe than when you saw it [last])."[22] Significantly, his proposal also paid homage to Mary Pendarves's stated preference for friendship over marriage by offering an alternative notion of the relationship between the two states to the antagonistic one characteristic of his future wife's early writings: "I have long been persuaded that perfect friendship is nowhere to be found but in marriage, I wish to perfect mine in that state." By offering Mary friendship, Patrick Delany was able to gain her consent to marriage.

Mary Delany's biographer calls this relationship "a comfortable marriage based on companionship not passion."[23] (Delany seems never to have experienced pregnancy despite her two marriages to men.) There is no doubt that her residence at Delville was a time of great artistic productivity. Indeed, as we have seen, her marriage did little to impede Delany's other relationships, as she continued to correspond, visit, and travel with women friends throughout her time in Ireland. She writes appreciatively to Anne

Dewes that Patrick Delany "bears all my flirtations and rambles with *unchangeable good humour*."[24] In particular Mary resumed her intimacy with Letitia Bushe, seeing her almost daily for several years. But the sting of losing Anne Donellan to Miss Kelly remained, and it may have been the origin of a maxim Mary Delany often repeated in her later writings: "I have always made it a rule in any friendship never to be a monopolizer."[25]

After Patrick Delany's death, the sixty-eight-year-old Mary rejoined the aristocratic and cosmopolitan world of Georgian London with apparently undiminished energy. She continued her interest in communities of politically, artistically, and intellectually active women, sometimes visiting the bluestocking gatherings of Elizabeth Montagu. For almost two decades, she lived half the year with Margaret Bentinck at Bulstrode. It was in this shared household that King George and Queen Charlotte solicited Delany's acquaintance, lured by the fame of her botanical "paper-mosaicks." Delany dedicated this epic work, collected in an album, to Bentinck, as she wrote in an introduction dated 1779:

> To *her* I owe the spirit of pursuing it with diligence and pleasure. To *her* I owe more than I
> dare express, but my heart will ever feel with the utmost gratitude, the tenderest affection,
> the honour and delight I have enjoy'd in her most generous, steady, and delicate friendship,
> for above forty years.[26]

Women's friendship rather than heterosexual marriage remains Delany's major frame of reference here, as she dedicates her last major work of art for posterity. Mary Delany's philosophy of friendship was heterosocial in theory; she sometimes offered her friendship to men, and nothing in her thinking ruled out disinterested friendship between men and women. But the work of friendship, for her, could be said to be homosocial in practice because of its emphasis on place: habitation, locality, landscape. Because she could only live with men in marriage, and only live with women outside of it, women's friendships became her affective laboratory. Situated firmly in landscapes that she helped shape and build, these intimacies—with her sister Anne Granville, Anne Donellan, Letitia Bushe, and most importantly Margaret Bentinck, Duchess of Portland—were the basis for Mary Delany's extensive writings on the practice of friendship.

"A HIGHER HAPPINESS": ENGLISH NATIONALISM AND THE IRISH GARDEN

The only pleasure Mary Delany rated as highly as that of friendship was gardening: "Next to being with the friend one loves best," she wrote in 1732, "I have no notion of a higher happiness, in respect to one's fortune, than that of *planting* and improving a country, I prefer it to *all other expenses*."[27] For Delany, the construction of a "fairy spot of ground" was both a work of art and a work of friendship. Beloved places bore the mark

of beloved faces; she not only created landscapes and landscape art with and for her friends, she saw absent friends in landscapes they had shared. Her best documented landscape garden is at Delville, the home she shared with Patrick Delany in Glasnevin, Ireland. Mary Delany certainly spoke of her second husband with great fondness; they were the best of friends. But she also conceived of many of her innovations at Delville as making space for her women friends, and she even dedicated a portico at Delville to Margaret Bentinck. Throughout this period, she also made several trips to Bulstrode and drew designs for the Duchess's landscape garden there. One feature of Bulstrode in particular, the grotto, became a lifelong project for the two women.

Patrick Delany had begun work on the garden at Delville in 1719, twenty-four years before he married Mary Pendarves. The garden's origins lay not in marriage but in same-sex friendship: Delany and his friend Richard Helsham, a physician, began the project as a mutual pleasure, happily adopting the nickname that their friend and neighbor Jonathan Swift gave to the eleven-acre estate, Heldelville, which incorporated both their names. Eventually Helsham "became inactive" in the relationship, and the name was shortened to Delville.[28] Over the subsequent years, Delany improved his tiny estate, gleaning ideas from visits to such English gardens as Rousham and Twickenham, as well as from the eager assistance of Jonathan Swift, whose correspondence with Alexander Pope ensured ready access to the latest English ideas in garden design. Swift's verse description of Delville offers a richly satiric account of Patrick Delany's circumstances during the 1720s and 1730s while he established the garden with Richard Helsham. In fact, Swift wrote at least three poems twitting the clergyman for having written a verse letter to a local nobleman, asking for a court position that would help him defray the enormous expenses of his garden. In "An Epistle upon an Epistle from a Certain Doctor to a Certain Great Lord: Being a Christmas-Box for D. D−−ny," Swift is merciless toward both the finances and taste of his friend, writing in part:

> And you forsooth, your *All* must squander,
> On that poor Spot, call'd *Del-Ville,* yonder:
> And when you've been at vast Expences
> In Whim, Parterres, Canals and Fences:
> Your Assets fail, and Cash is wanting
> For farther Buildings, farther Planting.
> No wonder when you raise and level,
> Think this Wall low, and that Wall bevel.
> Here a convenient Box you found,
> Which you demolish'd to the Ground:
> Then Built, then took up with your Arbour,
> And set the House to *R−−p−−t B−−b−−r.*[29]
> You sprung an Arch, which in a Scurvy

Humour, you tumbled Topsy Turvy.
You change a Circle to a Square,
Then to a Circle, as you were:
Who can imagine whence the Fund is,
That you *Quadrata* change *Rotundis*?[30]

This poem sees Patrick Delany's gardening debts (the squandered "All," the unimaginable "Fund") with Swiftian double vision as both the comic extravagances of the overambitious squire and the necessary greasing of the wheels of local economy. It also tells us much about Patrick's taste. "Parterres, Canals and Fences" and "Walls" are typical features of the seventeenth-century formal garden, with its regular alleyways, balanced designs, and clearly marked perimeters. Similarly, the geometric design features of "Circle" and "Square" suggest the geometric aesthetic that was rapidly going out of style by the time Mary Delany moved to Delville in 1743.[31]

FIGURE 1.1 Drawing by Letitia Bushe, Mary Delany's Irish "love." *Landscape with "Le Tombeau de Latitia,"* 1731.
COURTESY OF THE LILLY LIBRARY, INDIANA UNIVERSITY, BLOOMINGTON, INDIANA.

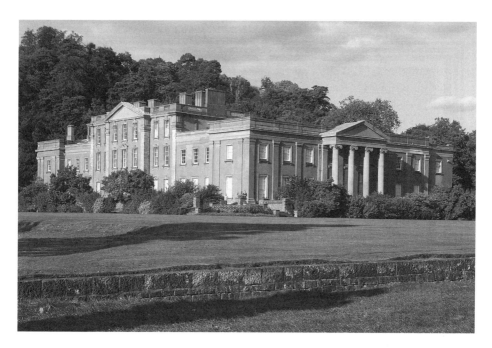

FIGURE 1.2 An example of a ha-ha, a sunken fence meant to preserve the view. Popularized by Lancelot "Capability" Brown, the ha-ha was characteristic of the new open English garden style that Mary Delany brought to Ireland. Himley Hall, Staffordshire, England. PHOTOGRAPH BY ILONA BRYAN.

By contrast, in a 1748 poem Laetitia Pilkington describes the garden's "prospects large and unconfin'd," suggesting that Mary Delany's influence on the garden helped create the more modern "natural" style associated with the innovator Capability Brown (Figure 1.1).[32] Mary Delany replaced much of the perimeter wall, for example, with ha-has, fences sunk into ditches so that the viewer saw an unbroken vista "into the central valley in which deer and cattle grazed."[33] In the context of an Englishwoman's intervention into the Irish landscape, these innovations carry a political as well as aesthetic weight. Brown's "English" style was so called by its proponents "in order to demonstrate that their nation was evidently progressive and free, not under an absolutist or tyrannical rule, as in France."[34] The ha-ha in particular, with its "project of tearing down fences," is "relished as a figure of liberty" in English landscape theory of the period (Figure 1.2).[35] (As mentioned in the introduction, the ha-ha also had equivocal sexual meanings, making possible erotic concealment in addition to open prospects.) If the English bluestocking saw her designs as liberating and modernizing the Irish landscape, however, the rocky coastal landscape had its own forms of resistance. Perhaps the recalcitrant Irish topography is one motive for Delany's Irish innovations to the "English" style. Her garden was full of hidden, irregular nooks and crannies, places of seclusion or effects of wilderness typical of the picturesque, "romantic-poetic" style usually associated with Humphrey Repton, whose practice did not start until the 1780s.[36] As both a site and a source of settler colonialism, Ireland occupied a paradoxical place in the construction

of English-speaking nationalisms of the eighteenth century.[37] Its garden history, too, is both an artifact of colonial oppression and a source of cosmopolitan styles diffused throughout the British Empire when Irish colonial administrators and settlers were themselves dispersed in the pursuit of imperialism.

Throughout the 1750s, Capability Brown was transforming the straight walls and hedges of English gardens into open parkland dotted with clumped trees and irregular lakes in the "natural" style that was to revolutionize landscape design. Mary Delany, through her own travels and through contact with prominent English gardeners such as Alexander Pope, was keenly involved in bringing such changes to her Irish gardens at Delville and Patrick Delany's second parish, Downpatrick. Brown and his followers thought of themselves as returning to nature by eschewing a highly formal aesthetic for one that was easy, open, and elegant. The next generation of designers, characterized by Repton, went even further in their appreciation of the natural in beginning to celebrate not nature's symmetry but her asymmetry, not the straight-growing oak but the blasted stump, not the clear, smooth lake but the rough waterfall. This picturesque aesthetic became predominant in Ireland, and Mary Delany's Delville was an important early example of this style, anticipating and perhaps even influencing Repton. The Irish garden historians Edward Malin and the Kight of Glin argue that the naturally mountainous and coastal landscape of Ireland, which made Capability Brown's shaved lawns impractical, influenced Repton in his 1783 visit to Dublin by inspiring him to begin trying to re-create the picturesque vistas of the Dublin area in his own English designs.[38] Thus, the picturesque aesthetic might be at least partly Irish in origin, and Mary Delany's Delville was its leading Irish example in the mid-eighteenth century.

As noted above, landscape design in Ireland has a distinct history, for "English" styles could not simply be copied in Ireland (any more than they could in Sarah Pierce's America, as I show in chapter 4). According to Malin and Glin, the wholesale deforestation and absentee landlordism that followed in the wake of Cromwell's plantation of English settlers in Ireland in the mid-seventeenth century had catastrophic effects on the Irish countryside (31). As landlords who owned Irish estates but lived in England pressed their lands harder and harder for cash income, forests were felled and agricultural land went unimproved. This tradition of absenteeism also meant that those with the means to design estate gardens had no inclination to do so in Ireland when they did not live there to enjoy the results. Thus, there were no extensive gardens built in Ireland in the Elizabethan and Jacobean periods, which were times of great productivity in the history of English garden design. During the eighteenth century, however, a period of relative peace and prosperity descended upon Ireland that facilitated a new interest in estate gardens (34). After several generations, many of the English settlers had been transformed into a new class of Anglo-Irish landowner that was much hated by the traditional Catholic aristocracy and certainly oppressive to the Catholic tenants upon whose labor their own wealth depended. Nonetheless, many settlers were "Irish" in their own minds

and sharers in some of the disadvantages of the colonized. Patrick Delany, as a priest and officeholder in the Church of Ireland, partook of this new spirit of improvement. It is not surprising, then, that he should have welcomed both Mary Pendarves's artistic talents and her English money in the project of improving his Irish estate.

Landscape gardens also required labor—and the wages paid to laborers—to maintain. Gardens were thus important contributors to the local economy, sometimes for generations, because of the scale of many estate park renovations.[39] The other material factor characterizing Irish landscape gardening is the topography of the countryside itself. The milder climate and higher rainfall of Ireland creates profuse horticultural growth little seen in England. In addition, the heavily indented coastline creates natural sea views and rocky promontories near or within many estates. The lough, or lake created by an arm of the sea, often avoided the necessity of creating lakes on an estate in order to conform to Brownian standards of beauty. In addition to its rocky shorelines, Ireland is also possessed of an often mountainous interior that while no boon to agricultural cultivation is certainly a natural strength for a designer attracted to the picturesque aesthetic. The colonial history of Ireland, which resulted in the wholesale destruction of Irish estate and ecclesiastical buildings, also contributed a central feature of the picturesque: the ruin. Such sought-after objects as "round towers, ruins of abbeys, monasteries and houses" did not have to be purpose built, as they often were in England: sadly, neglect and decay were all too common in the Irish landscape.[40] Thus, the influences of topography, economics, and colonialism, features later deemed picturesque, may have inevitably mixed with the English style in the Irish garden.

"A NEW WHIM": THE RIBALD GARDEN TRADITION AS A LESBIAN GENRE

The material conditions of Irish gardening practice shaped Delany's designs for the Delville garden. But another early conjunction of influences might be traced to a reference in a letter by Mary Hamilton, Delany's great-niece, who made long visits in the 1780s to the household her great-aunt shared with the Duchess of Portland. Hamilton wrote that her great-aunt remembered hearing in "her youth" about the Hell Fire Club, a group of libertines who supposedly met to celebrate black masses and pour out libations to Bacchus and Venus. According to Hamilton, Delany remembered that the club "consisted of about a dozen persons of fashion of both sexes, some of ye females unmarried," all guilty of "horrid impieties."[41] The leader of the Hell Fire Club, Sir Francis Dashwood, was also a notorious landscape designer of the early eighteenth century; starting in about 1745, he began renovations to create on his estate at West Wycombe near Oxford a "ribald garden."[42] The best-known features of this garden were the "Venus Temple" and "Venus Mound" that imitated, in the media of earth and stone, a woman's belly and vagina seen as if the woman were reclining on her back

FIGURE 1.3 An example of the eighteenth-century vogue for the "ribald garden," this structure was meant to imitate "the same entrance by which we all come into the world"—a vagina placed beneath a bellylike mound of earth. West Wycombe, the Venus Temple. PHOTOGRAPH BY DAVID CONWAY. COURTESY OF STEPHANIE ROSS.

(Figure 1.3).[43] The opening in the hillside below the bellylike mound (actually the grotto or temple entrance) was the subject of many jokes in the period; Dashwood's friend John Wilkes said of the temple that "the entrance to it is the same entrance by which we all come into the world and the door is what some idle wits have called the Door of Life."[44] Since Delany was familiar with the Hell Fire Club and spent much of her early life in Oxfordshire, there can be no doubt that she knew the West Wycombe garden, perhaps revisiting it during her trips to England during the 1740s and 1750s to visit her sister and Margaret Bentinck and to do garden research.

A drawing that Delany made of the hermit's retreat, or "Beggar's Hut," she designed for Delville shows a striking resemblance to the Venus Temple at West Wycombe (Figure 1.4). The gentle curve of a hilltop provides a horizon line across the middle of the drawing. The hillside below is furred with dark patches of shrubbery. Nested about halfway down is an arched doorway into the hill, much like Dashwood's "Door of Life." The shape of the doorway is prominently outlined by a stone arch. The texture of the drawing is soft, variegated, even fleshy. If not a conscious allusion to Dashwood's Venus Mound, it would seem that Delany's Beggar's Hut is at least strongly influenced by it. What does it mean that this bluestocking lady's representation of her own garden design should incorporate the opening under the hill that Dashwood made notorious? Certainly something other than the heterosexual rakery of the Hell Fire Club. In designing a ribald garden, Mary Delany was doing something distinctly unladylike and

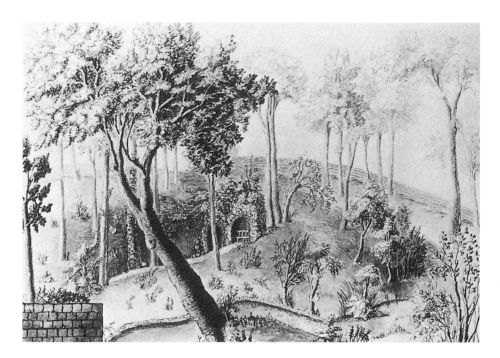

FIGURE 1.4 (ABOVE) Mary Delany, *A View of Ye Beggar's Hut in Delville Garden*, 1745. One of Delany's first projects in her Irish garden, this arched doorway placed beneath a hillside shares formal features with the Venus Temple. PHOTOGRAPH COURTESY OF THE NATIONAL GALLERY OF IRELAND.

FIGURE 1.5 (RIGHT) Thomas Jones, *A Scene in the Coliseum, Rome*. Jones's treatment of a hillside grotto contrasts with Delany's, showing that her drawing is designed to emphasize the anatomical associations of the Beggar's Hut design at Delville. Circa 1777. COPYRIGHT 2009 TATE, LONDON.

indicatively sexual. The Beggar's Hut places the artist in the role that Horace Walpole gave to Capability Brown: that of "Lady Nature's second husband."[45]

Delany's drawing is distinctive because it differs from the treatment of similar architectural and landscape features in the work of other designers and painters. Delany made hundreds of landscape sketches and copied famous landscape paintings in oil; she was very well educated in the conventions of the tradition. Her choices in making this drawing of a familiar subject, then, are informed and significant. In an oil sketch from the early 1780s by Thomas Jones, for example, we see a series of ruined archways in the Coliseum in Rome rendered monumentally (Figure 1.5).[46] The curved shapes with their dark interiors recede into space and are seen from below. The artist even gives us a glimpse of sky in the upper right corner. There is nothing in the subject itself requiring such a view: the foliage, rough stone, and underground entrances in the picture made it possible to depict the arches straight on and nestled into the earth. Delany clearly chose her distinctive interpretation.

What Fabricant calls the "dialectic of privacy and sociability, self-concealment and self-display," so important to the sexual emblematics of the eighteenth-century garden, can also be seen in Delany's work on two projects for Margaret Bentinck.[47] In a letter

from 1744, during the first summer after her marriage, Delany describes to her sister "a very pretty portico, very prettily painted within and neatly finished without," which was part of the original Heldelville garden.[48] By the following year, Delany appropriates this space for her own same-sex intimacies. She writes to her sister that she has dedicated her portico to the Duchess, and that one feature of the newly consecrated space is a work she calls a "shell-luster" or chandelier enameled with shells. This elaborate composition was, Delany remarks, an original idea of her own, a *new whim* that "shows the shells to great advantage."[49] The erotic and feminine connotations of shells, with their salty smell, vaginal shape, and association with Aphrodite rising out of the seafoam, were no doubt part of the effect of this work. With this unusual piece, Delany remakes the space of the portico, giving its dedication to her intimate woman friend a visual and spatial dimension. A second project for the Duchess also involved shells. On a visit to Bulstrode in 1743, Delany writes to her sister that the Duchess "intends to build a grotto in the hollow that you have a sketch of, and I am to design the plan for it."[50] The friends continued to collaborate on this intimate, concave interior space with its suggestive archway throughout the remainder of Delany's marriage (see the drawing of the grotto in Figure 2.8). After the widowed Delany moved to Bulstrode, she and the Duchess spent years decorating the grotto with shells and other artworks of mutual gratification. The grotto project was an occasion for furthering the spaces and occasions for their intimacy. Labor, craft, and art-making practices that mixed approaches high and low, professional and amateur, fine art and decorative have a significant relationship to one another not only in Delany's own oeuvre but in the group of works she created with and for other women, especially Margaret Bentinck and the Bulstrode circle. This context is even more illuminating when we come to interpret her famous botanical illustrations.

"THE CURIOUS HORTUS SICCUS": ENGLISH LINNAEANS AND THE REPRESENTATION OF WOMEN'S SEXUALITY

Delany's garden designs can be read as explorations of both female intimacy and female sexual anatomy. The same might be said about her beautiful flower mosaics from the 1770s. Arguably her greatest contribution to posterity, these "flower-mosaick" collages were perfected in her second widowhood, during which she spent six months a year living with the Duchess of Portland on the latter's Buckinghamshire estate. There, Delany worked with the famous botanical artists George Dionysius Ehret, Joseph Banks, and Daniel Solander, all frequent visitors to Bulstrode. They depended on her highly accurate collage images, expertly classified according to the newly popular Linnaean system, for their own work. Indeed, Banks and Solander visited Bulstrode just after their return from the South Pacific with Captain Cook. Profiting from such collaborations, Delany illustrated many of the estimated seven thousand plants that

arrived in Britain in the eighteenth century, as well as many native to the United Kingdom.[51] These collages are both a product and a project of British imperialism, and they were made possible by and further cemented Delany's sense of herself as central to a newly powerful definition of Englishness.

More immediately striking, however, is the lush and vivid sexual imagery that characterizes this group of works. *Papaver Somniferum, the Opium poppy* (1776), is a memorable example of this mammoth group of works (see Plate 2). It is as if the long view of her landscape drawing has given way to a close-up of the opened, vulval shape as Delany focuses meticulously on floral anatomy. These collages are distinctly unlike other eighteenth-century designs in their stark simplicity, marked by clear outlines and bold colors. The triangular shape of the whole composition, formed by three main stems joining at the bottom of the frame, is reminiscent of the mysterious V-shapes hidden by the folded hands of classic nudes. The slit in the seed pod on the left suggests an organism in an earlier stage of sexual development, which then is juxtaposed against the fully opened, blood-red blossom in the center as well as against the third pod depicted as dried up after blooming. Together, they suggest a sexual/botanical triad. The framing of all three blossom stems by the leaves, treated in a feathery, almost hairlike manner, works as another allusion to human and not just plant anatomy. This treatment of botanical features as if they were human hair is even more marked in *Passeflora Laurifolia, Bay Leaved* (1777) (see Plate 3). This image is a tour de force of artistic craft that in the bloom alone contains hundreds of tiny paper petals. The pink and purplish flesh tones of the blossom frame a stamen and pistil that spring potently from their soft, interleaved labial base. The clitoral connotations of this central structure are emphasized by the vivid circle of yellow surrounding it, as if to mark the bulls-eye of a target. And in *Magnolia Grandiflora* (1776) (see Plate 4), we see Delany's interest in representing exotic flowers brought back to England through trade and colonialism. This flower, originally from the Caribbean, was recorded in the New Jersey pine barrens by the famed botanist of North America, John Bartram, in the 1740s and was growing at Kew by the 1770s. As Delany's reputation grew, botanists and collectors sent her flowers so she could make a mosaic record of them. Again, the design of *Magnolia Grandiflora* is one of lush, overlapping, labia-like petals surrounding a central budlike structure that springs forward with preternatural force. Although hailed for their lifelikeness, there is nothing slavishly imitative in Delany's flower mosaics.[52] The lushness and vigor of her representations make them unique in the eighteenth-century visual canon as images of feminine sexual potency.

In the context of this emphatically anatomical imagery, Delany's lovely *Portlandia Grandiflora* works as an erotic tribute to the Duchess of Portland. The plant, originally from the Caribbean, was growing at Kew in 1782 when Delany made this image, "the associative plant portrait par excellence."[53] Named *Portlandia* in Linnaeus's *Systema Natura* (1758) in honor of the Duchess's work as a botanist, the flower was known for its

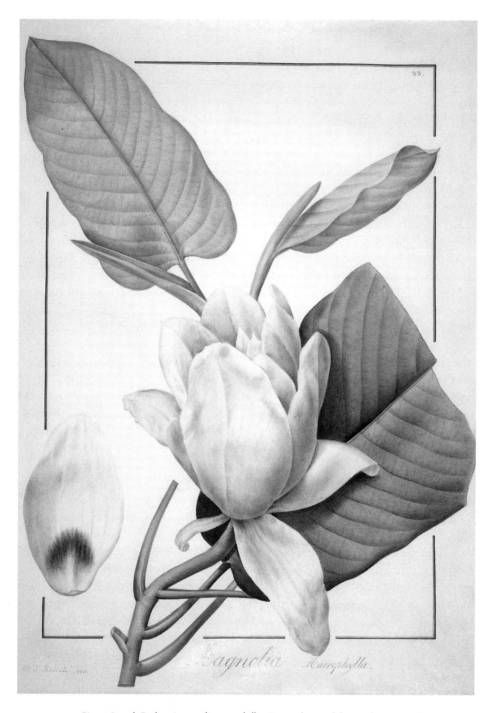

FIGURE 1.6 Pierre-Joseph Redouté, *Magnolia Macrophylla,* 1811. Redouté's delicate, almost translucent treatment is characteristic of botanical illustrations in watercolor, the favored medium of the period. The effect is very different from that of Delany's bold, matte paper collages. REPRODUCTION BY PERMISSION OF THE SYNDICS OF THE FITZWILLIAM MUSEUM, CAMBRIDGE, ENGLAND.

luscious, seductive scent. In the image, the bell-shaped flowers are shown in two pairs: gracefully arching pink-red buds above and heavy magnolia-white flowers, turned in profile this time, below. One of the flowers seems to hide modestly behind a large green leaf at the base of the stem, thereby adding a narrative quality to the way the image depicts the relationship between concealment and disclosure, that classic rhetoric of the ribald garden. The repeated pairing of similar plant parts—buds, flowers, and leaves—participates in this narrative by seeming to speak of the relationship between artist and subject as another beautiful pair in an erotic botanical context.

Comparing these images to more canonical renditions of similar flowers clarifies their distinctiveness. An 1811 *Magnolia Macrophylla* (Figure 1.6), by the renowned French flower painter Pierre-Joseph Redouté, is a much prettier and more conventional image than that by Delany. Redouté's use of watercolor gives his painting its signature translucency, and the delicacy of the creamy bloom on a white background, set off by luxuriant green leaves, is also typical of his work. By contrast Mary Delany's magnolia is a heavy yellow-white, its paper petals opaque against the startling black background. Not only the opacity of paper but its three-dimensionality distinguish Delany's illustrations. As collage, the designs have a physicality that is eschewed by watercolor art. The pasted-on slips of paper create a sculptural effect like that of haut-relief, and in some cases Delany has heightened this quality by working folds in the paper or even by pasting bits of the actual plant onto the page.[54] But the most striking difference between Delany's magnolia and that of Redouté is the position each artist has chosen for the flower. Redouté's blossom is chastely closed, presenting the outside of the vertically oriented petals to the viewer. Mary Delany has opened up her flower, seeming almost to pull the petals back to reveal the heavy, creamy yellow pistil in the center. This treatment emphasizes the clitoral appearance of the flower's reproductive parts, as well as the overlapping lips of the petals. The same difference is visible in the two artists' treatment of the poppy. Redouté's *Opium Poppy* conforms to what the art historian Alice Coats calls the conventional representation of this sensuous flower. Coats notes the "curious fact that both in painting and book-illustration this flower is more often shown from the back or in profile (with its leaves and buds) than from the front. . . . Perhaps the artists found the front-view shapeless."[55] Accordingly, Redouté shows us the back of the flower, thus hiding the plant's reproductive organs. Delany, however (perhaps following the example of George Ehret, a frequent visitor to Bulstrode who learned the technique from the German botanist Christoph Trew, an early patron), opens up the flower toward the front. Linnaeans such as Trew and Ehret insisted on the importance of this treatment in exposing the plant's reproductive organs in order to facilitate their system of classification.[56] The technique in Delany's hands serves to emphasize the dark areas at the base of each petal that give a suggestion of depth and mystery to the center of the flower cup. Delany, then, expresses an unconventional sense of what this flower looks like—not shapeless but anatomically shapely.

Delany's images also stand out because she placed them on black backgrounds. In this, she repeats the formal innovation of her celebrated court dress, which was created around 1740 as part of her bid for a court position. She designed the spectacular array of botanically accurate blooms scattered across the five-and-a-half-foot-wide skirt of the dress and then had them embroidered onto black silk rather than the buff or cream color usual for court dresses. The effect "certainly would have stood out," and its success may have played a role in her decision to mount her paper flowers on black grounds decades later.[57] Although dark backgrounds for botanical illustrations were not entirely unheard of, they were rare. A celebrated painter of botanical and zoological subjects in eighteenth-century Germany, Barbara Dietzsch, for example, frequently used a dark background for her paintings on vellum (see Plate 5).[58] The Duchess of Portland owned some of Dietzsch's paintings, and they may have influenced George Ehret to make a few botanical illustrations on black backgrounds while at Bulstrode in the 1750s.[59] The effect of Dietzsch's work, however, is quite different from that of Delany. Dietzsch's vellum backgrounds are not the matte black of Delany's paper ones but rather are a deep gray-brown, a tone varied by the natural textures of the animal skin. Dietzsch also chose a complex, subdued paint palette for the illustrations themselves, thereby rendering the contrast between image and background much less striking than that between Delany's monochrome reds, whites, and greens and their unmodulated black backdrop. Delany's images, while they come out of the traditions of women's craftwork and of botanical illustration, have a vividness and frank sensual appeal that is unprecedented in eighteenth-century visual culture. And her innovative choice to create paper collages rather than traditional watercolor paintings marks the *Flora Delanica* as an example of sister arts practice, one that mixes high and low genres, art and science, and plant parts, paint, paper, and glue to create representations that read on many levels, including the erotic.

It is not only the aesthetic boldness of these works, however, but also their taxonomic systematicity and botanical accuracy that distinguish them from those of flower-painters or flower-makers whose interests were primarily aesthetic. This factor connects Delany to the professional world of botanists such as Margaret Bentinck's visitors Ehret, Banks, and Solander. She also influenced the work of another Bulstrode visitor, the botanizing poet Erasmus Darwin. Darwin, like Delany, was a popularizer of the work of Linnaeus.[60] Darwin published "The Loves of the Plants" a year after Mary Delany's death, and he was a public admirer of her *Flora Delanica*. In his poem, he gives the work a stanza of its own. In his footnote to this passage, Darwin gives an early description of Delany's method in creating the paper mosaics, one based, as Anna Seward later pointed out, on hearsay, since he never met the artist:

> Mrs. Delany has finished nine hundred and seventy accurate and elegant representations
> of different vegetables with the parts of their flowers, fructification, &c. according with the
> classification of Linneus, in what she terms paper mosaic. She began this work at the age of

74, when her sight would no longer serve her to paint, in which she much excelled: between her age of 74 and 82, at which time her eyes quite failed her, she executed the curious hortus siccus above mentioned, which I suppose contains a greater number of plants that were ever before drawn from the life by any one person. Her method consisted in placing the leaves of each plant with the petals, and all the other parts of the flowers on coloured paper, and cutting them with scissars accurately to the natural size and form, and then pasting them on a dark ground; the effect of which is wonderful, and their accuracy less liable to fallacy than drawings.[61]

Darwin's description of the mechanics of making the images emphasizes their status as craftwork; in the same footnote he mentions another lady, "Mrs. North," who "is constructing a similar hortus siccus, or paper-garden." Like Delany's garden designs and her landscape sketches, her botanical illustrations promiscuously mix genres and traditions to create innovative sexual meanings. Darwin associates this paper collage method with women's artistic production, with domestic craft rather than high art, and with women's artistic communities.[62]

I sketch the wider queer and feminine legacy of this technique in subsequent chapters, but here it is worth noting that Mary Delany passed on the specifics of botanical paper collage in her own lifetime. She "certainly taught her technique to several ladies," and one, a Miss Jennings, helped her complete some of the last illustrations she made before her eyesight grew to poor to continue.[63] Mary Delany wrote approvingly of Miss Jennings that she was "a sensible, agreeable, and ingenious woman, a pupil of mine in the paper mosaic work (and the only one I have hopes of)."[64] Queen Charlotte, Mary Delany's late-life benefactor, created "a collection of dried plants pasted onto black paper, imitating the great paper collages of Mrs. Delany."[65] A younger artist named Charlotte Hanbury created a collection of nearly two hundred such collages as well.[66] Intriguingly, Delany may also have taught her technique to William Booth Grey, the brother-in-law of the Duchess of Portland's daughter Henrietta. A group of about ninety paper collages, created by at least five different people, are held at the Yale Center for British Art and are known as the Booth Grey collection after the original owner. Critics speculate that Booth Grey may have been more of a "patron or coordinator" than an artistic participant in this circle; his "participation in the female accomplishment of the collage appears unique, as no other gentleman is associated with that particular amusement."[67] Alternatively, however, Booth Grey's participation in Mary Delany's legacy, like that of Horace Walpole, as discussed in the next chapter, may signify the queerly heterosocial appeal of the lesbian sister arts for both women of masculine accomplishment and men with feminine interests. ✿

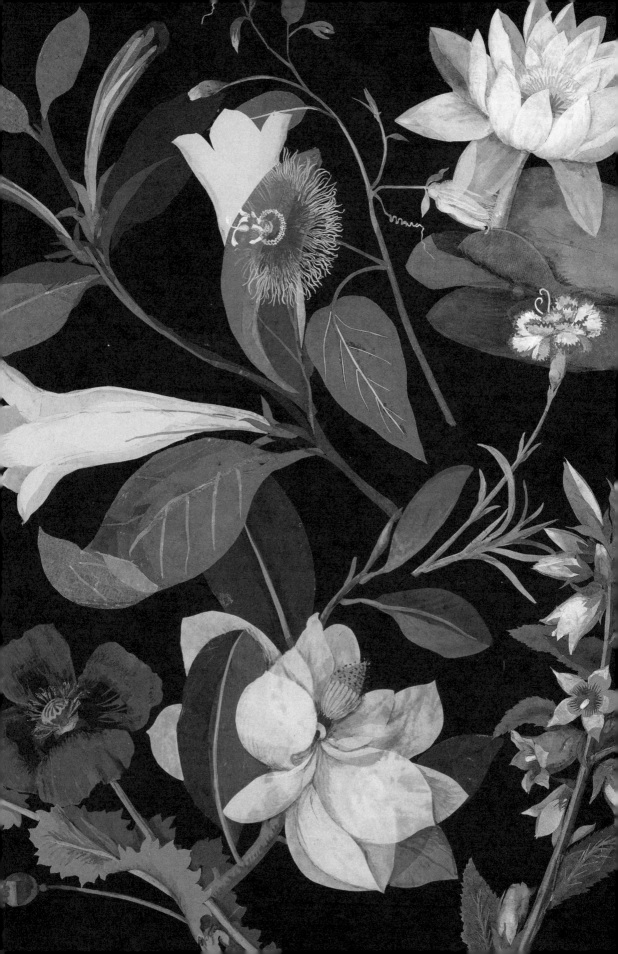

2

A Connoisseur in Friendship

THE DUCHESS OF PORTLAND'S COLLECTIONS
AND COMMUNITIES

MARY DELANY'S MASTERWORK, the *Flora Delanica,* resides in the British Museum, but the legacy of Margaret Harley Bentinck, Duchess of Portland, no longer exists (see Plate 6). Her immense collection of natural history, fine art, and antiquities, acquired over a lifetime of scientifically rigorous and lavishly funded research, was at the time the largest in Britain and possibly in Europe. However, while contemporary collections such as those of Sir Hans Sloane, Joseph Banks, and the Duchess's own father, Edward Harley, became the centerpieces of major museums, the Duchess's lifework was sold at her death to pay off the electioneering expenses and high living of her two sons (Figure 2.1).[1] As "matrimony" rather than patrimony, the Portland Museum was not seen as a family heirloom worth preserving. Also unlike Mary Delany, Margaret Bentinck did not leave a wealth of correspondence and other writing behind to secure her posterity. Although she was a regular, often weekly, correspondent of Mary Delany's from the time they met in 1736 until the Duchess's death in 1785, fewer than a dozen of these letters survive. Curiously, even the Duchess's letters to Jean-Jacques Rousseau, Edward Young, Queen Charlotte, and other eighteenth-century celebrities are for the most part no longer extant. And like Delville, the gardens at Bulstrode, redesigned entirely by the Duchess in collaboration with Mary Delany over a period of fifty years, have also disappeared, having been sold and divided in the nineteenth century. But a fragmented, collective, and collaborative record remains of the community the Duchess created at Bulstrode, a center of art, science, bluestocking feminism, and Tory electioneering that was a significant cultural engine of the mid-eighteenth century.[2]

Margaret Harley Bentinck was one of the great intellectuals of the Enlightenment. She came from a lineage of fearlessly accomplished women: her mother, Henrietta Cavendish Harley, was a renowned horsewoman who also restored the family seat at Welbeck in the Jacobean style and made it a showplace, and her grandmother, Margaret Cavendish (Figure 2.2), was a Restoration poet who authored, among many other works, the lesbian closet drama *The Convent of Pleasure.*[3] Margaret Bentinck inherited not just

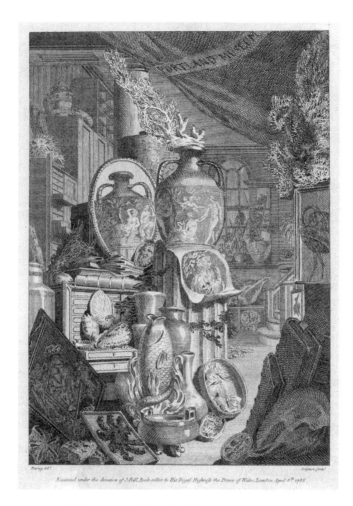

FIGURE 2.1 (ABOVE) Charles Grignion after Edward Francis Burney, engraving, frontispiece to John Lightfoot, *A Catalogue of the Portland Museum* (London, 1786). This catalogue of almost two hundred pages listed more than four thousand lots. The sale dispersing the Duchess's collection, the work of a lifetime, took thirty-eight days. COPYRIGHT THE HARLEY GALLERY.

FIGURE 2.2 (RIGHT) Print by Pierre Louis van Schuppen after Abraham van Diepenbeeck, *Portrait of Margaret Cavendish, Duchess of Newcastle, 1645–1673*. The Duchess of Portland's grandmother was a Restoration poet and dramatist and the author of many works, including the lesbian closet drama *The Convent of Pleasure*. COPYRIGHT TRUSTEES OF THE BRITISH MUSEUM.

learning but money and lands from her illustrious mother and grandmother; due to accidents of birth order and the complexities of family politics, the great Cavendish and Harley estates passed through the female line from Margaret Cavendish to Henrietta Harley to Margaret Bentinck. Yet the career of the Duchess of Portland exemplified not only this tradition of learned aristocratic women but an emerging social trend in which arguments in favor of women's education formed part of a new democratic humanism. By the time the Duchess died in 1786, the education of women had formed part of

Studious She is & all Alone,
Most visitants, when She has none,
Her Library on which She looks
It is her Head her Thoughts her Books.
Scorninge dead Ashes without fire
For her owne Flames doe her Inspire.

Revolutionary discourses extending women's responsibilities to republican motherhood and, briefly, even to citizenship.[4] Though she remained a thorough patrician in politics, the Duchess of Portland was nonetheless an important public figure exemplifying the achievements of learned women in this newly politicized context. She chose as friends some of the most accomplished women of her age. Writers, artists, and designers, these women shaped their relationships and daily lives around intellectual and artistic work while still fulfilling the social and familial obligations that came with their privileged stations in life. The Duchess of Portland—ambitious not for professional recognition, which would have compromised her status as a great lady, but for genuine learning, a sense of personal accomplishment, and acquaintance with the best minds in Europe—combined the tradition of aristocratic female learning with the emerging Enlightenment institution of the museum aimed at public edification. In the process she created a new world of women's art and science at Bulstrode.

"YOUR DELIGHTFUL LETTERS ARE THE JOY OF MY HEART": MARGARET BENTINCK IN LOVE AND FRIENDSHIP

Doted upon by her accomplished and wealthy parents, Margaret Cavendish Harley was encouraged in her academic pursuits and love of nature, and even as a child she had access to some of the leading intellectual figures of her day. Her mother, Henrietta Harley, Lady Oxford, was reputed to be the wealthiest woman in England, and she used her riches to create a famous renovation of the family estate, Welbeck in Nottinghamshire, thereby making it one of the architectural jewels of England. Her father, Edward Harley, was a bibliophile, collector, landscape gardener, and patron of the arts. Her education was supported by the great Harleian Library, and Edward Harley in letters to his own father spoke fondly and proudly of little "Peggy's" affinity for the natural world, and he encouraged her desire to follow the family tradition of collecting pets and natural history objects. At the age of five Margaret became the subject of a still-anthologized poem by Matthew Prior ("My noble, Lovely, little Peggy"). The Harleys were visited by Alexander Pope, Jonathan Swift, and leading aristocrats and politicians, all of whom made much of their patron's pretty only child.

But her childhood was a lonely one. Margaret's infant brother died at four days old in 1725, and as the only surviving child of her splendid parents, Margaret Harley was tempting bait for fortune hunters. She was closely guarded and rarely permitted out of sight of her governess, Philippa Walton, whom Margaret found oppressively strict. As she wrote, "I am not to Stir out of sight Least I should Break my nose or Tumble into the fire & if I was to go out I might be Stole for a Great Fortune."[5] Close friendships with other young women were her solace in this gilded cage. Two of these childhood

friendships, begun through family connections and sustained through letters and visits that were to last a lifetime, were especially important.

Elizabeth Robinson, whom Margaret nicknamed "Fidget," shared her intellectual interests and satirical bent (Figure 2.3). The few remaining letters between them are full of fantastic speculation and gossip conveyed through coded nicknames. After her marriage to Edward Montagu, Elizabeth became famous as the "Queen of the Bluestockings," the hostess of a group of intellectual women centered in London. (Mary Delany was to participate in this circle as well, although she was never as central to it as was the Duchess.) With a witty extravagance typical of their correspondence, Elizabeth Robinson urged her friend to attend a gathering at her own home, "if you think you shall be philosophically Disposed on Thursday":

> Indeed the Virtuosi are a quiet kind of people, & do not turn a meeting into a Rout or a Hurricane, but their Curiosity may be more troublesome than ye unthinking vivacity of the Gay: for they examine the motions of the heart, the Structure of the Head, & make nice Disquisition, into ye State of the Brain, whereas the Polite Visitant examines only the Brilliant Crop that glitters on the Bosom observes no more of the Head than the Curling of the Hair, and inquires no farther into the State of the Brain than to observe whether it has well directed in the choice of the Top Knott.[6]

This Swiftian satire of the shallowness of genteel society bristles with pungent language and bold images and ideas. The two brainy young women saw themselves as being in the polite world but not of it, and they made the most of their social power to pursue their philosophical interests and cement their own bond as women who see through the frivolity of the fashionable world they were born into. In another letter Elizabeth Robinson took her fantastic sense of humor even further by seeming to implicate the Duchess and their friends in some kind of secret coven:

> I have heard report Lady Man hemm'd in ye Antichamber & Mrs D−− taking it for the Brewing of the Book vanish'd but left something of a Diabolical scent behind her. I hear Lady Andover cross'd herself & said a short prayer old Lady Naplesford [?] taught her for sudden occasions, & that Lady Throckmorton has orderd five masses to be said for the peace & rest of Mrs D−−s Soul.

This imagery suggests that the "report" finds something "Diabolical" about what these powerful women do behind closed doors. Mrs. Delany in particular ("Mrs. D−−") is singled out as a fiendish creature who vanishes like a devil and for whom masses must be said to preserve her immortal soul. That Elizabeth Robinson addressed such tales to the Duchess of Portland speaks to the unconventional side of a lady who was also esteemed for her piety and virtue. Margaret Bentinck shared with Mary Delany a taste

FIGURE 2.3 Print by John Raphael Smith after Sir Joshua Reynolds, *Portrait of Elizabeth Robinson (later Montagu)*, 1776. As the "Queen of the Bluestockings," Robinson was a leading eighteenth-century intellectual and a lifelong friend of the Duchess of Portland. She dubbed the Duchess "a connoisseur in friendship."

for the society of women who raised eyebrows. Neither woman was afraid of a little scandal, and Bentinck relished the wit and heterodoxy of her intellectual friends.

There was, however, a coolness later in life between the Queen of the Bluestockings and the Duchess of Portland. In her thirties, Elizabeth Robinson married Edward Montagu, a wealthy gentleman but not an aristocrat. Her life was centered in London, and while Margaret Bentinck spent (and enjoyed) "the Season" there as her station required, her home and the center of her creative activities was the estate she married into, Bulstrode in Buckinghamshire. By the 1750s Elizabeth and Margaret had drifted apart. The Duchess even makes fun of her old friend in a letter to her son at school: "She is grown quite foreign and speaks broken English from her trip to Spain for six weeks with Ly. [Lady] Bath she told me *mi Lor he make verse all day long.*"[7] But there is no doubt that having Elizabeth as a confidant and colleague in her youth provided fertile ground for the flowering of both Margaret's intellectual talents and her sense of herself as set apart for better things than the ordinary aristocratic lady.

The young Margaret Harley's letters to Catherine Collingwood, her second important childhood friend, are much more passionate. Gossip is more intimate (the girls referred to Margaret's odious governess as Long Nose), and rather than seeking to entertain one another with wit, Margaret and Catherine assured one another of their extravagant love. Catherine shared Margaret's interest in plants and animals, and the nicknames and codes they used in their letters reflect this: "I think you should address Flora to be an Anenome, which always closes as the dew falls upon it and opens with the rays of Phoebus, and is a most beautiful flower!"[8] In the same letter, other friends are referred to as Roses and Nettles. Catherine herself is the Collyflower, and Margaret's husband Sir William Bentinck is referred to between the friends as "Sweet William":

> Now I think I have given you a full account of the gardening affairs. The Sweet William's as agreable as ever, and more so if possible; I wish you knew more of that flower, for I am sure you would be quite charmed with it; I assured you the *Collyflower* is a great favorite, and I don't doubt of its growing more so the better it is known.[9]

The sincere warmth of Margaret's feeling for her husband is indicated by the bestowal of a botanical nickname, putting him on the same level of intimacy as Catherine herself, long known as "the Collyflower." If for Mary Delany affections were to be built into gardens, for Margaret Bentinck they were to be cultivated like plants.

A crisis occurred in this friendship, however, in 1737. Margaret Bentinck learned from a third party that Catherine Collingwood, a Roman Catholic, had decided to enter a convent. Margaret, only three years the Duchess of Portland and still in her early twenties, was aghast at the prospect, assuming it meant losing contact with her intimate friend forever. The eighteenth century was the lowest point for Catholic civil rights in English history. Catholic males could not vote, and property and inheritance

rights were severely limited. Friendships between young Protestant and Catholic girls were probably rare, and it is unlikely that Catherine Collingwood spoke openly to her friend about her faith. Although this incident predates both Diderot's *La Religieuse* (1760) and the Radcliffean Gothic romances of the 1780s, Margaret Bentinck's reaction seems to participate in the literary stereotypes that these works popularized: the "forced vocation" narrative in which the ignorant Catholic maiden is coerced by the corrupt institutions of family and church to give up her freedom by taking the veil. For an English Catholic, joining a convent entailed further sacrifice because all Catholic religious institutions had been exiled to the Continent since the seventeenth century. English convents abroad were at the center of communities of exiled Catholic nobility and gentry and could even serve as centers of Jacobite organizing. Although in continental societies convent life could be seen as offering women freedom from family pressure to marry as well as opportunities for education and female community, such positive views of female religious life were unavailable to Margaret Bentinck. For her, the prospect meant only that Catherine was leaving England—and leaving her—for an uncertain and menacing future.[10]

Margaret's letter to Catherine at this time is full of feeling; it is the most passionate document we have of the Duchess's inner life:

> Dear Colly:
>
> Since my letter went last post, I have heard a piece of news that gives me great uneasiness— that you are *certainly going into a monastery!* I should have imagined you would have wrote me word of it, then I considered you were sensible it would give me vexation, and that (as indeed it has affected me extremely) prevented your telling me so disagreeable and cruel a piece of news. To be parted from my dear Colly for ever! the thoughts of it I am not able to bear. Good God! What motive in the world can induce you to *bury yourself alive* and leave your dear mama—who doats on you, and all your friends to whom you give the utmost torment? *It is barbarous* in you to forsake one in that manner. . . .
>
> I am not able to write more; for my heart is too full, and overflows with so much affection and grief, that it will not let me utter half what I think or feel. My dear friend, let me know as soon as possible whether I must remain miserable; *do not keep me in suspense,* for that will be cruel and against your nature; adieu, angels guard you and every happiness attend you! Wherever you are, or whatever you do, I shall be your faithful and Affectionate friend till *death.*[11]

By this time the Duchess had already begun to correspond with Mary Pendarves (later Delany) and her sister Anne Granville (later Dewes). They joined their entreaties to hers in a series of letters attempting to dissuade Catherine Collingwood from leaving by representing the consequences to the Duchess's health and happiness

as severe and reminding Catherine of all the Duchess had always done for and meant to her. Something in this effort apparently worked, for later that year Catherine Collingwood married and became Lady Throckmorton. As such, she remained part of the Duchess's inner circle until her death.

This letter bears a considerable burden of representation as one of the few documents in the Duchess's own voice to survive; it was preserved by Lady Augusta Llanover, who added it to the multivolume collection of writings by and about Mary Delany that she edited and then published in 1861–1862. And while her letters to Elizabeth Robinson and later to Mary Delany and Lady Andover do preserve evidence of her love and attachment to these women, nowhere do we hear the voice of naked desperation so clearly as in the letter to Catherine. Not just "disagreeable" but "cruel"; not just "*barbarous*" but resulting in "the utmost torment"—Catherine Collingwood's proposed isolation from the world is less a religious issue for Margaret Bentinck (elsewhere in the letter she says, "*As to your religion, I won't enter into it*") than a question of love, loyalty, and abandonment. Interestingly, Catherine kept the news of her decision from her friend, apparently surmising correctly that Margaret would do everything in her power to prevent her from following through on her decision. The Duchess uses charged, high-stakes rhetoric to represent to her friend the dire consequences, including religious terms ("utmost torment," "angels guard you"), rational persuasion ("what motive . . . ?"), and Gothic horror ("*bury yourself alive*," "*barbarous*," "*suspense*"). But the most consistent vocabulary is that of the desperation of inexpressible love. Catherine is called "cruel" twice, and the Duchess represents herself as "not able to write more; for my heart is too full, and overflows with so much affection and grief, that it will not let me utter half what I think or feel." The beating heart of the letter, however, is the exclamation in the middle: "To be parted from my dear Colly for ever! the thoughts of it I am not able to bear." Despite her happy marriage, great wealth, absorbing intellectual pursuits, and even other close women friends, for the Duchess, Catherine Collingwood was irreplaceable. At the end of the letter the writer seems to pull herself together and attempt to use the power of her undying love to reach her friend: "Wherever you are, or whatever you do, I shall be your faithful and Affectionate friend till *death*." Such assertions of eternal love, unaffected by place, time, and circumstance, come straight from an epistolary novel—and straight from the heart. We have no comparable record of the Duchess's feelings for her husband.

There is no doubt, however, that Margaret's marriage to William Bentinck, the Duke of Portland, was both a relief and a choice that augured well for her future happiness (Figure 2.4). Given her dangerous position as a young heiress and the increasingly untenable situation at home—not only was she walled up like a princess in a tower but her father, whom she adored, had begun to drink heavily and had mired the estate in debt—her guardians saw marriage as a necessity. Although William Bentinck was selected from all of her splendid suitors by her parents, their criteria were not only

FIGURE 2.4 C. F. Zincke, *Portrait of William Bentinck, Second Duke of Portland,* 1734. "Sweet William" gained the approbation of the Duchess's women friends on their marriage. He preferred flower gardens to the more gentlemanly pursuit of landscape design, which he left to his wife and Mary Delany. COPYRIGHT THE HARLEY GALLERY.

that his wealth could mend the family fortunes but that he seemed less addicted to fashionable vices than were most young men of his station. Indeed, "Sweet William" gained the approbation of all the Duchess's women friends, including Mary Delany, whom he included on a trip he planned to see the cabinet of Sir Hans Sloane in 1739. The planning of such a treat as well as his inclusion of his wife's closest friends (Mary Delany, her sister, and "Miss Dashwood") show great thoughtfulness toward his wife.[12] Another friend, Anne Vernon, wrote to Catherine Collingwood upon hearing of the Duchess's marriage, "I am very happy Lady Margaret is to be released *out of her prison.*"[13] Mary Delany's first marriage, arranged by her family for dynastic reasons, was itself a prison, but Margaret Bentinck's marriage was emancipation. It enabled her career

as a natural philosopher, and the couple remained companionable until the death of the Duke in 1762.

According to contemporary commentators, however, the friendship between Mary Delany and the Duchess of Portland surpassed all others in their lives. Those who wrote letters to one lady, especially when they were at Bulstrode, invariably asked after the health of the other; their mutual regard seemed only, according to Lady Llanover, to "*strengthen with age.*"[14] Horace Walpole's first thought on the Duchess's death, as we shall see later, was not for her children but for Mary Delany. For Mary Hamilton, a young lady-in-waiting to Queen Charlotte who met the pair at the end of their lives, the relationship seemed a model of excellence,[15] to be celebrated for its longevity, mutual devotion, and artistic, scientific, and intellectual fertility. The two women sought intimacy with one another amid the crowd of family, friends, social obligations, and work that characterized both of their lives: as the Duchess complained to Anne Dewes, "I have been much taken up I have hardly had a Tête a Tête with Penny [Mary Pendarves] this fortnight."[16] Using the same phrase for the intimacy of the couple, Mary Delany tells her sister how she enjoys the opportunity provided by the Duke's absence, when she can be the Duchess's "constant attendant, Monday, Tuesday and Wednesday the three days the Duke spent at Windr [Windsor]. Such tête a têtes you know are rarities."[17] Surpassing even the Duchess's friendship with Catherine Collingwood in longevity and productivity, if perhaps not in youthful passion, the relationship between Margaret Bentinck and Mary Delany was at the center of each of their lives as mature women. They shared work, family responsibilities, and often a household, and they valued what they built together enough to try to pass it on to younger women.

Although both women had happy marriages, those relationships did not become famous as did their devotion to one another. Indeed, while Mary Delany's marriage to Patrick Delany lasted twenty-three years, until his death in 1766, her relationship with Margaret Bentinck lasted nearly fifty years, from their meeting in 1736 until the Duchess's death in Mary Delany's arms in 1785. In addition to the visits of several months that Mary Delany often paid to Bulstrode while headquartered in Ireland, the two women lived together at least part of every year for the seventeen years between the death of Patrick Delany and that of the Duchess herself. Their relationship was as much an institution as their marriages. So involved was Delany in the upbringing of Margaret Bentinck's daughters (Lady Weymouth and Lady Stamford), in fact, that the artless three-year-old Princess Mary once asked Delany during a visit to court if she were "another mamma of Lady Weymouths."[18]

What was the nature of this relationship? Although it was admired and even idealized in its day, it has been controversial ever since. The novelist Frances Burney, who befriended the Duchess in the 1780s as an attendant of Queen Charlotte, reported in her diaries that Mary Delany was dependent on the Duchess, hinting that she might even have been a paid companion. It is true that on the death of Patrick Delany the

Duchess made Mary Delany an interest-free loan of four hundred pounds so that she could buy a house in London, and that amount was still not repaid when the Duchess's will was probated in 1785. But that seems to have been the only financial transaction between the two of them.[19] As I note below, they exchanged gifts constantly, both things they made and things they bought. As a member of the landed gentry the Duchess had access to game from her estate, and she often sent to Mary Delany presents of meat and other provisions. But, on the surviving evidence, this doesn't rise to a level of economic dependency. Mary Delany was financially independent enough to refuse ten offers of marriage before she wed Patrick Delany, and although a lawsuit diminished the Delany estate before his death, her own income remained in her hands from before her marriage.[20] There is nothing to indicate that she would have needed a home or an income provided by the Duchess or anyone else. Lady Llanover, in her role as editor of the 1861 collection of Delany's writings, goes to great pains to refute what she regards as Burney's calumny.

Nonetheless, the story has been repeated by contemporary commentators.[21] Other than Burney, one source for this misunderstanding might be the rank-inflected language that Mary Delany used to refer to the Duchess, especially when speaking of her to others. In letters to others, she invariably referred to her friend as "The Dutchess of Portland," "the Duchess" (she used both spellings), and occasionally to great intimates, "our dear Duchess" or "our precious friend at Whitehall [her London residence]."[22] (As was conventional, she also referred to her husband and even occasionally her mother by their surnames.) And at times it seems clear that the Duchess's claims of rank mean that Mary Delany feels she must consult her friend's convenience before her own: "I shall go to-morrow to Bill Hill, Lady Gower's, and shall stay there till the Duchess of P. sends a summons for Bulstrode."[23] At other times, particularly when Margaret Bentinck was ill or distracted by the illness of a child or grandchild, Mrs. Delany served as her secretary, answering even personal correspondents such as Lady Andover: "The Duchess of Portland was happy with your Ladyship's letter this morning." In some letters, however, Delany seems to be sending up the hierarchy between herself and the Duchess. In another letter to Lady Andover, for example, she satirizes her role as secretary by saying that the Duchess "is thank God very well, & good as–– but I dare not say what, as perhaps she will see my letter." Sometimes Delany goes even further, referring to "my inexorable Law Giver" and "my tremendous Dss [Duchess]."[24] Such teasing language is itself a sign of intimacy and certainly did not preclude direct expressions of great affection, even when expressed to a third person rather than the Duchess herself. Mary Delany's letters are full of such references, as in the following:

> I cannot see and hear everybody admire our dear Duchess without sighing, that she should
> be everybody's more than mine, for her conversation is really so great a pleasure and
> advantage, that I must regret the days and hours that destine it to a crowd.

And this:

> I have here such Happy enjoyments of my Dear Friend's company as cannot be expected in
> London, tho she is all goodness to me there, & every where. She has thank God had not back
> return of her Rheumatism . . . she is a gem of inestimable Price & worthy of being preserved
> with the Utmost care.[25]

It seems that the difference in rank between the two friends, like the difference in status between a man and a woman in the same society, could be experienced as a source of admiration, wit, and affection—and perhaps even as erotic difference.

In contrast to Mary Delany's respectful, if witty, formality, the Duchess referred to her friend by nicknames ("Aspasia," "Penny" for Pendarves) or simply as "Mrs. Delany."[26] The Duchess's style is less literary and more formulaic than that of her more writerly friend: "O! my dearest friend how happy I am the time draws so near for our meeting"; "I hope to-morrow to see dear Mrs. Delany, and that I shall have the joy and comfort of bringing her back with me on Wednesday."[27] The most extended account of the Duchess's feelings for Mary Delany come from a short letter from 1776:

> My dearest dear friend, I have worried you with two immoderate long letters, and I believe
> in both stopp'd short in the middle of a sentence (lest I should be too late for the post); your
> delightful letters are the joy of my heart. The other day I was on the beach, the wind blew a
> brisk gale; I got into a little sand grotto, and read your charming letter over and over while
> Mrs. Le Cocq was traveling about in search of shells, butterflys, and plants.[28]

Mary is her "dearest dear friend," the dearest of all. When the Duchess is away from her (as here, on vacation at the seashore for her health), she fills her time by either writing or reading the long letters they exchange. Even her favorite activities of collecting "shells, butterflys and plants" fail here to pull her away from the greater pleasure of communion through her friend's "charming letter." Interestingly, the Duchess describes the sheltered place she finds to read and reread her friend's words as a "grotto"; I describe below how grottoes were places of special significance in the iconography of the intimacy between Mary Delany and the Duchess of Portland.

Margaret Bentinck had passionate friendships with other women, as well as a happy marriage with the Duke of Portland that produced five children. What can we say about her erotic or romantic life on the basis of this meager evidence? Certainly some of her letters betray an intriguing pleasure in gender play: she has several masculine nicknames for Catherine Collingwood, for example, including "the Doctor," and in a letter to Collingwood she remarks about another pair of friends, "I am surprised by what you tell me about Lord Charles; there is some great alteration, and I imagine lady Sophia and she will be inseparable till they quarrel about a lover, which is not improbable." Even the

Victorian editor Lady Llanover notices, and remarks in a footnote to this passage, that "Lord Charles is evidently a lady."[29] In another letter to "Colly" from the same source, the Duchess notes that "Lord Rockingham is cried up for a great beauty. I think his face would be prettier for a woman; he is not so tall as my lord, and very slender, so that he looks quite a boy, and he has Lady Mary Sanderson's voice" (545). Another reference shows her sharing Mary Delany's sense of women's exceptionality, idealizing women's community with a classical allusion. As she writes to Catherine Collingwood,

> If you pick up any rarities or curiosities, pray keep them against I come to town, and don't lose them as you did the half moon; I think that is a bad omen, to be so negligent of Diana's badge. (514)

Just as friends are linked with flowers and thus botany for the Duchess, so too are they linked with collecting "rarities or curiosities," and here with women's communities (the wearing of "Diana's badge"). The Duchess here refers to a symbolic gift ("the half moon") that seemed to stand both for her friendship with Catherine Collingwood and for their joint connection to a larger community of women. Both botany and collecting are figured as ways of connecting with other women, and such connections are identified and authorized by references to classical stories of women who lived apart from men.

Further, the Duchess makes explicit reference to a Sapphic relationship, again in a letter to Colly, when she thanks her friend for some gossip about a mutual friend they call "the Speaker":

> I am of your mind about *the Speaker*; for I am sure she has had much such far-fetched thoughts; I don't imagine Sappho will be *out of favour* these seven years; though the passion is so violent, one could hardly think it would last so long, yet I can't answer for anything in this world: a thousand thanks for your intelligence. (563)

Although references to Sappho in this period were sometimes references to lyric poetry rather than lesbian sex, such is not the case here. "Sappho" as a figure for "violent" "passion" between women was evidently part and parcel of the social world shared by Margaret Bentinck and Catherine Collingwood. At the same time, the Duchess is clearly making a distinction between "such far-fetched thoughts" and her own relationships; like Mary Delany, she seems to know of Sapphic relationships but considers them quite different from her own friendships, even when the cast of characters overlaps. She does, however, notice and comment upon female beauty: "Cherry could hardly be spoilt with the small pox, for I suppose that pretty forehead remains, cat's eyes, and fine chin . . . I think Lady Mary Finch very pretty sure"(516). These are not the evaluations of a rival for male attention, but of a connoisseur of "rarities" who appreciates female beauty as an object of *vertù* and a source of pleasure.

As a connoisseur of women's beauty and women's friendship, the Duchess created a precious collectible that allowed her to keep her women intimates—or at least their beautiful images—close to her body at all times. Around 1740, she commissioned the court miniaturist Christian Friedrich Zincke to create a folding gold box decorated with portraits of herself, Elizabeth Robinson Montagu, Lady Andover, and Mary Pendarves (see Plate 1). For these portraits, each lady wore a costume that seems to have related to their private code of nicknames: the Duchess was Flora, with a rope of flowers across her bosom; Elizabeth Montagu appears in a period dress and headpiece she called "Anne Boleyn's dress"; Lady Andover is in a fur-trimmed dress perhaps meant to evoke Diana, goddess of the hunt; and Mary Pendarves wears a velvet drape that also recalls Renaissance fashion, especially the portraits of Peter Lely.[30] The edge of the box is decorated with floral and botanical designs in enamel; its tiny scale, according to one critic, "invites the intimacy of fond handling and close looking."[31] Each figure looks the same way, to the viewer's left, so that when the facing portraits are folded up into their flower-edged ring of gold, they face each other as if kissing.

The Duchess's friendship with the flamboyant Horace Walpole also suggests that she was on the fringes, at least, of some eighteenth-century homosexual worlds (Figure 2.5).[32] With Walpole she "shared a network of suppliers of natural history objects—sailors, ships' naturalists and travelers."[33] Walpole never hesitated to speak to and about the Duchess in sexual terms, describing himself when executing one of her collecting commissions among the sailors as "bawding for the Duchess of Portland" and calling her the "imperial procuress."[34] Walpole's nickname neatly brings together the Duchess's wealth and social standing with the global reach of her desires as a collector, casting them all in mischievously sexual terms (a "procuress" is a bawd or madam). Their friendship lasted until and even beyond the Duchess's death. Walpole was distraught to hear of his friend's passing and his immediate thought was for her longtime companion, Mary Delany. As he writes to a mutual friend:

> By a postscript in a letter I have just received from Mr. Keate, he tells me the Duchess of Portland *is dead*! . . . I fear it is but *too true*! you will forgive me therefore for troubling you with inquiring about poor Mrs. Delany! It would be to no purpose to send to her house.[35]

For Walpole, Mrs. Delany was the bereaved party, never mind the Duchess's surviving children. Walpole attended the Duchess of Portland's sale and wrote an account of her collection and its provenance in the flyleaves of his own copy of the sale catalogue. No doubt one goal was to establish the value of the pieces he himself purchased from the collection, but his writing also served the purpose of memorializing the Duchess's life's work at the moment of its dissolution. His language in describing her activities is that of desire: he speaks of her "passion" for collecting, as "indulging her taste" and "sparing no expence to gratify it." For Walpole, the Duchess was a sharer in his own "taste" for

"odd" items and a citizen of his aesthetic world.[36] The boundaries between friendship and erotic intimacy, between homosocial and homosexual, and between aesthetic and sexual taste, were far from distinct in the world of the Duchess of Portland. She may not have considered herself a "Sapphist," but her life and work belong to lesbian history.

"THIS GREAT VALUABLE COLLECTION": A MISSING LEGACY

In life, both the Duchess's person and her collection inspired passion. Posterity, however, has treated both more coolly. In thinking about why the Portland Museum was not kept intact or gifted to the nation as were other major collections in the period, I find myself fascinated by one story in particular. Margaret Bentinck's father, Edward Harley, had by the time of his death in 1741 amassed an important collection of printed books and manuscripts, "the most choice and magnificent that were ever collected in this Kingdom," in the words of one of his contemporaries.[37] This was the famous Harleian Library that educated the young Margaret, and it is the major reason Edward Harley merits an entry in the *Oxford Dictionary of National Biography*. As early as 1726, Harley had amassed considerable debt in his single-minded pursuit of rare books and manuscripts. He sold the family home at Wimpole in order to stave off disaster, but he was unable to retrench and turned increasingly to alcohol to medicate his money worries. Upon Edward Harley's death, most of his collection was sold, but Margaret Bentinck and her mother retained arguably its most valuable and distinctive aspect, the manuscripts. By 1753, however, even these had to go. Loathe to disperse the work of her father's lifetime and the last monument to her own learning, Margaret Bentinck arranged for the sale of the Harleian Manuscripts to the nation for ten thousand pounds, a fraction of their value but enough to restore the estate to solvency for the time being. The Harleian Manuscripts, along with the collections of Sir Hans Sloane and Robert Cotton, formed the tripartite basis of the British Museum, which was established by act of Parliament later the same year. Margaret Bentinck made sure that despite his imprudence, her father's passionately loved collection became a fitting monument to his life and a recognized national treasure by vowing that "this great valuable Collection shall be kept together."[38] Why did she fail to secure her own legacy thirty years later, allowing the Portland Museum to be sold and dispersed, when she clearly knew how to broker a deal that would have both realized some of its pecuniary value and preserved it for posterity? Why is the Duchess's collection missing from the British Museum?

Theories of collecting—anthropological, historical, psychological, Marxist, poststructuralist, and feminist—abound that might help us approach this question. Scholars agree that collecting is an important form of self-fashioning, as it provides, in the words of Russell Belk, "definition of self, fulfillment of fantasy, development of a sense of mastery, construction of meaning and purpose in life." Yet the corollary of

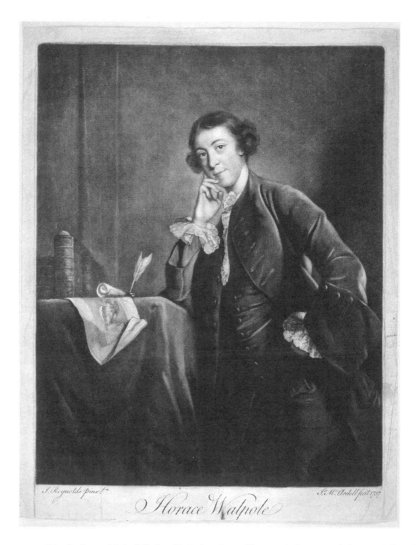

FIGURE 2.5 Print by James McArdell after Sir Joshua Reynolds, *Portrait of Horace Walpole*, 1757. A friend of many decades, Walpole shared the Duchess's antiquarian tastes. His activities "bawding for the Duchess" overlapped her world of piety and propriety with the elite homosexual subcultures in which he participated.

such theories involves careful attention to legacy: "The collector's desire for immortality" is taken as given. Collections, according to both anthropological and psychological theories, have a "sacred status" for collectors and viewers alike; collectors are supposed to be dominated by "the fear that [the collection] might fall into the hands of somebody who would profane it by failing to appreciate and it care for it properly."[39] Citing Sloane and Tradescant, Marjorie Swann notes that "early modern collectors agonized over what should become of their collections after their deaths"; certainly Margaret Bentinck's care for the Harleian Manuscripts bears out her own involvement in this question of legacy.

The fear was that "the previous owner of a group of objects could become absorbed—dissolved—within another man's collections," thus negating the lifetime work of identity building represented by the collection.[40] Such conclusions, however, clearly fail to account for the Duchess's dispersal of her museum. Given women's distinct relationships to inheritance and property in this period, it makes sense to ask what difference gender makes to our understanding of the collector's work of identity and legacy.

Considerations of gender in the literature on collections range from the reductive ("Women are creative in a sense in which men can only be creative symbolically: they bear children. It has been conjectured that this is one reason why women figure much less prominently than men in . . . collecting") to the unhelpfully general ("All collections reflect wider cultural rules—of rational taxonomy, of gender, of aesthetics").[41] The assumptions usually made about women's collections—for example, that "many accumulations created by women fall outside the traditional view of what constitutes a collection," as Susan Pearce notes—seem not to apply to the Portland Museum.[42] In the only dedicated study of the role of gender in collecting, Belk and Melanie Wellendorf argue that "men's collections are taken seriously while women's purchases are regarded as frivolous consumption."[43] It is unlikely that the Portland Museum, patronized by serious natural philosophers from Rousseau to Banks, could have been regarded this way. The same study goes on to argue that "women's collections tend to represent achievement in the world of connection to other people" while men's collections exemplify "the powerful achievements of masculine control over nature."[44] The Duchess's collection would seem to have manifested both of these qualities. In the pages that follow I argue that not only was the Portland Museum important in creating connections among women but also it was a prestigious natural history collection that would seem to assert "control over nature"; its other holdings were in the equally serious realm of antiquities. None of these accounts of the role of gender in collecting practice adequately describes the Portland Museum, it would seem. What is missing?

The role of sexuality in motivating the collector has been axiomatic since the time of Freud: "All collectors are anal-erotic" said one early psychoanalyst in 1912. Equally bluntly, another opined in 1927 that "a passion for collecting is frequently a direct surrogate for sexual desire."[45] However bald such statements may now appear, their assumption that collecting may represent an otherwise unrepresentable desire—including same-sex love—is at the root of psychological understandings of the topic. Anthropologists also conclude, as one scholar notes, that collecting "is grounded in passion rather than reason."[46] And another adds that in creating a collection, "the self generates a fantasy."[47] What "self," what "fantasy," is produced by the Portland Museum? It is one characterized by shells and other women. Recent "thing theory," as termed by Bill Brown, refines this approach by suggesting that all objects have the "potency" to "organize our private and public affection."[48] Belk and Wellendorf conclude their article by suggesting that collections allow "both genders to participate in the feminine world of consumption in

a way that simultaneously supports the masculine world of production"; collecting may permit "experimentation with androgyny as an individual participates in the masculine hunt for additions to the collection as well as feminine nurturance in curating the collection."[49] No consideration of collection as a landscape genre can fail to consider the relationship between collecting practices and colonialism, imperialism, nationalism, and indigeneity. As the essayist Anne Fadiman puts it memorably:

> Taxonomy, after all . . . is a form of imperialism . . . Take a bird or a lizard from Patagonia or the South Seas, perhaps one that has had a local name for centuries, rechristen it with a Latin binomial, and presto! It has become a tiny British colony.[50]

Thomas notes that for Enlightenment collectors such as the Duchess there exists

> a tension between an unstructured apprehension of diverse things ["curiosity"] and a scientific and imperialist project which affirmed certain relationships between Europeans and indigenous people and made it possible to classify and differentiate those who might become the objects of colonization.[51]

The very act of classifying, then, is an assertion of masculine privilege and imperial power; no doubt this is one reason it appealed to the Duchess. Botanical collections in particular, according to the historians of colonial botany Londa Schiebinger and Claudia Swan, "both facilitated and profited from colonialism and long-distance trade," and they gained prestige and social power from their strategic importance in struggles between imperial powers for global hegemony.[52] The Portland Museum benefited directly from voyages of exploration and discovery; the first Cook voyage provided the Duchess not only with numerous conchological specimens, but one of its botanists, the famed Daniel Solander, was hired to classify her shells. The knowledge and systematicity of the Linnaean system, as Fadiman suggests above, is of course a form of power. As Schiebinger and Swan argue, "achievements in European botany depended on systems of taxonomy that . . . enabled a system of global botanical exchange."[53]

In making Bulstrode a center of Linnaean taxonomy, Margaret Bentinck is able to trump the marginalization of her work as a mere "women's collection" and use her aristocratic and national privilege—and the wealth that comes with such privilege—to create a position of agency for herself that might be called masculine. Thus the history of a powerful subject position for female collectors—one we might call androgynous or even butch—is problematically intertwined with the uneven developments of global capital.

The connection between gender and larger economic and political processes in collection history is also noted by the powerful recent theorist, Susan Stewart. She argues that the collection creates a "smaller economy" that is "self-sufficient and self-generating with regard to its own meanings and principles of exchange."[54] As she concludes:

> The conception of woman as consumer is no less fantastic or violent than its literalization
> as the vagina dentata myth, which functions to erase the true labor, the true productivity of
> women. Yet this erasure forms the very possibility of the cycle of exchange.[55]

Perhaps the possibility of escaping the misogynist violence of the exchange economy is one of the reasons the mobility of objects that characterized the Duchess of Portland's collection were so appealing to her women friends. The Portland Museum represents an alternative system of value that could not survive beyond the Duchess's death. Certainly, male collectors also participated in the small scale of this economy, but the gendered status of central economic terms and concepts (in neoclassical economic theory, Stewart and many others observe, production is figured as masculine and exchange as feminine) means that their relation to this miniaturization is different. Through her collecting practice, the Duchess was able both to make herself bigger by creating a self-representation that took up space and required serious attention and to insist on the value of what Stewart calls the "miniature," the details of interior domestic spaces coded as feminine and through the Portland Museum also coded as powerful. The room in which the Duchess and Mrs. Delany most often worked classifying specimens at Bulstrode was the dining room; the transformation of such a space, normally feminized through its association with feeding the family and serving as hostess to guests, into a zone of scientific achievement that also made it possible for the friends to spend long days alone together in intimate activity, makes the Portland Museum a distinct transformation of the acquisitiveness of capital and empire. This is not to say that the collection represented a critique or dismantling of the troubling hierarchies of Enlightenment exchange economies in national or colonial terms; rather, I am suggesting that women's collecting practices created space both inside and outside such economies that made room for women's intimacy. The legacy of the Portland Museum, as I show in more detail below, lay not in the group of objects itself but in the kinds of relationships it facilitated among women.

A reading of the Portland Museum as a practice rather than a collection of objects, a practice inflected by women's same-sex desire, allows us to see connections between identity, gender, sexuality, and legacy not previously discussed in collection studies. The museum is an appropriation of masculinist and imperial attitudes and privilege that creates an androgynous or even butch representation of self in which exchange, relationship, and tactility replace inheritable objects as the guarantor of the self's effectiveness in the world. As a vehicle and medium for creating erotic and affective connections with other women and expressing and asserting same-sex desire, the Portland Museum figures differently in collecting history and theory than does the Harleian Library and other canonical men's collections; attention to its specificities refigures collecting as a lesbian genre in the sister arts tradition.

Although this chapter concentrates on Bulstrode as the center of the Duchess of Portland's collecting practice, the Portland Museum actually refers to two different

physical spaces. At the Bentinck family estate in Buckinghamshire, shells, fungi, fossils, and objects of *vertù* were classified, stored, and displayed indoors, while the Duchess's menagerie, botanical gardens, grotto, and other garden features were oft-visited sites outdoors. The Duchess's royal and aristocratic visitors were most often received at Bulstrode, and this is the home she shared with Mary Delany for much of the latter part of her life. The Duchess also kept a town house in Whitehall, London, and it was there that parts of her collection were occasionally on display to a paying public. The famous Portland Vase, discussed at the end of this chapter, was also kept at the London house. When the collection was sold in 1786, the sale catalogue listed 4,156 lots, "the majority of which were shells and other marine specimens."[56] The sale, which took thirty-eight days, netted over eleven thousand pounds (almost a million U.S. dollars in today's terms).

"YOUR PARADISE BULSTRODE": GARDEN DESIGN AS A SISTER ART

Aside from her collection, the work that the Duchess of Portland was best known for was also a collaboration: the gardens at Bulstrode were created over the course of fifty years with Mary Delany, who said of their work, "we devote as much of our Time to the Garden as we can."[57] Mary Delany's correspondent Francis North referred to the place as "your Paradise Bulstrode."[58] "Paradise" is not just a lay term for a heavenly place; it is also a technical term of garden design referring to an enclosed pleasure garden adapted from the Moorish gardens of Spain or "such as those constructed by rulers of the Ancient Near East." "Oriental" enclosed gardens were of course also linked with the seraglio in the English imagination and hence carried erotic and feminine connotations. With the term "paradise," Lord North acknowledges the Bulstrode gardens as a work of art that was not just a place of almost divine beauty and happiness but a location of desire, a female community, and a contribution to garden history.

Indeed, the Duchess drew on all the fashionable trends of eighteenth-century English garden design. She had an "excessively pretty" "Chinese House" and a pond of "Chinese fish," following the chinoiserie trend like her friend Horace Walpole (Figure 2.6).[59] But she was also influenced by the new "English" taste, exemplified by the work of Capability Brown, for cleared landscapes and open prospects. (Her son, the third Duke, was to hire Humphrey Repton to bring the estate up to the current fashion of the turn of the nineteenth century, and it is from this later period that we get Repton's Red Book images of Bulstrode.) The Duchess got her neighbor to "clear hedges away" on his land to open the view from her own, which she thought would "mend the Park very much," and she also hoped to get a "greener Coat" on the newly created meadows by "Rolling," that is, leveling and smoothing the ground by means of a cylindrical machine.[60] Another Brownian improvement took place when "all the *walls* of

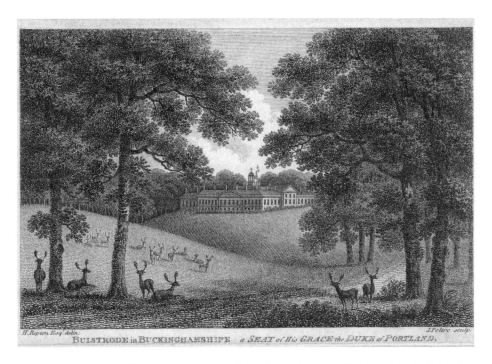

FIGURE 2.6 (ABOVE) Humphrey Repton, *Bulstrode in Buckinghamshire: A Seat of His Grace the Duke of Portland.*
Many of the rooms in the house were given over to studying, arranging, and displaying the Duchess's
collections. Mary Delany made most of her botanical illustrations here. COURTESY OF THE BUCKINGHAMSHIRE
COUNTY MUSEUM COLLECTIONS.

FIGURE 2.7 (RIGHT) Humphrey Repton's plan of Bulstrode Park from *An Enquiry into the Changes of Taste
in Landscape Gardening.* The third Duke of Portland hired the fashionable Repton when he inherited the estate,
updating some of the work of his mother and Mary Delany. COURTESY OF HARRY RANSOM HUMANITIES RESEARCH
CENTER, UNIVERSITY OF TEXAS AT AUSTIN.

the kitchen-garden" were "entirely removed" so that "the ground slopes off by degrees
and seems to join gradually with the park, as if it had never been distorted."[61] From
the Duke's letters to his son at school we know that the gardens also retained some
traditional elements such as "ye Flower Garden" and a "Bank" "cover'd with flowers."[62]
In an interesting reversal of the usual gendered distribution of landscape labor, the
Duke seems to have concerned himself more with the flower gardens and the Duchess
more with the park and architectural features. If the landscape park was considered a
masculine preserve and the flower garden the proper occupation of women, as Susan
Bell Groag argues, the Duke and Duchess of Portland seemed to have switched roles.[63]
The Duke's walk "round ye Garden" was a significant constitutional, long enough that
he felt he had to assure his son that he did not find himself "ye worse for it": "in at
ye drying yard Gate, up ye beach Walk, along ye Canal, down Constitution Hill and
ye Chinese fish and home" (Figure 2.7).[64] The Duke's circumscribed and domestic
peregrinations, carried out on foot and focusing on the flower gardens, suggest that he
left the improvement of the estate to his wife.

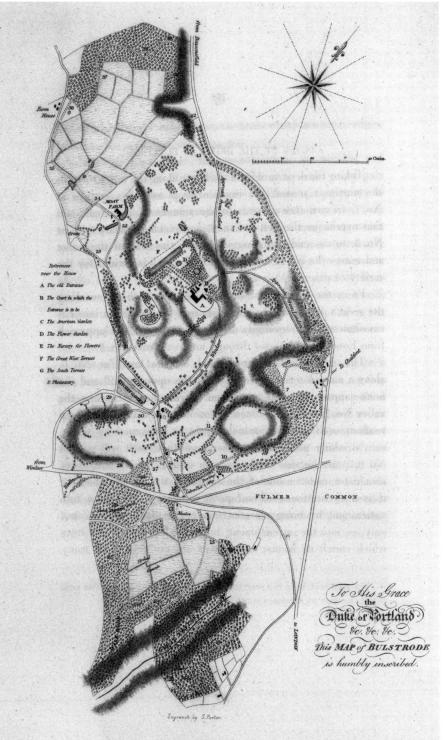

from Beaconsfield

Farm
House

MOAT
FARM

Green

References
near the House

A The old Entrance
B The Court in which the
 Entrance is to be
C The American Garden
D The Flower Garden
E The Nursery for Flowers
F The Great West Terrace
G The South Terrace
I Pheasantry

Approach from Oxford

To Oulslott

from
Windsor

Nailbrook

Calves Hut

Meadow

FULMER COMMON

to LONDON

To His Grace
the
Duke of Portland
&c. &c. &c.
This **MAP of BULSTRODE**
is humbly inscribed.

Engraved by S. Porter.

London, Publish'd 4 June 1802 by J. Taylor High Holborn.

While the Duke was walking, the Duchess was taking Mary Delany out in the carriage to see the larger prospects she had created. The two women enjoyed the multiple and overlapping sensory pleasures of the landscape together in a synesthetic experience that marks their sister arts practice:

> Sunday after chapel the Duchess carried me a very pleasant airing through a riding she has had cut through a wood, three miles and a half long, that joins to her park and goes out on the common, which from a brown, dreary-looking heath, she will by her bounty and good taste make very pleasant.[65]

On another occasion, Delany writes: "She invited me to take a tour in her chaise to smell her sweet hay in her farm-fields; all our senses were regaled."[66] In these instances the Duchess takes on a lordly role, comfortable with horses and vehicles and responsible for the progress of the great works on the estate. Significant too is the synesthetic appeal of gardens as works of art that appeal to all the senses, not only visually stimulating but, as here, a source of olfactory pleasure as well. Over the years Mary Delany too came to take a proprietary view of the Bulstrode gardens she helped design, stamping them with her characteristic vision of a beloved woman friend:

> Tho my Dear Lady Andover does not exhibit her aimiable figure to view at Bulstrode the Idea of such a companion (tho but in Imagination) makes every Grove; every winding path every wilderness of insects; every rural Scene, still pleasanter. The Affectionate remembrance of a dear Friend is of more real worth than all her fine accomplishments; yet 'tis but slender diet; I don't think I shall grow as fat upon it as the Sheep upon her Graces Lawn, now nibbling under my Window; and therefore wish, and pray, for a more substantial meal when the happy opportunity offers.[67]

In this splendid mixing of metaphors Bulstrode is figured as the setting for ideal female companionship, the face of the longed-for friend a "view" along with the "Grove," "path," "wilderness," and "rural Scene." But the landscape, here seen as the beloved woman's "figure" or face, is again a source of synesthetic pleasure, a "substantial meal" that satisfies taste and makes life more than mere survival upon a "slender diet." Mary Delany is as much at home as "the Sheep upon her Graces Lawn," part of the view indeed but also one that draws life-giving sustenance from the collaborative work of art that was the Bulstrode garden.

"THE GREAT CAVE IS BEGUN": THE BULSTRODE GROTTO

A distinctive expression of the friendship between Mary Delany and the Duchess of Portland in the Bulstrode gardens was the grotto that Delany designed beginning in 1760 (Figure 2.8). Many of the best-known shell grottoes in the period were in fact the work

FIGURE 2.8 Samuel Hieronymus Grimm, *Grotto in the Park at Bulstrode,* 1773. The grotto was a project of many years, designed and built by Mary Delany as a gift to the Duchess of Portland. COPYRIGHT THE BRITISH LIBRARY BOARD, ADDITIONAL MS 15537; ALL RIGHTS RESERVED.

of women, thus creating a story that runs alongside the male-dominated history of landscape gardening as a sister arts tradition. Lady Hertford, Henrietta Howard, and the Duchess of Richmond and her daughters were acknowledged experts in shellwork. The Duchess of Richmond's daughter Lady Emily carried the tradition to Ireland when she married the Duke of Leinster and created a well-known shell room at their seat in County Kildare in the late 1740s, which Mary Delany no doubt knew during her own second sojourn in Ireland in same period, when she was married to Patrick Delany. Lady Holland's "secret grotto" was another well-known example of women's work in this genre. Mary Delany herself advised Sir Charles Mordaunt's daughters on their shellwork at Walton in Warwickshire in the 1750s. Designing such "secret" spaces with other women, then, was a well-known eighteenth-century practice, which contradicts the usual view of women as participating little or not at all in the great garden design movement of the period.

Men also designed grottoes, of course, and they used shells to decorate them, but as with other aspects of the tradition of the bawdy garden, the erotic and feminine connotations of shellwork create a masculinist or at least heterosexual relationship between male designer and feminized material. For example, in addition to shells, marble, and fossils, Pope's famous grotto was also decorated with stalactites he gathered on a caving trip to Wales with several gentlemen friends. The visitors blew the phallus-shaped

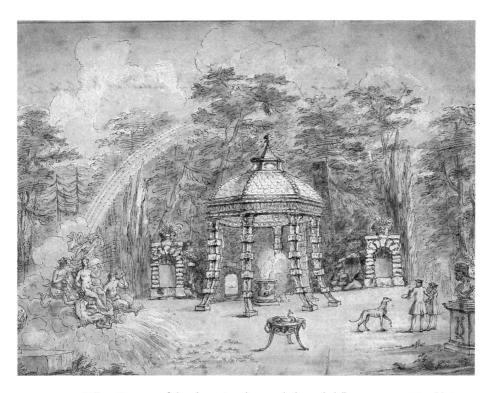

FIGURE 2.9 William Kent, *View of Alexander Pope's Garden at Twickenham with Shell House,* 1730–48. In addition to this above-ground example of shellwork, Pope's grotto was lined with shells and other materials, including stalactites that had been blasted with blunderbusses off the walls of a cave in Wales.

rock formations off the roofs of the caves with blunderbusses and brought them back to affix to Pope's ceiling. The meanings and associations that accrued to the shell grottoes designed by women—wombs, Aphrodite, labia—create masculine and heterosexual meanings when contextualized by Pope's choice to line his cave with phallic shapes (Figure 2.9).[68] Of course, men may also have decorated interiors with shells to express an identification with femininity. The earliest known example of an indoor shell room, at Woburn Abbey, Bedfordshire, is said to have been designed by Isaac de Caus. The effect of shellwork in an architectural interior that is part of a house, however, lacks the chthonian connotations of the underground shell grotto. And a well-known example of an underground grotto, Charles Hamilton's limestone cave at Painshill Park, Surrey, follows Pope's example in using limestone stalactites to line the interior. In lining their underground grotto with shells, then, Delany and the Duchess chose against these well-known examples by men.

During the 1740s and 1750s Delany traveled from Ireland to stay at Bulstrode for months at a time to work with the Duchess on their grotto project. The Duchess had become interested in shell grottoes as early as 1737, when she visited her friend Walpole's mother's example of this popular eighteenth-century art form:

I have been to see Lady Walpoles Shellery for Grotto I will not call it. It is a fine thing but I can't say it pleases me. That regularity is abominable besides all the Red coral is painted; mine shall not be made after that model.[69]

Although Mary Delany did much of the work (including the physical labor) on the Bulstrode grotto, as we shall see, the Duchess obviously had strong opinions about the design and aesthetics of the form, thus qualifying her as a worthy collaborator for her talented friend. Mary Delany had worked with Anne Donnellan on a grotto for Killala in Ireland when the two resided there in the early 1730s. She used shells she collected in Ireland when she designed another grotto for her uncle Sir John Stanley at Northend in 1736, during the construction of which she sometimes put in twelve-hour days without speaking to another person.[70] Later that same year she met the Duchess of Portland for the first time, and this may perhaps be the occasion that they conceived the idea of working together on a shell grotto. By this time, Mary Pendarves was already "a passionate collector of shells."[71] No doubt the friends conferred as Mary Delany worked out the kinks in her grotto work in her uncle's garden.

The Duchess had long collected shells for natural history purposes but now she began to sort them on aesthetic grounds, deeming some "too good for the grotto" and reserving them for other uses.[72] The opportunity to start the project held so long in view finally came to pass, as Mary writes:

The great cave is begun, and will be, I hope, when finished, very handsome. The outside is now doing, and is to be composed of very rough, bold rocks, mixed with clinkers and dross from the smith's forge: the inside must be the work of another year, but there are not yet half materials enough for the purposes.[73]

While in residence at Bulstrode Delany visited the cave every day, "directing the workmen." She herself probably also placed many of the rocks, clinkers (scraps of brick or lumps of mixed minerals fused by intense heat), and dross (bits of waste coal or metal) on the outside and the shells on the inside. The Duchess carried out her "Index-Work" on the botanical collections as Mary Delany did her "Grotto-work," and the two friends put in long days as visits and other obligations permitted.[74] This monument to their friendship was the work of ten years; it was not until 1770 was Mary Delany able to write,

I went yesterday morning, as soon as breakfast was over, &c., to the cave, attended diligently till one, was then visited by the enchantress of the grotto; received her approbation! How forcibly partiality acts! but it is a veil I cannot wish should be laid aside; as the greatest part of my merit must then vanish.[75]

Finishing touches took the rest of the year, with the seventy-year-old Mary Delany "working away heaping rude stones together (ruder than the Gothic)" in her "zeal to get it finished."[76] By November, the grotto was ready to take its place on one of the Duchess's long tours of her landscape. Delany writes of the grotto often to her niece, Mary Port of Ilam, who after the death of Delany's sister Anne in 1761 took her mother's place as Mary Delany's chief confidant and correspondent. As her mother had done, Mary Port exchanged shells, botanical specimens, and art objects with the two women. Her aunt reports on their role in the completion of the "great Cave":

> We took a tour yesterday to look at the plantations on the common, which thrive and have a very good effect, ended with the Cave, where the Duchess has directed a plantation of some trees on the right hand, which will be a great improvement. We also fixed upon a place in the Cave for the Ilam fossils, which are much admired, especially the great rock which is covered with coral, scientifically called *Madrepores*.[77]

In the Duchess's intention to plant trees near the grotto entrance, we again see evidence of her work as a designer. Further, the connections between women forged by the exchange of objects of *vertù* result here in an integration of the Duchess's scientific interest in shells with Mary Delany's aesthetic one. This collaboration creates a new landscape, a symbolically rich repository for and monument to the friendship of the "Ladies of Bulstrode" as Francis North called them.[78]

The choice of shells to decorate the interior of the grotto had both generic and personal significance for the two women. Shellwork was, according to Hazelle Jackson, "a veritable passion" that "raged among the rich and fashionable" in the eighteenth century: "rare shells were imported, bid for at auction, purchased at inflated prices from dealers and cajoled from fellow grotto-owners."[79] Although shellwork could be used to decorate interior surfaces, as at Delville, it was also associated with the outdoor underground grotto. Shells seemed a natural decoration for subterranean grottoes as both alluded to the use of maritime caves by the Romans as "nymphaea," shrines dedicated to female water spirits and later to Venus. The iconic image of the birth of Venus from a scallop shell refers to this same network of associations. (This set of associations may also have inspired Mary Delany's *Nymphaea alba* of 1776, a luscious, vulval portrait of a native English water plant that may have grown on the Bulstrode estate [see Plate 7]). The Duchess of Portland's shellwork grotto brings together several of the lesbian sister arts traditions: collaboration, an interest in transforming the landscape to create spaces for female intimacy or with feminine associations, the exchange of objects, designs, ideas and texts among women artists, and, of course, sexuality. The exotic frisson of the shell-lined grotto had much to do with the specifically feminine sexual connotations of lining a womb-shaped underground space with salty, fishy, cup-shaped seashells. The Latin word for such grottoes, "nymphaea," translates not only as "female water spirits"

but also as "labia." The *Oxford English Dictionary* quotes a 1764 treatise on midwifery with admirable directness: "From the lower part of the Clitoris the Nymphæ rising spread outwards and downwards." Of course it is true that, as Jackson notes, "shellwork was a popular and socially approved hobby for refined ladies throughout the eighteenth century."[80] Still, there were bawdy, anatomical, and erotic connotations to shellwork that existed alongside its canonical status as decorous feminine accomplishment, a context that is illuminated by reading it as part of a sister arts tradition.

Although the Duchess of Portland had access to the finest imported shells, the grotto at Bulstrode was actually created with local snail shells, thousands of which she and Mary Delany collected over several years. Because of the Duchess's keen interest in natural history, she wished to reserve the better specimens of her collection for the museum, where they could be properly examined, classified, and used for reference. Common and indigenous shells were deemed more appropriate for decorative purposes. Additionally and perhaps not inconsequentially, the joint project gave the women opportunities over many years for long private walks together. Snail shells are not easy to pick up; one imagines the two women on hands and knees, combing through wet grass and thickets amid earthy smells and organic textures in search of specimens. Of course, they also commissioned all their friends and even servants to help them gather shells, but the pastime of shell collecting was one of their signature activities together.

Given the erotic and affectional meanings of Mary Delany's shellwork for the Duchess of Portland, it is significant that Delany also made many objects of interior decoration for her friend using shell decoupage (Figure 2.10). "I am making some shell-work, (intended to be *ornaments*) over the Duchess's windows in the dressing-room—I wish they may prove such."[81] These ornaments were festoons, often with flower motifs, that were also used to decorate mantelpieces and doorways. In addition, Mary Delany created several "lustres" or chandeliers decorated with shells for her friend. On one visit she busied herself with "a troublesome job: the luster I made for the Duchess of Portland was fallen almost all to pieces, occasioned by the wood not being sufficiently seasoned, but this day I finished repairing it."[82] Tips, techniques, and materials were the currency of affection among the Duchess's women friends: as Elizabeth Robinson writes, "My most Dear friend will excuse my troubling her for the pot of Cement for shell flowers which your Grace offer'd to lend me."[83] Making shellwork was both a form of artistic collaboration among these women and a token of affection. As Mary Delany wrote about creating one such gift:

> Lady Andover and I have entered on a piece of work to *surprise* the Duchess of Portland on her return, which is flourishing. It is a frame of a picture, with *shell-work*, in the manner of the frame to your [Anne Dewes] china case; and we are as eager in sorting our shells, placing them in their proper degrees, making *lines, platoons, ramparts*, as the King of Prussia in the midst of his army, and as fond of our own compositions.[84]

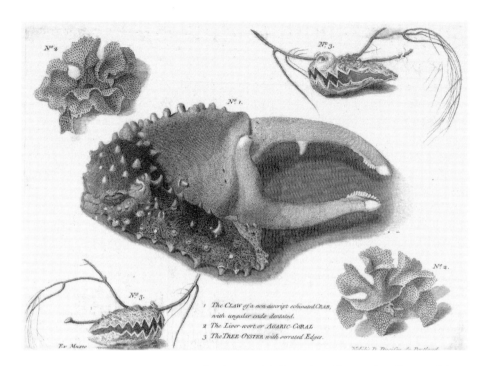

FIGURE 2.10 George Vertue, engraving of a selection of shells, coral, and fungi in the collection of the Duchess of Portland, n.d. Shell collecting allowed Mary Delany and the Duchess to spend long days together roaming the countryside. COPYRIGHT THE HARLEY GALLERY.

The image of the two ladies playing like little boys at toy soldiers is a pleasing piece of gender play. Also worth noting is the comparison of the collaborative work that Mary Delany and Lady Andover are embarking upon with the "canon" of such objects, here represented by Anne Dewes's china case.

"THE LINNEUS OF BULSTRODE": MARGARET BENTINCK AS NATURAL PHILOSOPHER

In building her natural history collection the Duchess relied not only on her well-documented relationships with the leading male natural philosophers and botanists of her time—Sloane, Ehret, Solander, Banks, Young, Rousseau, and others—but also, as we have seen, on her network of women friends. Mary Delany's sister Anne Dewes was, in Delany's estimation, a more expert botanist than herself and more nearly on a par with the Duchess, and the two carried on a correspondence and exchange separate from the friendship of the Ladies of Bulstrode. In her typical blunt fashion the Duchess describes her research to Anne Dewes:

> I have looked all over my Collection of moss & can't find any Kind Like yours that that most resembles it is the *Small flow'ring Green Stone moss*, & *the Beard of Brier* but the first is a Deeper Green

& not Scarlet & the other is not near so Beautifull as yours. I found to Day a very odd fly the Body Black the Legs Red & a Tail half an Inch Long. The whole fly rather Larger than a Gnat.[85]

Not only botanical specimens (the Duchess specialized in fungi and mosses) and shells, but also birds, animals, fossils, and insects were grist for her mill. The Duchess employed a professional, Georg Dionysius Ehret, to create an illustrated herbal to document the English plants in her botanical collection. Further, Mary Delany recorded in letters many of the new additions to the collection, linking the acquisitions to the Duchess's admirable personal qualities:

> Her birds are many and beautiful, I mean those in cages; for we have not yet been at the menagerie. It is pleasant to see how she *enjoys* all her own possessions, and at the same time is so ready to give every other place its due . . . Mr. Ehret is here, and she is very busy adding to her English herbal; she has been transported at the discovery of a *new* wild plant, a Helleboria.[86]

Not only intellectually stimulated but passionate, "transported," by her collection, for Margaret Bentinck Bulstrode it is a source of pleasure while also meeting the highest standards of botanical science. Indeed, Rousseau, on record as having a low opinion of learned women, addressed the Duchess as his superior in learning during his residence in England, when he sought acquaintance with her to pursue his botanical interests.[87] He even signed one letter designating himself her employee or artisan: "L'HERBORISTE DE MME LA DUCHESSE DE PORTLAND."[88]

Documentation such as that provided by Ehret was an important testimony to the intellectual seriousness of the collection. The Duchess also worked side by side with her chaplain and resident botanist, John Lightfoot, to classify her treasures according to the Linnaean system, "an arduous task" that took most of the 1770s.[89] Not only her shells, fungi, and mosses but also her "ores and minerals" and "insects and fossils" all had to be set "in scientifick order."[90] Ehret, who had worked with the great Linnaeus himself in Holland in 1736 and had provided illustrations for the Swedish botanist's *Hortus Cliffortianus*, was an important source of training in the Linnaean system for the Bulstrode ladies. In particular, he had absorbed, and was to pass on to the Bulstrode circle, the importance of the sexual organs in plant classification and the value of painting the specimen such that the plant's reproductive parts are prominent (Figure 2.11). In addition, when Cook's *Endeavour* returned from the South Seas in 1771, Daniel Solander brought to Bulstrode many of the shells he had collected on the voyage, thus solidifying the position of the Portland shell collection as the best in the country or perhaps in Europe. The Duchess employed Solander until his death in classifying and naming these conchological specimens, although his writings were never published.[91]

Even more important than the professional botanists she engaged, though, was the pleasure the Duchess took in putting together her collection with the collaboration of

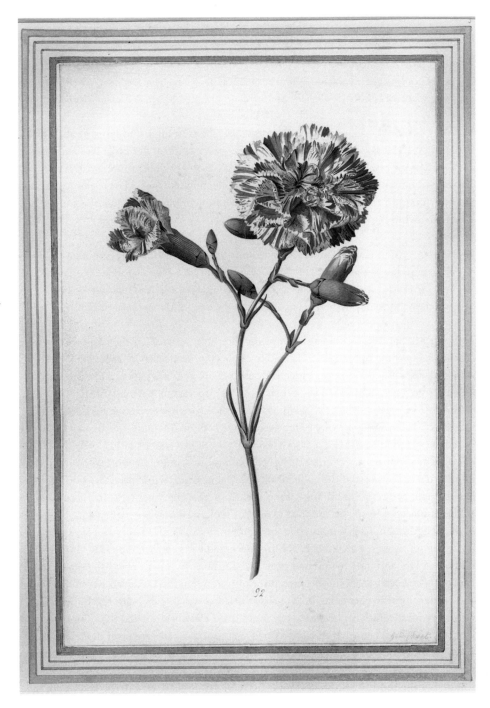

FIGURE 2.11 Georg Dionysius Ehret, *Dianthus Caryophyllus*, n.d. Ehret had worked with Linnaeus in Holland and brought the new Linnaean knowledge to Bulstrode when the Duchess hired him to create an illustrated herbal of her English plants. COPYRIGHT TRUSTEES OF THE BRITISH MUSEUM.

her women friends. Mary Delany describes a drive about the neighborhood, ostensibly to return social calls, that is frequently interrupted by botanizing:

> Made the road to Omersham [?] very pleasant: screams of admiration often interrupted the thread of our discourse; sometimes a Plant that the Linneus of Bulstrode, had long been in Search of, and other Vegetable objects that never escape the Piercing Eye, of a certain female Philosopher—but alas!—as all human joys are imperfect, notwithstanding expectation & every usefull implement for the Purpose, not one Moth, Butterflie, or Beetle made its appearance the Whole way; & we finish'd our Voyage about eight o'clock without a Prize, save one sprig of Dwarf Elder, wch. we brought home in triumph.[92]

"Screams of admiration" and "human joys" are as much a part of this joint project as scientific rigor, making the practice of collecting worth the trouble even without another "Prize." Such impassioned exclamations are continuous with the sexual connotations of Linnaean classification. At the same time, the status of the Duchess as a "female Philosopher" kept serious collectors engaged with her as friends, and made her friends into serious collectors.

"A THOUSAND THANKS FOR THE GIANT THROATWORT": EXCHANGE AMONG WOMEN

The Duchess and her friends exchanged information, plants, bibliography, and citation, and at times the Duchess even lent out her botanist, John Lightfoot, for the edification of her sister scientists. Although she corresponded with and worked closely at various times and on particular projects with male colleagues such as Ehret, Solander, Lightfoot, Rousseau, and Mary Delany's brother Bernard Granville, the Duchess's most sustained botanical relationships were with Mary Delany, Anne Dewes, and Mary Finch, Viscountess Andover. While living at Bulstrode, Mary Delany frequently carried out botanizing commissions on behalf of herself and the Duchess. As she wrote to her sister, for example:

> I have enclosed you a few specimens to add to your little book of dried vegetables, and will continue doing so as long as I stay here. The hot-house is very full; the coffee-tree loaded with berries: do you know the Ipecacuanha plant? It is very pretty.[93]

Anne Dewes not only received information and specimens from Bulstrode, she also joined her sister and the Duchess in creating a "book" or *hortus siccus,* a collection of dried plants with Linnaean labels and other information. The Duchess created many such "books" (really collections of dried plants used for classificatory purposes; Mary Delany referred to her paper mosaic flower illustrations as a *hortus siccus* as well). The Duchess also commissioned a conventional book of botanical illustrations, the famous English herbal illustrated by Ehret.

Evidence of the exchange that undergirded these projects suffuses Mary Delany's letters from Bulstrode. Her accounts are detailed and businesslike on matters botanical:

> The plant you call Runnet or Rundle grass she [the Duchess] cannot find under that name, but she thinks it is the jagged spearwort, which you will find in Gerrard, and answers to every particular of the specimen you sent her; it is in page 962, the 3rd Spearwort; I have returned you the specimen of the celastines, for fear you should not have another.[94]

The reference here is to John Gerard's *The Herball, or The Generall Historie of Plants* (1597), a classic work that resided in the Harleian Library and had formed part of the Duchess's botanical education. This reference suggests that the Duchess brought useful works such as the Gerard with her from Welbeck to Bulstrode upon or after her marriage, adding to them her own bibliographical acquisitions. It's also notable in this letter what close track the women keep of each other's collections, being scrupulous not to keep anything too long that makes a unique part of another collector's hoard. In addition to their botanical interest, of course, plants were often exchanged to furnish one another's gardens:

> [Mrs. Sandford] trying to amuse herself with a pretty garden she has now got to the house. . . . She is very busy preparing her ground for plants, and she is to have some from Bulstrode, for they are extravagantly dear at Bath, and she will be glad of the superabundance of any of her friends' gardens that can conveniently be conveyed to her.[95]

Bulstrode was a repository of plants for both study and pleasure, and it contributed to the garden and landscape projects of the women who had access to its riches. Although it was a private collection, it had a public or institutional function as a repository of materials and a center of intellectual activity for this community of women.[96]

After the death of Anne Dewes, her daughter Mary Port of Ilam in many ways took her mother's place in the Bulstrode circle. Mary Delany writes to her niece:

> A thousand thanks for the giant throatwort; it is gone to London with a large cargo from hence. I fancy I left the umbilicated lichen at Ilam. Will you be so good to let me know, for I can't find it, which I am very sorry for. My dearest friend, will you be so kind to get me some more? It grows on the rocks in the caves. Heaven bless you and all you love.[97]

The closely imbricated language of scientific exactness ("umbilicated lichen") and loving affiliation ("my dearest friend," "you and all you love") is characteristic of the correspondence of the women of the Bulstrode circle (Figure 2.12). In addition to botanical specimens, Mary Port also provided mineral samples for the Duchess's collection. Delany writes:

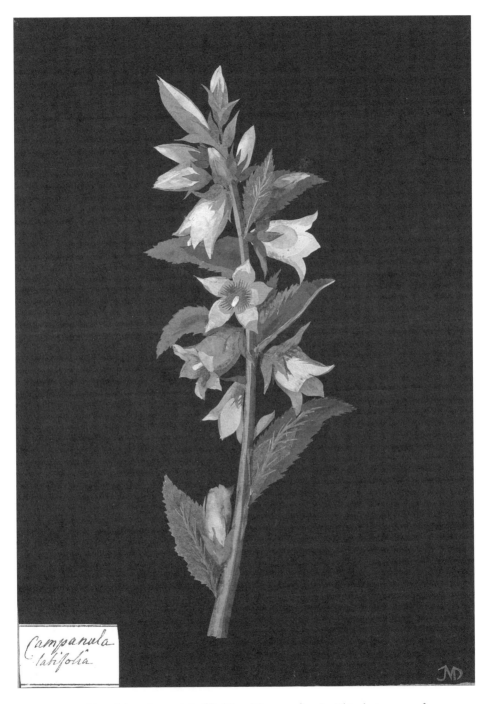

Campanula
latifolia

FIGURE 2.12 Mary Delany, *Campanula Latifolia* (Giant Throatwort), 1780. This plant was one of many emissaries of affection and learning that passed between Bulstrode and the household of Delany's niece, Mary Port.

Well the Box is come and all its pretty & curious contents safe and Welcome. The sparr (or rather Chrystalization) & munchic [bits of wood and mineral] in the coal is very curious, and much admired—you know how pleasant it is to offer a mite to our Dear, kind & much honour'd Duchess. You may be sure I gave her the best bits, & also bestow'd a specimen on Mr. Lightfoot who thinks it worthy the acceptance of a Philosopher, and desires me to tell you he values it as coming from Ilam. The fossils are good in their kind, the Dss. having of all those kinds I keep them for my own little cabinet, but shall delight in them more for the sake of the giver than the Gift—but tho I have, (or meant to have) made our acknowledgements, I have not done with the Subject; for you must inform us of their Birth and Parentage, particularly of some brown moss like substance that was pack'd into the largest Cockle, (which was crack'd in two but I can repair it) & a little Brassish, Copperish, Goldish thread like stuff adhering to a bit of slate or coal & has puzzled even Mr. Lightfoot to find out what they are without you inform us where they were found, whether on Rock or Tree, or Bog—you must be very minute in your account nothing less can satisfye such an accurate enquiress.[98]

As an "enquiress," a term marked both by the practice of investigation and by gender, the Duchess was not content with specimens alone. She also wants information—and notably, she considers Mary Port more botanically expert than the professional John Lightfoot—about the "Birth and Parentage" of the objects collected and the sites where they were found, the issues of provenance important to their scientific value of her collection. In addition, however, the "Philosopher" (surely both the Duchess herself and Mr. Lightfoot, her botanical chaplain) deals in the currency of "acknowledgements" and, like Mary Delany, "values" the specimens "as coming from Ilam"—"more for the sake of the Giver than the Gift." Affect and science are entwined in the relationships buttressing the Duchess's collection.

Although the Duchess of Portland was best known for her learning in natural history and philosophy, she was also an artist, and artistic exchange was another web of connections upon which the enterprise of Bulstrode rested. In one of the few letters we have in her own hand, she writes to Anne Dewes,

Pray accept my thanks for the roots of the Bea flower I shall take great care of 'em for I will plant 'em my self how can you say you have not Lady Andover's Art when you partly promised me some of your Drawing? I was in hopes you wou'd have fulfilled it by sending me that flower. I am going to make a muff of Jays Feathers yours came very Opportunely.[99]

She both asks Anne Dewes for a sample of her drawing and describes a project of her own (the "muff" that will be completed with the contribution of feathers from Anne). The comparison to "Lady Andover's art" suggests that the women sustained a high level of accomplishment and often compared their works with one another. In such a system

of exchange, botany ("the roots of the Bea flower"), natural history ("Jays Feathers"), art ("drawing"), and artisanship ("I am going to make a muff") form a seamless web of connection between the Duchess and the community she depends on for her ongoing projects at Bulstrode. As an artist the Duchess was well known for "turning," that is, working wood and sometimes minerals or gems on a lathe. She created many works in this genre, as Mary Delany describes here:

> The duchess has just finished a bunch of barberies [the fruit of an ornamental shrub] turned in amber, that are beautiful, and she is finishing an ear of barley—the corns amber, the stalk ivory, the beards tortoiseshell.[100]

Not surprisingly, the Duchess's subjects were often botanical. Besides the "barberies" and "barley" mentioned here, Mary Delany valued a gift that the Duchess turned for her, "a curious little vase with two or three sprigs of flowers."[101] Such little sculptures were the Duchess's version of still life or botanical illustration, her chosen medium for representing, rather than collecting, the natural world. In the sister arts tradition she shared with Mary Delany, the Duchess turned to the worlds of craft and amateurism to express her virtuosity.

"EMBLEM OF FRIENDSHIP'S SACRED TIE": THE PORTLAND ROSE AND THE PORTLAND VASE

Despite the sale of her collection, such was its fame that the Duchess's name remained attached to several of the objects associated with it. Most notable of these are the Portland moth, the *Portlandia* shrub (Mary Delany's image of this plant is discussed in chapter 1), the Portland Rose, and the Portland Vase. The latter two examples illustrate the Duchess's intertwined practices of botany and female friendship.

The Portland Rose has been a source of controversy in garden history; some have claimed it was named not for Margaret Bentinck but for her daughter-in-law, the third Duchess of Portland (Figure 2.13). This claim has recently been disproved on botanical grounds, but the historian of women's friendship need look no further than the following verse by Mary Delany, copied into the volume containing her mosaics and now in the British Museum:

> Fair flower! That bears the honoured name
> Of HER whose fair and spotless fame
> Thy purity displays.
> Emblem of Friendship's sacred tie,
> Thy form is graced with dignity
> Superior to all praise.[102]

FIGURE 2.13 *The Portland Rose*, from Henry Charles Andrews, *Roses, or, A Monograph of the Genus Rosa* (London: Printed by R. Taylor and Company and published by the author, 1805–28). As a leading botanist, the Duchess of Portland had many plants named for her, including this rose, which Mary Delany called an "emblem of Friendship's sacred tie." COURTESY OF THE UNIVERSITY OF ILLINOIS LIBRARIES.

In a gloss on these lines quoted earlier, Lady Llanover wrote that "Mrs. Delany's friendship for the Duchess of Portland . . . instead of declining appeared to *strengthen with age*." The rose itself is a "very lovely, vivid crimson-scarlet repeat-bloomer with . . . softly round petals and pointed buds." It was especially popular because it bloomed twice a year, which "set it apart as a desirable novelty before the arrival of the china roses" in England in the early nineteenth century.[103] The Duchess's daughter-in-law recalled the flowers "cultivated in great luxuriance" at Bulstrode.[104] But garden historians seem unaware of Delany's poem, assuming that "Mrs Delany never mentioned it in her correspondence."[105] It does seem odd that the Portland Rose was not one of the sixteen roses that Delany chose to illustrate in her collection, especially since one of those rose collages depicted "Lady Stamford's rose," named either for a relative of the Duchess's husband or for her daughter, Henrietta, the fifth Lady Stamford.[106] However, the poem quoted above links the rose emphatically with the Duchess's storied circle, as well as specifically to her relationship with Mary Delany as an "Emblem of Friendship's sacred tie." (Significantly for the lesbian provenance of the Duchess of Portland's legacy, the famous Ladies of Llangollen, discussed in more detail in chapter 3, probably grew the Portland Rose in their garden at Plas Newydd.)[107]

The Portland Vase, housed since the early nineteenth century in the British Museum, remains an object of fascination (Figure 2.14). Horace Walpole tells us that after a lifetime of lavish spending on her collections ("Her own purchases costing her not less than threescore thousand pounds"), the Duchess "checked her purchases" "for the last three or four years of her life," no doubt in consideration of the incumbrances on the estate created by the debts of her sons. But then, Walpole says, "she was tempted" to make the most splendid purchase of her career when the opportunity arose to buy "the celebrated Barberini Vase."[108] The Duchess paid two thousand pounds for the vase and three smaller items owned by Sir William Hamilton, who had just returned from his post as minister at Naples and had purchased the treasures in Rome.

The Duchess was to own this coveted object for only a year. After her death in 1785, however, her son, the third Duke of Portland, bought it back from the estate for about half what it had cost his mother a year earlier. Thus the vase retained its association with the Portland family and continued to be known as the Portland Vase. The object of no small amount of national pride, as a priceless antiquity smuggled out of Italy in defiance of papal edicts against the transportation of Italian art treasures, the vase was by the end of the eighteenth century the subject of dozens of English engravings, essays, and poems. Among the most famous of these, Erasmus Darwin's epic *The Botanic Garden*, contains a section describing the vase.

The pastoral scene pictured on the vase in white relief against a blue-black background has been subject to at least fifty published interpretations associating its iconography with classical mythology, with historical legend, or with allegory (Figure 2.15). The vase's meaning, then, is ambiguous; an eighteenth-century commentator

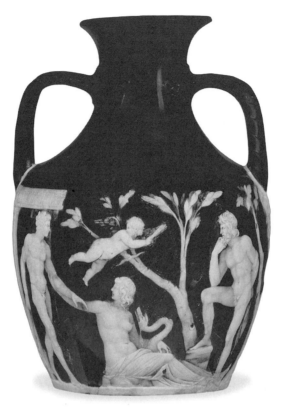

FIGURE 2.14 (TOP) The Portland Vase, ca. 27 BC–AD 14. This treasure retained the Duchess of Portland's name among connoisseurs even after the sale of her collection at her death. COPYRIGHT TRUSTEES OF THE BRITISH MUSEUM.

FIGURE 2.15 (BOTTOM) The Portland Vase, showing full frieze, ca. 27 BC–AD 14. The Duchess may have been attracted in part by the landscape features of this classic design. COPYRIGHT TRUSTEES OF THE BRITISH MUSEUM.

complained that "exquisite as the performance is, it is nevertheless a fault in the artist in not having duly characterized the (action or) story."[109] None of the existing interpretations, however, have suggested any explanation for the relationship between and among the three female figures on the vase, much less tried to connect this relationship to the landscape elements also depicted there—two trees, one budding and one mature, and the shrub on the other side—that frame the figures. Given the close association between landscape, botany, and female friendship in the works of the Duchess of Portland, this same conjunction on the storied vase may have been one reason why, after a period of reining in her collecting, she decided that this was an object she had to have.

The vase depicts six adult figures and a floating boy Cupid flowing around its perimeter in a sinuous line. A standing male nude reaches down to clasp the upraised right arm of a half-draped, seated female figure (traditionally identified as Aphrodite/ Venus). Her face is turned toward him, and an erect snake twines around her left arm, which rests in her lap. Her foot stretches past the legs of another standing male nude, possibly an older man because of his beard and pensive gesture, his chin resting on his hand. The outstretched feet of a seated male figure whose face is turned away continue the flow of figures around the vase. The last two figures are two seated women, both half-draped, seated on adjoining stacks of marble. The second woman's foot nearly touches the drapery of the first male figure, which he is in the process of discarding, thus completing the circular composition around the vase.

The two women placed next to one another are the only two figures on the vase that are seated side by side, and they are further set off by the framing effect of the vegetation on either side of them. On the left of the pair is a tree (the shape of the leaves suggests a fig), and on the right a sprig or shrub (Figure 2.16). These plantings create a pastoral space that sets the women apart from the other figures and connects them to one another. Although the women are seated with their bodies facing in opposite directions, each has turned her head toward the other, thus further emphasizing their relationship. (The seated male figure to the left of the pair seems to be gazing at the reclining woman, as Susan Walker states, "with concern"; "there is no erotic charge between them."). The women do not, however, gaze at one another directly; the figure on the left is reclining, her head at the level of the other woman's shoulder; the woman on the right looks over her head. The reclining figure, indeed, "sits in a pose used in Classical art to depict an abandoned female lover, or one . . . who is perceived to be in need of sexual arousal."[110] The second woman, seated upright, has frequently been identified as Venus, thus introducing another sexual element into the women's pastoral space. The Venus figure's higher ground line in the composition as well as her scepter attest to her divine status as a symbol of erotic love as well as female authority. As Walker further notes, "The Portland Vase is nothing if not insistent upon the centrality of the women in the story."[111] Darwin's poem also interprets the vase as a

FIGURE 2.16 The Portland Vase, detail showing two female figures, ca. 27 BC–AD 14. The female figures symbolizing eros and heartbreak are framed by landscape features. COPYRIGHT TRUSTEES OF THE BRITISH MUSEUM.

story about women's power; he sees it as a representation of the Eleusinian mysteries. The authoritative female figure, in Darwin's reading, "drives the profane," here identified as the male figure stepping out of the portal, "from Mystery's bolted door."[112] The vase, then, can be interpreted as an erotic representation of powerful women in a landscape setting.

This brief interpretation by no means comments upon the vase's intended or original meaning, and neither does it account for every figure on the vase. It does, however, connect the vase's imagery with themes and symbols resonant in other of the Duchess's collections, works, and practices and offers a suggestion about why this object should have appealed in particular to her. While the Duchess was a great connoisseur and the vase was a famous treasure, it holds a rather singular place in her collection. She did not collect either ancient Roman glass or classical vases on a systematic basis; although she owned many antiquities, this particular vase fit into no visible collecting program or paradigm. It seems, from Walpole's language, to have been an impulse purchase. Perhaps the imagery of the vase, its depiction of women together in a beautiful landscape, is what "tempted" the Duchess.

"NOT FORGETTING THE VASE":
WOMEN'S FRIENDSHIP AS LEGACY

The Portland Vase was important to the Duchess's circle of friends, not only for its own sake but for what it meant to her. Mary Hamilton records at least two visits to see the vase while she lived as Mary Delany's guest in late 1783 and early 1784.

> Saw ye fine *vase* [at "ye hotel King Str, S. James's"] &c., &c., staid there till ½ past 3 o'clock, and ye Dss and I went home wth Mrs. Delany (Mrs. D. eyesight *so well again* that she saw ye vase, &c.) we din'd wth this dear woman, and after dinner ye Dss made her go repose herself, and we remain'd below till she sent for us to coffee; ye Dss talk'd of [Mrs. Delany] "her excellent friend," &c.

The next day:

> The calm delightfull society of yesterday, *not* forgetting *the vase*, did me more good than freezing fingers can express.[113]

Like visiting the grotto, viewing the vase was a practice that the Duchess passed on to the young women she brought into her circle. Such visits provided the Duchess with opportunities to speak of "her excellent friend" and Mary Hamilton with a chance to experience the "calm delightfull society" provided by the storied friendship between Mary Delany and the Duchess of Portland.

As the Duchess got older, she and her friends began to pass the secrets of these landscape arts on to the next generation of women in her circle. Mary Delany speaks of finding the Duchess "encircled by her daughters, all at different works."[114] As her two daughters Lady Betty and Lady Harriet matured, they participated in their mother's projects, although they seem to have been more interested in the artistic than the scientific side of the work at Bulstrode. As Mary Delany writes, "Lady B. and Lady H. Bentinck turn and carve in ivory to the *utmost perfection*; I did not before know they had ever attempted it—I have not yet seen their painting."[115] The Duchess of Portland was no painter, but Mary Delany was, and she supervised the work of the young viscountesses who were to become Lady Weymouth and Lady Stamford (Figures 2.17 and 2.18). The Duchess returned the favor by taking an interest first in Delany's niece Mary Port and then in her daughter, also named Mary, who became a regular Bulstrode correspondent in both objects and letters when she was still learning penmanship. Mary Delany writes,

> Your little offering of fossils have the honour of being deposited in *the* cabinet, and what is still more honourable are more esteem'd as coming from "*our dear Mary*."[116]

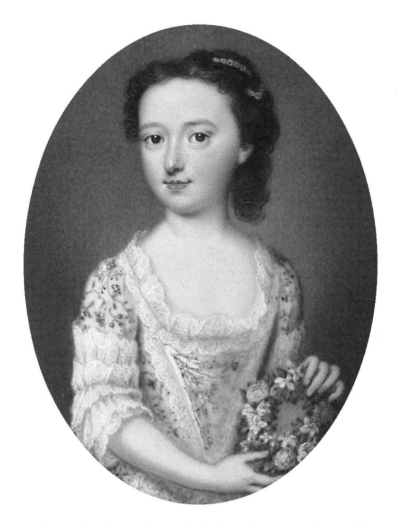

FIGURE 2.17 C. F. Zincke, *Lady Weymouth*, 1740. This daughter of the Duchess of Portland, along with her sister, the Countess of Stamford, grew up with Mary Delany, whom the little Princess Mary referred to as "another mamma of Lady Weymouths." COPYRIGHT THE HARLEY GALLERY.

"*The*" cabinet is of course the Duchess of Portland's collection, to which "our dear Mary" even as a young girl is now a contributor. Mary is instructed in the proper Linnaean classification of the plants she finds and is encouraged to pass them on: "I am sorry ye did not send your little flower it may come yet I believe by yr description it is a *Linaria* or *Toadflax*."[117] Equally important, the little girl is schooled in the particular mix of affect, art, and science that characterizes the women of the Bulstrode circle:

> The name is Helix Arbustorum. I wish my sweet bird [Mary] and I cou'd work together; I cou'd join my tears to yours that we are at so great a distance.[118]

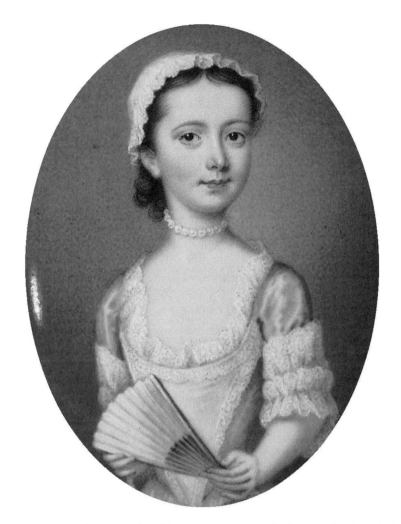

FIGURE 2.18 C. F. Zincke, *Countess of Stamford*, 1741. Mary Delany taught the sisters drawing and painting.
COPYRIGHT THE HARLEY GALLERY.

Scientific exactitude, pet names, work, and tears are among the languages in which the younger generation of Bulstrode women are expected to be fluent.

For Mary Delany, it is her beloved friend's excellent qualities that center the whole enterprise:

> Our most dear and valuable friend is in good health and spirits, has, indeed, enjoy'd the
> *shades and glories of her charming Bulstrode*, most meritoriously—how few know how to enjoy
> rationally and gratefully the blessings of Providence! but she truly has a *double* enjoymt. of
> them, by the *participation* she allows those whom she honours with her friendship; tho' no
> words are adequate to my thoughts on this subject—no heart can more warmly and gratefully
> feel its obligations.[119]

The "*shades and glories*" created by the landscape collaborations of the women of the Bulstrode circle offer "a *double* enjoym[en]t" as objects of aesthetic pleasure and opportunities for "*participation.*" Their works of landscape art are thus artistic achievements as well as monuments to the "honour" of their friendships.

As noted in chapter 1, when she reached her eighties Mary Delany required the services of a younger companion. In response to this need she took into her household at Bulstrode Mary Hamilton, a family connection and lady-in-waiting to the queen. Mary Hamilton's journal records her deep affection for the much older woman, whom she admired but also loved for her excellent qualities. Hamilton knew the value of the stories that Mary Delany was telling about her life and times, and she recorded them faithfully. One activity that was important to the older woman were visits to the grotto. "Mrs. Delany told me what a source of amusement the forming of it had been to her, it having been entirely form'd by her directions."[120] Hamilton often went there herself when Mary Delany was too ill or tired to walk with her, and she used the time and space created by the older couple exactly as it seems to have been intended: "I sat in it for some time and enjoy'd the calm serenity of the scene around me here: and I thought of all those whom I loved, of every one whose friendship I was so happy to enjoy!"[121] As was by now traditional at Bulstrode, Mary Hamilton used the Duchess's grotto to reflect on friendship. The community of artistic, intellectual, scientific, and affectional exchange centered at Bulstrode, then, did not disappear with the death of the Duchess. By that time women and girls down to the third generation (Miss Mary Port, Mary Delany's great-niece, and Mary Hamilton, born in 1756) had been schooled in its ways.

There's so much we'll never know about the Duchess of Portland, especially about her intimate life, and especially about her friendship with Mary Delany, simply because so little of her correspondence or other writings has survived. Much of it was apparently purposely destroyed; we have a record of one such occasion in a letter from Elizabeth Montagu:

> According to yr commands I did immediately burn yr note tho I was loth to destroy the pattern of yr gentle mind, it is the most gratefull office in human Life to give comfort to a friend, I should not lose an opportunity of doing it if it were possible but I know you will excuse.[122]

Montagu is clearly torn between admiration for the Duchess's letters and a sense of their historical importance as a record of her friend's "mind," on the one hand, and the requirement of their shared code to "give comfort to a friend" by shielding her privacy. Mary Delany also engaged in the practice of burning letters and in an early letter encouraged her sister Anne to burn the writings she had sent her:

> I desire you will burn this letter, for hereafter if it should come into a stranger's hand, they will say, Surely the person that writ it must have received great injuries from all mankind,

that she writes so inveterately against them. But indeed they will like under a mistake, for my reflections proceed from my observations on the world in general, which I will endeavour to profit by, and act as cautiously as possible, though that may not secure me from the common calamity; but when I have done my part to the utmost of my power, I will trust Providence with the rest, and be contented.[123]

The practice of burning letters is here directly connected to destroying information that may contribute to the image of the writer as a man hater and sufferer of the "common calamity" of a bad marriage. Delany refutes the idea that her critical views of "mankind" (here the term is explicitly gendered) derives from particular and personal "injuries." Rather, she avers, hers is the judicious view of "general" observer. Yet she wishes to do the "utmost" in her power to avoid the reputation of one who is too critical of men. Given that the letters between the Duchess and Mary Delany have virtually all disappeared, they probably contained such material. Not only the Duchess's letters to and from Mary Delany but any correspondence of the Duchess's that has survived seems to have done so by sheer chance, having been in the hands of someone not intimate enough with her to be asked to "give comfort" by destroying her writing or being inconsequential enough to slip through the scrupulous protection of her friends. What fragments remain, then, tempt us to read them hard. Applying such pressure on a line by the Duchess's friend "Fidget" attests to its value not only to her but to the practice of friendship as an artistic genre and its appreciation a form of connoisseurship: "I am sure you who I take to be a connoisseur in Friendship will allow [it] is the most natural of any [love].[124] The Duchess of Portland should be remembered as a "connoisseur of friendship," with the connotations of both terms kept in mind. In friendships as in natural history, the Duchess of Portland was a connoisseur, a collector, and one who knew how to value her treasures. ❀

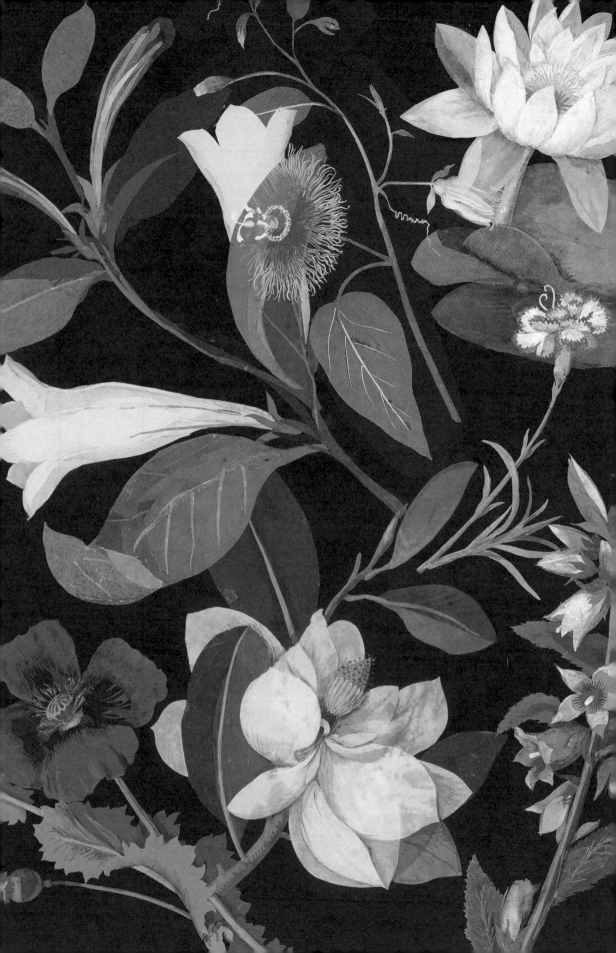

3

The Voice of Friendship, Torn from the Scene

ANNA SEWARD'S LANDSCAPES OF LESBIAN MELANCHOLY

REFLECTING ON THE RECENT MARRIAGE of her beloved friend Honora Sneyd in 1773, Anna Seward strikes a tone of mourning rather than of celebration:

> How horrid is the *Mid-day* silence of those apartments, those Gardens, or Fields which we have been accustom'd to see adorn'd by the Person of our Friend, to hear them enliven'd by their voice . . . [We] search in vain for the voice of Friendship, when it has been torn from the scene, as the flowers are to the mead, as the birds are to the grove, as the light to colours, such & so necessary is the society of those who are dear to us for giving life & beauty to all around.[1]

These words, hastily written in a tear-stained letter, could serve as a desideratum for Anna Seward's artistic and affectional practices. Her poetry has long been noted for its literary pictorialism ("there is so much picture in my poems")[2] as well as for its elegiac themes. Erasmus Darwin called her "the inventress of the Epic Elegy"[3] in referring to some of her earliest published poems that memorialized the deaths of public men such as the soldier John André and the explorer Captain Cook. But the tone of loss and mourning pervaded her pastoral lyrics as well, poems in which the absence of a beloved woman imbues the natural landscape with a poignant beauty that reminds the speaker of her friend's face and body ("the Person of our Friend"). As an accomplished musician and a connoisseur of scenic beauty and landscape painting, Seward turned habitually to analogies between the arts to describe both aesthetic effects ("as the light to colours") and the emotional state of loss and longing that suffused her work. Anna Seward created a body of work that gained much of its power from the attempted representation of the bodies of women as described in nature, "the lap of the universal mother,"[4] and from understanding women's friendship itself as a sort of "sister art" to her beloved poetry.

Unlike Mary Delany or Margaret Bentinck, Seward was a theorist as well as a practitioner of the sister arts (Figure 3.1). Her letters often mention the term as well

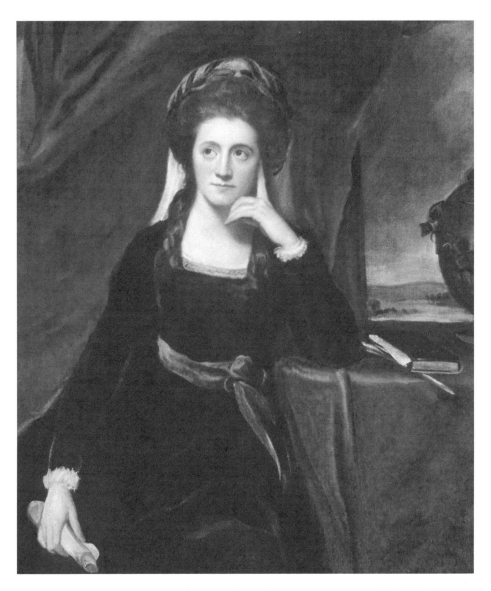

FIGURE 3.1 George Romney, *Portrait of Anna Seward*, 1782. The young poet was inspired by her love for the beautiful Honora Sneyd. THE ROBERT HULL FLEMING MUSEUM, UNIVERSITY OF VERMONT, GIFT OF MR. AND MRS. DOUGLAS BURDEN, 1953.9.

as include detailed discussions and disputes with correspondents about the aesthetic value of poetry, landscape, and painting, as well as music, which she called "younger, less important, but *still a sister*."[5] And while Delany and to a lesser extent Bentinck were interdisciplinary landscape artists who worked in a variety of media, Seward, despite her appreciation of the other arts, devoted her talents primarily to writing. Seward knew the work of Delany and the Duchess, however, and her admiration for Mary Delany's

botanical illustrations in particular helped shape her own understanding of both the sister arts and the expressivity of landscape genres.

Anna Seward has been most firmly located in lesbian history since Lillian Faderman argued in *Surpassing the Love of Men* (1981) that while Seward's relationship with Honora "probably had no genital expression" it was nonetheless "deep and intense" and was regarded by Seward at least as a "marriage" in which she "believed she had good reason to expect permanency."[6] Seward's attachment to the celebrated romantic friends the Ladies of Llangollen, according to Faderman, was one of "melancholy admiration and envy" because "the Ladies' love for each other reminded her of her own for Honora."[7] Since this important early work in lesbian literary history, scholars have developed more specific terms to try to understand the alterity of Seward's affectional world, as well as its continuity with our own understandings of lesbian identity and culture. Indeed, as I have argued elsewhere, representations of love between women in the heroine-centered eighteenth-century domestic novel are best understood as negotiating a continuum between the pathological sexualization of "Sapphism" and the exemplary chastity of "romantic friendship."[8] Susan Lanser extends this idea of uncomfortably similar relationships being held apart by the work of ideology by arguing that "a gentry class held in place a range of conventions dividing irreproachable female intimacies from dangerous ones and bifurcating friendship and sapphism along class lines."[9] She claims Seward for a category she calls "gentry sapphism" in which women used strategies including "the improvement of their properties, an assiduous control of visits and visitors, and a kind of literary self-fashioning" to distinguish themselves from their social inferiors whose love for other women could be considered vulgar.[10] Seward certainly did not shy away from association with things Sapphic in her lifetime; she even named her favorite lapdog Sappho. The dog, the "beautiful, the clean, the sensible, the beloved little creature," was the subject of verses by her neighbor, Mr. Green, who noted that the heart of Sappho's mistress was a place "where friendship and her train delight to rest."[11] As both a lover of women and a poet, "Sappho's mistress" seems a fit description for Anna Seward.

"THE CHARMS OF HER SOCIETY"

Anna Seward was born into the family of a bookish clergyman in 1742. Her father, Thomas Seward, himself an amateur poet, moved to the small cathedral city of Lichfield to become rector when Anna was seven. Even after her father's death, Seward was to live in the bishop's palace on the grounds of Lichfield Cathedral, by special episcopal dispensation, until her own death at the age of sixty-seven. As a very young child she showed literary promise, and her father taught her to read Shakespeare, Milton, and Pope at the age of three. She later recalled that her "progress in the composition of Verse met the chillness of Maternal discouragement, & her Father, as she grew up to

Womanhood, was induced to withdraw the animating welcome he had given her early Muse."[12] But by her teenage years she had attracted the attention and support of some of the luminaries of Lichfield, which in the period was a considerable center of culture and famous as the home of Samuel Johnson, a pupil of Seward's grandfather. Johnson became a lifelong friend—she attended his deathbed—as well as a sometime nemesis whose scorn for modern British poetry was a source of constant irritation to her. Erasmus Darwin, the local physician and poet known as "the Lunatic" for his founding of the local astronomy group, the Lunar Society, took a special interest in the precocious writer and sent some of her early verse out to magazines. She was also encouraged by a salon led by Lady Anna Miller at Batheaston, where writers dropped anonymous poems into an Etruscan vase from which they were drawn and read. The best of these poems were published annually and Seward's earliest work appeared in these volumes. By early adulthood, Seward's poetic skill had earned her the sobriquet of "the Swan of Lichfield."

If these early influences provided the skills and education necessary for the poet's career, her fateful meeting with Honora Sneyd at the age of fourteen provided much of the thematic inspiration for a lifetime of literary production. Many years later, Seward recalled the moment when the child who had joined the Seward family as a foster sister grew into Seward's "beloved Honora." Of Honora, then sixteen to Seward's twenty-four, the poet recalls:

> Honora . . . was commencing woman, and only eight years younger than myself; more
> lovely, more amiable, more interesting, than any thing I ever saw in the female form. . . .
> The charms of her society, when her advancing years gave equality to our connection, made
> Lichfield an Edenic scene to me, from the year 1766 to 1771.[13]

Seward herself credits two previous losses for directing "all the energies of my soul into the channel of friendship," with Honora as "its chief object." The death of Seward's only sibling, her sister Sarah, left her desolate. Around the same time she fell in love with a young Mr. Temple, but her parents forbade the match on the grounds that his fortune was insufficient. Although at the time she felt "the liveliest tenderness" for her suitor,[14] within a short time she had fallen in love with another man who did not return her affection, thus curing her of her first attachment. She also refused a proposal from a Lichfield neighbor, Cornet Vyse, and had a long passionate friendship with John Savile, the married chorister of Lichfield Cathedral. Indeed, her intimacy with Savile, whose wife Seward called "the vilest of women & the most brutally despicable," became so notorious that her parents forbade her to see him at all for a period of time, which she lamented as the "cruelty & injustice of arbitrary power."[15] But none of these relationships with men, although carried on with Seward's characteristic Romantic intensity, proved the wellspring of lifelong emotion and the poetic inspiration that was her love for Honora.

FIGURE 3.2 Lichfield Cathedral and its famous triple spires. Honora Sneyd, who lived with Anna Seward in the Cathedral Close, referred to them as the "Three Ladies." PHOTOGRAPH BY LEON HAWLEY.

Seward lived, first with her father and then after his death on her own, in the cathedral close sheltered by the famous three-spired Lichfield Cathedral (Figure 3.2). Another important landscape feature of the close is Minster Pool, part of a network of streams and "moggs" or swamps that runs throughout the Stowe Valley where Lichfield is situated. Minster Pool was periodically "scoured" by the Corporation of the City of Lichfield as a public service in order to keep it clean enough for use and beauty. In 1771, it was due for another such scouring when Anna Seward intervened. She had just returned from London where she had admired the work of Queen Charlotte in designing the new Serpentine in Hyde Park (Figure 3.3). Influenced by this, one of the few public landscape designs credited to a woman in the great age of English landscape design, Seward started a subscription to fund the creation of a new design for Minster Pool in the newly fashionable "serpentine" shape (Figure 3.4). As a result, the formerly rectangular pool was endowed with picturesque curves. The improvements also included a newly graveled walk on the south side of the pool, a grove planted on the north side, and a small island in the middle. Pool Walk in present-day Lichfield is thus famous in local legend as the landscape design work of Anna Seward.[16] Seward was also involved in a long-running civic campaign to save the cathedral limes, ancient trees in

FIGURE 3.3 (TOP) W. Schmollinger, engraving, *Hyde Park section of Improved map of London for 1833, from Actual Survey.* Seward designed the promenade around Lichfield's Minster Pool in imitation of Hyde Park's Serpentine Walk, shown here.

FIGURE 3.4 (BOTTOM) Minster Pool, Lichfield. Local legend credits Seward with this and other civic improvement projects. With its famous cathedral and major coach stop, Lichfield was a cosmopolitan center in the eighteenth century. COURTESY OF LICHFIELD CITY COUNCIL.

the cathedral close that the church wished to remove in order to improve the facilities serving the adjoining buildings. In a letter written in 1769, Seward's friend John André sympathized with her "resentment against the Canonical Dons, who stumpify the heads of those good tree people, beneath whose friendship shade so many of your happiest hours have glided away."[17] Seward was to live in the close for the rest of her life and continued to spearhead preservation efforts.

To the lesbian landscape poems that represent a beloved woman in and as an equally beloved landscape, Seward brings the eye not just of an appreciator but a designer of the lived environment and a conservationist. Among the most prominent of these poems is the "Epistle to Miss Honora Sneyd. . . . from the Grave of a Suicide."[18] As is typical of Seward's pastorals, the poem begins with the speaker situated in a beautiful outdoor setting. In "Grave of a Suicide," the tone of loss and mourning is established by this setting: the grave "where the love-desperate maid, of vanish'd years / Slung her dire cord between the sister trees" (84). The source for Seward's poem is the story of a young woman, disappointed in love, who kills herself and thus enters local mythology. We learn that the suicide victim died and was buried on the very spot the poet chooses for her "fond, fruitless plaints." Seated on "the bank that screens" the "mouldering form" (84) of the corpse, the poet surveys the prospect. She notes its lack of conventional pastoral adornment: "No labouring hinds on yonder meads appear"—"yet," she says,

> The nearly-meeting trees, with plenteous spray,
> Arch oe'r the darkling land that winds away
> Far to the right. (85)

Some characteristic images for this group of lesbian landscape poems are at work here. The arch, the notion of plenitude, and the synesthetic appeal of "spray" as both a visual and a tactile image (a spray of branches and a spray of moisture) are common to Seward's other poems in this group. The conceit of the poet as landscape painter is also key to this kind of poem. As she looks "to the right," she constructs a little landscape painting of words with the conventional image of the road dwindling away into the distance as in a Salvator Rosa painting. (Rosa was Seward's favorite painter: "Poetic descriptions and penciled resemblances please me best when they take the Salvatorial style.")[19] The speaker then looks "in front" and "then the left" in turn, thereby establishing small pictures in a few lines with each new perspective point. Another feature of these poems is their appeal to all the senses, both with the kind of overladen multisensory imagery noted above and with attention to the landscape's "rich perfume" and "fragrance," here rendered ironic and sad by its proximity to "the hapless grave" (85). Moisture—"balmy dews," (85) "tearful eye" (86)—is another common conceit in Seward's lesbian landscape poems. The final stanza of this poem contains the most explicit version of Seward's reshaping of the landscape in the image of her own desire. The final vista is of a landscape where:

each object seems array'd
In the fair semblance of the absent maid;
Where bowers and lawns her stamp and image bear,
At once, alas! so distant, and so near!
And, to the aching heart, and tearful eye,
Stand the mute spectres of departed joy. (86)

The poet's desiring gaze shapes the pastoral world such that it reflects back to
her the form and face ("stamp and image") of her lost love. Imaging the landscape is
important in Seward's poems to Honora because it allows her to remake the world
before the Fall. Her pastoral ideal, her unattainable Eden, is one in which the beloved
woman remains with her, as familiar and accessible as Lichfield itself.

Another landscape poem that also takes Lichfield as its setting and Honora as its
theme is "The Anniversary."[20] The poem makes use of one of Seward's characteristic
rhetorical devices, that of apostrophe. Notably, the two beings apostrophized are the
Lichfield landscape ("O lovely Lichfield! . . . Stately, yet rural!") and Honora Sneyd,
whose arrival in the Seward home is the anniversary being celebrated: "Ah, dear
Honora! That remembered day / First on these eyes when shone thy early ray" (69).
The speaker wanders through the present-day Lichfield landscape, using its natural
beauty as a spur to memory that recalls the beauty of the young Honora.

The ardent progress of thy shining hours,
Behold me rove through Lichfield's verdant bowers.

O! Hast thou marked the Summer's budded rose,
When 'mid the veiling moss its crimson glows?
So bloomed the beauty of that fairy-form,
So her dark locks, with golden tinges warm,
Played round the timid curve of that white neck,
And sweetly shaded half her blushing cheek. (70, 72)

The "bowers," "rose," and "moss" that the poet actually sees around her recall the
"fairy-form," or in the language of the letter quoted earlier, the "Person," emphatically
embodied here as "locks, with golden tinges warm," a "white neck," and "blushing
cheek," of the longed-for friend. Not only through imagery, however, but also through
the rhetorical position of the speaker established by her apostrophe, the landscape and
the beloved body are addressed as one.

In "Time Past,"[21] a poem Seward wrote shortly after Honora's marriage to Richard
Edgeworth, the lush summertime imagery of "The Anniversary" gives way to a bleak
winterscape: "Winter's bare, bleak fields," "the grey night-frost on the sounding plain,"
"the gloom of dim November's eve" (87–88). The poet explains that she prefers this

landscape to "green luxuriant vales" because in winter she and her "lov'd Honora" spent precious hours around the fireside behind "warm curtains" (88). Here, the characteristic apostrophe occurs not to conflate the landscape with the beloved's body but with the poet's love itself:

> Affection,—Friendship,—Sympathy,—your throne
> Is Winter's glowing hearth;—and ye were ours,
> Thy smile, Honora, made them all our own.—
> Where are they *now?*—alas! their choicest powers
> Faded at thy retreat (88)

Ironically, in the absence of the beloved the depleted winter landscape becomes the cherished object of the poet's gaze, its "loud Storms, that desolate the bowers" finding "dearer welcome" as the synechdochal replacement for lost love.

A series of sonnets that Seward wrote over the course of thirty years were published in 1799 as *Original Sonnets on Various Subjects, and Odes, Paraphrased from Horace.* A significant group of these poems concern the poet's relationship with Honora and her reaction to the marriage. Here, too, apostrophe is prominent. "Sonnet IV," an early work written in 1770 at the height of the women's intimacy, uses apostrophe as its simple title: "To Honora Sneyd, Whose Health Was Always Best in Winter." Again we see the poet's ironic reversal of the primacy of the springtime landscape as an image of love and beauty. The first ten lines of the poem catalogue the usual list of verdant nature in "youthful, gay, capricious Spring," "the prime of Hours that Beauty robes." Yet, the poet asserts,

> . . . all they gild,
> Cheer, and delight in this their fragrant time,
> For thy dear sake, to me less pleasure yield
> Than, veil'd in sleet, and rain, and hoary rime,
> Dim Winter's naked hedge and plashy field. (6)

The poet's "pleasure" consists not in what springtime can "gild"—significantly, an image of a mechanical process of the conversion of metal to a decorative surface. The poet prefers the "rime" or hoarfrost that glitters on the outdoor surfaces of the winter landscape. Indeed, the wintertime imagery here is surprisingly sensuous: the "naked," "plashy" dripping wet body of the landscape is seductively "veil'd" in sleet, rain, and "rime." Conventional beauty, then, gives way to surprising pleasure as the poet's highest value in her relationship to Honora.

Three years later in a sonnet that apostrophizes Honora in the first word, the meaning of the winter landscape has changed. Written shortly after Honora's marriage, the poem expresses the poet's fears about the effect of the match on the women's

FIGURE 3.5 Horace Hone, *Miniature Portrait of Richard Lovell Edgeworth*, 1785. Although Seward initially befriended Edgeworth, she came to hate him for marrying Honora and taking her away to Ireland, and ultimately she blamed him for his young wife's early death. COPYRIGHT NATIONAL PORTRAIT GALLERY, LONDON.

relationship. Ironically, although Honora's parents and many other friends thought the match ill advised—Edgeworth was a poor Irish clergyman with four children by his deceased first wife—Seward was, at first, a loyal supporter of her friend's choice, even serving as bridesmaid (Figure 3.5). As she wrote of the event shortly afterward: "The joy of united hearts & hands, esteem, friendship & congenial talents shone in the lovely faces of the charming Pair." Even in this early letter, though, there is a tone of foreboding when it comes to Edgeworth himself: "Well may he triumph, for he has obtained a matchless prize!"[22] Later that same year, Seward's tone had darkened. Although she still defended the marriage, she also wrote of its toll on her, recalling in a letter that unlike other guests whose "gloom was evident all the time of preparation for our Honora's nuptials," Seward herself experienced "joy which found its way to *my* heart thro' all the dismal prospects and cureless sorrows that surround it—Despair it self cou'd smile while it contemplated the lovely Couple."[23] Seward's mixed feelings find their way into "Sonnet X" as well. In

anticipating that an emotional separation might be loaded on top of the physical one (the couple's remove to Ireland) she so deplored, the poet appeals directly to the beloved:

> Honora, shou'd that cruel time arrive
> When 'gainst my truth thou should'st my errors poize,
> Scorning remembrance of our vanish'd joys;
> When for the love-warm looks, in which I live,
> But cold respect must greet me (12)

Initially, the apostrophe does not connect Honora with a landscape, real or remembered. But by the end of the poem, Honora has become a natural object, the sun whose "soul-cheering rays" in "dire eclipse" leave the landscape cold and cheerless:

> I cou'd not learn my struggling heart to tear
> From thy lov'd form, that thro' my memory strays;
> Nor in the pale horizon of Despair
> Endure the wintry and the darken'd days. (12)

The "lov'd form" moves through a remembered landscape that takes as its "horizon" an emotional state, "Despair," and as its weather "wintry and darken'd days." It is as if the poet anticipates, in a register of loss, the return of the cozy wintertime images of "Sonnet IV," revenants of a more profound absence that, paradoxically, has not yet been experienced.

"Sonnet X" was written in April 1773. Three months later, Seward begins "Sonnet XII" describing herself as "chill'd by unkind Honora's alter'd eye" (14). Stoically, she reminds herself not to be "thankless for much of good" that is still left to her, compared to victims of poverty and disease whose lives "beneath this wintry sky" make hers seem "blest." Again we see a reversal of expectation in relation to the seasons: the poet tells us, in a note at the end, that the poem was composed in July, yet she describes "this" sky, the one above head at the moment of writing, as "wintry." In another reversal, the poet mourns that "a plighted love is changed to cold disdain!" Here, it is the relationship between two women that is given sacred, public, "plighted" status, not the legal marriage that divides them.

Seward addresses "Sonnet XIX" to Edgeworth himself: "Farewell, false Friend!—our scenes of kindness close!" (21). We don't know exactly what happened to so definitively change Seward's opinion of Edgeworth. The poem itself only refers to his "alter'd looks, where truth no longer glows" and to a "falsehood avow'd" and a "broken vow." Again, the language of legal marriage ("vow") is here applied to a friendship, in this case that between Edgeworth and Seward, who "once were to each other" exchangers of "cordial looks" and "sunny smiles." Seward's use of apostrophe here is entirely rhetorical rather than metaphorical or pictorial—that is, the fourteen lines of the poem are simply an exhalation of disappointment and bitterness, punctuated by no less

than five exclamation points, aimed directly at the absent friend. The poem contains virtually no imagery, landscape or otherwise, as if the poet's very ability to be poetic— to make metaphor, to see one thing in terms of another—has been annihilated in the disappearance of her beloved Honora.

"Sonnet XXX" is undated. Here the poet records a moment in which a song heard in the wind brings back "the youth of chang'd Honora" (32). Seward had an Aeolian harp made after viewing one on her visit to the home of the Ladies of Llangollen in 1796 (Figure 3.6). She placed the instrument in her window so that incoming breezes would play a melody, and it may be to the sound of such an instrument that the poem refers:

Sing, yet once more, that well-remember'd strain,
Which oft made vocal every passing gale
In days long fled, in Pleasure's golden reign . . .

FIGURE 3.6 Aeolian harp in the old castle of Baden Baden. Seward saw such an instrument (which is placed in the window so that the wind plays a chance melody) in the home of the Ladies of Llangollen and had a similar one built for herself. *SCIENTIFIC AMERICAN SUPPLEMENT, NO. 483, APRIL 4, 1885.*

With characteristic synesthetic richness, the poem layers sound on top of image. The central lines of the poem are filled with landscape images:

> . . . Morn's calm dew on yonder hill,
> When slants the sun upon its grassy side,
> Tinging the brooks that many a mead divide
> With lines of gilded light; and blue, and still,
> The distant lake stands gleaming in the vale.

The song reminds the poet of Honora, taking her deep into memory's territory, yet it also brings her attention to the beauty of the immediate surroundings, of "yonder" hill visible to the poet at the moment of composition. The final couplet ampifies this layering or blurring of one sense into another: "now it wears / Her air—her smile—spells of the vanished years!" The referent for the pronoun "it" is "that well-remembered strain" named in the first line of the final sestet. Yet how can a sound, a song, "wear" the "air" and "smile" of a person? The conventions built up in Seward's previous Honora poems lead us to assign this personification to the hillside and the lake, the landscape shared by the two women in the past and in the poet's memory. This indeterminacy— the understanding of one sensory experience in terms of another, of sound in terms of sight, for example—expresses Seward's understanding of the "sisterhood" of all the arts, of the interconnection between sense experiences produced by different physiological systems and artistic genres.

Seward's poems about Edgeworth's perfidy toward herself and Honora, strikingly, are not landscape poems. Although "Sonnet XXXI" does begin by apostrophizing Honora ("O, ever dear!" [33]), the point of the poem is to calumniate the apparent indifference of Edgeworth ("the Rashly-Chosen of thy heart") in leaving his wife's deathbed for public gatherings "where dances, songs and theatres invite." The "scenes" in the poet's mind here are not landscapes but indoor spectacles where "Pleasure's light forms" waft across her tortured imagination. The poem ends:

> I hear him, who shou'd droop in silent woe,
> Declaim on actors, and on Taste decide!

Edgeworth here is pictured as entirely a creature of society rather than of nature. His disassociation from the natural world and his engagement with fashionable pastimes such as the theater are part of what make him the villain of the piece.

Seward's anger at Edgeworth, in fact, can't be contained within the boundaries of a single sonnet, so under the title "Sonnet XXXI" she writes, "Subject of the Preceding Sonnet Continued." Her epithet for Edgeworth here is even more vituperative, even as she once again addresses Honora as the putative addressee of the poem:

Behold him now his genuine colours wear,
That specious False-One, by whose cruel wiles
I lost thy amity (34)

In this poem, we see the poet forgive her dying beloved for her "broken faith,"
letting her feelings of betrayal go along with "the interesting, happy hours, / Days, years,
we shar'd together. They are flown!" Edgeworth is fixed in Seward's mental narrative
as the villain who drove her and Honora apart and whose neglect caused Honora's
"early-hasten'd tomb." Once again, there is very little imagery of any kind here, certainly
no extended vision of the beloved in the landscape. The work of these angry verses
seems to be rhetorical rather than figurative. They do not bring Honora into the
poet's presence; rather, they adjust the terms of memory so that Honora can keep her
place there. Through a fixed focus on the lost object ("long must I lament thy hapless
doom"), the poet remains close to the lost beloved, and the coolness between the two
women is incinerated in Seward's rage at Edgeworth.

In the final sonnet in this group about Honora, "Sonnet XXXIII," written just after
the young woman's death by consumption in 1780, Seward no longer addresses her
lost beloved. Instead, she addresses the "Spirit of dreams" (35), begging to see Honora
while she sleeps. This is a "Bliss, asked of thee with Memory's thrilling tears." Bliss and
memory are linked through the one image in the poem: the request that the spirit

. . . ordain
Her beauteous lip may wear the smile that stole
In years long fled, the sting from every pain!
Show her sweet face, ah show it to my soul!

Honora's body reappears here, but it is no longer linked to an equally beloved landscape.
The absence of the comforting hills and vales of Lichfield amplifies the poet's isolation,
leaving her bereft of all comfort except the company of melancholy.

Like so many Romantic poets, Seward values what in psychoanalytic terms would
be called melancholia over mourning, seeing inconsolable loss as a sign of genius, an
insight into what was classically seen as "the special truth of sadness."[24] The work of
mourning involves grieving a loss in a way that acknowledges it: the absence of the
loved object is felt, expressed, honored, and released. The therapeutic goal is to be
able to go on with life in the face of the devastating and catastrophic, but nonetheless
inevitable, losses that human relationships entail. Melancholia is much more romantic;
as David Eng notes, it is "an enduring devotion on the part of the ego to the lost
object."[25] Melancholia occurs when the absence itself comes to substitute for the lost
beloved object: that is, to "work through" the grief or to take up life again—to put the
loss in perspective and allow it to recede in time—is experienced not only as a betrayal

of the loved one but as a catastrophic loss in and of itself, the loss of the attachment to the loss. As long as the griever remains attached to the loss, experiences it as an ongoing, present-time event rather than an incident in the past, so long is the deepest level of traumatic bereavement averted. For eighteenth-century queer subjects, the anticipation of the loss and failure of a relationship that had little social space or visibility to countenance it might be worked into the fabric of same-sex desire itself.[26] For eighteenth-century women, marriage was all but inevitable, if not for oneself then for one's friend. Mourning a friend's marriage is a classic convention in the literature of women's friendship; for Seward, it brought death—Honora's, Edgeworth's, her own—immediately to mind. Seward's death wish is in fact a lesbian literary convention that should take its place as a key aspect of the lesbian history of queer melancholia.[27]

SEWARD AND THE TRADITION OF THE QUEER ELEGY

Seward was famed for her elegies; Darwin dubbed her "the inventress of the epic elegy" in acknowledgment of the innovation of such poems as "Monody on the Death of Major André" and "Elegy for Captain Cook." Recent queer literary history has noted the strong connection between the elegy and poems of male same-sex friendship, thus demonstrating the existence of a tradition of queer elegy at the heart of the canon.[28] (The AIDS elegy is the most distinguished recent flowering of this tradition.)[29] Poems by men marking a woman's loss of a beloved woman friend is a tradition that goes back to the seventeenth century, according to Valerie Traub, who notes the "conventional topos" of nostalgia for erotic girlhood friendships in Renaissance writing.[30] Seward's Honora poems represent an innovation in both traditions: as poems by a woman about the loss of a woman's love, they intrude both on a canonical tradition of elegiac male friendship and on a tradition in which love between women is a topos used by male writers for the pleasure of male readers, an opportunity to master such images in a narrative of heterosexual closure. Darwin's association of Seward with the elegy overlooks, and tempts us to overlook, that many of her poems of loss were not elegies or poems that end by offering consolation to the mourner through an invitation to rejoin the community of the living, but rather monodies—laments in a single voice that end where they begin, in a lonely howl of grief. The monody exists only to express loss, not to justify, rationalize, or console it. As such, it is the form par excellence for expressing Anna Seward's lesbian melancholy. Her poem about Captain Cook's death is an elegy; but the title of her work about John André, the only man Seward ever thought was good enough for Honora (and this only after her family refused the couple permission to marry and André died in the American war), is titled as a monody. The poem is in fact as much about Honora as it is about the unfortunate soldier; the loss of the British hero, Seward implies, is consonant with his earlier loss, one she shares, of Honora's love.

The monodist, then, does not seek the healthful consolations of society. In such an asocial state, according to Freud, the sufferer has "a keener eye for the truth than other people who are not melancholic"; the often unwelcome perceptions of the queer subject who mourns what others celebrate—for example, marriage—emerge from this skeptical vision of the normal. The political and creative work of melancholy has been richly reconsidered in queer theory in ways that help identify the characteristic queerness of Seward's position in these poems. Since the publication of Douglas Crimp's spectacular "Mourning and Melancholia" in the early days of the AIDS epidemic, much of this work has described the impossibility of so-called "healthy mourning" for those whose stigmatized desires are seen as the causes of their suffering. Melancholia has been of interest, then, because mere mourning "promises a return to normalcy that we were never granted in the first place."[31] In incorporating this insight into a broader consideration of the politics of loss, Eng argues that "a better understanding of melancholic attachments to loss might depathologize those attachments, making visible not only their social bases but also their creative, unpredictable, political aspects."[32]

Seward did write one poem to Honora that she named an elegy (though contra Darwin we would have to call it a "lyric" rather than an "epic" elegy).[33] As with the poems written after Honora's marriage, these verses imagine rather than remember the death of the beloved woman; Honora is still alive to be addressed at the time of composition. The sixteen-line poem begins with an attempt to engrave the lost beloved's name into the earth: "I write, Honora, on the sparkling sand!— / The envious waves forbid the trace to stay" (82). Here the poet's typical apostrophizing gesture, meant to summon the absent Honora into conversation, is equivocal. Is the poet actually addressing Honora ("I write, Honora, . . .")? Or is the word "Honora" simply meant to indicate the marks that the speaker carves into the sand? The full title of the poem, "Elegy Written at the Sea-Side, and Addressed to Miss Honora Sneyd," certainly conveys the intention of direct address. But the indeterminacy of the first invocation of the beloved's name suggests that the premonition of death has impaired the poet's imaginative ability to see the beloved in the landscape. The poem ends with conventional Shakespearean bravado, asserting that while "Time" and "Oblivion" will "soon dissolve" Honora's youth and beauty, the "lasting tablets" of the poem itself, empowered by "Love and the Muse," will preserve Honora forever for "her Anna" (83). Thus far, then, it follows the elegiac convention of turning to consolation at the end of the poem. The monodic context of her other laments for Honora's lost love, however, alert us to similar elements in this poem. The status of writing as a form of permanent memorial, asserted at the end of the poem, is undermined by the series of similes traced in the earlier stanzas. Just as the poet writes Honora's name on sand, "So Nature" writes the beloved's beauty on her face; Honora's "charms" are destined to wash away with the "stern tide" of mortality. The brave assertion that "Love and the Muse" can keep Honora alive forever insist on a melancholic relation to loss; only

by continuing to grieve can the beloved's name be written and rewritten in defiance of time and mortality. Indeed, the limits of "Love's" power is precisely what is being grieved here. Although Honora lives, their love has died and an elegy must be written for it. Even the title alerts us to the equivocal status of the loss being lamented; Honora is not dead yet, but the poet writes her an elegy. The allure of writing about the friend's death is so powerful that the poet creates an occasion to imagine it before it happens. The loss is more poetically generative than the friendship itself; when the beloved woman enters a heterosexual marriage, the fact that she is still living may be so painful as to result in a poem that seems like a death wish. The sentiment of wishing a beloved dead rather than in the arms of another is certainly not one we typically associate with the companionable feelings attributed to romantic friendship; Seward's poem demands that we attend to the dark passions at play in such a relationship. Their melancholic character stands revealed by the monodic strain in Seward's poems of loss.

Indeed, in "Epistle to Miss Honora Sneyd—Written, Sept. 1770," Seward takes the pleasures of melancholic attachment and the forms of monodic lament as her theme.[34] Written before Honora's marriage, on the occasion of a briefer separation when the young woman went to Bristol to "take the waters" for her health, this long lyric, departing from the sonnet form, depicts the speaker "alone, beneath these bowers," the tree-shrouded cathedral close whose "spires high" overlook the home that the two women shared. In the dark, the speaker "call'd Honora," knowing that there would be no response. The poem turns to apostrophe to ask,

> Yet, why, thou urgest, by deception gain
> A mimic joy, that must increase the pain
> When Disappointment brings her sick chagrin
> To lone Privation's melancholy scene?
> But O! each varied species Sorrow knows
> Endured for thee, Honora, welcome grows . . . (77)

"Pain," "Disappointment," "Privation," and "Sorrow" are all "welcome" in the absence of Honora. Indeed, in venturing into the tree-shrouded landscape they habitually share in order to call to an absent beloved she knows will not respond, the speaker calls to her instead these feelings, which substitute for the inaccessible person of the beloved. The poem then gives us the view of the landscape through the speaker's eyes. First her "enthusiast eyes" look up to the famous three spires of Lichfield Cathedral. (In a letter to Seward, John André remembered that Honora referred to these spires as "the *Ladies of the Valley*.") Next, the poet turns her gaze to "the most, silver'd ground . . . But, still each thought with fair Honora staid." Honora's absence "stole / Th'impassion'd dictates of her Anna's soul," which the poet seeks to replace first with overwhelming feelings and then with the body of the landscape itself. These substitutions allow the poet to

imagine Honora's return to "her favourite plain" with renewed health showing in her "lovely cheek" and "vermeil" lip (78). The next angle of view established by the poem is another glance upward at "the Ladies," "those conscious spires . . . Whispering my heart that Heaven would soon restore / Honora to her loved domestic scene" (79). Instead of hope, however, the speaker sees a "darkn'ing omen": "a cloud / The mist convolving, form'd a total shroud," hiding the cathedral spires from view. The landscape does not return comfort but rather fear and doubt. The poet pleads with "Grim Superstition," seeking to banish it from the scene. After all, "Vows not Honora that the vital flame / Relumes its course thro' her late languid frame?" (80). The poem then lurches somewhat unconvincingly back to "Hope's perspective," wherein the poet imagines the cycle of the seasons "blest" by Honora's health and presence that "gild," "shed . . . lustre" and "deck" the cloudy nighttime landscape that is its setting (80–81). Lament and loss, not consolation, remain the governing passions of the poem.

A LITTLE TEMPLE CONSECRATE: SEWARD AND THE LADIES OF LLANGOLLEN

Honora as a young woman remained present to Seward for the rest of her life. Not only did she write about her, but she also saw her in dreams and in resemblances to a succession of beautiful young women:

> The youthful and lovely lady Foster Cunliffe descended, like a goddess, amongst us . . . She is on a larger scale, both as to face and figure, but I never saw features, or a countenance so like my lost Honora's. Her complexion of as glowing bloom, with a superior degree of fairness;— the contour of the face; the form of the mouth; the nose, that between Grecian and Roman, is lovelier than either, the *etherial smile* on the lip, and the bright glance of intelligence and joy, are *all* HONORA.[35]

Honora was also present to Seward when she wrote in or about the Lichfield landscape:

> I sit writing upon this dear green terrace, feeding, at intervals, my little golden-breasted songsters. The embosomed vale of Stow, which you know it overlooks, glows sunny through the Claud-Lorain-tine, which is spread over the scene, like the blue mist over a plumb. How often has our lost Honora hung over the wall of this terrace, enamoured of its scenic graces! Never more will such bright glances discriminate and admire them.[36]

The loss of Honora's "discriminating" taste for landscape is what is felt here; her connoisseurship, her ability to appreciate the "Claud-Lorain-tine" or misty blue tint in the air that renders the feminine, curving, "embosomed" landscape picturesque, composed as for a painting. And indeed it was a painting that came closest to restoring

Honora to Anna Seward and that also cemented the friendship that was to anchor the latter part of Seward's life as Honora's had anchored her youth.

In 1782 the painter George Romney, for whom Seward sat as a young woman, sent to her as a gift a color print of his painting *Serena Reading* (see Plate 9). The painting, which illustrates a character from a poem by their mutual friend William Hayley, shows a seated young woman curved over a book whose page is lit only by a candle. Romney did another painting of the same subject in which he placed the young woman in a pastoral landscape, but here the effect is all chiaroscuro. Hayley's poem, "The Triumphs of Temper," was his most successful. In six cantos of rhyming couplets, it advises young women to master any faults in temper in favor of a uniformly pleasant manner. The notoriously querulous Anna Seward cannot have benefited much from this advice, but she admired the poem and seemed to fall in love with Romney's painting. When she received Romney's gift, she wrote that the image showed "exactly what Honora *was* . . . in the year '69—ev'ry feature exactly her—the Form, the countenance, *all all* Honora! Oh! what a blessing to possess it!"[37] Seward's joy was especially poignant because three years earlier she had been disappointed by the sight of a portrait of Honora by the miniaturist John Smart, which Edgeworth, visiting Lichfield, had brought for her to see.

> The picture is beautiful, but my disappointment was extreme for it gives me very little idea of Honora.—Oh! that it had been a striking likeness!—since, when she is no more, I might perhaps have procur'd a copy! As it is, it wou'd scarcely be an object of sufficient importance to make me ask a *favour* of a man who has so deeply injur'd me.[38]

Not only was the Smart portrait a poor likeness and owned by a man she hated, it was also a miniature. And characteristically, the poet thinks forward to Honora's death in her assessment of the painting. Seward enjoyed the larger scale of the Romney print as a major feature of the interior decoration of her home.

> A fortnight since, according to my annual custom, I removed [the picture] from my sitting-room below stairs, of western aspect, to my little embowered book-room, into whose northern window the sun never looks in his ardour, though it catches partially, in summer, the golden glances of his evening beams. Thus is this beauteous resemblance my constant companion, and contributes to endear, as the bright reality endeared, in times long past, this pleasant mansion to my affections;—and thus, whenever I lift my eyes from my pen, my book, or the faces of my companions, they anchor on that countenance, which was the sun of my youthful horizon.[39]

The west, the north, the sun, the light, the horizon, all these landscape features center in the painted face of which Seward says, "Such was Honora Sneyd!"[40] As a carefully considered feature of her physical surroundings, the painting is a material object and a psychic one that allows Seward to remain in Honora's presence in a state of melancholic

FIGURE 3.7 Lady Leighton, *The Ladies of Llangollen*, 1813. Seward visited the famous couple, Sarah Ponsonby and Lady Eleanor Butler, in their Welsh retreat in 1796 and wrote a book of verses dedicated to them.
COURTESY OF DENBIGHSHIRE HERITAGE SERVICE.

sadness that is not quite the same as complete loss. As long as Seward has the reminder that Honora is no longer with her, she has, in some paradoxical way, not quite lost Honora.

In 1796, Seward bought another copy of this sacred picture and sent it as a gift to her new friends, Lady Eleanor Butler and Sarah Ponsonby (Figure 3.7). These women, the "Ladies of Llangollen," were famous for female friendship. Seward was fifty-four years old when she met them for the first time, and the Ladies were fifty-seven and forty-one respectively. Butler and Ponsonby had lived together at Plas Newydd (Figure 3.8), a cottage outside the town of Llangollen in Wales, since eloping in 1778 from

FIGURE 3.8 Postcard photograph of Plas Newydd, postmarked August 7, 1923. Seward called their home "a fairy Palace . . . consecrate to Friendship, and the Muses." FROM THE COLLECTION OF GRAHAM GILMOUR GREASLEY.

their families (for the second time; after the first attempt, dressed as men, they were caught and brought back). Seward referred to them as "the Rosalind and Celia of Llangollen Vale," comparing them to the heroines of Shakespeare's *As You Like It*, who also dress in men's clothes to avoid unwanted marital fates. The pair were celebrities: they were visited by Wordsworth, Southey, the Duke of Wellington, and Sir Walter Scott; and they corresponded with Queen Charlotte and Hester Thrale Piozzi. Although they were not themselves artists or writers, their life of devoted friendship and almost conventual simplicity attracted the attention of Romantic writers. Many wrote of them admiringly, though they were also the object of jokes about their so-called mannish appearance and skepticism about whether or not their relationship was sexual. "I cannot help thinking that surely it was not platonic," wrote the Regency diarist Anne Lister to her lover Marianne, and she guessed that the women were united by "something more tender still than friendship."[41] Certainly the bed they shared, still visible at the restored Plas Newydd Museum, is small enough that physical contact of some kind must have been a fact of daily life.

Seward, already an enthusiast for the picturesque landscapes of Wales, eagerly cultivated the friendship of the Ladies, who were of course aware of her fame and invited her to tea during the poet's visit to friends in the neighborhood. These afternoon visits resulted in the poet's "promise to be their *intire* Guests two days" the next time she was in Wales, and the friendship was off to a roaring start. For Anna Seward, the beautiful natural setting of Plas Newydd was an important part of the charm:

they are Women of genius, taste, & knowledge; sought by the Great, the Lettered, & the Elegant. Their fairy Palace is curiously adorned; it is a little Temple consecrate to Friendship, & the Muses, & adorned by the hands of all the Graces. Their Lawns & Bowers breathe the same spirit of consummate elegance. Devoted as they are to each other, their expanding hearts have yet room for other warm attachments.[42]

Seward defended Plas Newydd against the charge of being more practical than picturesque:

Certainly this interesting retreat of lady Eleanor Butler, and Miss Ponsonby, might have been placed where it would have had sublimer scenic accompaniments—but its site is sufficiently lovely, sufficiently romantic. When two females meant to sit down for life in a sylvan retirement, with a small establishment of servants, it became necessary that the desire of landscape-charms should become subservient to the more material considerations of health, protection, and convenience. Their scene, not on those wild heights which must have exposed them to the mountain storms, is yet on a dry gravelly bank, favourable to health and exercise, and sheltered by a background of rocks and hills. Instead of seeking the picturesque banks of the dashing river, foaming through its craggy channel, and whose spray and mists must have been confined, and therefore unwholesome, by the vast rocks and mountains towering on either hand, they contented themselves with the briery dell and its prattling brook, which descend abruptly from a reach of that winding walk, which forms the bounds of their smiling, though small domain.[43]

Seward accepted the gift of a "Brocus Bergamot pear-tree" for her own garden from the women, for whom fruit trees furnished an important addition to their annual store of food. More congenial to Seward's taste in landscape, however, was the poem she soon began writing, inspired by both the relationship between Butler and Ponsonby and the natural beauty that was its setting.

In keeping with their shared interests in painting and gardening as well as poetry, Butler and Ponsonby sent Seward an engraving of a landscape drawing of the Welsh valley for which her poem was named to serve as an illustration on the title page (Figure 3.9). Seward declared herself delighted by "the scenic fidelity, and elegant execution" of the engraving.[44] The poem itself is dedicated to Butler and Ponsonby, and its inspiration was both their friendship and its splendid natural setting: "The ladies, whose bowers, whose talents and whose pursuits form its most considerable theme" are memorialized in a poem in which "the wild and the soft landscapes" were compared by a reader to "the greatness of Salvator, and the elegance of Claude."[45]

Seward's poem for Butler and Ponsonby, "Llangollen Vale," is an epic that traces the history of the area by ranking its current status as the setting for Plas Newydd alongside its role in the adventures of the Welsh national hero Owen Glendower and

in the medieval legend of the romance between the famous bard Hoel and the Princess Minwafy.[46] The first third of the poem describes these earlier claims to celebrity, after which it turns to the present moment when the Ladies's "sacred Friendship" sheds its "Vestal luster" on the valley. The first image of Butler and Ponsonby in the poem links them immediately with their appreciation of the natural landscape: "the peerless Twain, / Pant for coy Nature's charms" (76). The "Arcadian bowers" of Plas Newydd, the famous gardens designed by the couple, are figured "circling the lawny crescent" in front of the house; this landscape artistry is "to letter'd ease devote, and Friendship's blest repose." The women are represented as possessing the "Energy and Taste" of practitioners of the sister arts, "Whate'er the pencil sheds in vivid hues, / Th' historic tome reveals, or sings the raptur'd Muse" (77).

The gardens at Plas Newydd are described using the erotic conventions that Anna Seward has developed in her landscape poetry for Honora:

> Then the coy Scene, by deep'ning veils o'erdrawn,
> In shadowy elegance seems lovelier still;
> Tall shrubs, that skirt the semi-lunar lawn,
> Dark woods, that curtain the opposing hill;
> While o'er their brows the bare cliff faintly gleams,
> And from its paly edge, the evening-diamond streams. (78)

FIGURE 3.9 Engraving of Llangollen Valley, from the title page of the first edition of Anna Seward, *Llangollen Vale with Other Poems* (1796). Butler and Ponsonby provided this view for their friend's volume.

To the poet's gaze, the scene itself, like a shy maiden, is "coy," clad in "veils" that seductively both conceal and reveal. Further imagery of women's clothing—"shadowy elegance," even "skirts"—deepens the connection between the pleasure of the observed landscape and the mental image of a beloved woman's body. A "bare" vision in the distance "faintly gleams" through these layers of concealment and revelation.

The poem also seeks to establish the place of Butler and Ponsonby in the male-dominated tradition of classical friendship. Seward gives the friends names from stage tragedy, Eleanora and Zara (in fact these were roles played by another of Seward's objects of devotion, Sarah Siddons), to universalize the importance of their relationship. She argues that "the prouder sex" could never "win from this bright Pair pure Friendship's spotless palm":

> What boasts Tradition, what th'historic Theme,
> Stands it in all their chronicles confest
> Where the soul's glory shines with clearer beam,
> Than in our sea-zoned bulwark of the West,
> When, in this Cambrian Valley, Virtue shows
> Where, in her own soft sex, its steadiest lustre glows? (78–79)

The landscape itself, "sea-zoned" with all the connotations of Aphrodite the phrase invokes, weighs against male-dominated "tradition." Because Virtue is typically figured as female, the poet argues, why should we be surprised that her best exemplars are to be found in "her own soft sex?"

The women are figured as inhabiting a kind of epic time, in which neither "Summer-day" nor "Winter-night / Seem long to them" who can "wing their hours" with "the other's high esteem" (80). The "lovely bowers" created by the Ladies of Llangollen will not perish from "dark mildew," but will live on through "lengthen'd Life." The poem ends with the startling wish that "one kind ice-bolt" might kill the women suddenly and together, so that "no sad course of desolated hours" such as Seward has passed mourning for Honora might shadow their days. And the final image of the poem, like that of Sarah Pierce's verses discussed in the next chapter, concerns the legacy of this famous friendship to later generations of women:

> all who honor Virtue, gently mourn
> Llangollen's Vanish'd Pair, and wreath their sacred urn. (80)

Not only Seward's poem but objects in the landscape of Llangollen work to tell the story of the Ladies. The monodic strain of lament, what we might call the lesbian death wish of the Honora poems, marks these verses with Seward's own queer melancholy.

Seward also wrote some shorter occasional verse memorializing Butler and Ponsonby. "To the Right Honourable Lady Eleanor Butler, with the Same Present," is a souvenir of one of her early visits.[47] It opens with a matchless image of the addressee conquering the landscape in the name of women's friendship: "Thou, who with firm, free step, as life arose, / Led thy loved friend where sacred Deva flows" (107). This representation is obviously more interesting than accurate, as it paints a picture of two young women starting life together. In fact, Eleanor Butler was nearly thirty years old when she met Sarah Ponsonby, rather than at the youthful moment when "life arose," especially in eighteenth-century terms. And although Butler was older and came from a more elevated social background than did Ponsonby, it is not at all clear that she was the "leader" in the relationship. Both women dressed in men's clothes and armed themselves with pistols on their first attempt to escape from their families, and throughout their lives they continued to dress alike in women's riding habits that included tailored jackets, topped by men's hats over Prince Valiant cropped haircuts. Nonetheless, observers tended to assume that Eleanor, the older, richer, and more aristocratic, was also the more "masculine."[48] Seward seems to have cast Butler in the masculine role of the lover, pursuer, and protector of a beautiful younger woman—much as Seward saw herself in relation to Honora Sneyd. The theme of fragility in need of protection is expressed through the landscape imagery in the next two lines of the poem as well, when the women's home is described as an "eyrie" built high on a "rocky maze" (107).

But Seward also wrote another poem addressed not to the inhabitants of Llangollen Vale but to the landscape itself. "A Farewell to the Seat of Lady Eleanor Butler, and Miss Ponsonby, in Llangollen Vale, Denbighshire, 1802" relates to Seward's well-known elegies in its tone and theme.[49] The valley itself is personified as listener ("O Cambrian Tempe!") and Butler and Ponsonby are described as its "peerless mistresses" (345). As not just the setting for the famous friendship but its first cause, the valley is said to have had its "ancient witchery revived" by the presence of the couple. The major symbol of this "witchery" in the poem is the "river's thunder," the fast-flowing mountain stream that runs through the property at Plas Newydd, "roaring and foaming." It's hard to tell how much poetic license Seward is taking here; certainly the present-day watercourse is a small, quiet, and very pretty creek. But it fits in with Seward's vision of the Ladies as "mild Enchantresses," endowed through the valley's association with medieval heroes and lovers with their own magical powers. As for the poet's own power, after a conventional disclaimer about how time may have injured "Fancy's clear fires" in her own case, the poet charges:

> . . . but yet
> The benediction of increasing love,
> Bless'd pair, receive with no ungracious ear! (346)

Thus it is not only the women's love for one another but the poet's "increasing" love for them that is part of the "witchery" of the Vale. Significantly, the form of poetic power that the poet gains from her visits to Llangollen is the arrival of "the muse of landscape." Verse of pure description, "not unfaithful," was the result. But the poet needs more from the muse:

> Yet, even then
> In Friendship's primal hours, my soul perceiv'd
> Feelings, that more defied expression's power
> To speak them truly, than to paint the charms
> Of those distinguished bowers (347)

Ironically (or symptomatically), what follows is not an attempt to limn these inexpressible "Feelings," but more than sixty lines of landscape description. A process of displacement has occurred here. In fact, the poem performs a circuit tour of a landscape, much like Sarah Pierce's poem does in the next chapter. It directs our gaze first "Far to the left," then suggests "pause we there" to look over the cliff into the channel, and finally directs our attention to the "rude mound / That rises opposite" (347–48). The next several lines also anticipate Pierce's poem in their georgic fascination with work. The curious set piece describes in detail an engineering project by which "the guardian sisters" shored up the bank of the river "with tough, yet pliant withy . . . upright and transverse / Bars, crossing each the other" (348). This section ends with another salute to the violence of the river's course, a "tumultuous flood" from which "we shrink" in fear, but whose ultimate destination is useful and benign: "a clattering mill-wheel" (349). The poem ends by invoking the blessings of Lachesis—the second of the Three Fates, whose job it is to mete out length of days—and Hygeia, goddess of health. The poet requests that the goddesses "spin firm the vital thread" "on that bank, / Mossy and canopied with gadding boughs," "breathing soft, the while, / Dear Eleanora, and her Zara's name" (350). The names of the female friends, the improved landscape that is the work of their hands, and the supernatural powers that have come to the Vale of Llangollen with their residence there are thus united in the final scene of the poem.

"THERE IS SO MUCH PICTURE IN MY POEMS": SISTER ARTS THEORY

Seward's representations of women's love and friendship in her poems not only exemplify but also theorize her understanding of the relationships between different genres and forms, the "sisterhood" of various arts. Her characteristic synesthesia is a miniature version of the same thing. More than mere analogy, Seward's imagery insists on the inadequacy of any one sense to apprehend the overwhelming, even sublime, emotions

and experiences the poems record. Love between women is represented as interstitial, taking place in spaces "in between" not only marriage and friendship but also sense and sight, smell and sound, taste and touch. Thus the poet looks to the resources of music, painting, and landscape to construct verbal monuments to these relationships.

Indeed, Seward's letters are an important and underexamined source of sister arts theory in particular and of eighteenth-century literary criticism and theory in general. The collection of Seward's letters edited by Archibald Constable and published in 1811 is the only existing edition. Yet she corresponded with the major literary figures of her day, including Samuel Johnson, William Hayley, William Cowper, Edward Young, William Wordsworth, Charlotte Smith, Hannah More, Hester Thrale Piozzi, Frances Burney, and Helen Maria Williams, to name only the best known. For Seward, then, pulling together in her letters her thoughts on the sister arts must also serve as a metonym for her larger achievements as a critic and theorist, achievements that await another occasion to be elucidated.

As Seward writes, "It has always been my endeavour to paint from nature, rather than to copy from books, in my poetic landscapes."[50] Landscape poets, she argues, should work directly from nature, following the best plein-air painters. In both poetry and painting, Seward prefers a pictorialism that achieves the effects of classic landscape painting: "Poetic descriptions and penciled resemblances please me best when they take the Salvatorial style" (3: 131). She praises Darwin's "The Loves of the Plants" for just this quality: "It is everywhere picture" (3: 187). Indeed, she spent years defending her friend from the charge that his poem is overstuffed with imagery. She was willing to acknowledge that it might lack other poetic virtues, but for her his ravishing pictorial still lifes made this one of the finest poems in the language.

As a theorist of the sister arts, however, Seward did more than attempt painterly effects in her own poetry. Her sister arts aesthetic also extended to her evaluation of the other arts. Indeed, she repeats with evident pleasure the remark of a reader who "vows that I draw and paint well, because she says there is so much picture in my poems" (3: 267). In reality Seward, unlike Mary Delany, the Duchess of Portland, or Sarah Pierce, never attempted to draw or paint. But more than any of the other three artists discussed here, she theorized the visual:

> The leading principles of fine painting are so similar to those of fine poetry, that my imagination has always interwoven those sciences, and instructed me to look at the painting in poetry, and the poetry in painting. (2: 5)

As a relentless seeker of new ideas, Seward's aesthetic transcended her particular craft by constructing criteria that she used to judge the work of painters, musicians, and garden designers as well:

> Variety is the soul of pleasure in nature, and in all the arts. Prospects without hills; pictures
> without a due proportion of shadow; music without discords, and a language without
> consonants, must have inevitable monotony, and prove insupportably wearying to those who
> have been accustomed to the great effects produced by contrast in prospects, in pictures, in
> music, and in language. (1: 296)

Seward's point about consonants is part of an ongoing argument that modern English
poetry is superior to that of any other nation. Her critical remarks on Chaucer, Spenser,
and especially Milton and Pope throughout her correspondence all make this assertion
at some point. She argues that Chaucer's verse is somewhat primitive because his
"poetic landscape" is "very defective." She goes on to state:

> Since the time of Chaucer, its duties [i.e., that of poetic landscape] have been better
> understood. Milton's and Thomson's landscapes are so distinct, that the painter might draw
> from them as readily as from Nature herself; while, before the poetic imagination, they rise
> discriminate and complete in all the tints of their season. Nor less accurate is the scenic-
> painting of our best modern poets. The scene they delineate lives in their verse. (5: 121)

Poetry here is the equivalent of "nature," the source of inspiration for painters
rather than a coequal "sister." Seward never learned to read other languages well,
including Latin and Greek, and in some ways her literary nationalism could be seen
as a compensatory argument for this all-too-common failing in her female education.
But it also has to do with her appreciation for the roughness and variety of the English
language, a polyglot tongue that absorbs foreign words more easily than most and hence
had the largest vocabulary of any spoken language, even in the eighteenth century.
Though critics sometimes charge Seward the poet with a too-facile gift for rhyme
and meter, Seward the critic advocated rough terrain in both landscape and language.
Perhaps not surprisingly, however, her hierarchical thinking also led her to give priority
to her chosen art over its "sisters." In writing of a forthcoming publication she has
heard about, she says,

> The sketch promises a view of the present state of the polite arts, Painting, Sculpture,
> Architecture, and Music. Pray what has Poetry done, the eldest, the loveliest, the most
> intellectual, the most elevated of the arts, that her name is not enrolled with that of
> her sisters? (2: 7)

Seward confesses that it is natural to be "stung by the consciousness how much more
the musicians are patronized than the bards," especially considering that music is "a
sister-art—younger, less important, but *still a sister*" (2: 173). Between painting, poetry,
and landscape gardening, however, Seward saw a special relationship. She wrote to

encourage Humphrey Repton with an early commission, arguing that to be a landscape gardener one needs to be not only "skilled . . . in all its scientific branches" but also "possessing, as you do, the poet's feeling and the painter's eye" (2: 172). Seward considered Repton "the best initiated" into the "mysteries" of poetry and painting, and hence "the best qualified to make English nature dance her minuet de-les-Arcades with the most consummate grace" (2: 310). It is the painterly gifts of the poet, however, that best make the landscape dance.

Other analogies seemed less convincing to Seward. As she wrote to Erasmus Darwin,

> I differ from you about the analogy between music and her sister sciences, poetry and painting. The mathematical relationship between poetic syllables and musical sounds, has little to do with their congenial powers over the human mind. The real sources of the picturesque, and the stimulative effects of musical sounds, result from the judicious intermixture of discords, hurry and clashing in descriptive or in animating harshness. (2: 265)

Contrast, stimulation, mixture, harshness: these effects, not similar aspects of cognition or mental states, are for Seward what account for the power of the art object. Because poetry and music have a greater potential for heightened contrast, they are, in Seward's theory, superior or at least precursor artistic forms to painting:

> Upon R. Darwin's theory, we find that there are concords and discords in colours. If I understand him right, his discovery leads him to suppose that it might be eligible, instead of listening to the Allegro and Il Penseroso, exquisitely heightened by Handel's music, to procure the professors to set the landscapes, and history groups of our best painters; that is, to compose music, which may be performed while they are exhibited, and that shall express or describe their characteristic features. But those who have felt the enchanting result of music united, as from the earlier ages, with poetry, will never endure the divorce of this connexion, coeval with the birth of both, in favour of the third science, Painting—no, not even those who had rather see a fine picture than read a fine poem. (2: 266)

Poetry, especially English poetry, is the older sister and receives her due authority here. Seward's writing contributes a synesthetic, erotic perspective to eighteenth-century sister arts theory.

THE INVOLUNTARY LIBERTINISM OF A FUNGUS OR A FLOWER: SEWARD'S LINNAEANISM

Anna Seward, though no botanist ("poetic violations of natural history . . . have often great beauty"),[51] was a Linnaean. Indeed, she was not only the inspiration for Darwin's "The Loves of the Plants" but by her own account she was the author of the first fifty

lines of the poem (Figure 3.10). In her *Memoirs of the Life of Dr. Darwin* (1804) she writes that she was inspired by the improvements that Darwin had made to his own property to write a description, in verse, of his lovely landscape. The plan for an entire poem, in which plants in their reproductive functions would be represented as beaux and belles, apparently flashed before Darwin's eyes: "The Linnean System is unexplored poetic ground, and an happy subject for the muse."[52] At first Darwin wanted Seward to write the poem, but she demurred. Long an admirer of his privately circulated verse, she encouraged him to write the poem himself, arguing "that, besides her want of botanic knowledge, the plan was not strictly proper for a female pen; that she felt how eminently it was adapted to the efflorescence of his own fancy."[53] Although Darwin wrote and published the poem, its exordium, Seward always asserted, was none other than her own initial verses, with a few lines added by Darwin to connect them to the spirit of botany. Regardless, Darwin's poem was immediately controversial; what was seen by some as its sexual licentiousness was attacked as immoral and even Jacobin. Some critics even cited Seward's own refusal to write on the subject of the sexual functions of plants as evidence that the poem was harmful to feminine morality. Seward herself, however, rejected this argument. She always maintained that while the subject might not be an appropriate subject for female writers, it could never be inappropriate for female readers. As she wrote,

> Young women who could be endangered by such descriptions, must have a temperament so
> unfortunately combustible as to render it unsafe to trust them with the writings of our best
> poets . . . do not suppose that a virtuous girl, or young married woman, could be induced, by
> reading the Botanic Garden, to imitate the involuntary libertinism of a fungus or a flower.[54]

"Libertinism" there was, Seward acknowledges, but despite the power of its imagery, Darwin's poem would not confuse sensible women readers. Of course, in warning us not to "suppose" such possibilities, Seward also inevitably raises them.

Seward had another bone to pick with Darwin, however. In the 1780s she developed a friendship with Court Dewes, the son of Mary Delany's sister Anne and the brother of Delany's frequent correspondent, Mary Port of Ilam. On a visit in 1792 to Wellsburn, the Dewes home, Seward was "introduced to . . . the celebrated hortus siccus of Mrs. Delany."[55] Seward's description of Delany's flower mosaics is the most accurate and technical extant from the eighteenth century. The works, she wrote,

> contained in ten immense folios, each enriched with an hundred floral plants, representing,
> in cut paper, of infinitely various dyes, the finest flowers of our own, and every other climate,
> from the best specimens that the field, the garden, the greenhouse, and the conservatory
> could furnish; and with a fidelity and vividness of colouring, which shames the needle and
> the pencil. The moss, the film, the farina, everything, the minutest part, is represented
> with matchless delicacy. It was at the age of seventy-five that this prodigy of female genius

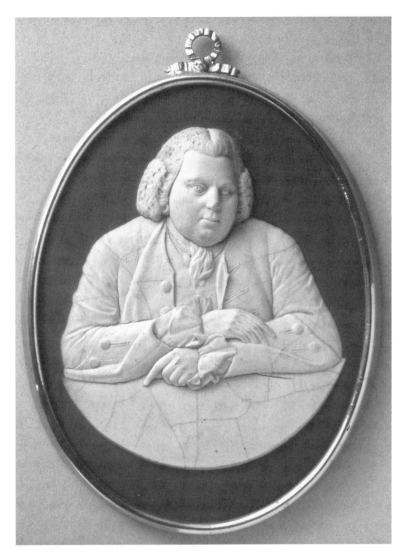

FIGURE 3.10 Josiah Wedgwood, *Miniature Portrait of Erasmus Darwin*, 1779. Darwin was an early sponsor of Anna Seward's verse, and she wrote a long biographical essay about him, *Memoirs of the Life of Dr. Darwin*. The first American edition of his famous poem *The Botanic Garden* was published by Sarah Pierce's correspondent Elihu Hubbard Smith in Litchfield, Connecticut.

> invented her art, and gave it that last perfection which makes imitation hopeless. Always
> a fine painter, and not ignorant of the arts of chemistry, she herself dyed her papers from
> whence the new creation arose.[56]

Darwin wrote admiringly about Delany's monumental work in "The Loves of the Plants," but as a sister artist Seward took exception to his slighting of Delany's originality and technical virtuosity:

Of this astonishing work Dr Darwin has given a most erroneous description in his splendid poem. He ought not to have taken such a liberty. It represents Mrs Delany as a mere artificial flower-maker, using wires, and moss, &c.; though writing-paper was her sole material—her scissars her only implement. The former, previously coloured by herself, in complete shades of every tint, was never retouched by the pencil after the flower was cut out; nor did she ever make a drawing; but, as her specimen lay before her, she cut from the eye. The easy floating grace of the stalks, the happiness with which the flower or flowers, their leaves and buds, are disposed upon those stalks, is exquisite; while the degree of real relief which they possess, besides that which arises from the skilful deception produced by light and shade, has a richness and natural effect, which the finest pencil cannot hope to attain.[57]

Seward does get several details wrong here: Delany did occasionally touch up her collages with watercolor or pencil, and sometimes she pasted actual botanical material such as leaves onto the paper. What matters, however is that although Anna Seward never met Mary Delany or the Duchess of Portland, and although she moved in genteel circles at least a step below theirs in social status and wealth, she was nonetheless influenced by the legacy of the Bulstrode circle.

Seward's own legacy was to cross the Atlantic and shape the lesbian landscape art of a Connecticut writer and educator, Sarah Pierce. "Pastoral Ballad," a poem by Seward that is different from many of the ones considered above and yet very similar to the work of Sarah Pierce, is striking because it is neither a poem of loss nor is the beloved named, as in so many of her poems of love between women. Instead, the poem is a utopian imagining of a Llangollen-like retreat that offers the comfort of fantasy rather than that of melancholy:

> O, share my Cottage, dearest Maid,
> Beneath a Mountain wild & high,
> It nestles in a silent glade,
> And Wye's clear Currents wander by:
> Each tender Care, each honest Art,
> Shall chase all future Want from thee,
> When thy sweet Lips consent impart
> To climb these steepy Hills with me.[58]

It is a traditional invitation that goes back at least to Marlowe's "The Passionate Shepherd to His Love." But in this poem, Seward insists on the central place of love between women in both the poetry of erotic invitation and the sister arts tradition of literary pictorialism. In making room for both "tender Care" and consideration of the beloved's "sweet Lips," the poem refuses a dichotomy between sex and friendship, creating a synesthetic, interstitial poetic landscape for both the sister arts ("honest

Art") and the sister artists themselves. In chapter 4, I show how the scientific-poetic communities of Lichfield, Staffordshire, and Litchfield, Connecticut, are connected via the publication history of Darwin's book *The Botanic Garden,* which contains "The Loves of the Plants." Beyond this material evidence that Connecticut intellectuals of the 1790s were reading the radical literature of English dissent, however, the formal echoes between the poetry of Anna Seward and that of Sarah Pierce suggests that not only the Lunatic but also the Swan of Lichfield made their marks on early American landscape art. ✸

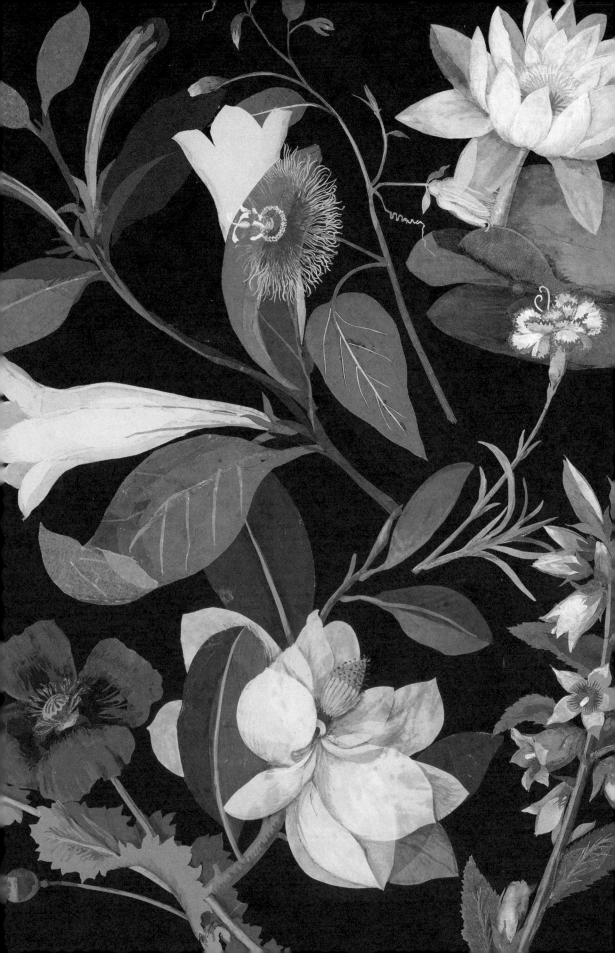

4

The Landscape Which She Drew

SARAH PIERCE AND THE LESBIAN GEORGIC

THE TRANSATLANTIC REACH of the sister arts tradition is evident in the life and work of Sarah Pierce. It is a story that connects the Seward circle of chapter 3 and the world of the Connecticut Wits of 1790s New England, the early U.S. intellectual milieu that is usually understood as exclusively masculine. My examination in this chapter of Pierce's "Verses to Abigail Smith" (1792) argues for the poem's contribution to the genre identified by William Dowling as "Connecticut georgic," a mode "through which an idealized Connecticut society will be proposed as a model to the new American republic."[1] I argue that Pierce was a participant in the sensibilities of the Connecticut Wits and their characteristic verse form, Connecticut georgic, and that she was so not only through her poem but through her subsequent work as a public intellectual, the founder of Litchfield Female Academy.[2] In the heady period of post-Puritan, pre-Victorian social loosening that characterized 1790s New England, Pierce's lesbian georgic detailed an "idealized Connecticut society" with a difference: an all-female erotic retreat that she imagined not only as a life for herself and Abigail Smith but also as a legacy to the "matrons and maids" of the future.[3] Litchfield was a cosmopolitan crossroads in this period; traffic from New England to New York and from the southern ports to Canada passed through the town's high road regularly, bringing in its wake mail, goods, travelers, and new ideas. Abigail Smith, the young woman to whom Pierce addressed her poem, was the sister of Elihu Hubbard Smith, a second-generation Connecticut Wit and a close friend of Charles Brockden Brown. Both Smith and Brown were at the center of the intellectual life of New Haven, New York, and Philadelphia in the 1790s. They were especially interested in radical scientific and political writing, including the work coming out of their namesake English city of Lichfield. Elihu Smith recorded Sarah Pierce's poem to his sister in his diary in 1798, along with the intriguing story of how it came to be written. Connecticut of the 1790s provided a context of sexual liberation, antimarital gender egalitarianism, and engagement with issues of labor and public culture that energized the English and Irish

sister arts tradition by continuing some of its conventions but revising and critiquing others as the tradition itself assumed transatlantic status.

Sarah Pierce was born in 1767 in Litchfield, Connecticut (see Plate 10). She lived all her life in Litchfield and died there in 1852. Pierce was the sixth daughter of an educated farmer and potter who had fallen on hard times; consequently, she had to find a way not only to earn a living but also to support her younger brothers and sisters. She did so by opening the Litchfield Female Academy, which became famous as the first American institution of higher education for women, and where her students included Catherine and Harriet Beecher. Pierce's four-volume *Sketches of Universal History Compiled from Several Authors, for the Use of Schools* (1811–18), was one of the first history textbooks written in the United States. In addition to her widely used *Sketches of Universal History*, Pierce composed short plays for her students to act in the early years of her school, before drama came to seem a suspect pursuit for young ladies. Further, she wrote commencement addresses that deserve to be ranked not only with some of the earliest feminist writing in the United States but also as documents presaging transcendentalism in their understanding of the relations between spirit and intellect. Among her lyric verse is the poem considered here, a work that combines elements of the georgic and the graveyard elegy, in which she suggests that rather than marrying she and Abigail Smith should set up house together and live in idyllic harmony in a beautiful landscape.[4] Pierce's poem renders the visual landscape as an embodiment of her desire for a particular beloved woman, the addressee of the poem. And it extends this trope to an understanding of the relation between the natural and built landscapes as a relation of power, bringing desire between the women into the political and economic mainstream of the new republic. The poem links the household it envisions to a critique of slavery, tyranny, and luxury, topics of enduring interest in intellectual and political life in the early United States.

Few of Sarah Pierce's personal writings—letters or journals—survive. Although she was a frequent correspondent of many notable New Englanders, and although keeping a journal was part of the curriculum she set for her own students, Sarah Pierce has come down to us primarily as a public figure. Several of her students transcribed and thus memorialized the plays she wrote for them to perform at school exhibitions, including a drama, entitled "Ruth," about the famous female friendship in the Bible. Many of the commencement addresses Pierce composed for graduation exercises at Litchfield Female Academy have also survived in manuscript. Works of embroidery, cross-stitch, drawing, and painting assigned by Sarah Pierce and made by her students are preserved in the Litchfield Historical Society, and I read some of these for what they can tell us about the material, artistic, and erotic world of the Litchfield Female Academy. Finally, the poem addressed to Abigail Smith survived because it was recorded in the journals of Abigail's brother and Sarah Pierce's friend and correspondent, Elihu Hubbard Smith. The poem is perhaps the most personal of

all the extant writings of Sarah Pierce, and it is a crucial item in the "archive of feelings" that makes up lesbian history.[5]

Pierce's lifelong personal avoidance of marriage, the antimarriage views she apparently shared with Abigail's brother Elihu, and her interest in the biblical story of Ruth all suggest that her primary attachments were to women. Even more intriguing, Pierce chose to write her poem to Abigail in a sister arts genre: that of the landscape poem of love between women. The poem uses many of the key images and tropes found in Anna Seward's landscape poems, but it puts them to the overtly political ends available to a New England spinster intellectual of the 1790s. The sister arts triad of poetry, painting, and landscape proved a specific and potent resource, one different from the better-known American women's novels of the period that tend to focus on damsel-in-distress narratives. In the light of this tradition, Sarah Pierce becomes newly visible, not as an obscure New England spinster important only as a footnote to the masculinist histories of the Connecticut Wits, the Friendly Club, and early American poetry, but as an artist and public intellectual who successfully drew on the literary, visual, and intellectual resources available to women in her time and place in order to leave a readable record of women's erotic space.

"STRICT INTIMACY": PIERCE'S "VERSES"

In December 1795 Elihu Smith transcribed Pierce's poem as "Verses, written in the Winter of 1792, & addressed to Abigail Smith Jr.—by Sally Pierce." According to Smith, the verses were written three years earlier, when his sister Abigail was seventeen years old and Sarah Pierce was twenty-five. Smith prefaces his transcription with a brief anecdote about how the poem came to be written, saying that "the knowledge of a few circumstances, connected with the following little Poem, is necessary to it's being understood." Smith goes to some lengths to establish the importance of the "strict intimacy" that had subsisted for "some years, between Miss Sally Pierce & my two eldest sisters, Mary and Abigail."[6] Mary, Smith tells us, had just announced her plans to get married, and the "conclusion" of Sally and Abigail was that "when Mary left them, the other two should unite, & spend their lives, together, 'in single blessedness.'" Smith tells us that the discussion was pursued "sportingly," but he also considers the poetic product of the discussion serious enough to have kept a copy of it for three years and to record it for posterity in his journals. In keeping with the nativist investments of the Connecticut Wits, Smith was very much interested in the promulgation of American letters and he probably valued Pierce's poem as an addition to an emerging canon of poetry by New Englanders. But as a second-generation Wit, Smith was also influenced by a postrevolutionary discourse of egalitarian same-sex friendship that worked against earlier, more traditional Wit ideas about women and the family. He goes to some lengths in his preface to explain the friendship between "Sally" and his sister, thus

suggesting that he considered the poem important as a document of a powerful and productive intimacy between women. One motive for transcribing the poem, then, seems to be to memorialize an intimacy that might otherwise go unrecorded, and which he thought was noteworthy and admirable.

Smith tells us that the verses had their origins in a failed drawing. Landscape drawing is understood as a spur to landscape poetry, a generic convention of the sister arts tradition. Here is the evening as imagined by Pierce's friend, during which his sisters Mary and Abigail provide inspiration:

> Sally Pierce was, at the time of writing these lines, just beginning to acquire, by her own exertions, some feeble knowledge of Drawing. The three young women were together; it was evening; Sally had shewn them some of the productions of her pencil. . . . Before separating, it was agreed that Sally, should design a house suitable for each, & sketch the surrounding scenery. This, as soon as my sisters were gone, she sat down to do. Her first care was directed towards accomplishing a plan for Mary; whose lot being more certainly decided, demanded the earliest attention. The inexperience of Miss Pierce, in the art of design, made her progress both slow & painful; so that, when she had effected her first picture, by the aid of the pencil, she had recourse to a readier instrument, & relied on the pen for a sketch of the second. And lo! this is the landscape which she drew.[7]

Both drawing and poem are "landscapes" for Smith, but the medium Sarah Pierce chose for her offering to Abigail was the "readier instrument" of poetic composition.

The Virgilian model of the georgic, a poem most often identified with the elucidation of farming techniques and rural virtues, enjoyed a revival in eighteenth-century English-language verse. New subjects, including methods of industrial manufacture and scientific discoveries, invigorated and modernized the tradition. (In this connection, many see Darwin's encyclopedic *The Botanic Garden,* which Pierce almost certainly knew, as a georgic poem.) Although Pierce's poem eschews the epic length typical of the eighteenth-century georgic, she adopts many of its other conventions. She begins by celebrating "the cultivated farm," "the flow'ry lawn," "the fertile meadows trim," a "garden . . . stored with herbs," "vines," "fruit-trees" and "roots" "bespeaking plenty," "golden corn," "fruitful fields," and "cows at rest." Rather than the untended pasture or mountainous hillside of the pastoral, the landscape in this part of the poem is intensely cultivated, its fecundity both result and proof of the civic virtue of its industrious inhabitants.[8] In the tradition of both Virgil and the eighteenth-century imitators who made the georgic a dominant mode in midcentury verse, Pierce offers not only a prescriptive account of rural "best practices" in household, farm, garden, and woodland management, but also a political critique of the implicit opposite of such practices, the "luxury and pomp" associated by the Connecticut Wits with English corruption and decline.[9]

William Dowling argues that the Connecticut Wits, "inhabiting a single transatlantic universe of thought," aligned themselves with Augustan critics of Walpole's ministry, and by extension, the policies of George III that led to the American Revolution.[10] Dowling singles out Timothy Dwight's poem *Greenfield Hill* as the emblematic statement of Wit ideology critique: we learn that it was in America, especially in Connecticut, that true English values have persisted, untainted by Whig corruption, luxury, and enfeeblement.[11] Litchfield in particular, with its affluent and highly educated populace, was singled out in the period as "a pattern of the finest community on earth."[12] Pierce's poem emphasizes this critique; it is studded with references to the "plain, neat and elegant" style of its author's imaginary landscape, the "simple elegance" and "neat array" it presents which "might teach even Pomp that, not to wealth confined, / Genius and taste might to a cottage stray."[13] Dwight's poem was published in 1794; according to Elihu Smith, Pierce wrote hers in 1792. Timothy Dwight was Smith's teacher at Yale in the 1780s, and it is through this connection that Smith is associated with the Connecticut Wits. It seems, however, that Sarah Pierce's poem may have been the first Connecticut georgic.

Also in keeping with the aims of the eighteenth-century georgic, the poem seeks to entertain as well as instruct. The verses start with a description of the house Sarah Pierce imagines building for her beloved, and then it moves to a description of the surrounding landscape, including not only the fruits and vegetables that the two women will grow but also the views they will cultivate and the walks they will take. The principle of variety as a georgic convention was explicitly compared to its value in landscape gardening in Joseph Addison's famous "Essay on the Georgics" (1697). Addison argued that the practical or instructive material in a georgic poem "shou'd all be so finely wrought together into the same Piece, that no course Seam may discover where they joyn," just as the ha-ha conceals the fence in a successful landscape garden.[14] Perhaps with this well-known connection in mind, Pierce turns for her version of a classical digression to a description of the garden and landscape views of the Connecticut landscape. The poem moves into a pastoral mode here, exhibiting "that cultivated impurity of genre" that characterizes eighteenth-century georgic, allowing it to incorporate even "its own alternative, pastoral, with confident self-awareness."[15] Indeed, it is this confidence, the foregrounding of the poet's skill in elevating seemingly simple topics to poetic greatness, that distinguishes the rhetorical position of the pastoral speaker, who seeks to conceal poetic art, and that of the georgic speaker, who seeks to foreground it. The "mixedness" of georgic, its ability to incorporate a variety of other poetic modes and conventions, demonstrates this rhetorical energy. Indeed, Pierce is never more skilful as a georgic poet than when she moves into a third mode, the elegiac, at the end of the poem.

Working in this mode she depicts the tombstone of the two women being visited by neighboring "maids and matrons" who read the epitaph and shed a tear for the beauty

of the relationship between Pierce and Abigail Smith. The poem imitates Thomas Gray's famous "Elegy Written in a Country Churchyard" (1751), not only in its stanza form (quatrains of iambic pentameter rhyming *abab*) but also in concluding with a short section entitled "Epitaph" that refers to the author of the poem itself.[16] George Haggerty has convincingly argued that Gray's poem demonstrates "the poet's awareness of his own homosexuality" and that it belongs in a tradition of homosexual elegy that celebrates male friendship and mourns its loss.[17] Pierce extends this celebration of same-sex friendship by addressing her work explicitly to a named beloved woman and imagining future readers as "matrons and maids" instructed to imitate the central romance of the poem: "Reader! Depart, reflect, and be as good." Pierce's affirmative account of same-sex love contrasts strongly with the melancholy tone of Gray's poem, and in fact despite the epitaph we would be hard pressed to call Pierce's poem an elegy. Indeed, while Gray's speaker is isolated from the village characters he observes from his vantage point in the churchyard, Pierce's speaker is coupled rather than alone as well as very much at the heart of the community she describes. Pierce's poem combines the form of the popular churchyard elegy with the conventions of the georgic and the erotic images of the sister arts landscape tradition to make an argument distinct from all three of these models: namely, that women's friendship in the Connecticut landscape embodied the best virtues of the young American republic. Pierce's poem, however, in its celebration of love between women no less than in its adaptation of the erotic language of the lesbian landscape arts tradition, also departs from—and may even implicitly critique— the nationalist and nativist ethos of the Connecticut Wits in significant ways. Jill Casid in *Sowing Empire,* her study of landscape and imperialism in the eighteenth century, argues that "taking on the georgic need not be a move toward normalization, but rather an opportunity to queer the 'master' discourses of nature and political economy" (160). Her book traces a paradoxical "queer self-inscription in the imperial georgic" (xiv) by adducing examples from Marie Antoinette's *ferme ornée* to American slave gardens to show how the georgic imperative to "make heterosexual reproduction and the husbanding of land seem at once synonymous and as pre-ordained and necessary as the cycle of the seasons and the harvest" (xvii) might serve "the double function of encoding homoerotic desire and of publicly visualizing that encrypted desire within a mise en scène that has historically signified innocence" (71). Sarah Pierce's poem draws on this potential in its mobilization of the georgic for the expression of same-sex eroticism.

What was the relation between the landscape in Pierce's poem and the actual physical setting of its composition? Litchfield is located in the scenic Northwest Hills region of Connecticut. During the Revolution, while Connecticut's coastal and river towns were under attack from the British, Litchfield's location away from attack and on the main roads from southern Connecticut to the Hudson Valley made it a major depot (Figure 4.1). The period from the 1790s to the 1830s, when Sarah Pierce's Litchfield Academy and Tapping Reeve's Litchfield Law School both brought young people from all over the

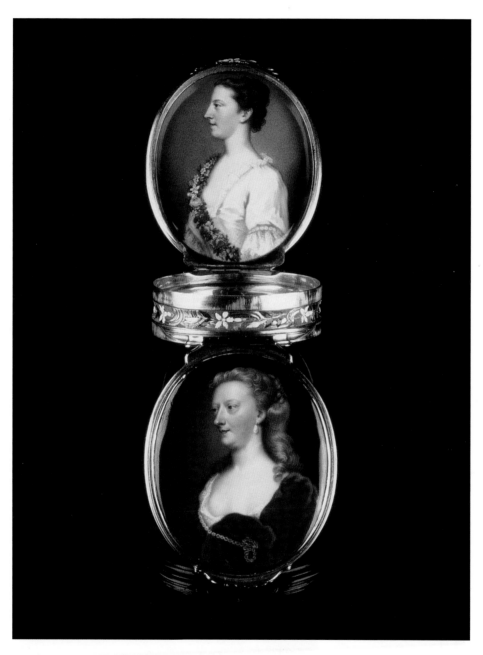

PLATE 1 Friedrich Zincke, portrait of Mary Delany from *Friendship Box,* ca. 1740. The Duchess of Portland had this exquisite keepsake made to commemorate her friendships with Mary Delany, Elizabeth Robinson, and Lady Andover. It is meant to be worn close to the body. Shown here are the Duchess of Portland (*top*) and Mary Delany (*bottom*). PRIVATE COLLECTION. PHOTOGRAPH COURTESY OF NATIONAL PORTRAIT GALLERY, LONDON.

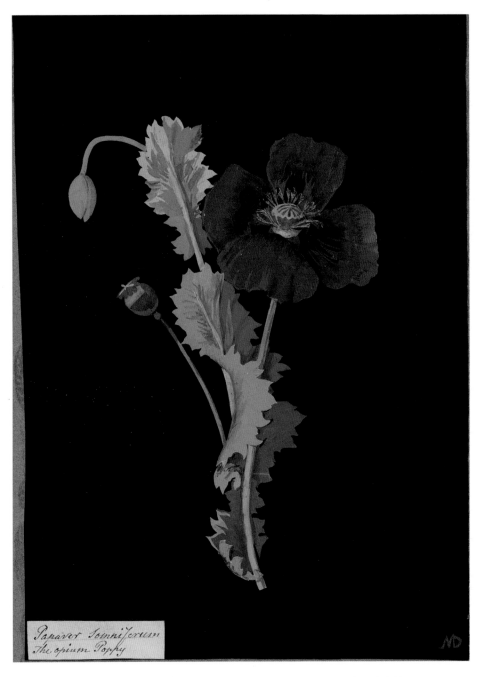

Papaver Somniferum
The opium Poppy

PLATE 2 Mary Delany, *Papaver Somniferum, the Opium Poppy*, 1776. Many considered it unladylike to represent the open flower turned toward the viewer, as Delany does here. COPYRIGHT TRUSTEES OF THE BRITISH MUSEUM.

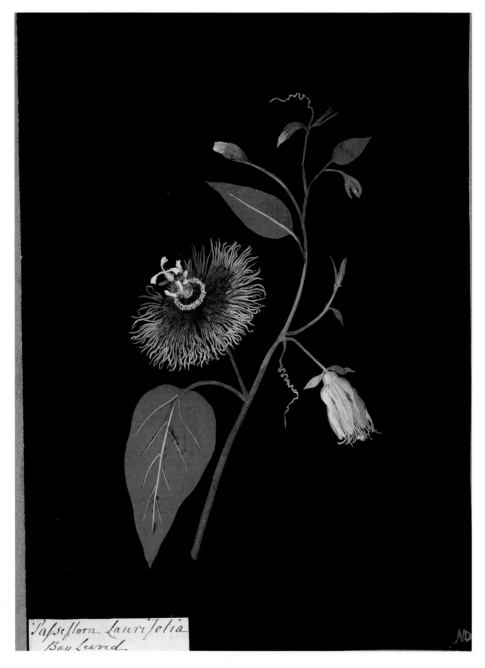

Passeflora Laurifolia
Bay Leaved

ND

PLATE 3 Mary Delany, *Passeflora Laurifolia, Bay Leaved*, 1777. As one of the English botanical illustrators to adopt the Linnaean sexual system of taxonomy, Delany emphasizes each plant's reproductive organs.

magnolia grandiflora

PLATE 4 Mary Delany, *Magnolia Grandiflora*, 1776. Through her aristocratic and court connections, Delany had access to plants from all over the world, brought back by traders and scientists such as Captain Cook. This magnolia is native to the Caribbean.

PLATE 5 Barbara Regina Dietzsch, *A Dandelion with a Tiger Moth, a Butterfly, a Snail, and a Beetle*, eighteenth century. Dietzsch was one of the few botanical illustrators prior to Delany to use a black background, although Dietzsch works on vellum rather than paper. Delany may have seen Dietzsch's work (or Joseph Ehret's imitations of it) in the Duchess of Portland's collection. OPAQUE WATERCOLOR ON PARCHMENT, 28.5 X 21 CM. COURTESY OF FINE ARTS MUSEUM OF SAN FRANCISCO.

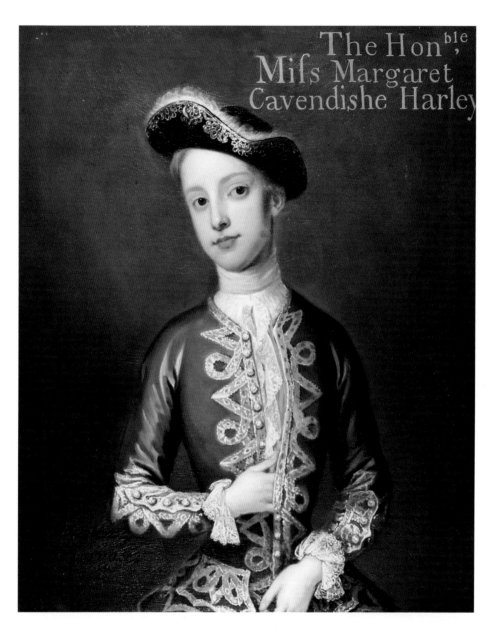

PLATE 6 *Portrait of Margaret Cavendish Harley, later Duchess of Portland, at about 12 years old,* 1727 (artist unknown). In this boyish image, young Margaret wears the costume of a cavalier. COPYRIGHT THE HARLEY GALLERY.

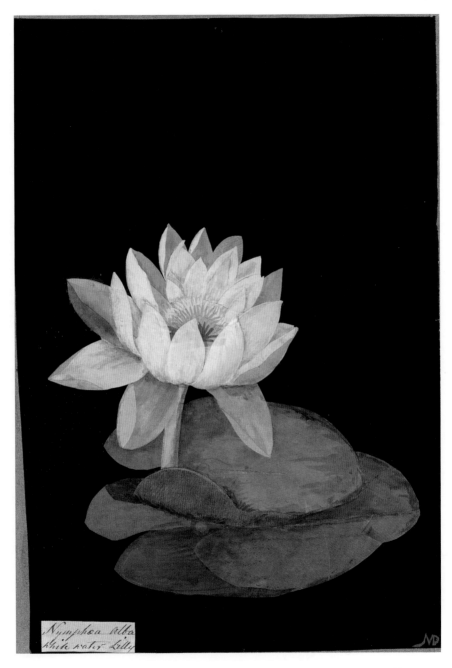

PLATE 7 Mary Delany, *Nymphaea alba*, 1776. The anatomical associations of grottoes are readable in their alternate name, *nymphae*, which means "feminine water spirit" (hence water lily, here). This is also the Latin name for labia. COPYRIGHT TRUSTEES OF THE BRITISH MUSEUM.

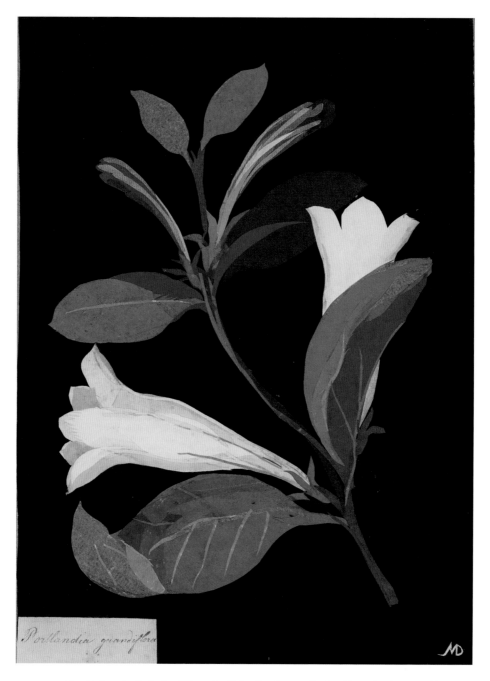

Portlandia grandiflora

MD

PLATE 8 Mary Delany, *Portlandia Grandiflora*, 1782. Delany's tribute to the Caribbean shrub renamed by English botanists for her friend. COPYRIGHT TRUSTEES OF THE BRITISH MUSEUM.

PLATE 9 George Romney, *Serena Reading*, ca. 1780–85. Anna Seward thought this was the nearest likeness to her beloved Honora of any painting, including a commissioned portrait. After Honora's death Seward moved the painting from room to room so it would always be in sight. COPYRIGHT OF THE HARRIS MUSEUM AND ART GALLERY, PRESTON.

PLATE 10 Attributed to George Catlin, *Miniature Portrait of Sarah Pierce*, ca. 1830. The eminent Connecticut intellectual, depicted here about forty years after writing "Verses to Abigail Smith." COLLECTION OF THE LITCHFIELD HISTORICAL SOCIETY, LITCHFIELD, CONNECTICUT. COPYRIGHT LITCHFIELD HISTORICAL SOCIETY.

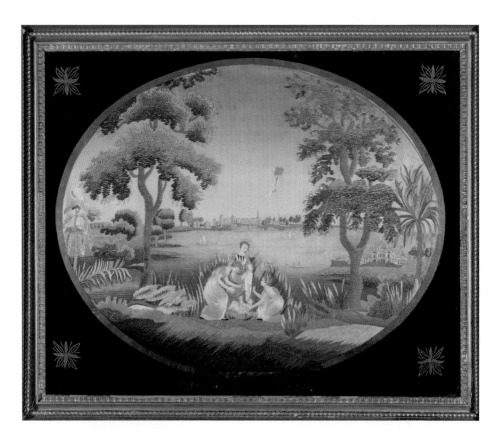

PLATE 11 Charlotte Hopper Newcomb, *Discovery of Moses in the Bullrushes*, ca. 1809–10. This version of the story emphasizes the role of relationships among women. COLLECTION OF THE LITCHFIELD HISTORICAL SOCIETY, LITCHFIELD, CONNECTICUT. COPYRIGHT LITCHFIELD HISTORICAL SOCIETY.

PLATE 12 Frida Kahlo, *Self-Portrait "The Frame,"* 1938. Kahlo adopts many elements of the classic Virgen de Guadalupe image in this depiction of herself. COURTESY OF ART RESOURCE, NY. COPYRIGHT 2010 BANCO DE MÉXICO DIEGO RIVERA FRIDA KAHLO MUSEUMS TRUST, MEXICO D.F. / ARTISTS RIGHTS SOCIETY (ARS).

PLATE 13 Judy Chicago, Sojourner Truth place setting from *The Dinner Party*, 1974–79. In representing one of the few African-American women in the piece, Chicago departed from the vulval forms she used for other important women. MIXED MEDIA. COPYRIGHT 2010 JUDY CHICAGO / ARTISTS RIGHTS SOCIETY (ARS), NEW YORK. PHOTOGRAPH COPYRIGHT DONALD WOODMAN.

PLATE 14 Mickalene Thomas, *La leçon d'amour*, 2008. Patterned household fabrics, a sister arts trope, fill the frame. PHOTOGRAPH. COURTESY OF MICKALENE THOMAS STUDIOS, INC.

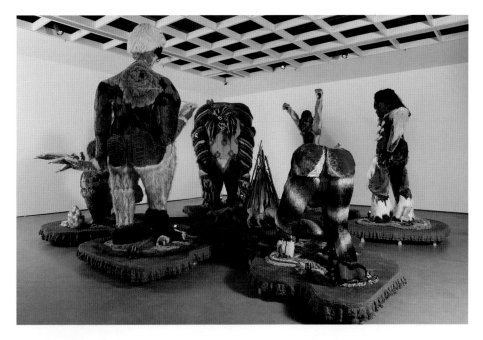

PLATE 15 Allyson Mitchell, *Ladies Sasquatch*, 2005–8. The artist calls this installation "a lesbian-feminist story-book garden." TEXTILES, PLASTIC, GLASS, WOOD. COURTESY OF ALLYSON MITCHELL.

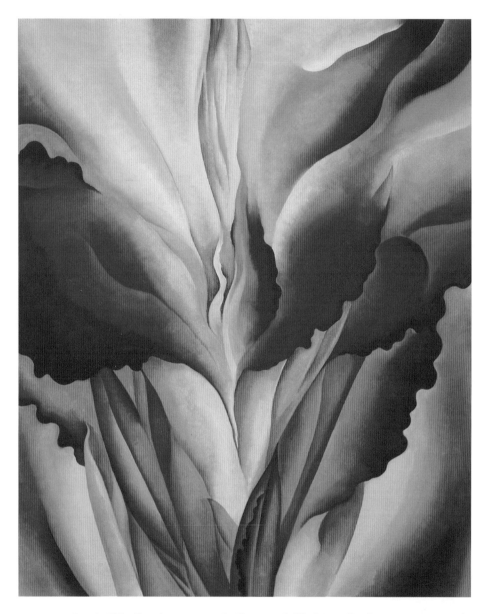

PLATE 16 Georgia O'Keeffe, *Red Canna*, 1925–28. Allyson Mitchell had O'Keeffe's flower painting in mind when creating Oxana's haunches in *Ladies Sasquatch*. COLLECTION OF THE UNIVERSITY OF ARIZONA MUSEUM OF ART, TUCSON, GIFT OF OLIVER JAMES, 1950.001.004. COPYRIGHT 2010 GEORGIA O'KEEFFE MUSEUM / ARTISTS RIGHTS SOCIETY (ARS), NEW YORK.

FIGURE 4.1 John Stockdale, *A Map of Connecticut,* 1794. Like its English namesake, Anna Seward's Lichfield, Sarah Pierce's Litchfield was a cosmopolitan crossroads. Her Litchfield Female Academy as well as the nearby Tapping Reeve Law School made it an important center of higher education. COURTESY OF LIBRARY OF CONGRESS, GEOGRAPHY AND MAP DIVISION.

United States as well as Ontario and Quebec to be educated, is known as Litchfield's golden age. Picturesque painters preferred the more dramatic landscapes of the Hudson Valley or the more charming agrarian scenes of the Connecticut Valley to the west; a traveler in 1825 even described the latter as "one vast garden divided into parterres."[18] In contrast with these more dramatic settings, Pierce follows the conventions both of georgic verse and of local topographical painting in directing our attention to recognizable features of local landscape that connote productivity, plenty, and honest toil:

> The cultivated farm, the flowery lawn,
> The fertile "meadows trimmed with daisies pied";
> The garden, breathing Flora's best perfumes;

> See yonder hillock, where our golden corn
> Waves its bright head to every passing breeze;
> Yon fruitful fields our sportive flocks adorn,
> Our cows at rest beneath the neighboring trees. (112)

The poem goes on to identify the "distant Town" sheltered on a "plain below" a "mount" typical of the Northwest Hills, which contain some of the state's highest peaks. We also see a "Wood" behind the house and a "river" (likely the Housatonic) winding through the scene. This area of Connecticut is typified by forested hills and rocky peaks, with farmland and small towns nestling in the valleys and plains, just as described in the poem. The first half of the poem offers the reader a "prospect" of these sights, all from the same vantage point, the one that "rushes" on the speaker's "view" in stanza 4. In stanza 10 the speaker's surveying eye comes to rest, and we withdraw with her into the wood or "grove" where she imagines that herself and her friend will "oft retire."

The work of Mary Delany and the Duchess of Portland exemplifies the association of the grove, grotto, or other secluded garden space with female sexual intimacy in the metropolitan tradition of eighteenth-century English landscape design. Pierce too draws on this fruitful set of associations. While stanza 10 tells us that the activity pursued by the friends in this retreat is "Contemplation," the next stanza plunges us into a multisensory experience that alludes to female sexual pleasure. The silence of the previous stanza is broken by intimate "murmurs," "whispering," and "echoes soft" emanating from the river and the pines. The noises rise to a "hoarse" crescendo as the water passes over rocks, and we are left with a vision of "a rainbow in the moistened sky." The curving shape of the rainbow rhymes with the arch of the sky, the representation of moisture here emphasizing the way the arching shape echoes the "Door of Life" of an erotic garden grotto. Like her sister artists across the Atlantic, Pierce adopts this trope to create representations of intimacy between women.

The poem then follows "a river solemn," giving us a tour of the remainder of the poem's landscape that works like a circuit garden. The idea of a classic circuit garden like Stowe, mentioned in chapter 3, was that promenading visitors would enjoy a visual narrative comparing the ruins of modern virtue to the classic beauty of its ancient counterpart, noting that the best of contemporary British culture could only seek to emulate the heights of the classical past. Pierce describes such a circuit in her "Verses," but she uses it to come to much more radical conclusions.

Circuit gardens were known in America at the time, but they were often too expensive to re-create. Much as in Mary Delany's Ireland, many American landscape parks instead anticipated the picturesque aesthetic of the late eighteenth century in their use of natural wildness as a design feature. Just as in England the picturesque had come to connote natural English liberty as opposed to formal French despotism, so in America gardenists came to believe that "the geometric or ancient style" could never prevail in a land where "the rights of man are held to be equal."[19] One of the most complete picturesque-style circuit gardens was Graeme Park in Pennsylvania, where the natural wetlands were framed by a series of views from the imposing stone house (Figure 4.2). Graeme Park was the setting of Elizabeth Graeme Fergusson's "Attic Evenings," an important series of salons that attracted major figures in Philadelphia and

FIGURE 4.2 The south facade of the Keith House at Graeme Park, Pennsylvania, home of Elizabeth Graeme Fergusson. Influenced by English garden trends, Fergusson created an American version of a landscape garden here. COURTESY OF THE FRIENDS OF GRAEME PARK.

colonial society prior to the Revolution. The poet Annis Boudinot Stockton and her husband Richard Stockton designed Morven (Figure 4.3), their estate near Princeton, New Jersey, after Alexander Pope's Twickenham, which Richard had seen on a trip to England. (Given the prominence of the garden grotto in the sister arts tradition, it is suggestive that the Stocktons also included a grotto on their estate.)[20] John Penn Jr.'s Pennsylvania estate name Solitude, designed in the mid-1780s, was described by a visitor as a circuit: "The flower garden was distant from the neighborhood of the house, reached by a circuitous path which took in as many as possible of the best points of view."[21] A French traveler in the same period described the Connecticut farms, houses, and hamlets through which he passed as forming a natural *jardin anglais,* "which art would have difficulty equaling" and which invited walks "in the English style."[22] Such walks, known as *promenades anglaises,* were like less formal versions of circuit gardens in that rather than a specific poetic program laid out by one artist, as at Stowe, the garden viewer was the author of the work's meaning, which he or she gleaned by putting together the series of picturesque views encountered along the way. Such a *promenade* is similar to the effect of the various views proposed in Pierce's poem, a more agrarian and casual Connecticut literary version of the formal English circuit garden.

FIGURE 4.3 Morven, estate of Richard Stockton and Annis Boudinot Stockton in Princeton, New Jersey. Like Mary Delany, the Stocktons were influenced by Pope in the design of their garden. PHOTOGRAPH BY ROBERT ENGLISH.

In Pierce's poem, we are taken past various symbolic views and objects that make up a spatial narrative that emphasizes the moral superiority of simplicity over luxury, freedom over slavery, honest toil over indulgent sloth, and women's same-sex friendship over marriage. The final object in the circuit is the "plain, smooth stone" beneath which the friends lie together, crowned with a "simple Epitaph":

> Beneath this stone two female friends interr'd
> Who past their lives content, in solitude;
> They wish'd no ill, yet oft, thro' ignorance, erred;
> Reader! Depart, reflect, and be as good. (113)

The intimacy of the two women in death dignifies and memorializes their relationship in life. Their "content" with their lives in a female couple is related to their "solitude," that is, their separation from the world in a utopian natural landscape that they are uniquely positioned to cultivate and enjoy.

The final apostrophe to the "Reader" raises once again the relationship between visual and literary art, and it even adds the element of three-dimensional landscape

FIGURE 4.4 Anna Stone's eighteenth-century gravestone in Litchfield, Connecticut, shows the typical tympanum shape imagined in Pierce's poem. FROM FARBER GRAVESTONE COLLECTION; CARVER UNKNOWN. COPYRIGHT AMERICAN ANTIQUARIAN SOCIETY.

design. Of course the "reader" of the epitaph in the poem would also be a "viewer" of the two-dimensional visual composition, the engraved stone itself, as well as an appreciator of the place of the women's monument in the surrounding landscape. The brevity of the epitaph compared to that of Gray makes reference to the actual practice of gravestone carving in early America—that is, single quatrains like Pierce's (as opposed to Gray's three stanzas) were inscribed on stones.[23] The inclusion of an epitaph argues for the "vital public role" of the poem's dead, thus giving point to Pierce's moral and political purposes.[24] We learn that "Matrons and maids shall often stoop" to read the words on the tablet, which tells us that it has been carefully placed low to the ground to emphasize the moral meaning of the poem's circuit. Colonial New England headstones were usually about thirty inches high, but the height could vary with the social importance and age of the deceased (Figure 4.4). Prominent citizens often rated taller stones, while children's graves were memorialized with much smaller markers.[25] We learn, then, that the speaker and her beloved, in keeping with their humility, modesty, and not least their thrift, have chosen a simple stone placed low to the ground. The visual cue of the gravestone continues the visual trope of the arch noted above; colonial gravestones in this period consisted of a rounded tympanum

flanked on each side by rounded shoulders, suggesting, as Jessie Farber notes, "the arches and portals that, through death, the Puritans believed the soul must pass to enter eternity."[26] Thus the erotic interior of the grove is connected to the privacy of the grave, we have followed the journey of the two friends through time and space, imbibing their values of simplicity, compassion, and community along the way. In this poem, intimacy between women is inscribed in the landscape as a generic feature of American versions of the georgic and the graveyard pastoral via the sister arts tradition.

"THEIR INIMITABLE WRITINGS": TRANSATLANTIC CONNECTIONS

Anna Seward's intellectual and artistic community of writers and botanists was tied to Pierce's circle of writers, educators, physicians, and clergymen through the medium of transatlantic correspondence. Recent scholarship on women's writing in eighteenth-century North America has revealed the extent to which publication as such was only one medium, and not always the most important one, for the transmission of literature, especially writing by women. For the women poets of the generation preceding that of Pierce, "the writers were known to one another and passed manuscripts among themselves—thus receiving a public notice like 'publication,'" according to Carla Mulford. Taking seriously manuscript poetry such as Pierce's work, Mulford argues, reveals "a culture more close to the oral and sociable networks that actually seem to have existed in the era of revolution."[27] For these coterie poets, as Catherine Blecki and Karin Wulf write, "the handwritten manuscript, circulated among friends and family, was their preferred form of publication."[28] It is evident from the form in which Pierce's poem survived—copied into the journal of her friend Elihu Smith—that it was in wide circulation, not only among the men of the Connecticut Wits and Smith's all-male Friendly Club in New York (where he went to further his medical studies) but also among the women with whom they regularly corresponded and conversed.[29] The thematic and formal connections between Seward's and Smith's poems adds a transatlantic dimension to arguments such as that of Mulford about early American women's manuscript culture. The sister arts tradition reveals movement between women's manuscript cultures on both sides of the Atlantic in the period, and as such revises our sense of the national boundaries of sexual cultures.

Seward's name was a well known one in New England by the time the *Lady's Magazine* declared in 1793 that "the FEMALES of Philadelphia are by no means deficient in *those talents*, which have immortalized the name of a *Montague*, a *Craven*, a *More*, and a *Seward*, in their inimitable writings."[30] Seward was an important influence on a group of well-known women poets, including Elizabeth Graeme Fergusson, Annis Boudinot Stockton, Susanna Wright, and Milcah Martha Moore, who wrote in the mid-Atlantic region before and during the Revolutionary War and were well known to literate

Litchfielders in the 1790s.[31] Other than her general celebrity, however, Seward had a particular link to the Litchfield circle in which Pierce's poem was circulating. Elihu Smith, long an admirer of Seward's mentor Erasmus Darwin, wrote to Darwin in 1798 asking permission to bring out the first American edition of *The Botanic Garden.* Smith had been an enthusiast of the work since its publication in 1789; he purchased a copy of the English edition when it became available in the fall of the same year.[32] The critical and popular success of the book in England had been almost immediately replicated in the young American republic, where, as Stephen Daniels notes, "it amounted to a compendium of progressive knowledge."[33] Darwin's critique of royal and religious tyranny and corruption (which Daniels links to the Masonic influences of his Derbyshire circle) was continuous with the politics of the Connecticut Wits, but his sexual libertarianism was a departure enthusiastically taken up by the next generation of Connecticut intellectuals such as Smith and Pierce. They were part of an "immediate post-Revolutionary generation" characterized by "its restless democracy, its aggressiveness, and its evolving practical secularism."[34] In the 1770s and 1780s— the years in which Seward's poems "Major André" and "Elegy on Captain Cook," her verse novel *Louisa,* and other works appeared in both English and American editions— Seward's landscape poems probably circulated in manuscript in the Lichfield circle of which she and Darwin were among the most prominent members. And these poems could well have formed part of the transatlantic correspondence and manuscript public culture that linked the Swan of Lichfield with the foremost female intellectual of "cosmopolitan" Litchfield, Connecticut.[35]

When we look again at the imagery of Pierce's poem, both Darwin's sexualization of the botanical world and Seward's eroticization of the landscape as female seem to be at play. The poem begins with one of the most common images used by eighteenth-century landscape gardeners to represent a woman's breast, belly, or buttock: "On rising ground we'll rear a little dome," an image repeated later as a "hillock" and "mount." The sensual imagery of the poem contributes to the construction of an eroticized, feminized landscape that not only "swells" with curvaceous mounds and cleftlike vales but also smells "fragrant," of "Flora's best perfumes," enabling the ravished senses of the observer to "delighted mark new beauties as they stray," from convention perhaps, or from propriety. This imagery of playful straying is repeated later as "sportive" and "play." The "flowery lawn" is a Darwinian description of pubic hair, especially as it "sucks the fragrance of the honied dew" in an image of combined smell and taste. (Liquid secretions are also imaged as "tear" and "dew.") The flowered meadow is "fertile," "fruitful," and "plenteous," the "garden, breathing." The curving "rain-bow in the moistened sky," noted above, can now be seen in context as part of a network of images of strong-smelling, curvaceous, moist, and dripping shapes in the poem that do much to convey the erotic intimacy to which the speaker never directly refers. These are key conventions of the sister arts tradition, continuous with the imagery we see in

Delany's and Seward's work as well as the ideals of community enacted by the Duchess of Portland. We can see emerging a language of lesbian landscape, flexibly put to use in new temporal and spatial contexts from aristocratic Georgian England through the dissenting Midlands to republican Connecticut.

This reading suggests that whether or not Sarah Pierce was articulating the direct influence of Anna Seward's poem, both poets were responding to a moment in literary and cultural history when imbuing the landscape with the lineaments of a beloved woman's body was a plausible and powerful way to represent lesbian desire. Eighteenth-century erotic literature, as we saw in Delany's bawdy garden in chapter 1, had long exploited the comic potential of seeing hills and valleys as "Mounds of Venus" and "Doors of Life;" the Romantic poets who were so important to 1790s New England radicals turned from ridicule to respect and even reverence in their personification of the natural world.[36] But when the erotic gaze that rests on the feminized landscape is that of another woman, we begin to glimpse a less-prominent tradition in which women's understandings of their own and one another's bodies was shaped by the personal, communal, and aesthetic possibilities of the sister arts.

"TO LOVE TOO WELL": THE LITCHFIELD WORLD OF LOVE AND FRIENDSHIP

Pierce's use of landscape also allows her to engage in issues of public importance and articulate a new vision for society, a vision she shared with her friend and correspondent Elihu Hubbard Smith. In Smith's diaries, we have a unique window into the sexually progressive world of the 1790s Litchfield he shared with Sarah Pierce. Elihu Hubbard Smith, like Sarah Pierce (whom he always called Sally, as did all her intimates), was a native of Litchfield. Smith was born in 1771 to Reuben Smith, an apothecary, and Abigail Hubbard. Elihu Smith graduated from Yale College in 1786 at the age of fifteen, by far the youngest in his class, and then he returned to Litchfield to study medicine, work in the family shop, and pursue his literary interests. He later moved to Philadelphia and then New York to further his studies, and it is from these locations that his letters to Sarah Pierce are dated. He is said to have written the first sonnets ever published by an American, and he was the author of magazine verse and essays. Both Smith and Pierce remained unmarried, though Smith died at the age of twenty-seven, passing his last moments in the arms of his friends and fellow-physicians Samuel Latham Mitchell and Edward Miller, while Pierce lived out her old age as a New England "spinster." Both challenged the economic norm of the male-headed household and the reproductive norm of republican motherhood, substituting in their place a vision of egalitarian same-sex unions and the production of education and writing as the basis for an enlightened republic.

The detailed, passionate essays that Smith wrote about his friends Reuben Hitchcock and Thomas O'Hara Croswell attest to the power of the institution of

romantic same-sex friendship between men as well as between women in the 1790s. Nancy Cott argues that the 1790s saw the invention of a new American ideology of same-sex friendship because "relations between equals—'peer relationships'—were superseding hierarchical relationships as the desired norms of human interaction."[37] The revolutionary politics and the religious iconoclasm of the period also encouraged sexual experimentation.[38] The late eighteenth century also saw increased geographical mobility and the growth of towns, thus fostering greater physical freedom and anonymity in a more mobile, porous, and urban New England world.[39] While the importance of urban spaces in the development of gay male communities is well documented, in the "sisterly" bond between Pierce and Elihu Smith we see both the distinctiveness of a sister arts tradition that sees the rural landscape as a space of potential sexual liberation and the love of women for one another, and the connections between these urban male and rural female worlds. The iconic city of male same-sex eroticism is informed by the egalitarian gender ideals articulated in the Pierce-Smith correspondence, and the lesbian georgic is suffused with a sense of new sexual publics not limited to urban spaces.[40]

It is in this context of this post-Revolutionary social loosening, this moment of early national utopian imagining and experimentation, that Elihu Smith articulates his closeness to other men. Smith's understanding of these relationships tells us something about the conventions of friendship at work in Sarah Pierce's Litchfield circle, among both men and women. For example, as Smith writes of himself and his school friend Thomas O'Hara Croswell: "Never, I believe, were two hearts more united in each other, more unreserved in their communications, in every respect more One."[41] And in a letter to another friend, Theodore Dwight, Smith sets out to clear himself of the charge of being "deficient in affection" toward his friend, one

> towards whom my heart has always gone forth in the full vigor of attachment; & in respect to whom—if it be—
> in heaven a crime to love too well—
> I am certainly chargeable with guilt.[42]

Smith's use of the terms "crime" and "guilt" in relation to his friendship with Dwight suggests a sexual element to their friendship. In its original context in Pope's "Elegy to the Memory of an Unfortunate Lady" ("Is it, in Heav'n, a crime to love too well?"[43]), the quoted line refers to the bloody ghost of a woman who committed suicide rather than marry the man of her uncle's choice. She is buried "without a stone, a name."[44] Something about Smith's relationship with Dwight caused him to compare himself to Pope's fictional sexual outlaw. Finally, the romantic aspects of the friendships between men in Smith's coterie can be glimpsed in the fact that his friend Mason Cogswell, another poet-physician, adopted for himself and a male correspondent friend

the noms de plume Edwin and Angelina—the names of the lovers from a play Smith wrote.[45] The erotic aspects of same-sex intimacies were clearly part of the Litchfield world shared by Elihu Smith and Sarah Pierce.[46]

Throughout his diaries and correspondence, Smith expresses skepticism about the possibility of happiness in heterosexual marriage. For her part, Pierce, in a 1789 poem written to her friend Ann Collins as the latter prepared for her wedding (also recorded in Smith's diary), Pierce refers to marriage as requiring "that fearful word *obey*."[47] Smith and Pierce shared an especially intense correspondence around the time of Abigail Smith's proposed marriage. Although Smith had confided to his diary after a visit with his sister that "her heart is too sensible: a husband firm, yet tender, is necessary for her"[48] he and Pierce agreed that the man that Abigail chose was highly unsuitable, and their remarks about the proposed match make it seem unlikely that the younger woman could have chosen anyone of whom the confirmed bachelor and the passionate spinster would have approved. Smith assures Pierce that "your apprehension" is well warranted: "Whatever good qualities, & whatever great talents & attainments, Mr. Bacon may possess, it is a serious deduction from the pleasure of having my sister form such a connection, that she must be so remotely separated from us." As Smith tells Pierce in a tone of doleful anticipation: "There are a hundred ways in which a man may contrive to break the heart of a wife, with such a heart as Abby's" (231). In a letter to Abigail herself, he warns that for the most part young people are motivated by lust rather than good judgment in forming marital attachments: "Instant gratification is all the parties pant after," resulting in nothing but "the groans of connubial anguish, & din of domestic discord" (276). Later letters to Pierce mention Mr. Bacon's "little, occasional asperities of temper," "faults," and "error" (277). Casid notes that the idea of a rural retreat, such as that pictured in Pierce's poem, "was, among other things, the means to get away from social obligations like marriage and the production of children."[49] The correspondence of Pierce and Smith shows this desire to have been one they shared.

"THE UNAVAILING TEAR": PUBLIC FEELINGS

Smith's record is especially helpful in reconstructing the affective context of Pierce's poem because the poem itself is rather reticent on the subject of the relationship between the poet and the addressee. Though the poem opens with an apostrophe to the sharer of the poet's future life, it speaks not of the feelings the lovers share but rather of their economic and political values. In this way the poem links the possibilities of a household headed by a female couple to the utopian vision of a politically, economically, and morally renovated republic:

> On rising ground we'll rear a little dome;
> Plain, neat, and elegant, it shall appear;

No slaves shall there lament their native home,
Or, silent, drop the unavailing tear. (112)

The epithets "plain, neat, and elegant" speak to the moral value attached by New England
Congregationalists such as Pierce to material simplicity. This language recurs later in
the poem (the village is characterized by "simple elegance, in neat array" and the ladies
will lie beneath a "plain, smooth stone" with a "simple epitaph" [112]), suggesting the
importance of this value for the poet as she conducts a muted argument against luxury
("pomp" and "wealth") throughout.

While a rural retreat may constitute a resistance to heterosexual marriage, female
friendship is here understood not as a refuge from the public world but as a community
that would engage with social issues in an emancipatory way. Although this utopian
landscape will be ideal, then, it will be no isolated retreat; rather, in its engagement
with political issues such as slavery it will provide a much-needed corrective to the
corruption of public institutions as the poet sees them. This corruption is a result of
the betrayal of the Revolutionary ideals of equality and freedom, ideals the poet aims
to create in her relationship with her beloved. This political understanding of women's
friendship perhaps accounts for the rather cool tone of the poem. The invocation
of affect in the first stanza is reserved not for the lovers but for Sarah Pierce's slave
neighbors, to whose "silent" "unavailing" tears she here bears witness. George Boulukos
argues powerfully that sentimental representations of slave suffering can work to
support ameliorationist views of slavery rather than abolitionist ones, "using emotional
response to oppression and torture as a way of distancing oneself" not only from slavery
but from slaves, newly perceived in the late eighteenth century as racially inferior
because of their childlike emotions. Slave tears, then, "could be embraced by ardent
supporters of the slave trade" as well as by abolitionists.[50] Pierce's immediate context,
however, suggests that this image in her poem is connected to abolitionist rather than
ameliorationist depictions of slave humanity. Litchfield had an active Manumission
Society of which Elihu Smith was a member in the 1790s.[51] Abolitionist commitments
such as these gave rise to a convention of Connecticut georgic in which, according to
Dowling, "within the American republic as a whole, the rottenness . . . is Negro or
chattel slavery."[52] Sarah Pierce's ideal female-headed Connecticut household, a model of
republican virtue, offers a clear rebuke to slavery.

The economic undergirding of this household is so important that the poet
gives it another stanza before she turns to the more conventional topic of the
georgic landscape. In this household, she tells us in the second stanza, "Content and
cheerfulness shall dwell within, / And each domestic serve thro' love alone" (112).
Pierce obviously imagines a household where mistresses and domestic servants share
labor. The idea that "love alone" will be enough to compensate her servants may be
another expression of the ideal of peer relationships referred to by Cott; as Albert von

Frank observes, this idea "may seem sentimentally at odds with economic realities," but "what is better worth noticing is simply the substitution, in this utopian vision, of love for force."[53] The contrast with Gray's "Elegy" is once again instructive: rather than observing Gray's "ploughman" who "plods his weary way" home from rural labor, we see both speaker and addressee in Pierce's poem participating in the work of household, farm, and garden. Indeed, for the Connecticut georgic poet, as Dowling notes, such participation in "work or physical labor" is "the basis for civic virtue."[54] The basis for this altered economic and political reality is "meek Religion" which will "build her throne" in the household.

Pierce's more conventional employment of such references for picturesque effect occurs in her reference to a "Wood" behind the visionary house in the poem, which she says is

> like those where Druids wont, in days of yore,
> When Superstition wore Religion's form,
> With mystic rites their unknown Gods adore. (112)

The poet imagines a landscape in which the indigenous non-Christian religion would be Druidism rather than the spiritual practices of the indigenous people who were her northwestern Connecticut neighbors.[55] Such an obvious blind spot, an adoption without revision of conventional British literary tropes from the metropolitan tradition, serves to underline the fictional status of the landscape in the poem; it is a utopian vision rather than a concrete plan of action. The same picturesque effect is sought in the reference to "Fairies" who, "(if Fairies e'er have been,) / Will featly foot the moonlight hours away" (112). The echo of Ariel's song from *The Tempest* ("foot it featly, here and there / And sweet sprites the burden bear") brings the political utopia decisively into the green world of pastoral convention.

It is in the poem's treatment of space that we see an emphatic revision of British traditions of landscape representation. As at Stowe in England, the circuit laid out by following the river in Pierce's poem is also enhanced by architectural features, but here, in line with the poem's republican valuing of simplicity, we see not purpose-built classical temples but a "Village":

> Where simple elegance, in neat array,
> Might teach even pomp that, not to wealth confined,
> Genius & taste might to a cottage stray. (113)

The poet's appreciation of simplicity extends to the features of the view such as the village's "level grass-plot, smooth and green." Next the river takes us to the hall where the friends reside, whose architectural features are delineated by their usefulness:

Our plenteous store we'll freely give to all;
Want ne'er shall pass, in sorrow, from our door;
With joy we'll seat the beggar in our hall,
And learn his tale of woe that sunk his store. (113)

The "door" and "hall" here are humble enough to receive the beggar and give easy access to those in need; they are not removed from the village scene but of it, spaces through which needy and fortunate alike may pass.

"THE EQUALITY OF FEMALE INTELLECT": LITCHFIELD FEMALE ACADEMY

In addition to the influences discussed above, Sarah Pierce had read Mary Wollstonecraft's *A Vindication of the Rights of Woman* in 1792, the same year it was published in England. She later described her goal in founding Litchfield Female Academy that same fateful year in Wollstonecraftian terms: "To vindicate the equality of female intellect."[56] Still later, Pierce read aloud to the young women from *A Vindication* and other works by Wollstonecraft as they worked with their needles on embroidery and cross-stitch compositions. Sarah Pierce herself taught botany, perhaps influenced by her early study of the English Linnaean tradition via Darwin and Seward. "Drawing, painting, and embroidery of maps and globes were . . . used to augment geography lessons," so the students often worked landscapes based on many of the same influences that had inspired Mary Delany and the Duchess of Portland.[57] Catherine Jerusha Bockee's *Carnations,* for example, may have been a botany assignment (Figure 4.5).[58] The Academy even maintained a "very extensive herbarium of five thousand species," which students collected, drew, painted, and pressed into albums.[59] Although it was unusual for young women at the time, Sarah Pierce's students were taught Latin, perhaps in part to enable them to master Linnaean classification. Catherine Beecher, one of the school's more famous pupils, said later that by 1811 when she attended, "the reputation of Miss Pierce's school exceeded any other in the country."[60]

Women's friendship was an important value at the Academy. Pierce assigned younger girls to older students to make them feel at home on first arriving at school (some after harrowing overland journeys lasting days or weeks). The older girls helped the younger ones study, and they shared their beds. This practice may have accounted for the popularity of "the theme of Minerva leading the Neophyte," which is exemplified in several surviving paintings, drawings, and needlework pieces worked by Academy students.[61] Although this was a popular subject in many school books of the period, most often the "neophyte" is rendered as male. In the Academy pieces, however, an older girl leads a younger one. In a watercolor by Lucretia Champion entitled *Minerva Leading the Neophyte to Temple of Learning*, the contrast between knowledge and innocence

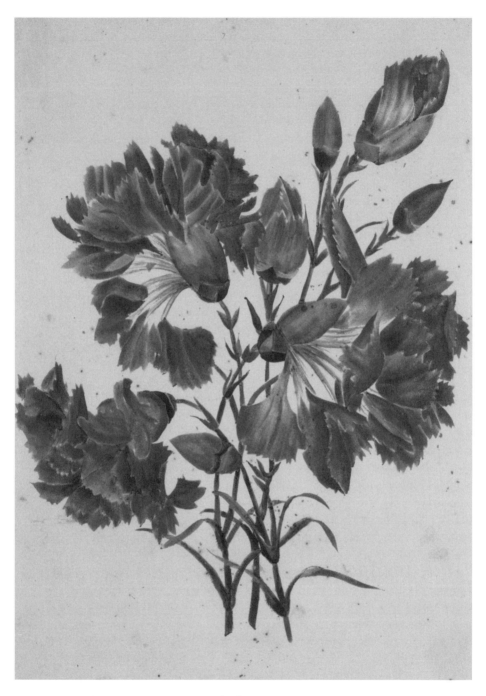

FIGURE 4.5 Catherine Jerusha Bockee, *Watercolor of Carnations,* ca. 1828. Botanical illustration was included in the curriculum at Pierce's Litchfield Female Academy. COLLECTION OF THE LITCHFIELD HISTORICAL SOCIETY, LITCHFIELD, CONNECTICUT. COPYRIGHT LITCHFIELD HISTORICAL SOCIETY.

is emphasized (Figure 4.6). The figure of Minerva on the right is rendered in rich, dark colors; she wears Grecian armor that bares her arms and legs and she holds an oversized spear that boldly cuts across the picture space. She lays a heavy hand on the shoulder of her young friend, who faces away from us toward the city pictured in the background. The young girl wears white; her classical drapery with its high neck and long sleeves is modest rather than either fashionable or historically accurate, and her feet are bare. Her light brown hair falls in ringlets down her back, and she wears a circlet of pink and green flowers around her brow. She holds a white lamb by a pink ribbon. The contrast between innocence and experience, between virginal ignorance and womanly knowledge, could not be more clearly depicted.

In a school commencement address, Pierce identified the role of the school as particularly valuable in forming female friendships:

> Now is the time when the heart is warm to form lasting friendships—it has frequently been observed that the most lasting and sincere friendships are formed when at school. Then there is a free intercourse:—no reserve, no disguise—we get perfectly acquainted with each others' dispositions—how necessary that we make a proper choice of friends, since such friendships are so permanent.[62]

According to the journals Pierce assigned every girl to keep, friendship and "the amiableness of sisterly affection" was a frequent composition topic. As Laura Wolcott wrote in her journal in 1826-27: "There is no pleasure equal to that of having some 'fond, faithful friend' in whose heart you can repose every little secret. I am sure I feel the need of such a friend; Oh! With what pleasure do I look forward to next summer with dear Elisabeth, my imagination will have full range."[63] The very formulaic expression of these sentiments, unattributed quotation and all, attests to their status as common knowledge, a central tradition in the same-sex culture of the Litchfield Female Academy. Perhaps for this reason the biblical story of Ruth and Naomi was one frequently studied in the Academy curriculum. Indeed, Pierce wrote a dramatic version of the story that was often performed by her students over the years. It is also the subject of the only known surviving drawing actually attributed to Sarah Pierce. The piece is a very modest, unfinished pencil sketch that curators at the Litchfield Historical Society have dated to 1801 (Figure 4.7). Naomi is on the left, in an elaborate robe, looking at the viewer. Boaz, in the middle, holds a scythe and looks past Naomi. The most expressive part of the drawing is the rendering of Ruth as a beautiful young woman in a Grecian draped gown, an early nineteenth-century Empire fashion associated with radical republicanism and free love. The figure's hair, in keeping with the Empire fashion, is drawn into a simple chignon held by a ribbon or fillet around the head. (A famous portrait of Mary Wollstonecraft by John Opie shows her in a similar gown and fillet.) The final figure in the portrait is another woman, perhaps a servant,

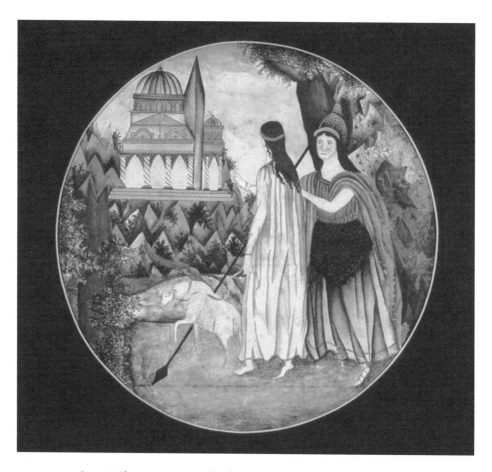

FIGURE 4.6 Lucretia Champion, *Minerva Leading the Neophyte to the Temple of Learning*, ca. 1800. This story of an older woman teaching a young girl was a frequently assigned topic at Litchfield Female Academy. COLLECTION OF THE LITCHFIELD HISTORICAL SOCIETY, LITCHFIELD, CONNECTICUT. COPYRIGHT LITCHFIELD HISTORICAL SOCIETY.

on the far right. The tree on the edge of the drawing shelters both the fourth woman and the Ruth figure much like the placement of vegetation in the Portland Vase; indeed, the whole design seems inspired by Greek vase decoration as much as by the Bible.

This simple drawing, executed with more heart than taste, shares this vegetation design feature with one of the finest examples of Litchfield Academy artwork we have, Charlotte Hopper Newcomb's *Discovery of Moses in the Bullrushes* (see Plate 11). Executed in silk needlework on a silk ground and including areas of ink drawing and watercolor, the sister arts convention by which vegetation is used to frame a scene of women's intimacy is rendered in luxurious materials with a high degree of skill. It is not often noticed that the story of Moses's birth in the biblical book of Exodus is a story of female community and strategy, but it is the women characters that Pierce's students foreground in their representations. In the story Pharaoh commands two Hebrew midwives to kill all male children born to Hebrew women when they attend at births. In resisting this

FIGURE 4.7 Sarah Pierce, *Boaz, Ruth, and Naomi,* 1801. Pierce referred often to the biblical story of Ruth and Naomi. She wrote a play about it and even attempted this drawing of its figures. COLLECTION OF THE LITCHFIELD HISTORICAL SOCIETY, LITCHFIELD, CONNECTICUT. COPYRIGHT LITCHFIELD HISTORICAL SOCIETY.

command the midwives tell Pharaoh that because Hebrew women are so strong they deliver before the midwives can arrive to carry out his commands. So Pharaoh changes his strategy, commanding the Hebrews to drown their sons, whomever attended their births, in the river. In a paradigmatic story of maternal resistance to slavery, the wife of Levi disobeys this command and hides her child until he is three months old. Pharaoh's daughter finds the baby, whom his mother has placed in a basket in the river, and tells her female servants to find a Hebrew woman to nurse him. Through the intervention of the baby's sister, the princess ends up giving the Hebrew woman her own baby to care for. Like the story of Ruth, this is one of the few in the Bible with women protagonists, and also like Ruth, it is a story of female friendship, community, and in this case, solidarity across the boundary of enslavement. It is striking that these are the stories that Sarah Pierce chose to emphasize in her curriculum.

Charlotte Hopper Newcomb's rendering of this story was probably a graduation piece, the capstone of her education. As in Sarah Pierce's drawing, the influence of Regency style, popularized by the circulation of Greek vase decoration, is visible in the Empire-waist gowns and filleted chignons worn by the three female figures at the center of the image. The bare arms and exposed necks and chests of the fashionable gowns emphasize the sexually free connotations of this style, which was often criticized in this period for the sexiness of both its bare lines and its clinging fabrics. The central figures are framed by what looks like a large yew tree on the left, worked in knot stitches, and a

FIGURE 4.8 Sandro Botticelli, *Birth of Venus*, c. 1486. The classic shell-shaped, arched background is echoed in Newcomb's framing of the central group of three women in *Discovery of Moses in the Bullrushes* (see Plate 11).
COURTESY OF SCALA / ART RESOURCE, NY.

different variety of tree worked in satin stitch on the right. Behind the central group of women hovering over the baby is a background of bulrushes, which encircle them like the shell in Botticelli's *Birth of Venus* (Figure 4.8). Rendered in sensuous peacock blue, green, umber, and gold, this luxurious piece was obviously a family treasure; indeed, it came back to the Litchfield Historical Society in an elaborate frame covered with black and gilt glass with the artist's name painted in large letters along the bottom. Erotically charged images of women framed by typical sister arts landscape elements were the means of Charlotte Hopper Newcomb's artistic self-assertion.

A group of three accomplished botanical illustrations by Catherine Jerusha Bockee, which beg comparison with those of Mary Delany more than fifty years earlier, attest to the mingling of scientific and artistic training received by students of Litchfield Female Academy. While Bockee's watercolors are executed in a more conventional style and medium than were Delany's powerful paper mosaics, the watercolors are confident assertions of expertise and accomplishment. In *Watercolor of Lilies*, Bockee shows us the blossom from the front and the side to aid in field identification and observation of the different plant parts (Figure 4.9). Like Delany, Bockee follows the Linnaean principle of emphasizing the plant's sexual organs, showing stamens and pistils with orange pollen on both blossoms. Indeed, one reason the lily was a favorite of Linnaean illustrators was because the flower's reproductive parts are prominent and easy to paint. Bockee also demonstrates expertise by depicting buds, stalks, and leaves. Obviously proud of her work, the artist signed the image with her initials in the upper-right corner of the

FIGURE 4.9 Catherine Jerusha Bockee, *Watercolor of Lilies*, ca. 1828. COLLECTION OF THE LITCHFIELD HISTORICAL SOCIETY, LITCHFIELD, CONNECTICUT. COPYRIGHT LITCHFIELD HISTORICAL SOCIETY.

drawing. *Watercolor of Carnations* (Figure 4.5) also shows the different parts and stages of the plant, but in addition it has a nice detail in the full bloom on the right: a petal grows back away from the rest of the flower, showing individual variation. *Watercolor of Grapes* is perhaps the strongest of these images in its striking inverted-pyramid composition that shows a lush bunch of grapes cascading downward through the frame (Figure 4.10). The artist highlights variations among the individual grapes, and the stalk, vine, and leaves are shown in a pleasing way: the stalk cuts diagonally across the picture space behind the fruit. The stalk is adorned with leaves, again to show another part of the plant, and

FIGURE 4.10 Catherine Jerusha Bockee, *Watercolor of Grapes,* ca. 1828. In this third extant painting, the artist confidently signs her name. COLLECTION OF THE LITCHFIELD HISTORICAL SOCIETY, LITCHFIELD, CONNECTICUT. COPYRIGHT LITCHFIELD HISTORICAL SOCIETY.

a sturdy vine attenuating to delicate tendrils winds around it and shoots a lovely triple loop shape out into the white space in the upper left of the image. This is a confident, accomplished, bold, and sensuous image, and it is signed with the artist's full name.

Sarah Pierce retired from teaching at the age of seventy or so after having brought her nephew, John Brace, into the business. Pierce's Academy was the expression of her vision of "a new social life between women," which she imagined into being in the first American lesbian georgic poem.[64] It was not only in the poem itself, then, but in the institutionalization of women's education and in the work of Sarah Pierce's students that the sister arts tradition rooted itself firmly in American soil. ⊛

CONCLUSION

......................................

The Persistence of Lesbian Genres

A CIRCUIT GARDEN

THE WORK OF THE SISTER ARTISTS discussed in this book is often oriented toward futurity. Mary Delany and the Duchess of Portland inducted Mary Port, Georgiana Port, and Mary Hamilton into their community of botanical artists and designers; Anna Seward dedicated her book *Llangollen Vale* to perpetuating the memory of the Ladies of Llangollen; and Sarah Pierce pictured "maids and matrons," perhaps avatars of her own future students, inspired by the gravestone memorializing her dreamed-of life with Abigail Smith. But the truth is that the sister arts tradition traced in this volume is one that disappeared time and time again, only to be reinvented by later generations of artists who often did not realize that the potent combination of the erotic landscape and the expression of love for another woman did not originate with them. The tradition of the ribald garden, the vision of nature as a woman to be wooed or subdued, and the association of floral imagery with female sexuality remained visible in art and literature by men, however, and it was here that women artists most often encountered these tropes and, as if for the first time, turned them to the purpose of expressing love and desire for other women. To speak of lesbian landscape art practices as an independent genre or a tradition, then, may seem paradoxical. If artists do not know they are adapting and appropriating existing conventions, can they really be said to be working in a genre, one of the basic definitions of which is the commonsense knowability of its rules? What follows is a brisk tour through the work of selected nineteenth-, twentieth-, and twenty-first century artists whose work attests to the persistence of the landscape arts as a lesbian genre. Like a circuit garden, this essay pauses for spectacles and seeks to persuade less through reasoned argument than sensory overload.

GENRE THEORY

While a case be made for identifying a lesbian aesthetic tradition as a contribution to literary and art history and the history of sexuality, is such an effort counter to Jacques Derrida's deconstruction of "the law of genre," and by the same token counter to the antinormative investments of much queer theory?[1] Is the identification of such a tradition a positivist move that inevitably falls into essentialism? The putative dangers of essentialism ought not to eviscerate the strengths of making historical and

even biographical arguments about representations of love and sex between women. Vulgar essentialism—the idea, for example, that all lesbians and only lesbians make the kind of work discussed in this book—is a description of a use to which such a history could be put rather than one of the history itself. A better use is to recognize that this minoritarian tradition also shows how love and sex between women is at the heart of patriarchal and heteronormative canons that seek, but always fail, to repress and abject this aspect of human experience. The feminist theorist Mary Jacobus reads Derrida's "Law of Genres" as a warrant that impurity always lies at the disavowed heart of strict definitions of genre. In fact, in identifying generic characteristics we are making space to recognize what Jacobus calls "invagination," monstrosity, deviance.[2]

What are the conventions of the sister arts as a lesbian genre? How can we recognize this tradition across time and in different media? In material terms, the sister arts are practiced by women artists working collaboratively or in community—which of course includes relationships such as rivalry, competition, jealousy, and critique. Sister arts artifacts are animated by the role of another woman or women as at least one important addressee, implied spectator, or intended recipient, patron, or reader. Such works may rely on shared materials, such as the plants, paints, and recipes for glue that circulated among the Duchess of Portland's friends. They might also rely on shared labor, as in the case of the Portland Museum, which included objects created and collected by the Duchess's wide circle of friends and colleagues—circles that importantly include women (but may also include important men, for example when Elihu Hubbard Smith records Sarah Pierce's poem). These artists and works will often cross the lines between amateur and professional, fine art and craft, personally expressive versus vocational or educational, urban and rural, and conventional versus experimental. In formal terms, we can look for floral, botanical, and landscape imagery (the representation of a flower opened to the viewer's gaze is a key trope); apostrophe to a beloved woman; a synesthetic representation of sensory and sensual experience in apprehending a beautiful landscape; ekphrasis; and topographical, botanical, and geographical description. Sister artists seek both to discover forebears and to leave legacies. They are involved with both older and younger women as lovers, mentors, teachers, and historians—and, like all relationships, these can have both positive and negative valences. The sister arts tradition both includes women of color and has a strong strain of racism and imperialism running through it. Artists and writers of color put the generic conventions of the tradition to distinctive uses as they worked with and against it.

JANE AND MARY PARMINTER

Like the Ladies of Llangollen, the cousins Jane and Mary Parminter resisted family and social pressure to marry and instead, in the 1840s, designed and built an eccentric rural retreat where they lived out their lives together. In an age when no women

were professionally engaged in architecture in England, the Parminters themselves designed their house, A la Ronde, in the county of Devon (Figure C.1). They had the benefit of ten years of travel on the Continent, where they had studied churches and castles in France, Italy, Germany, Switzerland, and beyond. The design of A la Ronde was influenced by the chapel of San Vitale in Ravenna, which they visited on their grand tour. The Devon house has sixteen sides, with wedge-shaped rooms raying out from a central octagonal hall. In style, the house is a picturesque *cottage ornée*—part of the vogue for small rustic retreats for middle-class families that swept England in the Regency period. The women decorated the interior of the house in media that would have been familiar to Mary Delany: they made paintings, shell pictures, feather decorations, furniture decorated with découpage and semiprecious stone inlay, and collections of souvenirs and relics brought back from their grand tour. And like Delany they were famous for their shellwork: the best-known feature of their house is its

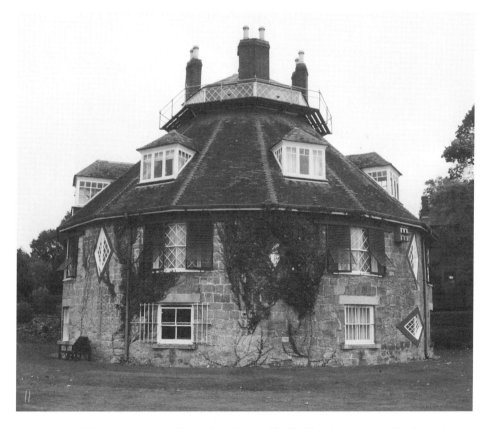

FIGURE C.1 A la Ronde, the home designed and inhabited by the Victorian travelers and architects Jane and Mary Parminter. PHOTOGRAPH COURTESY OF ELLIE MAY.

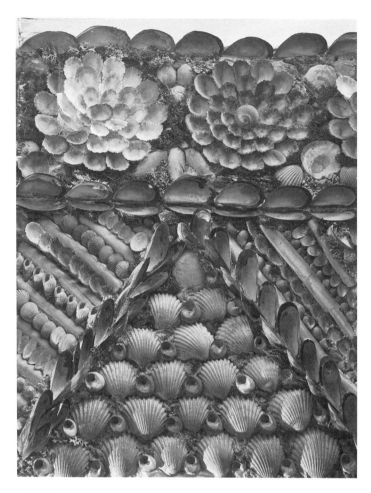

FIGURE C.2 Shell detail, A la Ronde. The ornate shellwork at the Parminters' home continues the tradition of sister arts shellwork in which Mary Delany excelled. PHOTOGRAPH BY NIC BARLOW.

shell gallery, which took the artists ten years to complete (Figure C.2). The loft above the octagonal hall is decorated not only with shells but also with lichen, glass, mica, pottery, stones, and paint. In addition to their own residence, Jane and Mary Parminter also designed a small chapel they called Point-in-View, which they surrounded with almshouses intended for elderly spinsters along with a school for girls. According to the terms of the will of Mary Parminter, who survived Jane by thirty-eight years, the house and estate were to pass to unmarried female relatives only. Until recently, the almshouses still afforded shelter to indigent unmarried women.[3] Little written evidence survives to record the affective tenor of the Parminters' relationship; Jane's travel diary, for example, was destroyed in 1942.[4] Their life together is documented in the sister arts media of shells, feathers, and space that were shaped to create, protect, and paradoxically also display intimacy between women.

EMILY DICKINSON

In midcentury Victorian America, Emily Dickinson was better known as a gardener than as a poet.[5] Dickinson's love of scientific study, first at Amherst Academy under the naturalist Edward Hitchcock and later following Mary Lyons's strict curriculum at Mount Holyoke Seminary, is well documented.[6] In one poem she satirized the more scientistic versions of the botanizing impulse:

> I pull a flower from the woods—
> A monster with a glass
> Computes the stamens in a breath—
> And has her in a 'class'![7]

Yet "so important were flowers to Emily Dickinson, so knowledgeable was she about botany, that the key to a successful reading of an individual Dickinson lyric can depend on one's knowledge of the background and identity of a plant or flower."[8] For her, growing flowers was a creative project akin to writing poems, and she often sent gifts of flowers and poems intertwined. Although not a painter herself, Dickinson lived in "a household. . . . absorbed by painting" and followed the latest developments in landscape and botanical painting.[9] A frequent subject of Dickinson's poems is the calla lily, which was also a favorite of botanical illustrators such as her contemporary Fidelia Bridges, whom Dickinson admired (Figure C.3). Paula Bennett's pathbreaking research demonstrates another relevant strand of imagery and influence in Dickinson's verse: clitoral, vaginal, and orgasmic imagery is especially prominent in her many poems written or sent to other women. As Bennett writes, "Like a painting by Georgia O'Keeffe or Judy Chicago," Dickinson's poem "I tend my flowers" "takes us into the very heart of the flower: its sight, smell, taste, and feel . . . It could well be orgasmic."[10] Bennett identifies a pattern of "small, round, and frequently hard objects" in Dickinson's verse as "clitoral imagery" that helps explain "the high value Dickinson places on littleness" as something other than retiring femininity. Rather, for Bennett, the association of these small objects with explosive, intense experience and insight in the poems gives us a much more powerful Dickinson, one for whom "the little could also be great."[11] Bennett identifies this trope as a wider pattern in Victorian women's poetry; another source is the sister arts tradition identified in this book's chapters. We can see a similar treatment of clitoral imagery, for example, in Mary Delany's *Passeflora Laurifolia* (Plate 3) and *Magnolia Grandiflora* (Plate 4), discussed in chapter 1, as well as in other images such as the spectacular *Bombax Ceiba*.

In *The Gardens of Emily Dickinson,* Judith Farr documents Dickinson's "two (unconsummated) love affairs with men" as well as the attachments to women that threaded throughout her life:

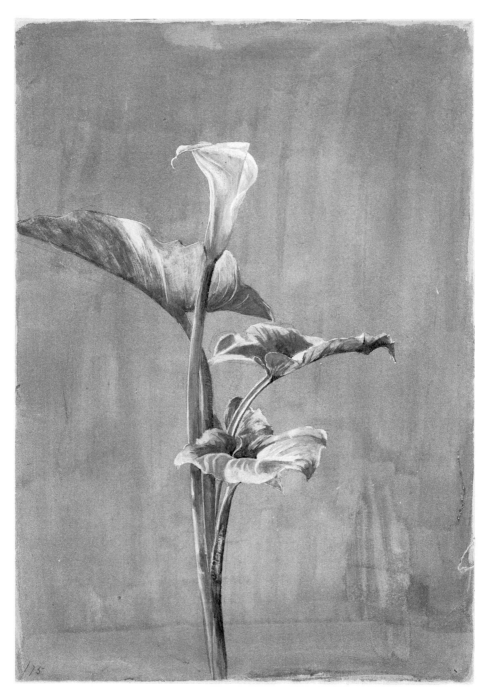

FIGURE C.3 Fidelia Bridges, *Calla Lily*, 1875. Emily Dickinson had extensive knowledge of flowers and gardening, and she admired the botanical illustrations of Bridges. COURTESY OF THE BROOKLYN MUSEUM.

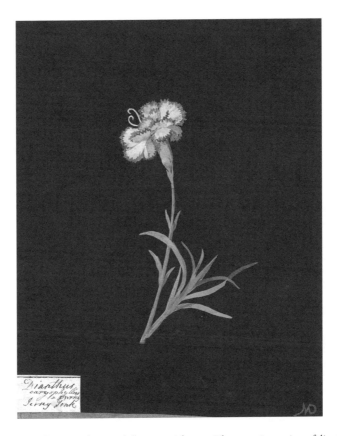

FIGURE C.4 Mary Delany, *Dianthus caryophyllus, Jersey Pink*, 1779. The carnation variety of dianthus was the flower to which Dickinson compared the aloof, alluring Susan Gilbert.

Her schoolmates (of five intimates whom she addressed with extreme sentimentality, pretty Abiah Root, first seen wearing a crown of Emily's loved dandelions, was the favorite); "Sister Golconda," the winsome and maternal Mrs. Elizabeth Holland, 'doll-wife' of the editor of *Scribner's Monthly*, Dr. Josiah Holland; handsome Kate Scott Anthon, for a brief period marked by sensuous letters; and for forty years, with her powerful sister-in-law Susan, to whom she wrote so passionately in youth that some scholars seek to name Susan as the unidentified "Master" of three of Dickinson's love letters.[12]

Dickinson wrote a poem associating Susan with the crown imperial lily, *Fritillaria imperialis*. This bold, strong-scented flower (its odor is sometimes used to ward off garden pests) seemed to capture not only Susan's sensuous appeal and commanding beauty but her sometimes repellently strong personality. Dickinson also associated Susan with other flowers, writing to her in 1878: "Susan—I dreamed of you, last night, and send a Carnation to indorse it."[13] In the Victorian "language of flowers," carnations mean "pride and beauty" or "disdain," which seem to be fitting epithets for Susan as

FIGURE C.5 Mabel Loomis Todd, *Indian Pipe Plant*. Loomis Todd made this painting for Dickinson, who called it "the preferred flower of life." Cover of Emily Dickinson's *Poems*, edited by Mabel Loomis Todd and Thomas Wentworth Higginson.

Dickinson saw her. Mary Delany also loved the carnation, and she made four different paper-mosaics illustrating varieties of it (Figure C.4). Dickinson preferred flowers with "strong perfumes" and "assertive blooms," and she chose women friends with the same qualities.[14] She persuaded her father to build her a conservatory, and she began collecting orchids and other hot-house flowers "proscribed for the drawing room" by Victorian convention because of their "connotations of sexual danger and intrigue."[15] According to Farr, Dickinson's "gardening—like writing poetry—was the manifestation of a profound and even occasionally rebellious desire."[16] Also like Mary Delany, Dickinson completed an herbarium or *hortus siccus*, although Dickinson's was in the more conventional form of flowers pressed into an album rather than the paper-mosaic medium pioneered by Delany. Like Delany and the Duchess of Portland, for Dickinson the construction of the herbarium was an occasion for the exchange of affectionate gifts among women. As Dickenson, while still at school, wrote to her intimate Abiah Root:

> My plants look finely now. I am going to send you a little geranium leaf in this letter, which you must press for me. Have you made an herbarium yet? I hope you will if you have not, it would be such a treasure to you . . . If you do, perhaps I can make some addition to it from flowers growing around here.[17]

Dickinson's herbarium eventually grew to include over four hundred plants and flowers. Late in life she was befriended by Mabel Loomis Todd, who recalled Dickinson sending her "queer, rare flowers that I never saw before."[18] Todd responded in kind, sending Dickinson a painting of the Indian pipe flower. Dickinson wrote back: "That without suspecting it you should send me the preferred flower of life, seems almost supernatural, and the sweet glee that I felt at meeting it, I could confide to none."[19] This queer, rare, and secret relationship was to blossom into Dickinson's legacy; Mabel Loomis Todd was the editor of the first collection of Dickinson's poetry, which was published after the poet's death (Figure C.5).

EDMONIA LEWIS

Emily Dickinson closely followed the events of the Civil War and she may have been aware of the sculptures of Edmonia Lewis, whose portraits of abolitionist and Civil War heroes such as John Brown and Robert Shaw were well known in New England. But Lewis also created powerful portraits of female figures, for which she drew on African-American and Ojibway sources to contest racist appropriations of the wilderness, the garden, and the female body. Lewis, born in 1845 near Albany, grew up among her mother's Ojibway people on the northern shores of Lake Ontario (Figure C.6). Because Lewis's father was African-American, her mother feared that Edmonia (her Ojibway name was Ish-scoodah) and her brother might be kidnapped by slave catchers working

FIGURE C.6 H. Rocher, *Edmonia Lewis, carte-de-visite* portrait ca. 1868. Lewis settled into an expatriate community of women artists in nineteenth-century Rome. The group centered around the household of the American actress Charlotte Cushman and the writer Matilda Hays. COURTESY OF WISCONSIN HISTORICAL SOCIETY (WHI-47870).

in upstate New York, and thus living among the Ojibway in Canada seemed the safest option.[20] Lewis grew up making and trading baskets, moccasins, blouses, snowshoes, and belts for sale to Niagara Falls area tourists—an activity that served as her apprenticeship in design. As she later recalled, "My mother was famous for inventing new patterns for embroidery, and perhaps the same thing is coming out in me."[21] After her mother's death, Lewis's brother Samuel, by then a successful prospector in California, was able to

provide her with formal education. At coeducational, interracial Oberlin College in the early 1860s, Lewis's talent was recognized and she studied with the artist Georgianna Wyett. Although Oberlin was a staunchly abolitionist and intentionally inclusive community, it was also run on strict lines of "Christian perfectionism." In part because the mixing of male and female and black and white students was considered scandalous by many of the neighboring farmers, African-American women students were policed especially vigilantly—partly for their safety, and partly to control and manage their behavior in a way that met the expectations of the school's "pious and puritanical" head of the Ladies Department, Mrs. Marianne F. Dascombe.[22] Lewis, raised among her mother's people and thus outside the institutions of white female propriety, was especially vulnerable. In January 1862, she became embroiled in a sex scandal that threatened to undo her career.

Interracial friendships were encouraged at Oberlin "if both are agreed" and Edmonia Lewis had become close to two white girls.[23] On a sleigh-riding date with two young men, these girls became ill, vomiting and experiencing cramps. Their symptoms were diagnosed as poisoning by cantharides or "Spanish fly," the well-known aphrodisiac. Asked where they could have found such a substance, the girls accused Lewis of adding it to some wine they said she had served them before the ride. The notion of two young white women affected by an aphrodisiac served to them by their African-American friend rocked the puritanical Oberlin community. Lewis's lawyer pointed out that poisoning by cantharides could not possibly have been correctly diagnosed without examining the sick girls' vomitus, urine, and feces, which was not done, and Lewis was exonerated. Yet many local people, long resentful of the openly abolitionist, integrated, and coeducational community in their midst assumed that Lewis was being protected by Oberlin because she was black. In a horrifying incident, Lewis was dragged from the home of Reverend John Keep where she boarded, and she was beaten and left for dead in the frigid February night. Fearful of further controversy but not wanting to outright expel Lewis, who had now become a political liability as well as a member of the community whose safety was at risk, Marianne Dascomb declined to allow Lewis to register for her final semester. Although she was recognized as an extraordinary talent, Lewis never graduated from Oberlin.

This shameful incident—summarized by Bearden and Henderson as "the false accusation by young women she considered friends, its sexual implications, the terrifying brutal beating by unknown attackers, followed by the need to defend herself everywhere"—may have been one source of a strong motif in Lewis's later work: identification with women seen as sexual outcasts.[24] "I have a strong sympathy for all women who have struggled and suffered," she later said.[25] Her training, reception, and status as an artist was shaped both by her Ojibway heritage and by her experience of racism against African-Americans. Dispossession and imperialism, racism and slavery, meant that Edmonia Lewis's relationship to questions of garden, land, and

FIGURE C.7 Edmonia Lewis, *Hagar in the Wilderness,* 1875. For Lewis, who had grown up on tribal lands, "wilderness" represented not banishment but freedom. The domesticated landscapes of other versions of the sister arts tradition, associated with slave wealth and the appropriation of Native lands, were transformed in her work. SMITHSONIAN AMERICAN ART MUSEUM, GIFT OF DELTA SIGMA THETA SORORITY, INC.

FIGURE C.8 Edmonia Lewis, *Hygieia,* ca. 1871–72. An early woman doctor commissioned this garden statue for her grave. PHOTOGRAPH BY CHRISTOPHER BUSTA-PECK.

property were tellingly different from that of her contemporary Emily Dickinson. After moving from Ohio to Boston and later to Rome, where she joined the community of Sapphic artists surrounding the American lesbian actress Charlotte Cushman, she created a body of work that deals explicitly with questions of racial and sexual oppression.[26] One of her most famous statues, *Hagar in the Wilderness* (Figure C.7), depicts "an erect female slave" as a counterpoint to the story of "the brutal treatment and abandonment of the biblical Egyptian slave woman."[27] Having grown up on tribal lands, and then experiencing dispossession and brutalization when she encountered American "civilization," for Lewis the term "wilderness" seems to have had a positive

and empowering meaning that was at odds with its connotation in the biblical story. Wilderness, in this piece, is where Hagar is finally free.

Lewis's Victorian neoclassical style alludes to the contemporary view of Greece as the more humane, democratic, and liberated ancient civilization, in contrast to the Augustan Rome admired by artists of the previous century. The sculptural tradition, however, remains a monumental one. Lewis made what can be considered a piece of garden sculpture. Through her friends in Rome, the actress Charlotte Cushman and the painters Anne Whitney and Adele Manning, Lewis was introduced, on a trip back to the United States in 1871, to Dr. Harriot K. Hunt, the first woman physician in Boston. Hunt, who was terminally ill, commissioned Lewis to create a funeral monument for her. The result was *Hygieia* (1874) (Figure C.8), an homage to the Greek goddess of medicine, to women's entry into the medical profession, to Hunt herself, and not least to the community of women artists and professionals that made the commission itself possible. (As we saw in chapter 3, Hygieia was also a subject for Anna Seward in her poem "A Farewell.")

Disgusted with the post–Civil War backlash against African-Americans, Lewis returned to Rome and settled there permanently. Interestingly, this is also when she drops out of the historical record. Even her death date and place of burial are not known. Our last glimpse of her comes in January 1887 in the diary of the abolitionist Frederick Douglass. Douglass and his wife were visiting Rome and looked up Lewis, an old acquaintance from their Boston days. "She seems," said Douglass, "happy and cheerful and successful."[28] Edmonia Lewis's companion at this time was Adelia Gates— a flower painter.

VITA SACKVILLE-WEST

Edmonia Lewis's sister arts community in Rome had many connections to the Bloomsbury circle of the next generation. But it's hard to imagine a greater contrast in terms of relationship to landscape than that between Lewis and Vita Sackville-West. Lewis was dispossessed of her mother's tribal lands through U.S. colonialism and violently beaten in what can be seen as a form of vicious discipline of African-American women's sexuality. Sackville-West mourned all her life that as a woman she was not able to inherit her beloved Knole, the family estate, yet through her mother she inherited the great wealth that allowed her to create the famous garden at Sissinghurst. Much like Mary Delany's Delville, Sissinghurst was a joint project between husband and wife in what seems to have been by that time a *mariage blanc*. Given the famous openness of Sackville-West's marriage to Harold Nicolson—after 1930 their sexual relations were exclusively extramarital and homosexual—it is nonetheless queer for that. Lesser known today, however, is Sackville-West's ambitious georgic poem of 1927, *The Land*. Dedicated to her lover, the poet Dorothy Wellesley, the poem modernizes Virgil's *Georgics* by

describing the seasonal round of the Kentish farming year. The poem received the Hawthornden Prize in 1927, but Sackville-West was reportedly even more pleased that local farmers approved the accuracy of her agricultural details.[29] The poem maintained its popularity, selling over one hundred thousand copies in England alone by 1971,[30] and it has received some attention from classicists examining its uses of Virgil and Hesiod.[31] Some consider it the first georgic poem in English to be composed by a woman.[32] As we have seen, however, there is a sister arts lesbian georgic going back to Sarah Pierce's "Verses" that provides another context for the poem. Sackville-West, whose tastes and ambitions were emphatically elite, makes the poet male instead of female, someone whose duty it is to "kiss the mouth of Helen."[33] Rhetorically, then, the poem emphasizes the transgender possibilities of the sister arts adaptation of masculinist traditions. As in the poetry of Seward, Pierce, and Dickinson, the eroticism of Sackville-West's poem is rendered indirectly through garden imagery, as in this passage describing bees and flowers:

> The Syrian queens mate in the high hot day
> Rapt visionaries of creative fray,
> Soaring from fecund ecstasy alone,
> While through the blazing ether, drops
> Like a small thunderbolt the vindicated drone.[34]

As Bennett observes about Dickinson's bee imagery, the drone may be a male bee, but "being small and round" in its state of satiation after an encounter with the "fecund ecstasy" of the queen, it can be read as a clitoral symbol, one that is able "not only to accept the clitoris's littleness but to rejoice in its wildness."[35] The small drone in Sackville-West's lines recalls Dickinson's images of erotically charged small-but-powerful items.

Sackville-West employs sexual imagery that owes much to English Linnaeanism such as Delany's in her depiction of the sexuality of flowers. Her description of the fritillary, the same flower that Dickinson associated with Susan Dickinson, routes its erotic charge through a disturbing network of racist images:

> And then I came to a field where the springing grass
> Was dulled by the hanging cups of fritillaries,
> Sullen and foreign-looking, the snaky flower,
> Scarfed in dull purpose, like Egyptian girls
> Camping among the furze, staining the waste
> With foreign colour, sulky-dark and quaint,
> Dangerous too, as a girl might sidle up,
> An Egyptian girl, with an ancient snaring spell . . .
> Holding her captive close with her bare brown arms.

Close to her little breast beneath the silk,
A gipsy Judith, witch of a ragged tent . . . [36]

This is one of the most erotic passages in the poem, and undeniably the most xenophobic. Seeing the flowers as "Egyptian girls" "camping among the furze" seems to refer to English Gypsies or Travellers, a frequent subject for Victorian and modernist writers who wished to evoke foreignness within Britain.[37] Sackville-West's unapologetic racism (her son Nigel Nicolson says she had a "dislike of Jews and coloured people") leads her here into a meadow of cliché.[38]

GEORGIA O'KEEFFE

Georgia O'Keeffe famously hated sexual readings of her work, but they dogged her from her first exhibition in 1916.[39] Such readings arose not only from the imagery itself but also from the frankly sexual way that Alfred Stieglitz, curator of her first gallery show, powerful sponsor of her early career, and subsequently her lover and husband, used his own photographic images to emphasize O'Keeffe's sexuality and that of her work. Although O'Keeffe resisted what she felt was the demeaning title of "woman artist" (most famously bestowed by Stieglitz himself in his iconic comment on first seeing her paintings: "Finally, a woman on paper"), she also struggled to distinguish her contribution from a male-dominated art canon in terms that were distinctly feminist. As she told the editor of the magazine *New Masses* in 1930:

> I am interested in the oppression of women of all classes . . . though not nearly so definitely and so consistently as I am in the abstractions of painting. But one has affected the other . . . I have had to go to men as sources in my painting because the past has left us so small an inheritance of woman's painting that has widened life . . . before I put a brush to a canvas I question, "Is this mine? Is it all intrinsically of myself? Is it influenced by some idea or some photograph of an idea which I have acquired from some man?" That too implies a social consciousness, a social struggle. I am trying with all of my skill to do painting that is all of a woman, as well as all of me . . . I have no hesitation in contending that my painting of a flower may be just as much a product of this age as a cartoon about the freedom of women— or the working class—or anything else.[40]

Both Stieglitz and O'Keeffe assumed that there was no important tradition of women's art (art that had "widened life") prior to O'Keeffe, who is seen to have emerged like Athena from the Zeus-like head of Stieglitz. Yet O'Keeffe's comments indicate her awareness that "social struggle" has a role to play in determining the meaning and form of a work of art. Her own early education at the Art Institute of Chicago was an apprenticeship to an alternative to the high-art modernist canon that was to

characterize her career. The Art Institute was, at the turn of the twentieth century, a hotbed of progressive art theory and practice that included a revaluation of the kind of decorative and craft work traditionally associated with women. The establishment of a William Morris Society in the city in 1903, as well as the influence of Louis Sullivan and Frank Lloyd Wright, made it one of the most important North American centers of the Arts and Crafts movement. Indeed, the curriculum at the Art Institute included a rigorous three-year training in artisanal disciplines such as illustration, textiles, and design. O'Keeffe's first professional work as an artist was a two-year stint as an embroidery and lace draftswoman in Chicago. This work was affiliated with early twentieth-century feminism through the involvement of Hull House, Jane Addams's settlement home, which offered classes in Arts and Crafts techniques and appreciation often taught by socially committed Art Institute faculty. Ten years before her immersion into the modernist avant-garde milieu of Stieglitz's New York, then, Georgia O'Keeffe was trained in a tradition that valued feminism, women's art, the artisanal, and the decorative—we might say, that is, in a sister arts tradition.

Although O'Keeffe may have been what we would now call bisexual, her primary erotic commitments were to men.[41] However, both in her early Arts and Crafts days and later in New Mexico (before and after the period in which she lived full time with Stieglitz, who had such strong views of her as an avatar of essential, meaning heterosexual, womanhood), she was affiliated with the lesbian subcultures that overlapped with the feminist and art worlds in which she traveled. Arts and Crafts had itself been associated with radical sexual as well as socialist politics since the days of William Morris's ménage-a-trois with Dante Gabriel Rossetti and Jane Morris; in its American incarnation, this movement provided the inspiration for utopian craft communities and other forms of collectivism, of which Chicago's Hull House was a distinguished example. Hull House was an experiment in socialist feminism and a leading laboratory of the settlement home movement; the lifelong relationship between founder Jane Addams and Mary Rozet Smith made it a visible image of women's same-sex eroticism as well. In New Mexico, where O'Keeffe traveled in the late 1920s and moved to permanently in the early 1930s, leaving Stieglitz behind in New York, one of her first hosts and sponsors was Mabel Dodge Luhan. Dodge Luhan had been an organizer and sponsor of the 1913 Armory Show, which introduced American audiences to postimpressionist European art for the first time. At the exhibition, Dodge Luhan distributed copies of Gertrude Stein's "Portrait of Mabel Dodge at the Villa Curonia," the first of Stein's publications to be available in the United States. Dodge Luhan wrote for Stieglitz's journal *Camera Work* and met O'Keeffe through this association. O'Keeffe hoped Dodge Luhan would be the critic to insert her into a women's tradition: in 1925, she asked her to write "something about me that the men can't . . . I feel there is something unexplored about woman that only a woman can explore—men have done all they can do about it."[42]

FIGURE C.9 Photograph of Georgia O'Keeffe (right) and Rebecca Strand at El Gallo's Pink House, New Mexico, 1929 (photographer unknown). Strand, also a painter, became lovers with O'Keeffe during their first stay at Mabel Dodge Luhan's ranch. There Strand began painting the small fabric flowers used by local Native women in religious ceremonies. COURTESY OF YALE COLLECTION OF AMERICAN LITERATURE, BEINECKE RARE BOOK AND MANUSCRIPT LIBRARY, YALE UNIVERSITY.

O'Keeffe's flower paintings of the early 1930s clearly carried forward a sister arts tradition, a heady mix of feminism, same-sex eroticism, socialism, crafts, and artisanal rather than high-art practice. But an even more direct lesbian influence can be traced in a flower painting she made in 1929, the summer of her first long-term stay at Mabel Dodge Luhan's ranch, El Gallo. Dodge Luhan and O'Keeffe were briefly lovers; like Vita Sackville-West, they were part of a circle of sexual radicals who struggled hard against jealousy and possessiveness in the practice of their open marriages, which made room for both heterosexual and homosexual affairs. Stieglitz was reluctant to let O'Keeffe make this, her second visit to New Mexico, unchaperoned, but he agreed to let his wife go if she were accompanied by her close friend and the wife of his protégé, Paul Strand. Rebecca "Beck" Strand was also a painter, albeit a less celebrated one than O'Keeffe, and she too planned to make work in the idyllic setting of Taos. Mabel Dodge Luhan was fiercely jealous of the intimacy between O'Keeffe and Strand, and the pair had to move into their intended guest quarters, El Gallo's "Pink House," when Dodge Luhan was visiting back East (Figure C.9). Beck Strand's letters to her long-suffering husband in New York are frank and detailed about her obsession with Georgia, and they are suffused with erotic passion: "I shall remember that first night for a long time . . . the miracle continues . . . happy and naturally and will to the end."[43] And as she wrote later, "We also have in mind trying to find a little house somewhere near New York where we can retire to."[44] The couple annoyed the other guests by walking around

FIGURE C.10 Georgia O'Keeffe, *The White Calico Flower,* 1931. O'Keeffe initially scoffed at the cheap artificial flowers Strand chose to paint, but ultimately she also began to use them as subjects. OIL ON CANVAS, 30 X 36 INCHES (76.2 X 91.4 CM). WHITNEY MUSEUM OF AMERICAN ART, NEW YORK; PURCHASE 32.26. PHOTOGRAPH BY SHELDAN C. COLLINS. COPYRIGHT THE GEORGIA O'KEEFFE FOUNDATION / ARTISTS RIGHTS SOCIETY (ARS), NEW YORK.

naked, kissing and caressing in public. They took daily "magic baths," as they called them, in the Rancho de Taos hot springs, sunning themselves in the nude afterward. And when they were not playing, they painted. One day Strand found in a local market some small fabric flowers that the townswomen used as votive offerings at the feet of the *santos,* the half-indigenous, half-Catholic figures of the Virgin and the saints that Mabel Dodge Luhan had introduced as "primitive" inspiration to the New York art world. Strand was apologetic about her subject matter, writing to Paul Strand that she knew that "artificial flowers sound horrible to you," but she defended them by saying, "They are really quite beautiful. Pure clear white and a nice shape."[45] On seeing Strand's painting, O'Keeffe decided the flowers were worth painting after all, and as Benita Eisler notes: "Beck's calico flowers were appropriated by Georgia later that summer and mentioned in interviews thereafter as her own discovery."[46] The small scale of Strand's painting and its folk-art palette of purple, dark-blue, black, and white made it look like "nineteenth-century mourning pictures," a genre most often practiced by women and one of the signature styles practiced by Sarah Pierce's students at Litchfield

Female Academy. These formal elements link Strand's painting to women's, amateur, and decorative traditions.[47] Although O'Keeffe referred to "the ridiculous artificial flowers that the women have all over the place," Beck's subject matter got monumental treatment in O'Keeffe's 1931 *White Calico Flower* (Figure C.10).[48] O'Keeffe's large-scale, modernist treatment of the folkloric flower that Strand had treated in her more Arts and Crafts–influenced manner, then, emerged from a sister arts practice of decorative craftwork and also from a fecund period of lesbian passion. No wonder O'Keeffe's image looks so much like Mary Delany's *Magnolia Grandiflora* (see Plate 4).

FRIDA KAHLO

Frida Kahlo, like O'Keeffe and Sackville-West, was part of a wave of modernist sexual liberation that included relationships with other women. Her stormy marriages to Diego Rivera (they divorced once and remarried) were punctuated by affairs with both women and men, including the dancer Josephine Baker, the surrealist painter Jacqueline Lamba, and Georgia O'Keeffe.[49] In a 1949 interview, near the end of her short life, Kahlo said simply, "Homosexuality is very correct, very good."[50] Although jealousy on both sides often tore through her relationship with Rivera, he was not threatened by her relationships with women. As Olga Campos remarked: "He even bragged about Frida's homosexuality."[51]

Kahlo's use of botanical and especially floral imagery is more directly symbolic than that of O'Keeffe, whose pictures aspire toward abstraction. Kahlo, on the other hand, is participating in a surrealist tradition that uses allusion to create a more poetic, narrative quality in her paintings. Her still life *Magnolias* once again takes up the flower that was a subject for sister artists ranging from Mary Delany to Georgia O'Keeffe. Painted in 1944 after Lamba had returned to New York to divorce her husband André Breton, the image uses the surrealist technique of trompe-l'oeil to contemplate the relationship between Kahlo and Lamba. The overall ivory-toned coloration of the objects in the painting seems to show a bouquet of magnolias with stems. Kahlo associated Jacqueline Lamba with the flowers, as seen in a photograph from 1945 that emphasizes the exquisite beauty of both the woman and the blossom she holds. On closer examination of Kahlo's painting, however, we see that what appear to be stems are in fact images painted on the vase itself. Further, the flower in the center of the image is not a magnolia but rather a cactus flower rendered so as to almost disappear into the surrounding bunch of magnolias. Kahlo often used the cactus flower to represent herself. Here, we see the damaged stamen on the cactus, which perhaps is a representation of Kahlo's sadness about her damaged reproductive abilities. (In a tram accident the artist suffered as a young girl, a metal railing pierced through her spine and uterus, and she was never able to have children. The accident also left Kahlo with a lifelong limp and chronic pain.) Finally, on the far right of the image, we see a calla

lily (a flower important to both Delany and Dickinson) in profile, again painted so as to blend in with the magnolias. The calla was a flower often painted by Diego Rivera as an attribute of women's beauty—here it symbolizes his presence on the edge of the women's relationship, his "approval" part of its milieu.[52]

Kahlo's images most often reproduced in popular culture, of course, are more literal self-portraits. Here too we see a sister arts use of floral imagery. Viewers and scholars have often noted Kahlo's association of her own image with female figures from Mexican folk traditions, especially her adoption of the embroidered skirt, *huipil* blouse, and lace veil embroidered with flowers typical of the pre-Hispanic "matriarchal culture" of "the courageous and indomitable Tehuana woman."[53] Provocatively, Kahlo also sometimes depicted herself in relation to less venerated figures, such as La Malinche/Malintzin, known as the traitorous indigenous woman who translated for the conquistador Cortés and bore him a son, and La Llorona, the folkloric figure of a mother who murders her children when abandoned by her lover and roams the countryside weeping forever after.[54]

Perhaps just as subversive, however, is Kahlo's bold depiction of herself as among the holiest of female figures in Mexican Catholic religious traditions, the nun and la Virgen de Guadalupe. La Virgen is an indigenous version of the Virgin Mary who is said to have appeared in 1531 to a Mexican peasant, Juan Diego (Figure C.11). La Virgen is said to have told Juan Diego to gather flowers to demonstrate the veracity of her apparition to church authorities; on a nearby hillside, he found Castilian roses in full bloom, although they were not native to the Americas and it was mid-winter. La Virgen rearranged the roses on Juan Diego's cloak, and caused an image of herself to appear there. In *Self-Portrait Dedicated to Dr. Eloesser* (1940), for example, Kahlo adopts a famous genre from viceregal times, the *monja coronada* or crowned nun portrait (Figure C.12). In these paintings, the nun is "portrayed bedecked with flowers the day she takes the veil."[55] Kahlo's image shows her in a dull-brown habit like that of a Mexican nun, wearing a crown of thorns puncturing the skin of her neck, thus alluding to Christ's Passion as well as the artist's own psychic and physical suffering. In contrast to the painful asceticism of the lower half of the portrait, the figure wears a voluptuous headdress of flowers framed by a soft grey-pink sky. The tropical leaves in the background form a series of spiky points gesturing upward, both to the celestial destination of the nun and to the sensuality of the figure's thoughts, seemingly indicated by her luscious crown. Kahlo's depiction of a blowsy, open pink rose in the center of this arrangement makes use of both the association of the rose with la Virgen de Guadalupe and the sister arts tradition of the overripe open blossom turned to face the viewer as a symbol of women's genital sexuality.

Kahlo figures herself as la Virgen in another way in the lush floral *Self-Portrait "The Frame"* (1938) (see Plate 12). Here Kahlo adopts the framing device made popular in Mexican folklore for representations of la Virgen. Tradition has it that the picture

FIGURE C.11 (ABOVE) Icon from 1531 of Nuestra Señora de Guadalupe, la Virgen de Guadalupe, that hangs in the Basilica de Guadalupe in Mexico City. Mexican and Mexican American women artists have both adopted and revised this image of revered femininity. PHOTOGRAPH BY GUILLERMO BUELNA ARAUJO.

FIGURE C.12 (RIGHT) Félix Zarate, *Sor María Francisca de San Calletano,* 1840. Kahlo imitates this classic "crowned nun" portrait style in her *Self-Portrait Dedicated to Doctor Eloesser.* OIL ON CANVAS. COURTESY OF THE SAN ANTONIO MUSEUM OF ART. PURCHASED WITH FUNDS PROVIDED BY THE ROBERT J. KLEBERG AND HELEN C. KLEBERG FOUNDATION. PHOTOGRAPH BY PEGGY TENISON.

of la Virgen that hangs in the Basilica de Guadalupe in Mexico City is actually Juan Diego's cloak with the image of the saint as it appeared on the cloth that day in 1531. In this depiction, a pointed oval surrounds the central figure, creating a gothic arch shape over the virgin's head. Kahlo's self-portrait repeats this shape, and it also renders la Virgen's patterned, rose-colored gown as a background of red and pink daisies. (As "marguerites," daisies are also a well-known symbol of the Virgin Mary.) Marigolds crown the figure; in Mexico the flowers are associated with death, and in pre-Hispanic

... de la P.ª Madre Sor M.ª Fransisca de S.ª Callétano, en el siglo se llamó D.ª Fransisca Leal y Budric hija legítima de D.ª Lauréano Leal... ...agalena Budric nació el día 10 de 9bre de 1620. Fue d.ste tierra edad enclinada... el claustro. Fue coligala del Com.t de S.ª M. de Grasia... ...er y profesó de belo negro en el mismo combento el día 7 de Abril del año de 1640 de 20 años de Edad.

traditions they are often placed on graves to guide the beloved dead back to the world of the living bereaved.[56] In this way Kahlo brings together her typical themes of women's power and vulnerability, sex and death, and the mixed cultural and religious heritages of Mexico.

JUDY CHICAGO

Judy Chicago considers Georgia O'Keeffe to be one of only three great women artists in history—the others being Barbara Hepworth and, of course, Chicago herself. (In Chicago's famous installation, *The Dinner Party*, Frida Kahlo is accorded a named space on the tile floor but not a ceramic plate of her own.) Chicago has paid homage to O'Keeffe's imagery throughout her career, and she has also spoken of her own desire to transcend it (Figure C.13). Chicago's sense of her own movement both with and beyond the work of previous women artists (indeed, her own research for *The Dinner Party* was an important catalyst to feminist art history's recovery of the neglected and erased women's art of the past) is signified in the title *Through the Flower*, which she used not only for an iconic painting but also for her own first memoir, originally subtitled *My Struggle as a Woman Artist*. In the book, she writes of her development of the vulval images for which she became famous: "I used the flower as the symbol of femininity, as O'Keeffe had done. But in my images the petals of the flower are parting to reveal in inviting but undefined space, the space beyond the confines of our own femininity."[57]

For her iconic installation *The Dinner Party*, Chicago made ceramic plates and embroidered table runners each symbolizing "a goddess, historical figure, or important woman."[58] This roster, based on years of painstaking research in the years before sources for women's history were readily available, especially to those who were not professional scholars, was gathered initially by Chicago herself and ultimately by a team of collaborators headed by the art historian Diane Gelon. Recovering various traditional women's artistic practices such as china painting and embroidery, Chicago, who was influenced by and influenced the West Coast feminist milieu of the early 1970s, created this massive work with the help of an "affinity group" of volunteers.[59] She links this practice both to women's side-by-side work in traditional domestic spaces, convents, and literary salons and to the Renaissance practice of a master artist training apprentices by having them work on a large-scale piece that ultimately bears the master's name—a practice, Chicago is quick to point out, that no one seems to think is problematic when carried out by male artists. Like the Duchess of Portland's collaborators on the Portland Museum, members of the team that over the course of several years produced *The Dinner Party* were divided and often ambivalent about their experience working with, but ultimately also for, a charismatic woman leader in service of her vision. Absent the aristocratic privilege that shielded Margaret Bentinck from direct criticism, Chicago has published many rationales for her practice, which

FIGURE C.13 Judy Chicago, Georgia O'Keeffe place setting from *The Dinner Party*, 1974–79. Chicago counted O'Keeffe (along with herself) as one of history's great women artists. MIXED MEDIA. COPYRIGHT 2010 JUDY CHICAGO / ARTISTS RIGHTS SOCIETY (ARS), NEW YORK. PHOTOGRAPH COPYRIGHT DONALD WOODMAN.

FIGURE C.14 Judy Chicago, Emily Dickinson place setting from *The Dinner Party*. Chicago sees an active sexuality behind Dickinson's lacy Victorian reputation. MIXED MEDIA. COPYRIGHT 2010 JUDY CHICAGO / ARTISTS RIGHTS SOCIETY (ARS), NEW YORK. PHOTOGRAPH COPYRIGHT DONALD WOODMAN.

she continued in her subsequent large-scale multiyear works such as *The Birth Project* and *The Holocaust Project*.[60] Her self-education in women's history means that Chicago is probably the first artist discussed in this book who was in a position to consciously situate her work in relation to the sister arts tradition; she includes, for example, not only O'Keeffe but Emily Dickinson among the thirty-nine women seated at *The Dinner Party* table (Figure C.14). Indeed, Chicago's own work has probably done more than that of any artist to, in her own words, "break through all the categories between fine arts, decorative art, painting, sculpture, male skills, female skills, etc. & present a holistic vision which has substantial content." In these ways, then, *The Dinner Party* stands as a visible culmination of the sister arts tradition.

In spite of these views, Judy Chicago does not see her work as part of lesbian history.[61] While often overtly erotic (less so in *The Dinner Party* than in other works such as *Clitoral Secrets*, a series of small paintings on ivory from 1975), her work is also explicitly heterosexual. In *Clitoral Secrets*, for example, the open cunt forms in two of the paintings embrace or enfold very literal images of penises (Figure C.15). Chicago has said that she thinks lesbian sexuality "presents very rich potential for subject matter" but that she is not "the right one to do it."[62] Early lesbian viewers of *The Dinner Party*, however, experienced the vulval imagery of the work as erotic in a way that Chicago herself did not, while also noting the explicit omission of information about the sexuality of some lesbians who were included. Jan Adams, writing in the iconic lesbian-feminist publication *Lesbian Tide*, expressed her ambivalence this way:

> though the charge that lesbians are treated as tokens seems justified, I feel a lesbian
> sensibility in the imagery of the art . . . [and] as a lesbian, I feel conflicted about our presence
> in *The Dinner Party*. We are there, highlighted by Sappho's green and lavender floral plate and
> an exquisite lily motif portraying Natalie Barney . . . [but] Jane Harrison, the early 20th c
> English student of Greek mythology, and Jane Addams, pacifist recipient of the Nobel Peace
> Prize [are not identified as lesbians].[63]

In Chicago's work, the sister arts tradition of identifying the vulva with women's erotic looking at one another becomes visible from the point of view of lesbian viewers themselves. For the artist, influenced by second-wave feminist critiques of women's sexual objectification, the vulva is a powerful symbol not primarily of the erotic but of women's creativity, power, history, and connection to birth and death, as indicated in the title of a work like *The Cunt as Temple, Tomb, Cave or Flower* (1974).

The Dinner Party was also criticized for its treatment of women of color. Like the work of many white feminists from the early 1970s, *The Dinner Party* refers only to a few iconic and oft-cited nonwhite women (see Plate 13). Chicago defends her choices by saying, "I was dealing with the history of Western civilization, which was (and still is in many cases) sexist, racist, and homophobic." Of course, *The Dinner Party* is specifically

FIGURE C.15 Judy Chicago, *Clitoral Secrets*, 1971. Though her work is often frankly erotic, Chicago considers herself "not the right one" to represent lesbian sexuality. GOUACHE ON IVORY IN EMBROIDERED POUCH, 12 X 18 X 12 INCHES. COLLECTION OF ZORA AND ED PINNEY. PHOTOGRAPH FROM THROUGH THE FLOWER ARCHIVES. COPYRIGHT 2010 JUDY CHICAGO / ARTISTS RIGHTS SOCIETY (ARS), NEW YORK.

intended to refute such a history, at least where sexism is concerned; perhaps in recognition of this contradiction, later in the same essay the artist cites "the intellectual limits of the period and the available scholarship" as constraints on her representation of women of color. Chicago personalizes what could be read as important critiques with the potential to move feminist art forward by sighing, "It seemed that no matter what I did, somebody got upset."[64]

ALMA LOPEZ

When Latina artists of Judy Chicago's generation began amassing images of female power and sexuality in Latin American art history, the iconic figure was not Georgia O'Keeffe but Frida Kahlo. Chicana artists in particular have been inspired by Kahlo's use of the image of mestiza femininity that is, according to Luz Calvo, "omnipresent in Chicano/a visual space" in the Southwest, that of la Virgen de Guadalupe.[65] Whereas la Virgen has been seen as iconic, religious, and nationalist, the pious counterpart to negative female images such as la Malinche or la Llorona, Chicana feminists have

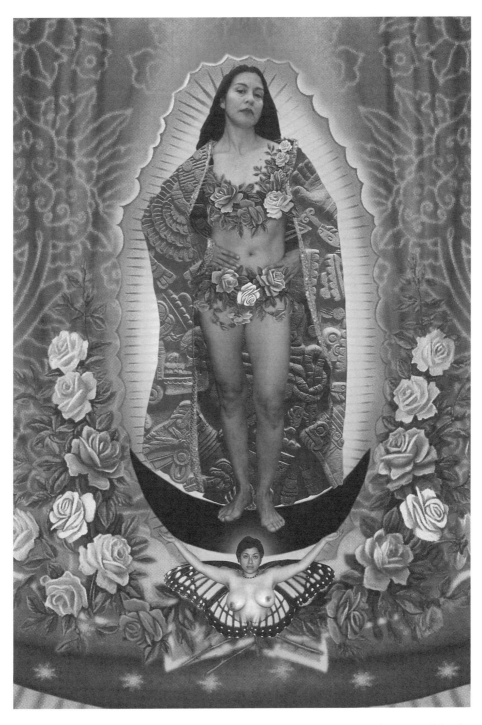

FIGURE C.16 Alma Lopez, *Our Lady*. Lopez's image sparked immediate controversy when it was exhibited in 2004 for its lesbian version of La Virgen de Guadalupe. DIGITAL PRINT BY ALMA LOPEZ COPYRIGHT 1999. SPECIAL THANKS TO RAQUEL SALINAS AND RAQUEL GUTIÉRREZ.

seen la Virgen differently.[66] Alma Lopez's digital print *Our Lady* (1999) (Figure C.16) attracted outrage when it was exhibited at the Museum of International Folk Art in Santa Fe in 2001. Lopez's image of la Virgen as an exuberantly sexual Chicana lesbian wearing a bikini made of roses was in the first place an allusion to Yolanda Lopez's widely reproduced *Portrait of the Artist as the Virgin of Guadalupe* (1978), an iconic image of the Chicano movement. Exhibited as part of the important traveling exhibition *Chicano Art: Resistance and Affirmation* that toured the Southwest in 1990, Yolanda Lopez's image was also considered sacrilegious by some. Its image of a laughing Chicana bursting out of the traditional frame that surrounds la Virgen summarized for many the position of Chicana feminism, in dialogue with the canons of Mexican-American culture but critical of its masculinism and limited roles for women. The controversy that surrounds Alma Lopez's *Our Lady*, as well as its importance to Chicana feminism and *jotería* (or what Cherríe Moraga calls "queer *Atzlán*"), have been well documented by Luz Calvo and others. I would argue, however, that the treatment of floral imagery in *Our Lady* offers another layer of sexual meaning to the image that connects it to the sister arts tradition by way of its allusion to Frida Kahlo's use of flowers.

The model for Alma Lopez's Virgen is the Latina performance artist Raquel Salinas. She wears a bikini made of roses, the flower that la Virgen made appear to Juan Diego as proof of her authenticity. The figure's head, rather than dropping forward as does the traditional Virgen's, tilts up and back defiantly. A bare-breasted angel, portrayed by the activist Raquel Gutiérrez, holds her aloft. The round shape of Gutiérrez's breasts is repeated in the luscious open roses that surround the bottom half of the iconic oval frame. As in Kahlo's and Yolanda Lopez's images, the oval shape around the figure is one of the major ways in which it alludes to the canonical image of la Virgen. Provocatively, Alma Lopez has also placed a fully open rose blossom directly on top of the bikini-clad Salinas's vulva, and another on her left breast. The use of roses in *Our Lady* connects the image not only to canonical versions of la Virgen but also to the sister arts tradition through which its depiction of lesbian sexuality can be read.

TEE CORINNE

The writer and visual artist Tee Corinne came out of the same West Coast feminist ferment that nurtured Chicago in the 1970s. In 1980, Corinne's explicitly sexual images were included in The Great American Lesbian Art Show at the Women's Building in Los Angeles, for which Chicago had served as one of the founding organizers. Although Corinne, like Chicago, was very ambitious, asserting "I want a show at MOMA before I die," her immersion in the sex radical and women's land cultures of San Francisco in the 1980s, as well as her involvement with lesbian and feminist small-press publishing, led her to create alternative venues for her increasingly challenging lesbian erotic imagery.[67] The Linnaean titles of Corinne's two memoirs, *The Sex Lives of Daffodils* and *Wild Lesbian*

FIGURE C.17. Tee Corinne, from *The Cunt Coloring Book,* 1975. Like Delany's eighteenth-century botanical illustrations, Corinne's cunt drawings, inspired by the women's health movement, served both artistic and scientific purposes. COURTESY OF THE UNIVERSITY OF OREGON LIBRARIES.

Roses, suggest the crossover of her botanical and landscape interests from her art to her writing. Corinne is best known for the exquisite line drawings of *The Cunt Coloring Book,* first published as a contribution to the women's health movement in 1975 and the only one of Corinne's works still in print, and for the 1985 series *Yantras of Womanlove.* The drawings in the *Coloring Book* manage to be both anatomically correct and to look like botanical drawings of flowers (Figure C.17). Corinne wrote about using "flowers as symbols of women's genitals, hoping for all the things one does hope for with

FIGURE C.18 Tee Corinne, *Isis in the Sand*, from *Yantras of Womanlove*, 1985. Corinne makes explicit the long-standing sister arts connection between landscape and lesbian sexuality. COURTESY OF THE UNIVERSITY OF OREGON LIBRARIES.

symbolism: that the image will be understood to have ramifications beyond the specifics actually portrayed."[68] Corinne created a series entitled "Women Eating Flowers" that included an image of "hands making the lesbian (cunt) symbol around a grouping of sea snails."[69] Corinne was to push this both/and quality further in the *Yantras*, where she

collaged explicit erotic photographs into landscape forms (Figure C.18). This format made the Corinne's imagery more palatable outside the women's bookstore and music festival circuits where she had been selling notecards and calendars, and it resulted in her first published book of photographs.

Corinne's late work includes a series of landscape photographs of women's land that documents the architectural innovation that sustained communities even as inhabitants came and went. As she writes: "I realized how many women travel through our community, become part of it for a while, then move on. But the structures stay, they change, grow, get repaired. They are the touchstones, the building blocks of a common language, repositories of our group memory." Corinne describes her favorite image from this series, a photograph of storage cans behind a small cabin, which she calls

> substitutes for large closets, the place where she stores off-season clothing, bulk grains and household linens. To me these cans typify the resourcefulness and creative problem solving which exemplifies the best of our community endeavors.[70]

Like Mary Delany's grotto, the storage cans are a sister arts reimagining of conventional spaces that have practical, affectional, and erotic uses and effects. Like Chicago, Corinne set herself the task of reconstructing a hidden or destroyed history in order to place her images in a context or tradition.[71] As an activist in the back-to-the-land movement of the 1970s, Corinne helped create an iconography of lesbians in rural environments, which in the sister arts context can be understood as twentieth-century feminist versions of Llangollen Cottage or A la Ronde. At the same time, Corinne's fine-art training, which includes a master of fine arts degree from the Pratt Institute, sent her to erotic images in the work of canonical old masters as she developed a visual iconography of lesbian sexual imagery.[72] She learned from men's erotic images of women, from her own persistent desires, and from working in communities of women how to create a lesbian way of seeing, insisting that "erotica is a genre" like any other whose conventions must be learned to be transcended.[73] "The lack of a publicly accessible history is a devastating form of oppression," she wrote in an important essay entitled "Lesbian Photography on the U.S. West Coast: 1972–1997." She goes onto note that

> lesbians face it constantly. The impact of this on art is that lines of development are obscured, broken, sometimes destroyed beyond reconstruction . . . The vast majority of our imagery is hidden in private scrapbooks or published in small circulation magazines and newspapers . . . The most famous of contemporary lesbian photographers are still totally closeted.[74]

Corinne's work in all media—as a writer, photographer, printmaker, painter, sex education worker, rural activist, scholar, and critic—was dedicated to unearthing and re-creating that history.

ALICE WALKER

Second-wave feminism, through means as diverse as the women's land movement, the promotion of goddess spirituality, and eco-feminism and the revaluing of women's work, inaugurated a recovery of gardens as a sister art. Central to this feminist understanding is Alice Walker's essay "In Search of Our Mothers' Gardens" (1974). In this piece, Walker syncretizes the Afrocentrism of the Black Arts movement with the analogous impulse emerging in cultural feminism. Though the essay does not explicitly address black women's sexuality, it has a "lesbian continuum" understanding of the relationships between historical and contemporary African-American women that forecasts Walker's more explicitly lesbian texts, such as the iconic 1982 novel *The Color Purple*.[75] "In Search of Our Mothers' Gardens" identifies what some might see as the yardwork of a working-class African-American woman in the middle of the twentieth century "so hindered and intruded upon in so many ways," with a tradition of African-American women's art going back to Phillis Wheatley.[76] Another important goal of this essay, though, is simply to document the artistic practice of the writer's mother:

> My mother adorned with flowers whatever shabby house we were forced to live in. And not just your typical straggly country stand of zinnias, either. She planted ambitious gardens— and still does—with over fifty different varieties of plants that bloom profusely from early March until late November. Before she left home for the fields, she watered her flowers, chopped up the grass, and laid out new beds. When she returned from the fields she might divide clumps of bulbs, dig a cold pit, uproot and replant roses, or prune branches from her taller bushes or trees—until night came and it was too dark to see.
>
> Whatever she planted grew as if by magic, and her fame as a grower of flowers spread over three counties. Because of her creativity with her flowers, even my memories of poverty are seen through a screen of blooms—sunflowers, petunias, roses, dahlias, forsythia, spirea, delphiniums, verbena . . . and on and on.
>
> And I remember people coming to my mother's yard to be given cuttings from her flowers; I hear again the praise showered on her because whatever rocky soil she landed on she turned into a garden. A garden so brilliant with colors, so original in its design, so magnificent with life and creativity, that to this day people drive by our house in Georgia—perfect strangers and imperfect strangers—and ask to stand or walk among my mother's art.[77]

In a variation on the lesbian georgic mode discussed in chapter 4, beauty is here seen as a form of utility—useful, even necessary, for survival in a racist culture.

A key insight of Walker's essay is the realization that women's domestic chores are not just labor but also art. Once again, the sister arts tradition is hiding in plain sight.

KARA WALKER

For Alice Walker, then, women's domestic art and craft forms have a positive valence. Kara Walker, a contemporary artist who creates disturbing images of sexual and racial taboos, looks explicitly back to the eighteenth-century sister arts technique of the silhouette (Figure C.19)—a medium in which Mary Delany famously worked (Figure C.20)—as an eerily appropriate methodology for excavating horrifying relations of power between white and black women (and men). Walker cites the apparent simplicity and innocence of this medium as a source of power. This form, she says, "spoke to me in

FIGURE C.19 (TOP) Kara Walker, detail from *The Means to an End,* 1996. Walker is drawn to eighteenth-century silhouettes (one of Mary Delany's media) for her brilliant satirical images. COURTESY OF SIKKEMA JENKINS AND COMPANY.

FIGURE C.20 (BOTTOM) Mary Delany, cut-paper silhouette, ca. 1750. The image shows a domestic scene at Longleat House, the home of Lady Weymouth, where Delany often visited. The Longleat gardens were improved by Capability Brown during this period, when new wealth generated by the slave trade poured into England.
REPRODUCED BY PERMISSION OF THE MARQUESS OF BATH, LONGLEAT HOUSE, WARMINSTER, WILTSHIRE, GREAT BRITAIN.

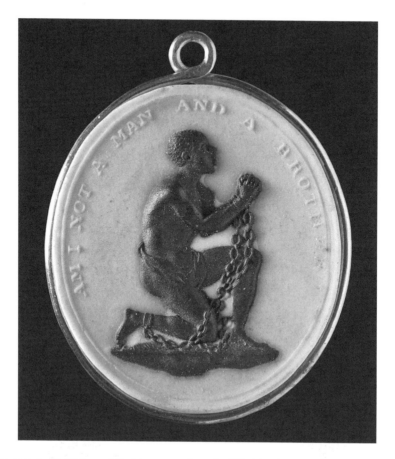

FIGURE C.21 Josiah Wedgwood, *"Am I Not a Man and a Brother?"* black basalt ware, c. 1787. Kara Walker alludes to this iconic abolitionist image by Wedgwood, a member of Anna Seward's circle, in *The Means to an End.* COPYRIGHT TRUSTEES OF THE BRITISH MUSEUM.

the same way that minstrel show does" because "it's white middle-class people rendering themselves black, making themselves somewhat invisible." Kara Walker says that like the black woman's body during slavery, the silhouette itself is "a blank space that you project your desires into . . . It's just a hole in a piece of paper, and it's the inside of that hole."[78]

Walker's familiarity with eighteenth-century aesthetics is further visible in *The Means to an End: A Shadow Drama in Five Acts* (1995) (see Figure C. 19). Here, she presents an image that signifies on Josiah Wedgwood's famous abolitionist medal of c. 1787, *Am I Not a Man and a Brother?* (Figure C.21).[79] This image has a troubled history in the sister arts tradition. In 1788, Wedgwood wrote to Anna Seward requesting that she write a poem to be used in the abolitionist cause, but Seward refused to do so. She rationalized her decision by saying that Wedgwood's letter had nevertheless had good effects: while she had until then believed that slavery was economically necessary, not unduly cruel, and justified by the need of "Negroes" for a strong governing hand, her friend's arguments had convinced

her of the necessity of abolition. Nonetheless, she demurs, her friend Thomas Day's "beautiful and sublime Poem, the dying Negro," failed to receive the praise it deserved. Seward, her eye not on human suffering but on her own poetic reputation, declines to take a similar chance.[80] Such is the imbrication of the sister arts with histories of race and slavery, one of the many powerful legacies revealed by Walker's work.

MICKALENE THOMAS

Rather than turning to predominantly Anglo-American genres such as silhouette for taking on the past, the New York artist Mickalene Thomas turns to African-American women's textile arts for her imagery in many of her bold acrylic paintings. In *La leçon d'amour* (2008), for example, a glamorous woman holds her lover on her lap, her right hand moving up her high-heeled leg underneath her skirt (see Plate 14). The women are surrounded by an array of patterned fabrics and household items—florals and animal prints—that seem to comprise pieces like those used in quiltmaking. An explicitly lesbian image, the painting is reminiscent in both subject matter and design of Faith Ringgold's *Marlon Riggs: Tongues Untied, a Painted Story Quilt* (1994). Here, the central image of the dying Riggs (with his lover Jack Vincent represented by a white bird on his shoulder) is framed by rectangular piecing of various sizes, much like the forms scattered behind the figures in Thomas's painting. Ringgold, however, uses more obviously floral imagery; she draws on this traditional quilt motif as another way to signify Riggs's homosexuality by surrounding him with images of a beautiful, verdant femininity. The many small, round blossom shapes that ring the quilt recall one of the earliest attributed works of African-American textile art, Harriet Powers's *Bible Quilt* (1898), in which flowerlike starburst images ring animals and human figures, giving them a vitality and even a sense of exploding feminine sexuality. Both Thomas and Ringgold are engaged in the project of bringing African-American queer lives into view in their work. Ringgold, who is associated with the civil rights and feminist movements of the 1960s and after, adopts a more serious and political tone in her work by picturing important leaders such as Audre Lorde, Harriet Tubman, James Baldwin, and Riggs's own grandmother. Thomas takes a more playful approach by using glamorous images and high-gloss paint to convey a view of African-American lesbian life that is sexy and fun rather than victimized and political. Yet through their use of botanical and fabric allusions and materials, both of these works engage a sister arts tradition in which queer sexuality has been visible all along.

ALLYSON MITCHELL

The mixed-media, cross-genre, landscape-reshaping aspect of the sister arts tradition has a well-informed exponent in the Toronto artist Allyson Mitchell. Mitchell works

in a variety of contemporary sister arts genres, updating garden design as installation in the mode of neocraft maximalism. She has been called "one of a small group of contemporary artists using craft as a largely unregulated site of protest."[81] Much like Mary Delany and the Duchess of Portland, Mitchell is, according to Ann Cvetkovich who has written extensively on her work, "committed to craft as both art and everyday activity."[82] Like Corinne, she works with the rural (as well as the urban) in a playful style that depends on the often ironic, always affectionate juxtapositon of kitsch, craft, and natural beauty. The author of "The Deep Lez Manifesto" and a professor of women's studies at York University, Mitchell is intentional and explicit about creating a historical context for her work that includes lesbian feminism, and she describes her artistic practice as "cafeteria-style mixings of craft, context, food, direct action, and human connections" that "maintain radical dyke politics and resistant strategies."[83] She is the curator of a recent exhibition of Judy Chicago's needlework entitled "When Women Rule the World: Judy Chicago in Thread." The exhibition includes works from the range of Chicago's career, including early "central core" imagery from the *Dinner Party* period. In a short film entitled *Dyke Pussy*, commissioned for Toronto Pride 2008, Mitchell playfully alludes to this tradition (Figure C.22). To a driving soundtrack of house music, the film opens with the image of a tiny ceramic kitten placed on a toy

FIGURE C.22 Allyson Mitchell, still from the short film *Dyke Pussy,* 2008. In motion, these sculptures turn into a whirling yantra reminiscent of Tee Corinne's work. COURTESY OF ALLYSON MITCHELL.

velvet footstool, which in its own right is whirling around on an audio turntable. As the music speeds up, so does the speed of the turntable. The words "Dyke," "Pussy," "2 gether," and "4 ever" flash on the screen. The whirling kitten is replaced by an image with a similar form, that of a sugar cookie with candy-pink icing. Next we see two kittens face-to-face as if kissing. As the turning image speeds up, the kittens meld into a whirling yantra. Witty, affectionate, and historically savvy, *Dyke Pussy* is a twenty-first-century take on the floral imagery we first saw in Mary Delany's botanical illustrations as well as in works by Kahlo, O'Keeffe, Chicago, and Corinne.

Mitchell has also created a significant body of sculptural work that engages issues of rurality, wilderness, and lesbian sexuality. Her series *Ladies Sasquatch*, which the artist has been making since 2005, consists of female sasquatch figures on a heroic scale installed in a wilderness landscape feminized and domesticated through materials: the figures are rendered in fun fur, and the hills, rocks, and trees around which they ramble are created from "found fabrics, needlepoint, rug hookings and carpet samples, to make rocks and hills and logs"[84] (see Plate 15). Invoking the historical complexities of landscape politics in Canada, Mitchell acknowledges the provenance of this imagery in "Aboriginal tales about the Sasquatch, 'Wild Man of the Forest' or Big Foot (as he is referred to in the US)," which "have been appropriated by the white Canadian mainstream—arguably an expression of the racist fears around the "otherness" of native culture—and by default—nature in general."[85] The setting alludes both to a canonically pastoral "wild forest glen" and to "the bush," that definitively Canadian location "outside what is formally understood as the city-state."[86] (Mitchell's work also potentially puns on "the bush" as an affectionate term for women's pubic hair.) As Cvetkovich describes the work, Mitchell merges "Canadian wildlife myth with the tradition of feminist counterheroines" by taking "the stuffed animal of both natural history diorama and childhood toys" to a colossal scale.[87] Averaging more than nine feet tall, the sculptures are fur covered and feminine, with prominent vulvas and pubic hair, breasts and nipples, and underarm hair. "Lady Sasquatch is your dream girl," reads the artist's statement for a 2005 exhibition, "only bigger and hairier, and she may just eat you if you don't watch out."[88] In a 2009 lecture, Mitchell said that she wants to engage viewers' potential discomfort with women's hairiness in these images of wild but somehow approachable female sexuality.[89] The contrast in tone between the fun-fur fabric and long eyelashes of the figures and their often menacing poses and great size, makes them both alluring and repulsive, depending on the viewer's relationship to female sexuality. For the figure entitled "Oxana," Mitchell draws attention to the figure's buttocks and vulva (Cvetkovich calls the butt "especially important" in this work) by creating a highly colored collage of fur reminiscent of a mandrill's hind end.[90] "You want nature?" the artist says, "I'll give you nature!"[91] One visual model that Mitchell drew upon for creating Oxana's butt are the flower paintings of Georgia O'Keeffe (see Plate 16). Mitchell alludes to O'Keeffe again in a mirrored red and pink rose in the hooked rug

FIGURE C.23 Allyson Mitchell, *Ladies Sasquatch,* 2009. This still of a foot at the base of the figure "Oxana" shows carpet remnants, rug hooking, fringe, and needlework. COURTESY OF ALLYSON MITCHELL.

covering the base of the sculpture, just below the vulva (Figure C.23). Mitchell says she is interested not only in how the figure's haunches and vulva can be read as a flower but also as anatomical parts—a key convention in the sister arts tradition.[92]

Importantly, Mitchell's figures are not exhibited alone but rather are installed in relation to one another "in a gathering, as though they've come together in some sort of clutch, or meeting, or who knows, maybe even a sacrifice."[93] In intentional contrast to the canonical Sasquatch myth, in which the creature is always pictured as male and alone, this is a community of powerful female figures gathering for their own mysterious purposes. The female bodies created here are specifically queer or lesbian bodies. For example, "Maxie" is "an homage" to Mitchell's friend, the fat activist Max Airborne. The large back, small buttocks, and short legs are meant to evoke a specific, recognizable type of woman's body often seen among lesbians, which Mitchell calls "the refrigerator back." In her evocation of female bodies rarely seen in canonical art history, Mitchell marries the myth of sasquatch wildness to "the mythology of lesbian culture . . . something like the Michigan Womyn's Music Festival, five thousand lesbians running around naked in the woods and all of the mythology surrounding that kind of a space."[94] Cvetkovich notices in the work "a queer erotics . . . one that lends itself to new worlds that enable different kinds of feelings."[95] In referring explicitly to both previous practitioners in the sister arts tradition and contemporary queer and lesbian communities, Mitchell creates in *Ladies Sasquatch* "a lesbian feminist storybook garden."[96]

FIGURE C.24 Allyson Mitchell, still from the short film *Unca Trans,* 2007. The transgender possibilities of the sister arts landscape tradition. COURTESY OF ALLYSON MITCHELL.

Mitchell addresses the political valence of queer, transgender, and lesbian politics in relation to Native rights and the environmental movement even more explicitly in a short film from 2007, *Unca Trans.* In the four-and-a-half minute film, we watch a bearded cloth puppet sitting on a log of split wood, telling us the story of the trans, environmental, and Native land claims activism in which zhe participated (Figure C.24).[97] (The conceit is that this is found footage from a 2045 documentary, discovered in the Canadian National Archives in 2077.) The most visible movement in the film is provided by the landscape. Using stop-motion photography, Mitchell and her collaborator Christina Zeidler create a continuous pattern of cloud shadows passing rapidly across the pasture and grass stems waving in a triple-time breeze behind the figure of Unca Trans. Dotted with round hay bales and striped with a barbed-wire fence and lines of trees, the setting of gently rolling hills is idyllic but worked—agrarian life in a georgic mode. The pastoral effect of the film's setting is enhanced by the background soundtrack of birdsong, which like the position of the puppet does not change throughout the film. Amid this tension between stillness and movement, Unca Trans narrates how, after leaving the family farm to discover a trans community in "the big smoke" of Toronto and apprenticing as an activist in the native land claims movement, he returned to rural Ontario to "teach my town how to organize." The film "documents" the events leading up to "the great standoff of 2015" in which a utopian coming together of antiracism, environmentalism, organic food politics, and trans, queer, and lesbian advocacy create

"big-time social change." Gender reassignment surgery is recognized as "a universal health care right," all Native land claims are settled, industrial polluters are shut down, and the rural community welcomes the prodigal transman home. Mitchell has expressed herself as dissatisfied with a conception of queer communities and politics limited to urban settings, and this film intervenes in that assumption.[98] She is also committed to moving "radical lesbianism and identification with (or allegiance to) trans communities out of the realm of *either/or* and into the space of *both/and*."[99] In the film, movement— social, political, sexual—is indicated as a natural part of the rural landscape through the racing cloud shadows and waving grass, but the figure of Unca Trans remains seated throughout the film in what zhe calls "my special spot," emphasizing rootedness and belonging; a storybook garden indeed.

THE LANDSCAPE ACCORDING TO THE SISTER ARTS

The sister arts persist. They persist as a lesbian practice of decorative, erotic appropriations of landscape and botanical imagery in craft genres that are circulated in women-dominated spaces outside the canons of literature and art history. This practice persists as a problem by carrying forward histories of violence, colonialism, genocide, and racism in their innocent-looking pastoral and georgic conventions. But it also persists as a solution by allowing writers and artists to rediscover, time after time, the erotic power of the lesbian landscape. Sometimes sister arts work is hiding in plain sight, as in Georgia O'Keeffe's unavoidable flower paintings or Emily Dickinson's gardener's ethos; sometimes we have to dig for it, as in Sarah Pierce's connections to Delany via Anna Seward; and sometimes it has disappeared forever, like Mary Delany's Delville and the Duchess of Portland's Museum, to be re-created only in the lesbian imagination. In an essay written toward the end of her life, Tee Corinne referred to lesbian aesthetics as a "broken tradition."[100] This book joins Corinne and the other artists discussed herein in the craft work of limning that tradition: gluing the shells together, japanning the surfaces to make the flowers pop, and excavating the underground spaces in which to enjoy the erotic landscape. As both reverent observers and powerful makers, sister artists continue the dream of remaking the world in the image of our desire. ❀

Acknowledgments

AN ARCHIVAL PROJECT such as this one is dependent, more than most, on the kindness of both friends and strangers. Thanks, then, to the staff at the Harry Ransom Humanities Research Center at the University of Texas at Austin; the Beinicke Library, the Lewis Walpole Library, and the Yale Center for British Art at Yale University; the Litchfield Historical Society, Connecticut; the William Andrews Clark Memorial Library, University of California, Los Angeles; the British Library; Sir John Soane's Museum, London; the Lichfield Botanical Society, Staffordshire; the William Salt Library and Staffordshire Record Office; the Samuel Johnson Birthplace Museum; the John Rylands University Library at the University of Manchester; the University of Nottingham Manuscripts and Special Collections Library; the Harley Gallery, Welbeck; the University of Birmingham Special Collections Library; the National Gallery of Ireland; the National Botanic Gardens of Ireland; Trinity College Library, Dublin; and the Newport Reference Library, Wales.

Grants and fellowships from the following institutions supported this work over several years, and I gratefully acknowledge them: the University of Texas Department of English, especially chair Elizabeth Cullingford and research and travel grant chair Sara Kimball; the University of Texas Faculty Research Award Program; the Paula Backscheider Archival Travel Fellowship of the American Society for Eighteenth-Century Studies; and the Lewis Walpole Library Fellowship, Yale University.

Illustration costs were supported by the University Co-operative Society Subvention Grant and the Department of English Research Funds Committee at the University of Texas. Special thanks to Elizabeth Cullingford for her remarkable support, especially in the home stretch.

I have benefited greatly over the years from the skills, patience, and humor of superb graduate research and editorial assistants, and I thank them warmly: George Boulukos, Ashley Shannon, Aména Moinfar, Layne Craig, Laura Smith, and Molly O'Hagan Hardy. Thanks to my dissertation writers' group in 2007–8 for reading the first draft of chapter 2, and to my graduate class in spring 2008, Transatlantic Feminisms in the Age of Revolutions, for similar attention to chapter 3.

My appreciation goes to my treasured friend Georgina Carson and her family, who honored me with the "Princess Motoika Fellowship" at their spectacular cottage on Georgian Bay in fall 2007.

I am fortunate to work in a collaborative community of scholars, artists, and activists whose members contributed directly and indirectly to this work. For helping me refill the well, I thank the women of The Austin Project, especially producer Omi Osun Jones and anchor artist Sharon Bridgforth. For first telling me that I had a book and for tireless draft reading and discussing, I thank the brilliant Joanna Brooks. For unstinting emotional and intellectual support on this project and others, I thank the stellar Ann Cvetkovich. For her patience, love, and listening throughout this process and always, I thank Ixchel Rosal: Ixchel is my rock. For a lifetime of friendship and for warm hospitality on New York research trips, I thank the sterling Paisley Currah. Jill Dolan and Stacy Wolf were among the first to hear early versions of this work, and their interest has been sustaining throughout. I thank my funny, smart, and affectionate children, Max and Milo Darlington, for their excellent company at the beginning and the end of a writing day.

Finally and most centrally, I thank my beloved, brilliant, and beautiful Madge Darlington, who came up with creative budgets for my research trips as well as provided child care for the occasional hour, the frequent day, the last-minute summer of 2006, the crucial Thanksgiving weekend of 2007, the single-handed move-in of 2008, the final Mother's Day Weekend push of 2010, and so much more. For pushing me to dream big, for modeling the life of the artist in community, and for telling me again and again "it's a barn-burner, baby," I will be forever grateful. I dedicate this book, with all my love, to Madge. ❀

Notes

PREFACE

1. Delany, "Letter to Anne Granville," March 11, 1732, Delany Letters.

2. Online Etymological Dictionary, http://www.etymonline.com (site accessed March 17, 2009).

3. I owe a debt to numerous excellent studies of gossip, especially in its feminist and queer instantiations. See Sedgwick, "Introduction: Axiomatic" in *Epistemology of the Closet,* 23; Abelove, *Deep Gossip*; Spacks, *Gossip*; Goodman and Ben-Ze'ev, eds., *Good Gossip*; Parsons, *Reading Gossip in Early Eighteenth-Century England*; Vermeule, "Gossip and Literary Narrative"; and Bennett, "Word of Mouth."

I am also informed here by the recent "turn to the archive" in queer studies, including Cvetkovich, *An Archive of Feelings*; Taylor, *The Archive and the Repertoire*; Halberstam, *In a Queer Time and Place*; Cohen, "Velvet Is Very Important"; Tinsley, "Black Atlantic, Queer Atlantic"; Retzloff, "From Storage Box to Computer Screen"; Morris, "Archival Queer"; and Juhasz, "Video Remains."

INTRODUCTION

1. Darwin, *The Botanic Garden,* part II, canto II, line 155 (note).

2. Ibid., part I, canto III, line 319.

3. "The Loves of the Plants" was conceived by Darwin as the second part of a two-part project. In 1791 he completed this project when he published a volume called *The Botanic Garden* that included "The Loves of the Plants" and another long didactic poem in heroic couplets entitled "The Economy of Vegetation."

4. Darwin, *The Botanic Garden,* Part II, Interlude I; Interlude III.

5. Ibid., canto IV, note to line 303.

6. Ibid., canto I, line 9–10.

7. Ibid., Preface; canto IV, note to line 303; canto I, line 172; canto IV, note to line 285.

8. I am of course alluding to Smith-Rosenberg's famous essay "The Female World of Love and Ritual," later included in *Disorderly Conduct*.

9. Of course many individual lesbian artists have insisted fiercely on their right to masculinist and elite high-art traditions. In describing her own interest in formal verse such as the sonnet, Marilyn Hacker speaks of the importance of not ceding high culture's claims to masculine exclusivity but of insisting on knowing its own miscegenated origins, the importance of "taking the power of definition out of the hands of the canon-makers and saying, 'this

belongs to us too; we had as much to do with creating this as anyone else, and it's equally appropriate for our own expression, our experience, and our relationship with the language'" (Finch, "Marilyn Hacker," 24.) Similarly, women have been defined out of the sister arts and friendship philosophical traditions, as discussed below, but those definitions have never stopped women from participating in, challenging, and shaping those traditions even if this aspect goes unrecognized by scholars.

10. Sedgwick's famous distinction between paranoid and reparative readings is described in her essay "Paranoid Reading and Reparative Reading, or, You're So Paranoid You Probably Think This Essay Is About You" (chapter 4 of *Touching Feeling*).

11. Others have of course put the words "lesbian" and "genre" together, but previous usages mean either contemporary "genre fiction" such as detective stories and romances (Bona, "Gay and Lesbian Writing in Post-World War II America," 234), genres of women's music since the 1970s (Morris "Stories Coming Out," 220–40), or poetic genres used by poets on the island of Lesbos in Greek antiquity (Wilson, *Sappho's Sweetbitter Songs*, 23). Similarly, "landscape arts" has been used specifically to describe garden and park design. Rarely have visual genres and virtually never literary ones been included in the category "landscape arts." With both terms, then, I aim for a more inclusive and heterogenous account of the relationship between women's artistic and erotic practices on the one hand and the shaping and representation of landscape on the other. See Finch, "Marilyn Hacker," 3.

12. Sharon Harris calls it "lesbian in spirit," and notes that it is "one of the earliest recorded utopian visions in American literature" (*American Women Writers to 1800*, 157).

13. Jellicoe et al., *The Oxford Companion to Gardens*, 165.

14. Addison, *Selections from Addison's Papers Contributed to the Spectator*, no. 477 (September 6, 1712).

15. Ibid., no. 414 (June 25, 1712).

16. Pope, "Essay on Criticism," 48.

17. Walpole, *On Modern Gardening*, 51.

18. Repton, *Fragments on the Theory and Practice of Landscape Gardening*, 191, 192.

19. For an account of a virtual 3-D re-creation of Delville, see Moore, "Virtual Delville as Archival Research."

20. Leonardo, *On Painting*, 22.

21. As Alexandra Wettlaufer notes, "Behind the rhetoric of the *paragone* almost always lurks a struggle for status, prestige, and domination" ("Composing Romantic Identity," 45).

22. Quoted in Hunt, *The Genius of the Place*, 11.

23. Constable, ed., *Letters of Anna Seward Written between the Years 1784 and 1807*, 172.

24. See Mitchell, *Iconology*; Hurley and Greenspan, eds., *So Rich a Tapestry*; Wendorf, ed., *Articulate Images*; and Heffernan, *Museum of Words*. Casid's important study, *Sowing Empire*, is discussed in more detail in chapter 4.

25. Mitchell, *Iconology*, 3.

26. Mitchell, "Going Too Far with the Sister Arts," 5.

27. Mitchell, *Iconology*, 130.

28. See Moore, *Dangerous Intimacies*, especially the introduction and chapter 3, for a fuller account of the relations between lesbian sexuality and imperialism, nationalism, and professionalization in the period.

29. Martinez, "Women Poets and the Sister Arts in Nineteenth-Century England," 626.

30. To take just one example, Mary Delany wrote the following to her sister in 1743–44: "As to pasting paper, I use flour boiled in water as smooth as it can be boiled, and paste both the papers very evenly that are to be pasted together" (*The Autobiography and Correspondence of Mary Granville, Mrs. Delany,* series 1, vol. 2, 259). Delany's letters are full of such tips.

31. Shields, *Civil Tongues and Polite Letters in British America.*

32. A striking recent example that argues for this continuity from the perspective of eighteenth-century Native American and African-American writing is found in Brooks, *American Lazarus.*

33. Stabile, *Memory's Daughters,* 4.

34. Parrish, *American Curiosity.*

35. See also Brueckner, *The Geographic Revolution in Early America.*

36. For a foundational discussion of flower painting and embroidery as gendered genres, see Parker and Pollock, *Old Mistresses,* 51 ff.

37. "Synaesthesia," *Oxford English Dictionary,* http://dictionary.oed.com.

38. Jody Greene, in her introduction to the GLQ special issue "The Work of Friendship," defines "friendship studies" as "a field that resolutely and carefully reads the history of friendship and the history of sexuality into, through, and across each other" (321).

39. Ibid., 325.

40. The separatist strand includes, notably, Todd, *Women's Friendship in Literature;* Faderman, *Surpassing the Love of Men;* and Curran, "Anna Seward and the Dynamics of Female Friendship." Notable examples of the second group include Easton, "Were the Bluestockings Queer?; Herz, "Of Circles, Friendship, and the Imperatives of Literary History"; and Guibbory, "Conversation, Conversion, Messianic Redemption."

41. Ivy Schweitzer notes that early European travelers to the Americas "encountered indigenous people who had their own notions of love, friendship, exchange, power, and otherness," but that "Europeans often cloaked their imperial projects in the noble characters of friendship or the related rhetoric of Christian brotherhood and an enlightened notion of natural rights" (*Perfecting Friendship,* 17).

42. For example, Sylvia Myers writes: "The current views of feminists who stress a relationship between female friendships and lesbianism are leading to some serious distortions about friendships" (*The Bluestocking Circle,* 18). Janet Todd, despite her pioneering identification of "erotic friendships" among women in eighteenth-century literature, keeps such relationships crisply distinct from what she calls "sentimental friendship": "In eighteenth century literature, erotic and sentimental friendships are antithetical . . . [in erotic friendships] the women are not elevated and their passion rarely reaches the mythical and allegorical level of much male love" (*Women's Friendship in Literature,* 327). In this study I contest such a distinction. Lillian Faderman's classic *Surpassing the Love of Men* argues both sides of this question, calling some individual

relationships erotic while arguing that participants in romantic friendships did not see themselves as sexual partners until Freud "pathologized" women's friendships by seeing them as lesbian. Such a "both/and" approach anticipates the methods of many more recent studies, including this one.

43. Schweitzer, *Perfecting Friendship*, 6.

44. Traub, "Friendship's Loss," 344, 350.

45. Shannon, "Poetic Companies," 454.

46. Connolly, "A Woman's Life in Mid-Eighteenth-Century Ireland," 447.

47. See Faderman, *Surpassing the Love of Men*; Traub, "Friendship's Loss"; Donoghue, *Passions between Women*; and Vicinus, *Intimate Friends*.

48. This book, then, is in conversation with recent works in queer cultural studies that approach very different historical periods and kinds of cultural production from a similar methodological standpoint. See, for example, Cvetkovich, *An Archive of Feelings*; Dolan, *Utopia in Performance*; and Cohen, "Velvet Is Very Important."

49. Janine Barchas has collected the best of these in *The Geography and Natural History of Mid-Eighteenth-Century Erotica*.

50. Turner, "The Sexual Politics of Landscape," 357.

51. Fabricant, "Binding and Dressing Nature's Loose Tresses," 109–35, 111.

52. Ibid., 110. Fabricant quotes Richard Brantley's remarks from his *New Improvements of Planting and Gardening, both Philosophical and Practical* (1739).

53. Fabricant, "Binding and Dressing Nature's Loose Tresses," 121.

54. Turner, "The Sexual Politics of Landscape," 351.

55. This may be a hitherto unacknowledged first use of this term to denote "homosexual" or "transgender." The *Oxford English Dictionary* gives the first reference for this sense of the word as Havelock Ellis's *Studies in the Psychology of Sex* (1897). The relevant quotation from Darwin is as follows: In "the class of Gynandria, or masculine ladies . . . the flower may be said to be inverted" (*The Botanic Garden*, canto IV, note to line 285).

56. Darwin, *The Botanic Garden*, canto IV, line 304; canto I, note to line 69; canto I, note to line 183; canto IV, notes to lines 285, 184, 184, 138, 142, 184.

57. D. A. Miller in *The Novel and the Police* coined the phrase "open secret" as a critical category. It was subsequently widely circulated by Eve Kosofsky Sedgwick as a methodology of queer theory, first mentioned in her essay on *Billy Budd* (*Epistemology of the Closet*, 101).

58. This example, from a letter by Mary Delany, is cited in chapter 1.

59. Seward is included in canon-making discussions of lesbian literary history such as Faderman's *Surpassing the Love of Men* and anthologies including Castle, ed., *The Literature of Lesbianism*, and Lillian Faderman, ed. *Chloe plus Olivia*.

1. QUEER GARDENS

1. The spectacular exhibition *Mrs. Delany and her Circle*, co-curated by Alicia Weisberg-Roberts and Mark Laird for the Yale Center for British Art and Sir John Soane's Museum,

provides the opportunity for a scholarly and critical renaissance of interest in Delany's work. The exhibition opened in New Haven in September 2009 and closed in London in May 2010.

2. Blunt, *The Art of Botanical Illustration,* 154–55.

3. Bermingham, *Learning to Draw,* 184. See also Vickery, "The Theory and Practice of Female Accomplishment." Vickery is more interested than Bermingham in the possibility that female accomplishments might be created for an audience of women in addition to or instead of men, and she writes of "the power [craftwork] had to connect women" and to create "self-consciously women-only interiors" (102, 104).

4. Hyde famously identifies this aspect of the role of art "the gift economy" in *The Gift.*

5. Vickery does not address questions of desire in her discussion of the circulation and meaning of women's amateur traditions among women themselves. Instead, she goes only so far as to notice "attempts at separatist female living . . . characterized by an inveterate culture of flamboyant female ornamentation, suggesting the spinsters were consecrated to a domestic cloister of curiosities and crafts" ("The Theory and Practice of Female Accomplishment," 105).

6. "Sapphism" is the most frequently used eighteenth-century term for sexual intimacy between women. For a more thorough discussion, see Moore, *Dangerous Intimacies,* especially chapter 1.

7. Delany, "Letter to Anne Granville," November 29, 1727, Delany Letters. All transcriptions from the original manuscripts are my own. I have retained variations in spelling and punctuation.

8. Ibid., 1727–28.

9. Ibid., June 18, 1728.

10. Ibid., March 19, 1727.

11. Ibid., January 17, 1731–32.

12. March 16, 1751. Delany, *The Autobiography and Correspondence of Mary Granville, Mrs. Delany,* series 1, vol. 3, 25.

13. Delany, "Letter to Anne Granville," June 18, 1728, Delany Letters.

14. See Campbell-Orr's discussion of the practice of classical nicknaming among Mary Pendarves and her friends in "Mrs. Delany and the Court," 50.

15. The phrase is that of Augusta Llanover, Delany's nineteenth-century editor (*The Autobiography and Correspondence of Mary Granville, Mrs. Delany,* series 1, vol. 1, 404).

16. Delany, "Letter to Anne Granville," n.d. [1732–33?], Delany Letters.

17. Delany, "Letter to Anne Granville," March 11, 1732, Delany Letters. The phrase "makes violent love to me" and all that follows in this quotation has been omitted from Lady Llanover's published version of the letter in *The Autobiography and Correspondence of Mary Granville, Mrs. Delany,* series 1, vol. 1, 57.

18. May 27, 1732. Delany, *The Autobiography and Correspondence of Mary Granville, Mrs. Delany,* series 1, vol. 1, 348.

19. Connolly, "A Woman's Life in Mid-Eighteenth-Century Ireland," 435.

20. Cited in ibid., 448–49.

21. Hayden, *Mrs. Delany, Her Life and Her Flowers,* 61.

22. April 23, 1743. Delany, *The Autobiography and Correspondence of Mary Granville, Mrs. Delany,* series 1, vol. 2, 211.

23. Hayden, *Mrs. Delany, Her Life and Her Flowers,* 61.

24. March 30, 1744. Delany, *The Autobiography and Correspondence of Mary Granville, Mrs. Delany,* series 1, vol. 2, 287–88.

25. Delany, "Letter to A. Dewes," January 19, 1744–45, Delany Letters.

26. Mary Delany, botanical illustrations collection, frontispiece, British Museum.

27. Delany, "Letter to A. Granville," October 30, 1732, *The Autobiography and Correspondence of Mary Granville, Mrs. Delany,* series 1, vol. 1, 389.

28. Pilkington, *Memoirs of Laetitia Pilkington,* vol. 2, 388.

29. This is a reference to Rupert Barber (1736–72), the miniaturist, and his wife, a poet, who lived in a house at the end of the Delville garden (Malin and Glin, *Lost Demesnes,* 52).

30. Swift, *An Epistle upon an Epistle from a Certain Doctor to a Certain Great Lord, n.p.*

31. Laird, analyzing photos from the early 1900s, notes walls and straight allées "surviving into maturity at Delville," and he suggests that "this hybrid garden was not a pure landscape garden." Laird compares Patrick Delany's Delville to Pope's "villa gardening" at Twickenham because of its similar scale, and he credits Mary Delany with "embroidering" its topography through horticultural plantings. I think this hybrid quality is also at play in the garden's early adoption of picturesque effects mixed with miniature versions of Brownian "open prospects" ("Introduction," *Mrs. Delany and her Circle,* 8–9).

32. Pilkington, *Memoirs of Laetitia Pilkington,* vol. 2, 388, line 25.

33. Malin and Glin, *Lost Demesnes,* 37.

34. Weltman-Aron, *On Other Grounds,* 2.

35. Ibid., 10. Horace Walpole explains the origins of this odd name thus: "But the capital stroke, the leading step to all that has followed was . . . the destruction of walls for boundaries, and the invention of fossès—an attempt then deemed so astonishing, that the common people called them Ha! Ha's! to express their surprize at finding a sudden and unperceived check to their walk" ("The History of Modern Taste in Gardening," 25).

36. Malin and Glin, *Lost Demesnes,* 46.

37. The classic distinction between "colonies of exploitation" such as India and "colonies of settlement" such as Australia and the Americas is that of Richard Pares. For a discussion, see Wolfe's introduction to *Settler Colonialism and the Transformation of Anthropology,* 1–7.

38. Malin and Glin, *Lost Demesnes,* xxi.

39. Williamson warns against relying too heavily on literary and philosophical discussions of eighteenth-century gardens in tracing their history. Such sources, he argues, tended to circulate among a small elite and may not have represented the practice of many of the landed gentry who were nonetheless actively designing and building parks and gardens. According to Williamson, "The fortunes of the principal landowning groups in society . . . are important because parks and gardens existed in a real world, not just in one of abstract ideas: a world in which land and money needed to be found for their creation, in which wages had to be paid for their maintenance" (*Polite Landscapes,* 14–15).

40. Malin and Glin, *Lost Demesnes,* 2.

41. For details about the Hell Fire Club, see R. W. Postgate's biography of John Wilkes, *That Devil Wilkes.* The reference appears in Mary Hamilton's journal, December 8, 1783. Delany, *The Autobiography and Correspondence of Mary Granville, Mrs. Delany,* series 2, vol. 3, 162.

42. Ross, *What Gardens Mean,* 66.

43. The Venus Temple is still extant at present-day West Wycombe.

44. Ross, *What Gardens Mean,* 67.

45. Quoted in Fabricant, "Binding and Dressing Nature's Loose Tresses," 110.

46. Arts Council of Great Britain, *Painting from Nature,* a catalogue of an exhibition held at the Fitzwilliam Museum, Cambridge, November 25, 1980, to January 11, 1981, and at the Diploma Galleries, Royal Academy of Arts, London, January 31 to March 15, 1981. The Jones sketch is on page 21.

47. Turner, "The Sexual Politics of Landscape," 351.

48. July 19, 1744. Delany, *The Autobiography and Correspondence of Mary Granville, Mrs. Delany,* series 1, vol. 2, 315.

49. M. Delany to A. Dewes, October 3, 1745. Delany, *The Autobiography and Correspondence of Mary Granville, Mrs. Delany,* series 1, vol. 2, 391.

50. December 9, 1743. Delany, *The Autobiography and Correspondence of Mary Granville, Mrs. Delany,* series 1, vol. 2, 238.

51. Hayden, *Mrs. Delany, Her Life and Her Flowers,* 133.

52. Erasmus Darwin praised the "accuracy" of Delany's compositions, saying they were "less liable to fallacy than drawings" (*The Botanic Garden,* canto IV, note to line 285). And the botanist Joseph Banks, a frequent visitor to Bulstrode, said that he would "venture to describe botanically any plant from Mrs. Delany's imitations without the last fear of committing an error" (quoted in Blunt, *The Art of Botanical Illustration,* 155).

53. Laird, "Mrs. Delany's Circles of Cutting and Embroidering in Home and Garden," 164.

54. The bits of leaf and stem are still visible when one looks at the originals in the British Museum. See Reeder, "The 'Paper-Mosaick' Practice of Mrs. Delany and her Circle," for a detailed account of Delany's materials and process.

55. Coats, *The Treasury of Flowers,* Plate 68.

56. Slatter, "George Dionysius Ehret."

57. Browne, "Mary Delany's Embroidered Court Dress," 75. While the majority of Delany's paper mosaics were on black grounds, a few were on buff or other colors. See Reeder, "The 'Paper-Mosaick' Practice of Mrs. Delany and Her Circle," 225.

58. Tomasi, *An Oak Spring Flora,* 324.

59. See Laird, "Mrs. Delany's Circles of Cutting and Embroidering in Home and Garden," 160.

60. For a thorough account of Delany's use of Linnaean nomenclature and its relationship to eighteenth-century botanical knowledge, see Edmondson, "Novelty in Nomenclature."

61. Darwin, *The Botanic Garden,* canto II, notes to lines 155, 156.

62. Darwin also discusses the botanical paintings of Emma Crewe in *The Botanic Garden,* canto II, note to lines 295, 158.

63. Reeder, "The 'Paper-Mosaick' Practice of Mrs. Delany and Her Circle," 226.

64. November 3, 1780. Delany, *The Autobiography and Correspondence of Mary Granville, Mrs. Delany,* series 2, vol. 2, 571–72.

65. Campbell-Orr, "Mrs. Delany and the Court," 59.

66. Reeder, "The 'Paper-Mosaick' Practice of Mrs. Delany and Her Circle," 234.

67. Ibid., 226.

2. A CONNOISSEUR IN FRIENDSHIP

1. Horace Walpole wrote that the sale was actually "for the benefit of her second Son Lord Edward Bentinck, & her Daughters the lady Viscountess Weymouth & the Countess of Stamford" (*The Duchess of Portland's Museum,* 6–7), but Pat Rogers, in the standard account, says that "the aim was to recoup the family fortunes, drained by the electioneering expenses of her elder son and the high living of the younger" (quoted in Fitzmaurice, "Margaret Cavendish").

2. There is little sustained scholarship on the Duchess of Portland. She is usually mentioned along with Mary Delany in histories of botany and botanical illustration such as Blunt's *The Art of Botanical Illustration.* Studies of elite women and aristocratic politics in eighteenth-century England such as Vickery mention her. In conjunction with a 2006 exhibition at the Harley Gallery on the Welbeck estate, the Duchess's childhood home, the first dedicated biographical study of the Duchess was published as an exhibition catalogue; Rebecca Stott's *Duchess of Curiosities.* Recent scholarship that includes more than passing reference to the Duchess includes Moore, "Queer Gardens"; Cook, "Jean-Jacques Rousseau and 'Exotic Botany,'" and "Botanical Exchanges"; Festing, "The Second Duchess of Portland and Her Rose"; Brown, "Domesticity, Feminism, and Friendship"; Shteir, *Cultivating Women, Cultivating Science;* and Pascoe, *The Hummingbird Cabinet.*

3. See Traub, *Renaissance of Lesbianism in Early Modern England,* 177 ff.

4. For the French context, see Landes, *Women and the Public Sphere in the Age of the French Revolution;* for the American context, see Kerber, *Women of the Republic;* and Davidson, *Revolution and the Word.*

5. Quoted in Stott, *Duchess of Curiosities,* 16.

6. E. Robinson, "Letter to Margaret Harley Bentinck," n.d., Hallward Library.

7. Bentinck, "Letter to Lord Titchfield," 1763, Hallward Library.

8. November 3, 1734. Delany, *The Autobiography and Correspondence of Mary Granville, Mrs. Delany,* series 1, vol. 1, 514.

9. Ibid., 509.

10. Recent histories of the early modern convent include Choudhoury, *Convents and Nuns in Eighteenth-Century French Politics and Culture;* and Walker, *Gender and Politics in Early Modern Europe.* Choudhoury makes it clear that the dissolution of convents at the time of the Revolution was by no means a foregone conclusion, as female religious members had been important in emerging democratic discourse, and Walker argues that convents could serve as significant locations of feminist organizing and resistance. English convents abroad were also seen as "breeding grounds

for sedition against the English state" (116), which may have accounted in part for the patriotic Duchess's horror.

11. Delany, *The Autobiography and Correspondence of Mary Granville, Mrs. Delany*, series 1, vol. 1, 607.

12. William Bentinck, "Letter to Sir Hans Sloane," n.d., Sloane Collection.

13. Delany, *The Autobiography and Correspondence of Mary Granville, Mrs. Delany*, series 1, vol. 1, 482.

14. Ibid., series 1, vol. 3, 95.

15. She refers to her "dear dear Mrs Delany" throughout her diary, and she speaks of Mrs. Delany's frequent discussion of her "excellent friend" in the letter quoted below (Delany, *The Autobiography and Correspondence of Mary Granville, Mrs. Delany*, series 2, vol. 3, 57).

16. Bentinck, "Letter to A. Dewes," June 22, 1742, Newport Reference Library.

17. Delany, "Letter to Anne Granville," 1741, Delany Letters.

18. Delany, "Letter to Miss Mary Port," August 21, 1778, Delany Letters.

19. For a detailed discussion of Mary Delany's social position and court ambitions, see Campbell-Orr, "Mrs. Delany and the Court." Regarding the Duchess of Portland, Campbell-Orr writes, "To the modern reader it might seem strange—even cruel—that the wealthy duchess bequeathed nothing but some chosen mementos to her friend," but she explains that the Duchess did not have discretion about most of her property ("landed wealth was always strictly settled at marriages") and "aside from this Mrs. Delany was not and did not want to be a client, but a friend" (61).

20. Brown, "Domesticity, Feminism, and Friendship," 413.

21. Bannet, "The Bluestocking Sisters."

22. Delany, "Letter to Lady Andover," May 27, 1776. Osborn Collection.

23. Delany, *The Autobiography and Correspondence of Mary Granville, Mrs. Delany*, series 2, vol. 1, 538.

24. Delany, "Letter to Lady Andover," 1768, Osborn Collection.

25. Delany, "Letter to Miss Mary Port," 1769, Osborn Collection.

26. Duchess of Portland Margaret Harley Bentinck, "Letter to A. Dewes," June 2, 1742, and 1768, Newport Reference Library.

27. Delany, *The Autobiography and Correspondence of Mary Granville, Mrs. Delany*, series 2, vol. 1, 445.

28. Ibid., 254.

29. Ibid., series 1, vol. 1, 521.

30. See Weisberg-Roberts, "Introduction—Mrs. Delany from Source to Subject."

31. Exhibition placard, "Mrs. Delany and Her Circle," Yale Center for British Art, New Haven, October 2009.

32. For an account of Walpole's erotic attachments to other men and his place in queer cultural studies, see Haggerty, "Queering Horace Walpole."

33. Stott, *Duchess of Curiosities*, 10.

34. Ibid., 11.

35. Delany, *The Autobiography and Correspondence of Mary Granville, Mrs. Delany*, series 2, vol. 3, 262–63.

36. Walpole, *The Duchess of Portland's Museum*, 6.

37. Collins, *Historical Collections of the Noble Families of Cavendishe, Holles, Vere, Harley and Ogle*, 213.

38. Quoted in Swann, *Curiosities and Texts*, 242.

39. Belk, "Collectors and Collecting," 323.

40. Swann, *Curiosities and Texts*, 197.

41. Bakeland, "Psychological Aspects of Art Collecting," 208; Clifford, "Collecting Ourselves," 260.

42. Pearce, "The Urge to Collect," 157.

43. Belk and Wellendorf, "Of Mice and Men," 243.

44. Ibid., 251.

45. Formanek, "Why They Collect," 328.

46. Thomas, *Entangled Objects*, 126.

47. Stewart, *On Longing*, 158.

48. Brown, "Thing Theory," *Critical Inquiry*, 7.

49. Belk and Wellendorf, "Of Mice and Men," 251.

50. Fadiman, *At Large and at Small*, 19.

51. Thomas, *Entangled Objects*, 139.

52. Schiebinger and Swan, eds., *Colonial Botany*, 3.

53. Ibid., 7.

54. Stewart, *On Longing*, 159.

55. Ibid., 158.

56. Arnold and Pearce, eds., *Early Voices*, vol. 2, 139.

57. Delany, "Letter to Lady Andover," 1772, Osborn Collection.

58. Lord Francis North, "Letter to Mary Delany," August 2, 1781, Osborn Collection.

59. William Bentinck, "Letter to Lord Titchfield," 1751, Hallward Library.

60. Duchess of Portland Margaret Harley Bentinck, "Letter to Lord Titchfield," 1763, Hallward Library.

61. Delany, "Letter to A. Dewes," 1760, Delany Letters.

62. William Bentinck, "Letter to Lord Titchfield," 1751, Hallward Library.

63. Susan Groag Bell calls the landscape park "that magnificent eighteenth-century English male creation," while for women, "their passion was for flowers and shrubs," the commonplace accomplishments of the domestic garden rather than the political and aesthetic fashion statement made by improvements in the style of Capability Brown ("Women Create Gardens in Male Landscapes," 481, 487). Even by Bell's own evidence, not to mention (as she doesn't) the work of Mary Delany and Margaret Bentinck, it is empirically untrue that women did not design large-scale landscape parks. But the association of this work with masculinity in the popular imagination of both eighteenth-century garden theorists and later garden historians is unequivocal. For an extended account of the relations between elite status, political power,

and landscape gardening, see Weltman-Aron, *On Other Grounds;* and Alistair Duckworth, *The Improvement of the Estate.*

64. William Bentinck, "Letter to Lord Titchfield," 1751, Hallward Library.

65. Delany, *The Autobiography and Correspondence of Mary Granville, Mrs. Delany,* series 2, vol. 1, 170.

66. Ibid., 274.

67. Delany, "Letter to Lady Andover," 1776, Osborn Collection.

68. For descriptions of Pope's grotto, see Willson, "Alexander Pope's Grotto in Twickenham," 31–59. According to Willson, Pope's earliest grotto decorations were shells, but in a renovation carried out in 1739–1743, he replaced the shellwork with minerals, mirrored glass, and other harder materials.

69. Delany, "Letter to A. Dewes," 1737, Delany Letters.

70. Delany, *The Autobiography and Correspondence of Mary Granville, Mrs. Delany,* series 1, vol. 1, 570.

71. Stott, *Duchess of Curiosities,* 24.

72. Delany, *The Autobiography and Correspondence of Mary Granville, Mrs. Delany,* series 1, vol. 1, 619.

73. Delany, "Letter to A. Dewes," 1760, Delany Letters.

74. John Lightfoot, "Letter to the Duchess of Portland," n.d., Hallward Library.

75. Delany, *The Autobiography and Correspondence of Mary Granville, Mrs. Delany,* series 2, vol. 1, 274.

76. Ibid., 289.

77. Ibid., 374.

78. North, "Letter to Mary Delany," August 2, 1781, Osborn Collection.

79. Jackson, *Shell Houses and Grottoes,* 11.

80. Ibid., 15.

81. Delany, "Letter to A. Dewes," 1760, Delany Letters.

82. Delany, *The Autobiography and Correspondence of Mary Granville, Mrs. Delany,* series 1, vol. 3, 258.

83. E. Robinson, "Letter to Duchess of Portland," n.d., Hallward Library.

84. Delany, *The Autobiography and Correspondence of Mary Granville, Mrs. Delany,* series 1, vol. 3, 469.

85. Duchess of Portland Margaret Harley Bentinck, "Letter to A. Dewes," August 24, 1737, Newport Reference Library.

86. Delany, *The Autobiography and Correspondence of Mary Granville, Mrs. Delany,* series 2, vol. 1, 168.

87. Cook, "Botanical Exchanges," 143.

88. Delany, *The Autobiography and Correspondence of Mary Granville, Mrs. Delany,* series 2, vol. 1, 140.

89. Ibid., 562.

90. Ibid., vol. 2, 19.

91. Arnold and Pearce, eds., *Early Voices,* vol. 2.

92. Delany, "Letter to Lady Andover," 1776, Osborn Collection.

93. Delany, *The Autobiography and Correspondence of Mary Granville, Mrs. Delany,* series 1, vol. 3, 293.

94. Ibid., 474.

95. Ibid., series 2, vol. 2, 51.

96. Bentinck's collections were open to the public at a nominal charge on occasion, both at Bulstrode and at her town house at Whitehall (Arnold and Pearce, eds., *Early Voices,* vol. 2, 139).

97. Delany, *The Autobiography and Correspondence of Mary Granville, Mrs. Delany,* series 2, vol. 1, 359.

98. Delany, "Letter to Mary Port," 1774, Delany Letters.

99. Duchess of Portland Margaret Harley Bentinck, "Letter to A. Dewes," n.d., Newport Reference Library.

100. Delany, *The Autobiography and Correspondence of Mary Granville, Mrs. Delany,* series 1, vol. 3, 473.

101. Delany, "Letter to Mary Port," 1760, Delany Letters.

102. For an account of the botanical identity of the rose, see Festing, "The Second Duchess of Portland and Her Rose"; and Delany, *The Autobiography and Correspondence of Mary Granville, Mrs. Delany,* series 2, vol. 3, 95.

103. Festing, "The Second Duchess of Portland and Her Rose," 194.

104. Ibid., 195.

105. Ibid., 197.

106. John Edmondson argues that Mary, Dowager Duchess of Stamford, is the most likely namesake as she probably provided roses from her childhood estate of Dunham Massey, which was famous for its rose gardens (personal correspondence with John Edmondson, December 14, 2009). See Edmondson, "Novelty in Nomenclature," 201.

107. See Thomas, *Some Account of the Roses in the Garden at Plas Newydd.* For understudied figures such as the Duchess of Portland, local historians such as Thomas often have the most information.

108. Walpole, *The Duchess of Portland's Museum,* 6.

109. Quoted in Walker, *The Portland Vase,* 43.

110. Walker, *The Portland Vase,* 45, 46.

111. Ibid., 63.

112. Darwin, *The Botanic Garden,* part 1, canto 11, line 339.

113. Delany, *The Autobiography and Correspondence of Mary Granville, Mrs. Delany,* series 2, vol. 3, 192.

114. Ibid., series 1, vol. 3, 239.

115. Ibid., 293.

116. Delany, "Letter to Mary Port," 1774, Delany Letters.

117. Ibid., July 27, 1775.

118. Ibid., January 22, 1778.

119. Delany, *The Autobiography and Correspondence of Mary Granville, Mrs. Delany,* series 2, vol. 1, 525.

120. Ibid., vol. 3, 160.

121. Ibid., 158.

122. E. Robinson [Montagu], "Letter to Duchess of Portland," n.d., Hallward Library.

123. Delany, *The Autobiography and Correspondence of Mary Granville, Mrs. Delany,* series 1, vol. 1, 182.

124. E. Robinson [Montagu], "Letter to Duchess of Portland," n.d., Hallward Library.

3. THE VOICE OF FRIENDSHIP, TORN FROM THE SCENE

1. Seward, "Letter to Mrs. Sykes," 1773, Samuel Johnson Birthplace Museum.

2. Seward, *Letters of Anna Seward,* vol. 3, 267.

3. Seward, "Biographical Sketch of Miss Seward," Staffordshire Record Office. Stafford, England, n.p. This manuscript is in third person, but is in Anna Seward's hand.

4. Seward, *Letters of Anna Seward,* vol. 3, 53.

5. Ibid., vol. 2, 173.

6. Faderman, *Surpassing the Love of Men,* 135.

7. Ibid., 137.

8. Moore, *Dangerous Intimacies,* 12.

9. Lanser, "Befriending the Body," 183.

10. Ibid., 189. Other scholars who have discussed Anna Seward in the context of lesbian history and literature include Donoghue, *Passions between Women*; Castle, *The Apparitional Lesbian*; and Brideoake, "'Extraordinary Female Affection.'"

11. Seward, *Letters of Anna Seward,* vol. 3, 109. Mr. Green's poem imitates some of Seward's own favorite themes and images on the death of a beloved friend. Seward seems never to have taken up the poem's challenge to ensure her dog's immortality by composing "matchless verse" of her own.

12. Seward, "Biographical Sketch of Miss Seward," n.p.

13. Seward, *Letters of Anna Seward,* vol. 4, 217.

14. Seward, "Letter to Miss Powys," 1770, Samuel Johnson Birthplace Museum.

15. Seward, "Letter to Mrs. Sykes," 1773, Samuel Johnson Birthplace Museum.

16. There is no placard confirming this account of Seward's work on Minster Pool. I was told about it by the staff at the Samuel Johnson Birthplace Museum, and it is described by the local historian Howard Clayton in his book *Coaching City,* 64–65.

17. Seward, "Monody on the Death of Captian André," *The Poetical Works of Anna Seward,* vol. 1, 34.

18. Seward, "Grave of a Suicide," *The Poetical Works of Anna Seward,* vol. 1, 84–86. Subsequent cites from this work are given as parenthetical page numbers in the text.

19. Seward, *Letters of Anna Seward,* vol. 3, 131.

20. Seward, "The Anniversary," *The Poetical Works of Anna Seward,* vol. 1, 70, 72.

21. Seward, "Time Past," *The Poetical Works of Anna Seward,* vol. 1, 87–88.

22. Seward, "Letter to Mrs. Sykes," 1773, Samuel Johnson Birthplace Museum.

23. Seward, "Letter to Miss Powys," n.d., Samuel Johnson Birthplace Museum.

24. Eng, *Loss,* 17. The classic account is of course Sigmund Freud, "Mourning and Melancholia," *A General Selection from the Works of Sigmund Freud,* 125 ff.

25. Eng, *Loss*, 3. Eng's important collection is part of a rising interest in "bad affects" in queer theory, including not only melancholy but also shame, depression, and other stigmatized emotions. See Sedgwick and Frank, eds., *Shame and Its Sisters;* Love, *Feeling Backward;* and Cvetkovich, *Depression.*

26. The proleptic loss expressed in Seward's poems echoes Agamben's observation that "melancholia offers the intention to mourn that precedes and anticipates the loss of the object" (*Stanzas,* 20).

27. For a detailed consideration of a canonical expression of women's loss and mourning in the face of marriage, see the discussion of Jane Austen's *Emma* in my book *Dangerous Intimacies.*

28. Jody Greene writes that "all of the great pre- and early modern discourses" on same-sex friendship "concern themselves fundamentally with death. All of these writings, in fact, are precipitated by the death of a friend" ("Introduction: The Work of Friendship," 326). George Haggerty argues that "by equating desire with loss, the elegy allows a public articulation of the inner workings of patriarchal, homosocial culture at the same time that it pushes the 'traumatic, real kernel' or male-male erotic love so deeply into the cultural unconscious that these poems can be celebrated for their beauty even as their erotic significance is ignored" ("Love and Loss: An Elegy," 395–96). See also Haggerty's chapter on Gray's "Elegy," an important source for both Seward and Pierce, in *Men in Love.*

29. See, for example, Riegel, *Response to Death;* Zeiger, *Beyond Consolation;* and Hoffman, "Representing AIDS."

30. Traub, *The Renaissance of Lesbianism in Early Modern England,* 172–75.

31. Crimp, "Mourning and Militancy," 6.

32. Eng, *Loss,* 3.

33. Seward, *The Poetical Works of Anna Seward,* vol. 1, 82–83.

34. Ibid., 76–81.

35. Seward, *Letters of Anna Seward,* vol. 1, 5.

36. Ibid.

37. Seward, "Letter to Miss Powys," n.d., Samuel Johnson Birthplace Museum.

38. Seward, "Letter to Unknown Recipient." n.d., Samuel Johnson Birthplace Museum.

39. Seward, *Letters of Anna Seward,* vol. 5, 110.

40. Ibid., 258.

41. Lister, *I Know My Own Heart,* 210.

42. Seward, "Letter to Miss Powys," 1795, Samuel Johnson Birthplace Museum.

43. Seward, *Letters of Anna Seward,* vol. 4, 209.

44. Ibid., 150.

45. Ibid., 150, 195.

46. Seward, *The Poetical Works of Anna Seward,* vol. 3, 70–80.

47. Seward, *The Poetical Works of Anna Seward,* vol. 3, 107. The poem is also reprinted in Faderman, *Chloe plus Olivia,* 42.

48. See, for example, Elizabeth Mavor's entry in the *Oxford Dictionary of National Biography*: "Apparently [Butler was] of too 'satirical' and 'masculine' a cast of mind to make the advantageous marriage that might help restore the family fortunes" (n.p.). See also the oft-cited Welsh newspaper account that called Ponsonby "effeminate, fair and beautiful" and Butler "tall and masculine . . . with the air of a sportsman" (cited in Mavor, *A Year with the Ladies of Llangollen*, 135.)

49. Seward, *The Poetical Works of Anna Seward*, vol. 3, 345–50.

50. Seward, *Letters of Anna Seward*, vol. 1, 219. Subsequent cites of this work in this section are given as parenthetical volume and page numbers in the text.

51. Seward, *Letters of Anna Seward*, vol. 1, 18.

52. Seward, *Memoirs of the Life of Dr. Darwin*, 131.

53. Ibid., 135.

54. Seward, *Letters of Anna Seward*, vol. 6, 142, 144.

55. Ibid., vol. 3, 195.

56. Ibid., 195.

57. Ibid.

58. Seward, *The Poetical Works of Anna Seward*, vol. 1, 156.

4. THE LANDSCAPE WHICH SHE DREW

1. Dowling, *Poetry and Ideology in Revolutionary Connecticut*, 15.

2. Frederika Teute argues that women such as Pierce, Idea Strong, and Susan Bull Tracy were important participants in the intellectual culture of the all-male Friendly Club ("The Loves of the Plants," 320).

3. An earlier poem by Susanna Wright, entitled "To Eliza Norris—at Fairfield," while not entirely a landscape or georgic composition, does contain a passage of suggestive pastoral description in imagining the addressee's idealized life of virtuous retirement:

> Far from the proud, the busy & the vain,
> Where rural views soft gentle joys impart,
> Enlarge the thought, & elevate the heart
> Each changing scene adorns gay Nature's face,
> Ev'n winter wants not its peculiar grace,
> Hoar frosts & dews, & pale & summer suns,
> Paint each revolving season as it runs.
> The showery bow delights your wond'ring eyes,
> Its spacious arch, & variegated dyes,
> [You] watch the transient colours as they fade,
> Till, by degrees, they settle into shade,
> Then calm reflect, so regular & fine,
> Now seen no more, a fate will soon be mine.

Wright does not imagine herself into the landscape with her friend, and neither does she use landscape imagery to express romantic or erotic longing, as do the figures I examine in this book,

but the poem remains interesting as a forerunner to Pierce's Americanization of the women's landscape arts tradition. The *Heath Anthology of American Literature* gives no date for the poem (742), but Pattie Cowell in "'Womankind Call Reason to Their Aid'" places it as late as 1779.

4. Albert J. von Frank in "Sarah Pierce and the Poetic Origins of Utopian Feminism in America" cites Pierce's artistic debts (sometimes in the form of quoted lines) to the canonical English poets Milton, Pomfret, and Gray.

5. The term is that of Ann Cvetkovich; see her *An Archive of Feelings*.

6. Smith, *Diary of Elihu Hubbard Smith,* 112.

7. Ibid., 113.

8. In an earlier version of this argument I emphasized the pastoral elements of the poem, which I now think are actually part and parcel of its georgic "mixed" quality. See my "The Swan of Litchfield," 253–78. Emma Donoghue argues that "pastoral poetry—set in idealized landscapes— provides some of the most uninhibited poems of female passion" in the eighteenth century" (*Passions between Women,* 116).

9. Typically, the eighteenth-century georgic posits an expert speaker who offers advice based on experience, whether on the classical topic of rural labor (Smart's *The Hop-Garden*) or themes more flexibly adapted from Virgil (Gay's *Trivia: or The Art of Walking the Streets of London* or his *Rural Sports,* for example). Exhaustive detail is the hallmark of this characteristic of the georgic. See Rothstein, *Restoration and Eighteenth-Century Poetry, 1660–1780,* 149. Pierce's poem treats the practices she endorses in a much more summary form, and the rhetorical convention of speakerly expertise is here moral rather than practical, perhaps reflecting Pierce's awareness of her relative youth and inexperience at the time of composition (she was twenty-five, and was to start her life's work by founding Litchfield Female Academy later that year).

10. Dowling, *Poetry and Ideology in Revolutionary Connecticut,* xvii.

11. Ibid., 48.

12. Samuel Miles Hopkins, quoted in Brickley, "The Litchfield Female Academy," 20.

13. Smith, *Diary of Elihu Hubbard Smith,* 112. Subsequent cites of this poem appear as parenthetical page numbers in the text.

14. Addison, "An Essay on the Georgics," 146.

15. Pellicer, "The Georgic," n.p.

16. Joshua Scodel suggests that the use of elegiac couplets as opposed to epic dactylic hexameters in Greek epitaphic poems "might have implied . . . a link to ritual expressions of grief, since contemporary funerary laments used this meter" (*The English Poetic Epitaph,* 3). Gray's use of quatrains may similarly have made reference to eighteenth-century hymnodic forms.

17. Haggerty, "'The Voice of Nature' in Gray's Elegy," 202.

18. Betts and Bear, eds., *The Family Letters of Thomas Jefferson,* 455.

19. Downing, *A Treatise on the Theory and Practice of Landscape Gardening,* 23.

20. Grieff, "The Architecture of Morven," 187.

21. Kornwolk, "The Picturesque in the American Garden and Landscape before 1800," 100.

22. The Marquis de Chastellux quoted in ibid., 99.

23. A comparable example cited by Jessie Lie Farber in "Early American Gravestones," 10, is as follows:

Stranger, stop and cast an eye
As you are now so once was I
As I am now, so you will be
Remember Death and follow me

Farber notes that nearly one in three eighteenth-century gravestones included a verse, most often of four lines (25).

24. Scodel, *The English Poetic Epitaph*, 6. Scodel calls the "elegy with final epitaph" form a "classical generic combination" (7).

25. Farber, "Early American Gravestones," 12.

26. Ibid., 13. I'm describing the standard Puritan gravestone; Farber says that after the mid-eighteenth century, "variations on the basic shape" began to appear, but since this "transition was accompanied by an increase in height" (n.p.), I think Pierce means to allude to the simpler, older headstone style here.

27. Mulford, ed. *Only for the Eye of a Friend*, xv.

28. Blecki and Wulf, eds., *Milcah Martha Moore's Book*, xii.

29. In addition to Teute, "The Loves of the Plants," see Waterman, *Republic of Intellect*, especially chapter 3, "Unrestrained Conversation and 'The Understanding of Woman.'"

30. Roscoe, "Biography of Miss Anna Seward," 169.

31. Elizabeth Fergusson in particular publicized the work of Seward and her associates in poems circulated in the 1780s. According to Susan Stabile, the poet "sees the Litchfield group as a model for American arts and letters" (*Memory's Daughters*, 233).

32. Teute, "The Loves of the Plants," 332.

33. Daniels, *Fields of Vision*, 61.

34. Sizer and Sizer, introduction to *To Ornament Their Minds*, 10.

35. Lynne Brickley calls Litchfield "cosmopolitan" in this period ("The Litchfield Female Academy," 20).

36. Both of these terms were used to describe features of the infamous West Wycombe erotic garden designed by Francis Dashwood. See Ross, *What Gardens Mean*, 67.

37. According to Cott, both the libertarian rhetoric of the American Revolution and the renewed emphasis on the equality of persons before Christ in the religious revivals hastened this process (*The Bonds of Womanhood*, 187).

38. John D'Emilio and Estelle Freedman argue that "individual choice, rather than parental or state control, became more important, whether in courtship, marriage, or the treatment of sexual deviance . . . at a time when 'the pursuit of happiness' became a political ideal, individual pleasure, and not simply the duty to procreate or to give comfort to one's spouse, came to be valued as a goal of sexual relations (*Intimate Matters*, 40).

39. Ibid., 43.

40. Rather than characterizing this difference as an opposition, what Casid calls "a counterdiscourse of the rural" (*Sowing Empire,* 131), I suggest that for Sarah Pierce, these sexual cultures are connected and mutually informing and supportive.

41. Smith, *Diary of Elihu Hubbard Smith,* 40.

42. Ibid., 174.

43. Pope, "Elegy to the Memory of an Unfortunate Lady," line 6.

44. Ibid., line 69.

45. Smith, *Diary of Elihu Hubbard Smith,* 273 n. 82.

46. Elihu Smith's close friend, Charles Brockden Brown, was a central figure in early national homosocial networks, and much of the information we have about this aspect of his life comes from Smith's diaries. See Crain, *American Sympathy,* 53–97; and Waterman, *Republic of Intellect,* chapter 3.

47. Quoted in Brickley, *To Ornament Their Minds,* 24. Brickley cites Smith's *Diary* as her source, but the page reference she gives is actually for the "Verses to Abigail Smith" (and I was unable to locate the poem referenced here in the *Diary*).

48. Smith, *Diary of Elihu Hubbard Smith,* 134.

49. Casid, *Sowing Empire,* 146.

50. Boulukos, *The Grateful Slave,* 14.

51. As Edgar J. McManus notes, "Connecticut's lawmakers were extremely cautious about moving against slavery. Negroes were more numerous in the state than in the rest of New England combined, and racial anxieties were correspondingly more acute" (*Black Bondage in the North,* 169–70).

52. Dowling, *Poetry and Ideology in Revolutionary Connecticut,* 83.

53. von Frank, "Sarah Pierce and the Poetic Origins of Utopian Feminism in America," 52.

54. Dowling, *Poetry and Ideology in Revolutionary Connecticut,* 84.

55. In this period these would probably have been Mahican, Schaghticoke, and Paugusset peoples (Joanna Brooks, personal communication, August 25, 2005).

56. Pierce, "Address at the Close of School, October 29, 1818," 177.

57. Brickley, "The Litchfield Female Academy," 47.

58. Krueger, "Paper and Silk," 95.

59. Brickley, "The Litchfield Female Academy," 49.

60. Quoted in ibid., 27.

61. Krueger, "Paper and Silk," 88.

62. Quoted in Brickley, "Sarah Pierce's Litchfield Female Academy, 1792–1833," 399–400.

63. Quoted in Blauvelt, *The Work of the Heart,* 71.

64. Brickley, "The Litchfield Female Academy," 61.

CONCLUSION

1. Derrida, "The Law of Genre."

2. See, for example, Jacobus, "Is There a Woman in This Text?"

3. Bagshawe, "Jane Parminter."

4. Pohl, *Women, Space and Utopia,* 94.

5. Farr, *The Gardens of Emily Dickinson,* 3.

6. See White, "'Sweet Skepticism of the Heart.'"

7. Quoted in ibid., 6.

8. Farr, *The Gardens of Emily Dickinson,* 9.

9. Ibid., 30.

10. Bennett, "The Pea That Duty Locks," 111.

11. Bennett, "Critical Clitoridectomy," 236.

12. Farr, *The Gardens of Emily Dickinson,* 34. Farr thinks it more likely that the identity of the "Master" is Samuel Bowles, the married editor with whom Dickinson corresponded.

13. Dickinson, *The Letters of Emily Dickinson,* vol. 2, 632.

14. Farr, *The Gardens of Emily Dickinson,* 151.

15. Ibid., 151, 158.

16. Ibid., 294.

17. Dickinson, *The Letters of Emily Dickinson,* vol. 1, 13.

18. Quoted in Farr, *The Gardens of Emily Dickinson,* 174.

19. Dickinson, *The Letters of Emily Dickinson,* vol. 3, 740.

20. Lewis's Ojibway name survives in a letter written by her friend Anne Whitney. Whitney tells the story, recounted to her by Lewis, of Lewis's 1868 surprise visit to one of her Mississauga aunts, who exclaimed, "Is that you, Ish-scoodah?" (Anne Whitney, "Letter to Sarah Whitney," Whitney Correspondence, December 12, 1869).

21. Quoted in Bearden and Henderson, *A History of African-American Artists from 1792 to the Present,* 61.

22. Ibid., 56.

23. Ibid.

24. Ibid., 58.

25. Bullard, "Letter from Rome," 1.

26. For a definitive account of Cushman and her circle from the perspective of lesbian history, see Vicinus, *Intimate Friends,* 31–60.

27. Bernier, *African American Visual Arts from Slavery to the Present,* 46.

28. Quoted in Bearden and Henderson, *A History of African-American Artists from 1792 to the Present,* 76. Douglass records that Lewis and Adelia Gates accompanied him and his wife on a trip to Naples.

29. Pomeroy, "Within Living Memory," 281. Pomeroy quotes a reviewer who noted that "a farmer wrote to her to say that he didn't know anything about poetry, but he could tell her that there was nothing wrong with her agriculture."

30. According to Stevens, *V. Sackville-West,* 179.

31. In addition to Pomeroy, "Within Living Memory," see Nagel, "Farming Poetry," 1–22.

32. "Until the appearance of Vita Sackville-West's *The Land* 1926, formal georgic is written by men" (Pellicer, "The Georgic," n.p.).

33. Sackville-West, *The Land,* 5.

34. Ibid., 40.

35. Bennett, "Pea That Duty Locks," 112, and "Critical Clitoridectomy," 255.

36. Sackville-West, *The Land,* 49.

37. See Blair, "Gypsies and Lesbian Desire," 141–66.

38. Nicolson, *Portrait of a Marriage,* 230.

39. Peters notes that although O'Keeffe considered the watercolors she sent to Stieglitz to be pure abstractions, they "seemed wholly sexual to the first viewers at 291 [Stieglitz's gallery] in 1916" (*Becoming O'Keeffe,* 29).

40. Quoted in Oaks, "Radical Writers and Women Artists Clash on Propaganda and Its Uses," 4.

41. Peters, *Becoming O'Keeffe,* 158.

42. Cowart, Hamilton, and Greenough, eds., *Georgia O'Keeffe: Art and Letters,* 180.

43. Quoted in Eisler, *O'Keeffe and Stieglitz,* 394–95. This entire anecdote is taken from Eisler's chapter "Up in Mabel's Room." Eisler calls the letters from this period "transparent with the wonder of passion" (395).

44. Eisler, *O'Keeffe and Stieglitz,* 400.

45. Quoted in ibid., 393.

46. Ibid., 393.

47. Strand, like O'Keeffe, was to resettle permanently in New Mexico, where she became proficient in the local women's craft of colcha needlework. Her embroidery and paintings on glass are in the collection of the Museum of Fine Arts in Santa Fe.

48. Quoted in Lynes, *Georgia O'Keeffe Museum Collections,* Plates 162–63.

49. Grimberg documents Kahlo's schoolgirl infatuation with her gym teacher, which led Kahlo's mother to transfer her to a coeducational school ("Introduction" in *Frida Kahlo,* 22) as well as her relationship with Lamba (*The Still Lifes,* 92). Grimberg writes that Kahlo "took lovers of both genders" throughout her life ("Introduction" in *Frida Kahlo,* 23). The detail about O'Keeffe is referenced in Dexter and Barson, eds., *Frida Kahlo,* 213.

50. Kahlo, "Sex," 103.

51. Campos, "My Memory of Frida," 39.

52. Grimberg documents the associations of these flowers with Kahlo and people in her life in *Still Lifes,* 93–94.

53. Dexter and Barson, eds., *Frida Kahlo,* 77.

54. For more information on La Llorona, see Perez's *There Was a Woman.* Dexter and Barson note that Kahlo sometimes signed herself "Frida, La Malinche" (*Frida Kahlo,* 70).

55. Dexter and Barson, eds., *Frida Kahlo,* 41.

56. Grimberg, *Still Lifes,* 43.

57. Chicago, *Beyond the Flower,* 141.

58. Chicago, *The Dinner Party,* 11.

59. Chicago quotes historian Gerda Lerner (*The Dinner Party,* 13).

60. Most recently, in the 2007 volume that accompanied the opening of the permanent installation of *The Dinner Party* in the Elizabeth A. Sackler Center for Feminist Art at the Brooklyn Museum, Chicago writes that she still "cannot explain why these accusations have continued to haunt both me and the piece; they have no basis in reality . . . Did I want to pay everyone? Of course. Was that a possibility? Absolutely not. But the important point is that *nobody cared.* Our motivation was not money; it was changing history, which was absolutely thrilling" (*The Dinner Party,* 14). It is certainly true that many of Chicago's collaborators on the project have gone on record as saying they valued the experience, including many who ultimately left because of differences with Chicago or loss of interest in continuing the work. However, it's not true that "nobody" among those who worked with Chicago "cared" about being paid or recognized as colleague artists. In her 2007 biography, Gail Levin, who is very sympathetic to Chicago throughout, has to admit that "not everyone who worked on *The Dinner Party* was so collegial," and she adduces several examples of dissatisfaction and criticism (*Becoming Judy Chicago,* 292). Note that Mary Delany's stunning embroidered botanical illustrations on a court dress, exhibited in 2009 at the Yale Center for British Art, were also stitched by professional embroiderers, not Delany herself (although she designed and oversaw the work).

61. Levin documents a brief affair with a participant in *The Dinner Party,* who remains nameless in the biography (as do all of Chicago's female lovers except the philanthropist and art patron Mary Ross Taylor, with whom she was involved for a few months in the late 1970s). As Levin remarks, "Chicago never publicly acknowledged her intimate relationship with Taylor; nor did she fully conceal it" (*Becoming Judy Chicago,* 337). In 1973 Chicago remarked, "I'm not a lesbian. Therefore my art is not universal . . . I think it presents a rich potential for subject matter, but it's hard subject matter to use and not fall into rhetoric. And I don't think I'm the right one to do it" (Quoted in Levin, *Becoming Judy Chicago,* 280).

62. Quoted in Levin, *Becoming Judy Chicago,* 280.

63. Ibid., 313.

64. Chicago, *The Dinner Party,* 19.

65. Calvo, "Art Comes for the Archbishop," 201.

66. For a fascinating study of Chicana/o cultural uses of la Llorona, see Perez, *There Was a Woman.* The triumvirate of la Llorona, la Virgen, and la Malinche was noticed by José Limón in his essay "La Llorona, the Third Legend of Greater Mexico."

67. Kyne, "Tee Corinne." Corinne's account of the women's back-to-the-land movement in southern Oregon in the 1970s and 1980s can be found in her essay "Communes, Communities and Cultural Institutions in Three Rural Counties" in *Wild Lesbian Roses,* 53–57.

68. Corinne, "Lesbian Photography on the West Coast, 1972–1997."

69. Ibid.

70. Corinne, "Photographing Our Homesteads" in *Wild Lesbian Roses,* 58–59.

71. Corinne's catalogue "Lesbian Artists: A List" includes artists discussed in this book: namely, Sarah Ponsonby, Edmonia Lewis, and Frida Kahlo (*Wild Lesbian Roses,* 62–63).

72. Guide to the Tee A. Corinne Papers, "Biographical Note," n.p.

73. Corinne, "The Future of Sex Writing," in *Wild Lesbian Roses,* 20.

74. Corinne, "Lesbian Photography on the West Coast, 1972–1997," n.p.

75. Rich, "Compulsory Heterosexuality and Lesbian Existence," 631–60.

76. Walker, *In Search of Our Mothers' Gardens,* 242.

77. Ibid., 241.

78. Quoted in Bernier, *African American Visual Arts,* 212.

79. Henry Louis Gates Jr. identified the importance of "signifying" as an African-American aesthetic practice of appropriation and invention in *The Signifying Monkey.*

80. Seward, "Letter to Josiah Wedgwood," February 22, 1788, Anna Seward Papers.

81. Garnet, "Allyson Mitchell," 15.

82. Cvetkovich, "Touching the Monster," 27. See also Cvetkovich's *Depression: A Public Feelings Project* for a more extended discussion of Mitchell's work.

83. Mitchell, "Deep Lez I Statement," 12.

84. Rhodes, "Allyson Mitchell Video."

85. Mitchell, "Artist's Statement for *Lady Sasquatch*," n.p. Mitchell has begun working with Native artists, activists, and communities to contextualize and create new meanings for these figures. For example, Mitchell spoke in July 2009 at the Winnipeg Art Gallery (Manitoba) on a panel accompanying her exhibition, entitled "Sightings at the Fringe: The Real Ladies Sasquatch." The event was a round table with Melissa Wastasecoot and Lynnel Sinclair from an organization called A.P.E.S. (Aboriginal People Enthusiastic for Sasquatches) (Allyson Mitchell, e-mail communication, August 11, 2009).

86. Garnet, "Allyson Mitchell," 14–15.

87. Cvetkovich, "Touching the Monster," 28.

88. Mitchell, "Artist's Statement for *Lady Sasquatch*," n.p.

89. Lecture, University of Texas at Austin, April 20, 2009.

90. Cvetkovich, "Touching the Monster," 29.

91. Mitchell, "Artist's Statement for *Lady Sasquatch*," n.p.

92. Allyson Mitchell, e-mail communication, August 11, 2009.

93. Mitchell, "Artist's Statement for *Lady Sasquatch*," n.p.

94. Rhodes, "Allyson Mitchell Video."

95. Cvetkovich, "Touching the Monster," 31.

96. Lecture, University of Texas at Austin, April 20, 2009.

97. Although Unca Trans refers to himself as male ("a guy like me"), here I am following the convention of using neologisms such as "zhe" and "shim" to clarify a subject's transgender identity.

98. Lecture, University of Texas at Austin, April 20, 2009. See the discussion of Casid's similar intervention in chapter 4 of *Sowing Empire*.

99. Mitchell, "Deep Lez I Statement," 12.

100. Corinne, "Lesbian Photography," 38.

Bibliography

Abelove, Henry. *Deep Gossip*. Minneapolis: University of Minnesota Press, 2005.

Addison, Joseph. "An Essay on the Georgics." In *The Works of John Dryden*, edited by William Frost and Vinton A. Dearing. Berkeley: University of California Press, 1987.

———. *Selections from Addison's Papers Contributed to the Spectator*, edited by Thomas Arnold. Oxford: Clarendon Press, 1891.

Agamben, Giorgio. *Stanzas: Word and Phantasm in Western Culture*, translated by Ronald L. Martinez. Minneapolis: University of Minnesota Press, 1993.

Andrews, Henry Charles. *Roses, or, A Monograph of the Genus Rosa*. London: Printed by R. Taylor and Company and published by the author, 1805–28.

Arnold, Kenneth, and Susan Pearce, eds. *Early Voices*. Vol. 2. Aldershot, U.K.: Ashgate, 2000.

Arts Council of Great Britain. *Painting from Nature: The Tradition of Open-Air Oil Sketching from the 17th to 19th Centuries*, edited by Janet Holt. London: Arts Council of Great Britain, 1980.

Bagshawe, Kaye. "Jane Parminter." In *Oxford Dictionary of National Biography*. Oxford: Oxford University Press, 2004.

Bakeland, Frederick. "Psychological Aspects of Art Collecting." In *Interpreting Objects and Collections*, edited by Susan M. Pearce. New York: Routledge, 1994.

Bannet, Eve Tavor. "The Bluestocking Sisters: Women's Patronage, Millenium Hall, and 'The Visible Providence of a Country.'" *Eighteenth-Century Life* 30, no. 1 (2005): 25–55.

Barchas, Janine, ed. *The Geography and Natural History of Mid-Eighteenth-Century Erotica*, edited by A. Pettit and P. Spedding. London: Pickering and Chatto, 2002.

Bearden, Romare, and Harry Henderson. *A History of African-American Artists from 1792 to the Present*. New York: Pantheon Books, 1993.

Belk, Russell W. "Collectors and Collecting." In *Interpreting Objects and Collections*, edited by Susan M. Pearce. New York: Routledge, 1994.

Belk, Russell W., and Melanie Wellendorf. "Of Mice and Men: Gender Identity." In *Interpreting Objects and Collections*, edited by Susan M. Pearce. New York: Routledge, 1994.

Bell, Susan Groag. "Women Create Gardens in Male Landscapes: A Revisionist Approach to Eighteenth-Century English Garden History." *Feminist Studies* 16 no. 3 (Fall 1990): 471–91.

Bennett, Chad. "Word of Mouth: Gossip and American Poetry." Ph.D. dissertation, Cornell University, 2010.

Bennett, Paula. "Critical Clitoridectomy: Female Sexual Imagery and Feminist Psychoanalytic Theory." *Signs* 18, no. 2 (1993): 235–59.

———. "The Pea That Duty Locks: Lesbian and Feminist-Heterosexual Readings of Emily Dickinson's Poetry." In *Lesbian Texts and Contexts: Radical Revisions*, edited by Karla Jay and Joanne Glasgow. New York: New York University Press, 1990.

Bentinck, Duchess of Portland Margaret Harley. "Letters to A. Dewes," August 24, 1737; June 2, 1742; 1768; n.d. Newport Reference Library, Newport, Wales.

——. "Letter to Lord Titchfield," 1763. Hallward Library, Nottingham, England.

Bentinck, William. "Letter to Lord Titchfield," 1751. Hallward Library, Nottingham, England.

——. "Letter to Sir Hans Sloane," n.d. Sloane Collection, British Library, London.

Bermingham, Ann. *Learning to Draw: Studies in the Cultural History of a Polite and Useful Art.* New Haven, Conn.: Yale University Press, 2000.

Bernier, Celeste-Marie. *African American Visual Arts from Slavery to the Present.* Chapel Hill: University of North Carolina Press, 2008.

Betts, Edwin Morris, and James Adam Bear, eds. *The Family Letters of Thomas Jefferson.* Columbia: University of Missouri Press, 1966.

Blair, Kirstie. "Gypsies and Lesbian Desire: Vita Sackville-West, Violet Trefusis, and Virginia Woolf." *Twentieth-Century Literature: A Scholarly and Critical Journal* 50, no. 2 (Summer 2004): 141–66.

Blauvelt, Martha Tomhave. *The Work of the Heart: Young Women and Emotion, 1780–1830.* Charlottesville: University of Virginia Press, 2007.

Blecki, Catherine La Courreye, and Karin A. Wulf, eds. *Milcah Martha Moore's Book: A Commonplace Book from Revolutionary America.* University Park: Pennsylvania State University Press, 1997.

Blunt, Wilfred (with the assistance of William T. Stearn). *The Art of Botanical Illustration.* London: Collins, 1950.

Bona, Mary Jo. "Gay and Lesbian Writing in Post-World War II America." In *A Concise Companion to Postwar American Literature and Culture,* edited by Josephine Hendin. Malden, Mass.: Blackwell Publishing, 2004.

Boulukos, George. *The Grateful Slave: The Emergence of Race in Eighteenth-Century British and American Culture.* Cambridge: Cambridge University Press, 2008.

Brickley, Lynne Templeton. "The Litchfield Female Academy." In *To Ornament Their Minds: Sarah Pierce's Litchfield Female Academy, 1792–1833,* edited by Catherine Keene Fields and Lisa C. Kightlinger. Litchfield, Conn.: Litchfield Historical Society, 1993.

——. "Sarah Pierce's Litchfield Female Academy, 1792–1833." Ph.D. dissertation, Harvard University, 1985.

Brideoake, Fiona. "'Extraordinary Female Affection': The Ladies of Llangollen and the Endurance of Queer Community." *Romanticism on the Net: An Electronic Journal Devoted to Romantic Studies* (November 2004–February 2005): 36–37.

Brooks, Joanna. *American Lazarus: Religion and the Rise of African-American and Native American Literatures.* Oxford: Oxford University Press, 2003.

Brown, Bill. "Thing Theory." *Critical Inquiry* 28, no. 1 (2001): 1–21.

Brown, Irene Q. "Domesticity, Feminism, and Friendship: Female Aristocratic Culture and Marriage in England, 1660–1760." *Journal of Family History* 7, no. 4 (1982): 406–24.

Browne, Claire. "Mary Delany's Embroidered Court Dress." In *Mrs. Delany and Her Circle,* edited by Mark Laird and Alicia Weisberg-Roberts. New Haven, Conn.: Yale Center for British Art, 2009.

Brueckner, Martin. *The Geographic Revolution in Early America: Maps, Literacy, and National Identity.* Chapel Hill: University of North Carolina Press, 2006.

Bullard, Laura Curtis. "Letter from Rome." *New National Era* (May 4, 1871): 1.

Calvo, Luz. "Art Comes for the Archbishop: The Semiotics of Contemporary Chicana Feminism and the Art of Alma Lopez." *Meridians: Feminism, Race, Transnationalism* 5 (2004): 201–24.

Campbell-Orr, Clarissa. "Mrs. Delany and the Court." In *Mrs. Delany and Her Circle,* edited by Mark Laird and Alicia Weisberg-Roberts. New Haven, Conn.: Yale University Press, 2009.

Campos, Olga. "My Memory of Frida." In *Frida Kahlo: Song of Herself,* edited by Salomon Grimberg. London: Merrell, 2008.

Casid, Jill H. *Sowing Empire: Landscape and Colonization.* Minneapolis: University of Minnesota Press, 2005.

Castle, Terry. *The Apparitional Lesbian: Female Homosexuality and Modern Culture.* New York: Columbia University Press, 1995.

———, ed. *The Literature of Lesbianism: A Historical Anthology from Ariosto to Stonewall.* New York: Columbia University Press, 2005.

Chicago, Judy. *Beyond the Flower: The Autobiography of a Feminist Artist.* New York: Viking, 1996.

———. *The Dinner Party: From Creation to Preservation.* London: Merrell, 2007.

Choudhoury, Mita. *Convents and Nuns in Eighteenth-Century French Politics and Culture.* Ithaca, N.Y.: Cornell University Press, 2004.

Clayton, Howard. *Coaching City: A Glimpse of Georgian Lichfield.* Bala, North Wales: Dragon Books, 1971.

Clifford, James. "Collecting Ourselves." In *Interpreting Objects and Collections,* edited by Susan M. Pearce. New York: Routledge, 1994.

Coats, Alice M. *The Treasury of Flowers.* London: Phaidon Press, in association with the Royal Horticultural Society, 1975.

Cohen, Lisa. "Velvet Is Very Important: Madge Garland and the Work of Fashion." *GLQ: A Journal of Lesbian and Gay Studies* 11, no. 3 (2005): 371–90.

Collins, A. *Historical Collections of the Noble Families of Cavendishe, Holles, Vere, Harley and Ogle.* London: Printed for Edward Withers, 1752.

Connolly, S. J. "A Woman's Life in Mid-Eighteenth-Century Ireland: The Case of Letitia Bushe." *Historical Journal* 34, no. 2 (2000): 433–51.

Cook, Alexandra. "Botanical Exchanges: Jean-Jacques Rousseau and the Duchess of Portland." *History of European Ideas* 33, no. 2 (2007): 142–56.

———. "Jean-Jacques Rousseau and 'Exotic Botany.'" *Eighteenth-Century Life* 26, no. 3 (2002): 181–201.

Corinne, Tee. "Communes, Communities and Cultural Institutions in Three Rural Counties." In *Wild Lesbian Roses: Essays on Art, Rural Living and Creativity, 1986–1994.* Wolf Creek, Ore.: Pearlchild, 1997.

———. "Lesbian Photography on the West Coast 1972–1997." Women Artists of the American West, http://www.cla.purdue.edu/waaw/Corinne/.

———. "The Tee A. Corinne Papers: Biographical Note." Northwest Digital Archives (NWDA), http://nwda-db.wsulibs.wsu.edu/findaid/ark:/80444/xv98508.

Cott, Nancy. *The Bonds of Womanhood: "Woman's Sphere" in New England, 1780–1935.* New Haven, Conn.: Yale University Press, 1977.

Cowart, Jack, Juan Hamilton, and Sarah Greenough, eds. *Georgia O'Keeffe: Art and Letters.* Washington, D.C.: National Gallery of Art, 1987.

Cowell, Pattie. "'Womankind Call Reason to Their Aid': Susanna Wright's Verse Epistle on the Status of Women in Eighteenth-Century America." *Signs: Journal of Women in Culture and Society* 6, no. 4 (1981): 795–800.

Crain, Caleb. *American Sympathy: Men, Friendship, and Literature in the New Nation.* New Haven, Conn.: Yale University Press, 2001.

Crimp, Douglas. "Mourning and Militancy." *October* 51 (Winter 1989): 3–18.

Curran, Stuart. "Anna Seward and the Dynamics of Female Friendship." In *Romantic Women Poets: Genre and Gender*, ed. Lilla Marie Crisafulli and Cecilia Pietropoli. Amsterdam: Rodopi, 2007. 11–22.

Cvetkovich, Ann. *An Archive of Feelings: Trauma, Sexuality, and Lesbian Public Cultures*. Durham, N.C.: Duke University Press, 2003.

———. *Depression: A Public Feelings Project*. Durham, N.C.: Duke University Press, 2011.

———. "Touching the Monster: Deep Lez in Fun Fur." In *Allyson Mitchell: Ladies Sasquatch*. Hamilton, Ontario: McMaster Museum of Art, 2009.

Daniels, Stephen. *Fields of Vision: Landscape Imagery and National Identity in England and the United States*. Princeton, N.J.: Princeton University Press, 1993.

Darwin, Erasmus. *The Botanic Garden. A Poem, in Two Parts. Part I, Containing the Economy of Vegetation. Part II, The Loves of the Plants. With Philosophical Notes*. 2nd American edition, edited by Elihu Hubbard Smith and including Smith's "Epistle to the Author of the Botanic Garden." New York: T. and J. Swords, 1807.

Davidson, Cathy. *Revolution and the Word: The Rise of the Novel in America*. New York: Oxford University Press, 1986.

Delany, Mary Granville Pendarves. *The Autobiography and Correspondence of Mary Granville, Mrs. Delany*, edited by Lady Augusta Waddington Llanover. 6 vols. London: Richard Bentley, 1861–62.

———. Delany Letters. Newport Reference Library, Newport, Wales.

———. "Letters to Lady Andover," 1768; 1772; 1776. Osborn Collection, Beinecke Library, Yale University, New Haven, Conn.

———. "Letter to Miss Mary Port," 1769. Osborn Collection, Beinecke Library, Yale University, New Haven, Conn.

D'Emilio, John, and Estelle B. Freedman. *Intimate Matters: A History of Sexuality in America*. New York: Perennial Library, 1989.

Derrida, Jacques. "The Law of Genre." In *Modern Genre Theory*, edited by David Duff. London: Longman, 2000.

Dexter, Emma, and Tanya Barson, eds. *Frida Kahlo*. London: Tate Publishing, 2005.

Dickinson, Emily. *The Letters of Emily Dickinson*, edited by Thomas H. Johnson. 3 vols. Cambridge, Mass.: The Belknap Press of Harvard University Press, 1958.

———. *Poems*, edited by Mabel Loomis Todd and Thomas Wentworth Higginson. Boston: Roberts Brothers, 1892.

Dolan, Jill. *Utopia in Performance: Finding Hope at the Theater*. Ann Arbor: University of Michigan Press, 2005.

Donoghue, Emma. *Passions between Women: British Lesbian Culture, 1668–1801*. New York: Harper Collins, 1993.

Dowling, William C. *Poetry and Ideology in Revolutionary Connecticut*. Athens: University of Georgia Press, 1990.

Downing, A. J. *A Treatise on the Theory and Practice of Landscape Gardening*. New York: A. O. Moore, 1859.

Duckworth, Alistair. *The Improvement of the Estate*. Baltimore: Johns Hopkins University Press, 1994.

Duff, David. "Introduction." In *Modern Genre Theory*, edited by David Duff. London: Longman, 2000.

Easton, Celia A. "Were the Bluestockings Queer? Elizabeth Carter's Uranian Friendships." *Age of Johnson* 9 (1998): 257–94.

Edmondson, John. "Novelty in Nomenclature: The Botanical Horizons of Mary Delany." In *Mrs. Delany and Her Circle,* edited by Mark Laird and Alicia Weisberg-Roberts. New Haven, Conn.: Yale Center for British Art, 2009.

Eisler, Benita. *O'Keeffe and Stieglitz: An American Romance.* New York: Doubleday, 1991.

Eng, David L. *Loss: The Politics of Mourning.* Berkeley: University of California Press, 2003.

Fabricant, Carole. "Binding and Dressing Nature's Loose Tresses: The Ideology of Augustan Landscape Design." In *Studies in Eighteenth-Century Culture,* edited by Roseann Runte. Madison: University of Wisconsin Press, 1979.

Faderman, Lillian, ed. *Chloe plus Olivia: An Anthology of Lesbian Literature from the Seventeenth Century to the Present.* New York: Viking, 1994.

———. *Surpassing the Love of Men: Romantic Friendship and Love between Women from the Renaissance to the Present.* New York: William Morrow, 1981.

Fadiman, Anne. *At Large and at Small: Familiar Essays.* New York: Farrar, Straus and Giroux, 2007.

Farber, Jessie Lie. "Early American Gravestones: Introduction to the Farber Gravestone Collection." American Antiquarian Society, http://www.davidrumsey.com/farber/.

Farr, Judith. *The Gardens of Emily Dickinson.* Cambridge, Mass.: Harvard University Press, 2004.

Festing, Sally. "The Second Duchess of Portland and Her Rose." *Garden History* 14, no. 2 (1986): 194–200.

Finch, Annie. "Marilyn Hacker: An Interview on Form by Annie Finch." *American Poetry Review* 25, no. 3 (May 1996): 24.

Fitzmaurice, James. "Margaret Cavendish." In *Oxford Dictionary of National Biography.* Oxford: Oxford University Press, 2004.

Formanek, Ruth. "Why They Collect: Collectors Reveal Their Motivations." In *Interpreting Objects and Collections,* edited by Susan M. Pearce. New York: Routledge, 1994.

Freud, Sigmund. *A General Selection from the Works of Sigmund Freud,* edited by John Rickman. New York: Anchor Books, 1989.

Garnet, Carla. "Allyson Mitchell: The Ladies Sasquatch, Theory and Practice." In *Allyson Mitchell: Ladies Sasquatch.* Hamilton, Ontario: McMaster Museum of Art, 2009.

Gates, Henry Louis Jr. *The Signifying Monkey: A Theory of African-American Literary Criticism.* New York: Oxford University Press, 1989.

Goodman, Robert F., and Aaron Ben-Ze'ev, eds. *Good Gossip.* Lawrence: University Press of Kansas, 1994.

Greene, Jody. "Introduction: The Work of Friendship." *GLQ: A Journal of Lesbian and Gay Studies* 10, no. 3 (2004): 319–37.

Grieff, Constance M. "The Architecture of Morven." In *A House Called Morven: Its Role in American History,* edited by Alfred Hoyt Bill and Walter E. Edge. Princeton, N.J.: Princeton University Press, 1978.

Grimberg, Salomon. *Frida Kahlo: The Still Lifes.* London: Merrell, 2008.

———. "Introduction." In *Frida Kahlo: Song of Herself,* edited by Salomon Grimberg. London: Merrell, 2008.

Guibbory, Achsah. "Conversation, Conversion, Messianic Redemption: Margaret Fell, Menasseh Benisrael, and the Jews." In *Literary Circles and Cultural Communities in Renaissance England,* edited by Claude J. Summers and Ted-Larry Pebworth. Columbia: University of Missouri Press, 2000.

Haggerty, George E. "Love and Loss: An Elegy." *GLQ: A Journal of Lesbian and Gay Studies* 10, no. 3 (2004): 385–405.

————. *Men in Love: Masculinity and Sexuality in the Eighteenth Century.* New York: Columbia University Press, 1999.

————. "Queering Horace Walpole." SEL: *Studies in English Literature* 46, no. 3 (Summer 2006): 543–61.

————. "'The Voice of Nature' in Gray's *Elegy.*" In *Homosexuality in Renaissance and Enlightenment England: Literary Representations in Historical Context,* edited by Claude J. Summers. New York: Haworth Press, 1992.

Halberstam, Judith. *In a Queer Time and Place: Transgender Bodies, Subcultural Lives.* New York: New York University Press, 2005.

Harris, Sharon M., ed. *American Women Writers to 1800.* New York: Oxford University Press, 1996.

Hayden, Ruth. *Mrs. Delany, Her Life and Her Flowers.* New York: New Amsterdam Books, 1980.

Heffernan, James A. W. *Museum of Words: The Poetics of Ekphrasis from Homer to Ashbery.* Chicago: University of Chicago Press, 1993.

Herz, Judith Scherer. "Of Circles, Friendship, and the Imperatives of Literary History." In *Literary Circles and Cultural Communities in Renaissance England,* edited by Claude J. Summers and Ted-Larry Pebworth. Columbia: University of Missouri Press, 2000.

Hoffman, Tyler B. "Representing AIDS: Thom Gunn and the Modalities of Verse." *South Atlantic Review* 65 no. 2 (Spring 2000): 1–27.

Hunt, John Dixon. *The Genius of the Place: The English Landscape Garden, 1620–1820.* Cambridge, Mass.: MIT Press, 1990.

Hurley, Ann, and Kate Greenspan, eds. *So Rich a Tapestry: The Sister Arts and Cultural Studies.* Lewisburg, Pa.: Bucknell University Press; London: Associated University Presses, 1995.

Hyde, Lewis. *The Gift: Creativity and the Artist in the Modern World.* New York: Random House, 1979.

Jackson, Hazelle. *Shell Houses and Grottoes.* Oxford: Osprey Publishing, 2001.

Jacobus, Mary. "Is There a Woman in This Text?" In *Reading Women: Essays in Feminist Criticism.* New York: Columbia University Press, 1986.

Jameson, Fredric. *The Political Unconscious: Narrative as a Socially Symbolic Act.* Ithaca, N.Y.: Cornell University Press, 1981.

Jellicoe, Geoffrey, Susan Jellicoe, Patrick Goode, and Michael Lancaster, eds. *The Oxford Companion to Gardens.* Oxford: Oxford University Press, 1986.

Juhasz, Alexandra. "Video Remains: Nostalgia, Technology, and Queer Archive Activism." GLQ: *A Journal of Lesbian and Gay Studies* 12, no. 2 (2006): 319–28.

Kahlo, Frida. "Sex." In *Frida Kahlo: Song of Herself,* edited by Salomon Grimberg. London: Merrell, 2008.

Kerber, Linda. *Women of the Republic: Intellect and Ideology in Revolutionary America.* Chapel Hill: University of North Carolina Press, 1986.

Kornwolk, James D. "The Picturesque in the American Garden and Landscape before 1800." In *British and American Gardens in the Eighteenth Century: Eighteen Illustrated Essays on Garden History,* edited by Robert P. Maccubin and Peter Martin. Williamsburg, Va.: Colonial Williamsburg Foundation, 1984.

Krueger, Glee. "Paper and Silk: The Ornamental Arts of the Litchfield Female Academy." In *To Ornament Their Minds: Sarah Pierce's Litchfield Female Academy, 1792–1833,* edited by Catherine Keene Fields and Lisa C. Kightlinger. Litchfield, Conn.: Litchfield Historical Society, 1993.

Kyne, Barbara. "Tee Corinne: Obscurely Famous." Queer Arts Resource, http://www.queer-arts.org/archive/9809/corinne/corinne.html.

Laird, Mark. "Introduction: Mrs. Delany and Compassing the Circle: The Essays Introduced." In *Mrs. Delany and Her Circle*, edited by Mark Laird and Alicia Weisberg-Roberts. New Haven, Conn.: Yale Center for British Art, 2009.

———. "Mrs. Delany's Circles of Cutting and Embroidering in Home and Garden." In *Mrs. Delany and Her Circle*, edited by Mark Laird and Alicia Weisberg-Roberts. New Haven, Conn.: Yale Center for British Art, 2009.

Laird, Mark, and Alicia Weisberg-Roberts, eds. *Mrs. Delany and Her Circle*. New Haven, Conn.: Yale Center for British Art, 2009.

Landes, Joan B. *Women and the Public Sphere in the Age of the French Revolution*. Ithaca, N.Y.: Cornell University Press, 1998.

Lanser, Susan S. "Befriending the Body: Female Intimacies as Class Acts." *Eighteenth Century Studies* 32, no. 2 (1998–1999): 179–98.

Lauter, Paul, ed. *The Heath Anthology of American Literature*. 5 vols. Boston: Houghton Mifflin, 2006.

Leonardo da Vinci. *Leonardo on Painting*, edited by Martin Kemp. New Haven, Conn.: Yale University Press, 1989.

Levin, Gail. *Becoming Judy Chicago: A Biography of the Artist*. New York: Harmony Books, 2007.

Lightfoot, John. "Letter to the Duchess of Portland," n.d. Hallward Library, Nottingham, England.

Limón, José. "La Llorona, the Third Legend of Greater Mexico: Cutural Symbols, Women, and the Political Unconscious." In *Between Borders: Essays on Mexicana/Chicana History*, edited by Adelaida R. Del Castillo. Encino, Calif.: Floricanto, 1990.

Lister, Anne. *I Know My Own Heart: The Diaries of Anne Lister, 1791–1840*, edited by Helena Whitbread. New York: New York University Press, 1992.

Love, Heather. *Feeling Backward: Loss and the Politics of Queer History*. Cambridge, Mass.: Harvard University Press, 2009.

Lynes, Barbara Buhler. *Georgia O'Keeffe Museum Collections*. New York: Abrams, 2007.

Malin, Edward, and the Knight of Glin. *Lost Demesnes: Irish Landscape Gardening, 1660–1845*. London: Barrie and Jenkins, 1976.

Manalansan, Martin F. IV. "Diasporic Deviants/Divas: How Gay Filipino Transmigrants 'Play with the World.'" In *Queer Diasporas*, edited by Cindy Patton and Benigno Sanchez-Eppler. Durham, N.C.: Duke University Press, 2000.

Martinez, Michelle. "Women Poets and the Sister Arts in Nineteenth-Century England." *Victorian Poetry* 41, no. 4 (2003): 621–28.

Mavor, Elizabeth. "Lady (Charlotte) Eleanor Butler (1739–1829)" In *Oxford Dictionary of National Biography*. Oxford: Oxford University Press, 2004.

———. *A Year with the Ladies of Llangollen*. New York: Penguin, 1984.

McManus, Edgar J. *Black Bondage in the North*. Syracuse: Syracuse University Press, 1973.

Miller, D. A. *The Novel and the Police*. Berkeley: University of California Press, 1988.

Mitchell, Allyson. "Artist's Statement for *Lady Sasquatch*." Paul Petro Gallery, http://www.paulpetro.com/mitchell/2005.shtml.

———. "Deep Lez I Statement." In *Allyson Mitchell: Ladies Sasquatch*. Hamilton, Ontario: McMaster Museum of Art, 2009.

Mitchell, W. J. T. "Going Too Far with the Sister Arts." In *Space, Time, Image, Sign: Essays on Literature and the Visual Arts*, edited by James A. W. Heffernan. New York: Peter Lang, 1987.

———. *Iconology: Image, Text, Ideology*. Chicago: University of Chicago Press, 1986.

Moon, Michael. *A Small Boy and Others: Imitation and Initiation in American Culture from Henry James to Andy Warhol.* Durham, N.C.: Duke University Press, 1998.

Moore, Lisa L. *Dangerous Intimacies: Toward a Sapphic History of the British Novel.* Durham, N.C.: Duke University Press, 1997.

———. "Queer Gardens: Mary Delany's Flowers and Friendships." *Eighteenth-Century Studies* 29, no. 1 (Fall 2005): 49–70.

———. "The Swan of Litchfield: Sarah Pierce and the Lesbian Pastoral Poem." In *Long before Stonewall: Histories of Same-Sex Sexuality in Early America,* edited by Thomas A. Foster. New York: New York University Press, 2007.

———. "Virtual Delville as Archival Research: Rendering Women's Garden History Visible." *Poetess Archive Journal* 2, no. 1 (2010), http://paj.muohio.edu/paj/index.php/paj.

Morris, Charles E. "Archival Queer." *Rhetoric and Public Affairs* 9, no. 1 (2006 Spring): 145–51.

Morris, Mitchell. "Stories Coming Out." *Journal of Popular Music Studies* 18, no. 2 (2006): 220–40.

Mulford, Carla, ed. *Only for the Eye of a Friend: The Poems of Annis Boudinot Stockton.* Charlottesville: University Press of Virginia, 1995.

Myers, Sylvia Harcstark. *The Bluestocking Circle: Women, Friendship, and the Life of the Mind in Eighteenth-Century England.* Oxford: Clarendon Press; New York: Oxford University Press, 1990.

Nagel, Rebecca. "Farming Poetry: Vita Sackville-West and Virgil's Georgics." *Classical and Modern Literature* 24, no. 1 (2004): 1–22.

Nicolson, Nigel. *Portrait of a Marriage.* New York: Atheneum, 1973.

North, Lord Francis. "Letter to Mary Delany," August 2, 1781. Osborn Collection, Beinecke Library, Yale University, New Haven, Conn.

Oaks, Gladys. "Radical Writers and Women Artist Clash on Propaganda and Its Uses." *New York World* (March 16, 1930): 4.

Parker, Rozsika, and Griselda Pollock. *Old Mistresses: Women, Art and Ideology.* New York: Pantheon, 1981.

Parrish, Susan Scott. *American Curiosity: Cultures of Natural History in the Colonial British Atlantic World.* Chapel Hill: University of North Carolina Press, 2006.

Parsons, Nicola. *Reading Gossip in Early Eighteenth-Century England.* London: Palgrave Macmillan, 2009.

Pascoe, Judith. *The Hummingbird Cabinet: A Rare and Curious History of Romantic Collectors.* Ithaca, N.Y.: Cornell University Press, 2005.

Pearce, Susan M. "The Urge to Collect." In *Interpreting Objects and Collections,* edited by Susan M. Pearce. New York: Routledge, 1994.

Pellicer, Juan Christian. "The Georgic." In *A Companion to Eighteenth-Century Poetry,* edited by Christine Gerrard. Blackwell Reference Online, www.blackwellreference.com.

Perez, Domino Renee. *There Was a Woman: La Llorona from Folklore to Popular Culture.* Austin: University of Texas Press, 2008.

Peters, Sarah Whitaker. *Becoming O'Keeffe: The Early Years.* 2nd ed. New York: Abbeville Press, 2001.

Pierce, Sarah. "Address at the Close of School, October 29, 1818." In *Chronicles of a Pioneer School from 1792 to 1833: Being the History of Miss Sarah Pierce and Her Litchfield School,* edited by Elizabeth C. Barney Buel and Emily Noyes Vanderpoel. Cambridge, Mass: The University Press, 1903.

Pilkington, Laetitia. *Memoirs of Laetitia Pilkington,* ed. A. C. Elias Jr. 2 vols. Athens: University of Georgia Press, 1997.

Pohl, Nicole. *Women, Space and Utopia, 1600–1800.* New York: Ashgate, 2006.

Pomeroy, Elizabeth W. "Within Living Memory: Vita Sackville-West's Poems of Land and Garden." *Twentieth Century Literature: A Scholarly and Critical Journal* 28, no. 3 (1982): 269–89.

Pope, Alexander. "Elegy to the Memory of an Unfortunate Lady" (1717). In *The Poems of Alexander Pope,* edited by John Butt. New Haven, Conn.: Yale University Press, 1919.

———. "Essay on Criticism." In *Miscellaneous Poems and Translations, by Several Hands.* London: Printed for Bernard Lintot between the Temple-Gates in Fleet-Street, 1720.

Postgate, R. W. *That Devil Wilkes.* Rev. ed. London: Dobson, 1956.

Propp, Vladimir. "Fairy Tale Transformations." In *Modern Genre Theory,* edited by David Duff. London: Longman, 2000.

Reeder, Kohleen. "The 'Paper-Mosaick' Practice of Mrs. Delany and Her Circle." In *Mrs. Delany and Her Circle,* edited by Mark Laird and Alicia Weisberg-Roberts. New Haven, Conn.: Yale Center for British Art, 2009.

Repton, Humphrey. *An Enquiry into the Changes of Taste in Landscape Gardening.* London: Printed for J. Taylor, 1806.

———. *Fragments on the Theory and Practice of Landscape Gardening.* New York: Garland Publishing, 1982.

Retzloff, Tim. "From Storage Box to Computer Screen: Disclosing Artifacts of Queer History in Michigan." *GLQ: A Journal of Lesbian and Gay Studies* 7, no. 1 (2001): 153–81.

Rhodes, Richard. "Allyson Mitchell Video: Interview with a Sasquatch." Canadian Art, http://www.canadianart.ca/online/video/2009/01/15/allyson-mitchell/.

Rich, Adrienne. "Compulsory Heterosexuality and Lesbian Existence." *Signs* 5, no. 4 (Summer 1980): 631–60.

Riegel, Christian. *Response to Death: The Literary Work of Mourning.* Edmonton: University of Alberta Press, 2005.

Robinson, E. "Letter to Duchess of Portland," n.d. Hallward Library, Nottingham, England.

———. "Letter to Margaret Harley Bentinck," n.d. Hallward Library, Nottingham, England.

Roscoe, William. "Biography of Miss Anna Seward." *The Weekly Magazine of Original Essays, Fugitive Pieces, and Interesting Intelligence* 4, no. 45 (1799): 169–75.

Ross, Stephanie. *What Gardens Mean.* Chicago: University of Chicago Press, 1998.

Rothstein, Eric. *Restoration and Eighteenth-Century Poetry, 1660–1780.* Boston: Routledge and Kegan Paul, 1981.

Sackville-West, Vita. *The Land.* New York: George H. Doran, 1927.

Schiebinger, Londa, and Claudia Swan, eds. *Colonial Botany: Science, Commerce, and Politics in the Early Modern World.* Philadelphia: University of Pennsylvania Press, 2005.

Schweitzer, Ivy. *Perfecting Friendship: Politics and Affiliation in Early American Literature.* Chapel Hill: University of North Carolina Press, 2006.

Scodel, Joshua. *The English Poetic Epitaph: Commemoration and Conflict from Jonson to Wordsworth.* Ithaca, N.Y.: Cornell University Press, 1991.

Sedgwick, Eve Kosofsky. *Epistemology of the Closet.* Berkeley: University of California Press, 1990.

———. *Touching Feeling: Affect, Pedagogy, Performativity.* Durham, N.C.: Duke University Press, 2003.

Sedgwick, Eve Kosofsky, and Adam Fran, eds. *Shame and Its Sisters: A Silvan Tomkins Reader.* Durham, N.C.: Duke University Press, 1995.

Seward, Anna. "Biographical Sketch of Miss Seward." Manuscript. Staffordshire Record Office, Stafford, England.

———. Letters. Samuel Johnson Birthplace Museum, Lichfield, England.

——. *Letters of Anna Seward: Written between the Years 1784 and 1807,* edited by A. Constable. 6 vols. Edinburgh: George Ramsay and Company, 1811.

——. "Letter to Josiah Wedgwood," February 22, 1788. Anna Seward Papers. John Rylands University Library, Manchester, England.

——. *Memoirs of the Life of Dr. Darwin.* London: Printed for J. Johnson by T. Bensley, 1804.

——. *Original Sonnets on Various Subjects, and Odes, Paraphrased from Horace.* London: Printed for G. Sael, 1799.

——. *The Poetical Works of Anna Seward,* edited by Walter Scott. 3 vols. Edinburgh: John Ballantyne and Co.; London: Longman, Hurst, Rees, and Orme, 1810.

Shannon, Laurie. "Poetic Companies: Musters of Agency in George Gascoigne's 'Friendly Verse.'" *GLQ: A Journal of Lesbian and Gay Studies* 10, no. 3 (2004): 453–83.

Shields, David. *Civil Tongues and Polite Letters in British America.* Chapel Hill: University of North Carolina Press, 1997.

Shteir, Ann B. *Cultivating Women, Cultivating Science: Flora's Daughters and Botany in England, 1760–1860.* Baltimore: Johns Hopkins University Press, 1996.

Sizer, Theodore, and Nancy Sizer. "Introduction." In *To Ornament Their Minds: Sarah Pierce's Female Academy, 1792–1833,* edited by Catherine Keene Fields and Lisa C. Kightlinger. Litchfield, Conn.: Litchfield Historical Society, 1993.

Slatter, Enid. "George Dionysius Ehret." In *Oxford Dictionary of National Biography.* Oxford: Oxford University Press, 2004.

Smith, E. H. *Diary of Elihu Hubbard Smith,* edited by James E. Cronin. Philadelphia: American Philosophical Society, 1973.

Smith-Rosenberg, Carroll. *Disorderly Conduct: Visions of Gender in Victorian America.* Oxford: Oxford University Press, 1985.

Spacks, Patricia Meyer. *Gossip.* Chicago: University of Chicago Press, 1986.

Stabile, Susan M. *Memory's Daughters: The Material Culture of Remembrance in Eighteenth-Century America.* Ithaca, N.Y.: Cornell University Press, 2004.

Stevens, Michael. *V. Sackville-West.* New York: Scribner, 1974.

Stewart, Susan. *On Longing: Narratives of the Miniature, the Gigantic, the Souvenir, the Collection.* Baltimore: Johns Hopkins University Press, 1984.

Stott, Rebecca. *Duchess of Curiosities: The Life of Margaret, Duchess of Portland.* Welbeck, U.K..: Pineapple Press, 2006.

Swann, Marjorie. *Curiosities and Texts: The Culture of Collecting in Early Modern England.* Philadelphia: University of Pennsylvania Press, 2001.

Swift, Jonathan. *An Epistle upon an Epistle from a Certain Doctor to a Certain Great Lord: Being a Christmas-Box for D. D––Ny.* Dublin: Printed in the year 1730.

Taylor, Diana. *The Archive and the Repertoire.* Durham, N.C.: Duke University Press, 2003.

Teute, Fredrika J. "The Loves of the Plants; or, the Cross-Fertilization of Science and Desire at the End of the Eighteenth Century." *Huntington Library Quarterly* 63, no. 3 (2000): 319–45.

Thomas, Gill. *Some Account of the Roses in the Garden at Plas Newydd.* Llangollen, Wales: Hanes Llangollen History, 2006.

Thomas, Nicholas. *Entangled Objects: Exchange, Material Culture, and Colonialism in the Pacific.* Cambridge, Mass.: Harvard University Press, 1991.

Tinsley, Omise'eke Natasha. "Black Atlantic, Queer Atlantic: Queer Imaginings of the Middle Passage." *GLQ: A Journal of Lesbian and Gay Studies* 14, no. 2–3 (2008): 191–215.

Todd, Janet. *Women's Friendship in Literature.* New York: Columbia University Press, 1980.

Todorov, Tzvetan. *Genres in Discourse.* Translated by Catherine Porter. Cambridge: Cambridge University Press, 1990.

Tomasi, Lucia Tongiorgi. *An Oak Spring Flora: Flower Illustration from the Fifteenth Century to the Present Time.* Upperville, Va.: Oak Spring Garden Library, 1997.

Traub, Valerie. "Friendship's Loss: Alan Bray's Making of History." *GLQ: A Journal of Lesbian and Gay Studies* 10, no. 3 (2004): 339–65.

———, ed. *The Renaissance of Lesbianism in Early Modern England.* Cambridge: Cambridge University Press, 2002.

Turner, James. "The Sexual Politics of Landscape: Images of Venus in Eighteenth-Century English Poetry and Landscape Gardening." In *Studies in Eighteenth-Century Culture,* edited by Harry C. Payne. Madison: University of Wisconsin Press, 1982.

Vermeule, Blakey. "Gossip and Literary Narrative." *Philosophy and Literature* 30, no. 1 (April 2006): 102–17.

Vicinus, Martha. *Intimate Friends: Women Who Loved Women, 1778–1928.* Chicago: University of Chicago Press, 2004.

Vickery, Amanda. "The Theory and Practice of Female Accomplishment." In *Mrs. Delany and Her Circle,* edited by Mark Laird and Alicia Weisberg-Roberts. New Haven, Conn.: Yale University Press, 2009.

von Frank, Albert J. "Sarah Pierce and the Poetic Origins of Utopian Feminism in America." *Prospects: An Annual Journal of American Cultural Studies* 14 (1989): 45–63.

Walker, Alice. *In Search of Our Mothers' Gardens: Womanist Prose.* San Diego: Harcourt Brace Jovanovich, 1983.

Walker, Claire. *Gender and Politics in Early Modern Europe: English Convents in France and the Low Countries.* New York: Palgrave Macmillan, 2003.

Walker, Susan. *The Portland Vase.* London: British Museum Press, 2004.

Walpole, Horace. *The Duchess of Portland's Museum,* edited by W. W. Lewis. New York: The Grolier Club, 1936 [1785].

———. "The History of Modern Taste in Gardening." In *Horace Walpole: Gardenist,* edited by Isabel Wakelin Urban Chase. Princeton, N.J.: Princeton University Press, 1943 [1798].

———. *On Modern Gardening,* edited by Rebecca More. Hackney, England: Stourton Press, 1987 [1780].

Waterman, Bryan. *Republic of Intellect: The Friendly Club of New York City and the Making of American Literature.* Baltimore: Johns Hopkins University Press, 2007.

Weisberg-Roberts, Alicia. "Introduction: Mrs. Delany from Source to Subject." In *Mrs. Delany and Her Circle,* edited by Mark Laird and Alicia Weisberg-Roberts. New Haven, Conn.: Yale Center for British Art, 2009.

Weltman-Aron, Brigitte. *On Other Grounds: Landscape Gardening and Nationalism in Eighteenth-Century England and France.* Albany: State University of New York Press, 2001.

Wendorf, Richard, ed. *Articulate Images: The Sister Arts from Hogarth to Tennyson.* Minneapolis: University of Minnesota Press, 1983.

Wettlaufer, Alexandra. "Composing Romantic Identity: Berlioz and the Sister Arts." *Romance Studies* 25, no. 1 (2007): 43–56.

White, Fred D. "'Sweet Skepticism of the Heart': Science in the Poetry of Emily Dickinson." *College Literature* 19, no. 1 (1992): 121–28.

Whitney, Anne. "Letter to Sarah Whitney," December 12, 1869. Whitney Correspondence. Wellesley College Library, Wellesley, Mass.

Williamson, Tom. *Polite Landscapes: Gardens and Society in Eighteenth-Century England.* Stroud, England: A. Sutton; Baltimore, Md.: Johns Hopkins University Press, 1995.

Willson, Anthony Beckles. "Alexander Pope's Grotto in Twickenham." *Garden History* 26, no. 1 (1998): 31–59.

Wilson, Lyn Hatherly. *Sappho's Sweetbitter Songs.* New York: Routledge, 1996.

Wolfe, Patrick. *Settler Colonialism and the Transformation of Anthropology: The Politics and Poetics of an Ethnographic Event.* London: Cassell, 1999.

Zeiger, Melissa Fran. *Beyond Consolation: Death, Sexuality, and the Changing Shapes of Elegy.* Ithaca, N.Y.: Cornell University Press, 1998.

Index

abolition, 143, 163, 188
Adams, Jan, 179
Addams, Jane, 169
Addison, Joseph, 5, 131
aeolian harp, 104
African-Americans, 143, 161–66, 186, 187, 189
AIDS, 107, 108
Airborne, Max, 192
A la Ronde, 155–56
amateur traditions. *See* craftwork
American Philosophical Society, 19
Amherst Academy, 157
amicitia, 14, 25
"Am I Not a Man and a Brother?"
 (Wedgwood), 188
André, John, 99, 107, 109
"Anniversary, The" (Seward), 100
archive. *See* historical archive
Aristotle, 14
Armory Show (1913), 169
Articulate Images (Wendorf), 9
Art Institute of Chicago, 168–69
Arts and Crafts movement, 169
As You Like It (Shakespeare), 113
Austen, Jane, 6, 16

Bacon, Mr., 142
Baker, Josephine, 172
Baltimore, Lord ("Basilisk"), 26
Banks, Joseph, 38, 74, 203n52
Barberini Vase. *See* Portland Vase
Bartram, John, 39
Bearden, Romare, 163
Beecher, Catherine, 128, 145

Beecher, Harriet, 128
Belk, Russell, 60–61, 62–63
Bell, Susan Groag, 206n63
Bennett, Paula, 157, 167
Bentinck, Elizabeth (Lady Weymouth), 87, 88
Bentinck, Henrietta (Lady Stamford), 87, 89
Bentinck, Margaret. *See* Portland, Duchess of
 (Margaret Bentinck)
Bentinck, William. *See* Portland, Duke of
 (William Bentinck)
Bermingham, Ann, 23
Bible Quilt (Powers), 189
Birth of Venus (Botticelli), 150
Black Arts movement, 186
Blecki, Catherine, 138
Bligh, Anne, 28
Blunt, Wilfred, 23
Boaz, Ruth, and Naomi (Pierce), 147–48, 149
Bockee, Catherine Jerusha, 145, 150–52
Booth Grey, William, 43
Botanic Garden, The (Darwin), 1, 8, 83, 139
botany. *See* Delany, Mary Granville Pendarves;
 hortus siccus (herbarium); Linnaean system
 of classification; Portland, Duchess of
 (Margaret Bentinck)
Botticelli, Sandro, 150
Boulukos, George, 143
Brace, John, 152
Breton, André, 172
Bridgeman, Charles, 6
Bridges, Fidelia, 157
British Museum, 45, 60
Brown, Bill, 62
Brown, Charles Brockden, 127, 214n46

Brown, Lancelot ("Capability"): influence on Bulstrode's design, 65–66; influence on Delany, 32; "natural" style of, 6, 33; Walpole on, 36

Bulstrode: "Capability" Brown's influence on, 65–66; devaluation as "woman's" garden, 7; as monument to friendship, 72; "Oriental" features at, 65; Repton's plan of, 67; role switching of Duke and Duchess of Portland at, 66, 68; shell grotto at, 38, 68, 70–73, 90; synaesthesia at, 68

Burke, Edmund, 10

Burney, Frances, 55–56

Bushe, Letitia, 28–29

Butler, Eleanor. *See* Ladies of Llangollen

calla lilies, 172–73

Calla Lily (Bridges), 158

Calvo, Luz, 180, 182

Campbell-Orr, Clarissa, 205n19

Campos, Olga, 172

cantharides ("Spanish fly"), 163

carnations, 151, 159, 161

Carnations (Bockee), 145, 146, 151

Casid, Jill, 132, 142, 214n40

Catholicism, 51–52, 204–5n10

Caus, Isaac de, 70

Cavendish, Margaret, 45–46, 47

Champion, Lucretia, 145

Charlotte, Queen, 7, 24, 29, 43, 97

Chaucer, 120

Chicago, Judy, 21, 176–80, 182, 217n60, 217n61

Chicana Art: Resistance and Affirmation (exhibit), 182

Cicero, 14

circuit gardens, 110, 134–35, 153

clitoral imagery: in Chicago's work, 179–80; in Delany's work, 39, 157; in Dickinson's work, 157; in *The Land* (Sackville-West), 167

Clitoral Secrets (Chicago), 179

Coats, Alice, 41

Cogswell, Mason, 141–42

Coliseum, 36–37

collecting: as economic system, 63–64; gender-based understandings of, 62–63; and imperialism, 63; psychological reasons for, 60–62; sexuality's role in, 62

Collingwood, Catherine, 51–53, 58

Collins, Ann, 142

Color Purple, The (Walker), 186

Connecticut Wits, 127, 129, 131

Connolly, S. J., 15, 28

Constable, Archibald, 119

Convent of Pleasure, The (Cavendish), 45

convents. *See* Catholicism

Cook, James, 63, 75, 107

Corinne, Tee, 182–85, 190, 194

Cott, Nancy, 141, 143

Cotton, Robert, 60

craftwork: as connecting force for women, 201n3; and Darwin, 42–43; of *Flora Delanica*, 42–43; and Allyson Mitchell, 190; and O'Keeffe, 169. *See also* lesbian genres; sister arts

Crimp, Douglas, 108

Croswell, Thomas O'Hara, 140, 141

Cunt as Temple, Tomb, Cave or Flower, The (Chicago), 179

Cunt Coloring Book, The (Corinne), 183–84

Cushman, Charlotte, 165–66

Cvetkovich, Ann, 190, 191, 192, 212n5

Daniels, Stephen, 139

Darwin, Erasmus: *The Botanic Garden*, 1, 8, 83, 139; "The Economy of Vegetation," 1; on *Flora Delanica*, 42–43, 203n52; and links between Delany, Duchess of Portland, Seward, and Pierce, 1; and Linnaean system of classification, 17; "The Loves of the Plants," 1–2, 17, 119, 121–22; miniature of, 123; and Portland Vase, 83, 85–86; and Seward, 96, 121–22; on Seward, 93; and Smith, 139

Dascomb, Marianne F., 163

Dashwood, Sir Francis, 16, 34

Day, Thomas, 189

"Deep Lez Manifesto, The" (Mitchell), 190
Delany, Mary Granville Pendarves: as
 "another mamma of Lady Weymouths,"
 55; black court dress of, vii, 42, 217n60;
 Bockee's work compared to, 150–52;
 botanical accuracy of, 42, 203n52; and
 Bulstrode shell grotto, 68, 70–73, 90;
 and Bushe, 28–29; and carnations,
 161; clitoral imagery in work by, 157;
 compared to O'Keeffe, 172; critical
 devaluation of work by, 23; and Patrick
 Delany, 24, 27, 28; and Delville, 32, 35–
 36; Dickinson compared to, 157; Dietzsch
 compared to, 42; and Donnellan, 24,
 25, 26, 27–28, 29, 71; and Duchess of
 Portland (Margaret Bentinck), 8, 29,
 55–57, 59, 77; on the Duke of Portland
 (William Bentinck), 54; *Flora Delanica*, 2,
 38–43, 122–24; on friendship, 24–29;
 and friendship tradition, 14–15; and
 historical archive, 18, 90–91; landscape
 arts of, 4; and landscape gardening, 29–30;
 and "The Loves of the Plants," 1; *Magnolia
 Grandiflora* (1776), 39; on marriage, 25–
 27; *Nymphaea alba* (1776), 72; overview of
 life, 24; *Papaver Somniferum, the Opium poppy*
 (1776), 39; *Passeflora Laurifolia, Bay Leaved*
 (1777), 39; and Alexander Pendarves, 24;
 Portlandia Grandiflora (1782), 39–40; on
 Portland Rose, 81; Redouté compared to,
 41; Seward's discovery of work by, 2, 122;
 shellwork, 38, 73–74; silhouette techniques,
 187; students of, 43; wealth of, 56;
 widowhood of, 25, 29. *See also Flora Delanica*
Delany, Patrick, 24, 27, 28, 30–31
Delville, 7, 30–36
D'Emilio, John, 213n38
Derrida, Jacques, 153–54
Dewes, Anne Granville, 28, 29–30, 74, 77, 80
Dewes, Court, 8, 122
Dickinson, Emily, 157–61, 178
Dickinson, Susan, 159
Diego, Juan, 173, 174, 182
Dietzsch, Barbara, 42

Dinner Party, The (Chicago), 176–80, 217n60,
 217n61
Discovery of Moses in the Bullrushes (Newcomb),
 148–50
Dodge Luhan, Mabel, 169–71
Donnellan, Anne ("Phill"), 25–29, 71
Donoghue, Emma, 212n8
Douglass, Frederick, 166
Dowling, William, 127, 131, 143, 144
Downpatrick, 33
Druidism, 144
Dwight, Theodore, 141
Dwight, Timothy, 131
Dyke Pussy (Allyson Mitchell), 190–91

"Economy of Vegetation, The" (Darwin), 1
Edgeworth, Richard, 100, 102, 105–6, 111
Ehret, George Dionysius, 38, 41, 42, 75, 77
Eisler, Benita, 171
"Elegy to the Memory of an Unfortunate
 Lady" (Pope), 141
"Elegy Written at the Sea-Side, and
 Addressed to Miss Honora Sneyd"
 (Seward), 108–9
"Elegy Written in a Country Churchyard"
 (Gray), 132, 144
El Gallo, 170
Eng, David, 106, 108, 210n25
"Epistle to Miss Honora Sneyd . . . from the
 Grave of a Suicide" (Seward), 99–100
"Epistle to Miss Honora Sneyd—Written,
 Sept. 1770" (Seward), 109–10
"Epistle upon an Epistle from a Certain Doctor
 to a Certain Great Lord, An " (Swift), 30–31
"Essay on the Georgics" (Addison), 131
essentialism, 153–54

Fabricant, Carol, 16, 36
Faderman, Lillian, 95, 199–200n42
Fadiman, Anne, 63
Farber, Jessie, 138, 213n23, 213n26
"Farewell to the Seat of Lady Eleanor Butler,
 and Miss Ponsonby, in Llangollen Vale,
 Denbighshire, 1802, A" (Seward), 117–18

Farr, Judith, 157, 159

Fergusson, Elizabeth Graeme, 134–35, 213n31

Flora Delanica (Delany): black backgrounds of, 42; botanical accuracy of, 42, 203n52; Darwin on, 42–43; erotic imagery of, 38–41; inclusion in lesbian genres, 2; Seward's defense of, 122–24. *See also hortus siccus* (herbarium); Linnaean system of classification

floral imagery: in Chicago's work, 176; in *Magnolias* (Kahlo), 172–73; in Mitchell's work, 191–92; in *Our Lady* (Alma Lopez), 182; in Ringgold's work, 189; in Thomas's work, 189. *See also specific flowers*

Freedman, Estelle, 213n38

Freud, Sigmund, 108, 200n42

Friendly Club, 138, 211n2

friendships: and botany, 58; Bulstrode as monument to, 72; and death, 210n28; Delany on, 26–29; egalitarian same-sex, 129–30, 141, 213n37; emphasized at Litchfield Female Academy, 145, 147; and "fairy spot" landscapes, 27; political understanding of, 143; and sapphism, 95; and sexuality, 124–25

friendship tradition: *amicitia* and *philia*, 14; and *Boaz, Ruth, and Naomi* (Pierce), 147–48, 149; and Delany, 14–15, 24–25; and *Discovery of Moses in the Bullrushes* (Newcomb), 148–50; and Duchess of Portland, 15; Greene on, 199n38; indigenous American vs. European, 199n41; and Ladies of Llangollen, 116; masculine vs. feminine, 14; and Pierce, 15; and Seward, 15; and sexuality, 15–16, 199n38, 199–200n42; women's exclusion from, 13–14

fritillary, 159, 167

gardens: circuit, 134–35; erotic, 16–17, 34–38, 65; ha-ha, 6, 16–17, 32; Irish topography, 32; overview of 17th- and 18th-century English, 5–6; 17th- and 18th-century English, 32; symbolism of, 5; value of

men's over women's, 7. *See also* grottoes; landscape gardening; *specific gardens*

Gardens of Emily Dickinson, The (Farr), 157, 159

Gates, Adelia, 166

Gelon, Diane, 176

George, King, 29

georgic mode, 1; Connecticut Georgic, 127, 131; conventions of, 130, 212n9; defined, 130; "In Search of Our Mothers' Gardens" (Alice Walker), 186; *The Land* (Sackville-West), 166–68; Pierce and, 212n9; and Seward, 118; as subversive, 132; *Unca Trans* (Allyson Mitchell), 193–94; and "Verses to Abigail Smith" (Pierce), 130–32

Gerard, John, 78

Glendower, Owen, 114

Glin, Knight of, 33

Graeme Park, 134–35

Granville, Anne. *See* Dewes, Anne

gravestones, 131–32, 136–38, 213n23, 213n26

Gray, Thomas, 132

Great American Lesbian Art Show, 182

Green, Mr., 95, 209n11

Greene, Jody, 13, 199n38, 210n28

Greenfield Hill (Dwight), 131

Greenspan, Kate, 9

Groag, Susan Bell, 66

grottoes: at Bulstrode, 38, 68, 70–73, 90; compared to Corinne's "storage cans," 185; and erotic gardens, 16; Jones's treatment of, 36; in letter from Duchess of Portland to Mary Delany, 57; men's vs. women's, 69–70; at Morven, 135; as sister arts tradition, 69; at Twickenham, 69–70, 207n68; in "Verses to Abigail Smith," 134. *See also* shellwork

Gutiérrez, Raquel, 182

Hacker, Marilyn, 197–98n9

Hagar in the Wilderness (Lewis), 164, 165–66

Haggerty, George, 132, 210n28

Hagstrum, Jean, 9

ha-ha, 6, 16–17, 32, 202n35

Hamilton, Charles, 70

Hamilton, Mary, 34, 55, 87, 90
Hamilton, William, 83
Hanbury, Charlotte, 43
Harleian Library, 48, 60
Harley, Edward, 48, 60
Harley, Henrietta Cavendish, 45–46, 48
Harley, Margaret Cavendish. *See* Portland, Duchess of (Margaret Bentinck)
Hawthornden Prize, 167
Hayley, William, 111
Heldelville, 30
Hell Fire Club, 34–35
Helsham, Richard, 30
Henderson, Harry, 163
Hepworth, Barbara, 176
Herball, or The Generall Historie of Plants, The (Gerard), 78
high art, 43, 168, 185, 197–98n9
historical archive: lack of, 17–19, 45, 90–91; and Pierce, 128–29; and Portland Museum dissolution, 60
Hitchcock, Edward, 157
Hitchcock, Reuben, 140
Hoel, 115
Holland, Lady, 69
homosexuality: elegaic poetry and, 107, 132; and Smith, 141–42. *See also* queer sexuality; sapphism
Horace, 8, 101
hortus siccus (herbarium): Darwin on Delany's, 42–43; of Delany, 77; of Anne Dewes, 77; of Emily Dickinson, 161; of Duchess of Portland, 77; *Flora Delanica* (Delany), 38–43; at Litchfield Female Academy, 145; Seward's description of Delany's, 122–24
Howard, Henrietta, 69
Hull House, 169
Hume, David, 14
Hunt, Harriot K., 166
Hurley, Ann, 9
Hyde Park, 97, 98
Hygieia (Lewis), 165, 166

"In Search of Our Mothers' Gardens" (Alice Walker), 186
"I pull a flower" (Dickinson), 157
Ireland, 32–34. *See also* Killala (Dublin)
"I tend my flowers" (Dickinson), 157

Jackson, Hazelle, 72, 73
Jacobus, Mary, 154
Jennings, Miss, 43
Johnson, Samuel, 14, 96
Jones, Thomas, 36–37

Kahlo, Frida, 172–76, 180
Keep, John, 163
Kelly, Miss, 27
Killala (Dublin), 71
Kit-Kat Club, 6

Ladies of Llangollen, 83, 95, 104, 112–18, 211n48
Ladies of the Valley, 109
Ladies Sasquatch (Allyson Mitchell), 191–92
Lady's Magazine, 138
Laird, Mark, 202n30
La leçon d'amour (Thomas), 189
La Llorona, 173
La Malinche/Malintzin, 173
Lamba, Jacqueline, 172
Land, The (Sackville-West), 166–68
landscape arts: and Lancelot "Capability" Brown, 6, 32, 33, 65–66; clitoral imagery in, 157; definitions of, 4; in early America, 12; as lesbian genre, 153–54; as mode of lesbian erotic expression, 8; overview of, 4–5. *See also* gardens
landscape gardening: and Delany, 29–30; and Dickinson, 157; and English imperialism, 7, 33; historical overview of, 5–6; in Ireland, 32–34; and local economies, 34; and masculinity, 206n63; Romanticism in, 6, 32, 34; and Seward, 97; as sister art, 9
landscapes: in Corinne's work, 183–85; erotic imagery in *The Land* (Sackville-West), 167; and female friendships, 27; in

Mitchell's work, 191–94; Old vs. New World, 7; sexuality of, 16–17; in "Verses to Abigail Smith," 132–34, 139–40. *See also* gardens

Lanser, Susan, 95

"Law of Genre, The" (Derrida), 153–54

Leinster, Duchess of, 69

Leonardo da Vinci, 9

lesbian genres: definitions of, 2–3, 198n11; Delany's "Beggar's Hut," 35–36; Delany's shellwork, 38, 68, 70–73, 73–74; *Flora Delanica*, 2, 38–43; interdisciplinary nature of, 11; landscape arts, 153–54; Portland Museum, 64. *See also* sexuality; sister arts

lesbianism: and *The Convent of Pleasure* (Cavendish), 45; and *The Dinner Party* (Chicago), 179; and Duchess of Portland, 58; eroticized landscapes and, 140; and literary history, 200n59; and Mitchell's figures, 192; overlap between friendship and, 15–16, 199–200n42; Seward's death wish as lesbian literary convention, 107; and Seward's melancholia, 107–8, 116

"Lesbian Photography on the U.S. West Coast: 1972–1997" (Corinne), 185

lesbians: artists and masculine exclusivity, 197–98n9; lack of historical archives regarding, 17–21; use of term, 2–4, 153–54

Lesbian Tide, 179

Lessing, G. E., 9, 10

Levin, Gail, 217n60–61

Lewis, Edmonia, 161–66, 215n20

Lichfield Cathedral, 95, 97, 99, 109

Lichfield Minster Pool, 97, 98, 209n16

Lightfoot, John, 75, 77, 80

Linnaean system of classification: at Bulstrode, 75–77, 88; and Corinne, 182–83; and Darwin, 17; as exertion of power, 63; and *Flora Delanica* (Delany), 38–39, 41; at Litchfield Female Academy, 145, 150–51; and Sackville-West, 167; and Seward, 121–22; sexuality in, 16–17

Linnaeus, Carl, 1

Lister, Anne, 113

Litchfield, Connecticut, 127, 131, 132–34

Litchfield Female Academy: founded by Pierce, 19, 128; *hortus siccus* (herbarium) of, 145; Linnaean system of classification at, 150–51; students' work compared to Strand's, 171–72; women's friendships, 145, 147

Litchfield Historical Society, 147, 150

Litchfield Law School, 132

Litchfield Manumission Society, 143

Llangollen, Ladies of. *See* Ladies of Llangollen

"Llangollen Vale" (Seward), 114–16

Llanover, Augusta, 18, 53

Lopez, Alma, 180–82

Lopez, Yolanda, 182

"Loves of the Plants, The" (Darwin), 1–2, 17, 119, 121–22

Lunatic of Lichfield. *See* Darwin, Erasmus

Lyons, Mary, 157

Magnolia Grandiflora (Delany), 39

Magnolia Macrophylla (Redouté), 40, 41

Magnolias (Kahlo), 172–73

Malin, Edward, 33

Manning, Adele, 166

Mansfield Park (Austen), 6, 16

Marlon Riggs: Tongues Untied, a Painted Story Quilt (Ringgold), 189

Marlowe, Christopher, 124

marriage: Delany on, 25–27; Pierce on, 142; Seward on, 101–2; Smith on, 142

Martinez, Michelle, 11

Mary, Princess, 55

Mavor, Elizabeth, 211n48

"Maxie" (Allyson Mitchell), 192

McManus, Edgar J., 214n51

Means to an End: A Shadow Drama in Five Acts, The (Kara Walker), 188

melancholia, 106–7, 108, 210n25–26

Memoirs of the Life of Dr. Darwin (Seward), 122

Miller, Anna, 96

Miller, D. A., 200n57

51–53; compared to Chicago, 176, 179; as
connoisseur of women's friendship, 58–
59; and Mary Delany, 8, 29, 55–57, 59, 77;
dissolution of legacy, 45; and friendship
tradition, 15; gender play in letters,
57–58; and historical archive, 18, 45, 90;
lack of research on, 204n2; landscape
arts of, 4; marriage of, 51, 53–55; maternal
lineage of, 45–46, 48; and Montagu,
49–51; romantic life of, 57–60; students
of, 87–89; as subject of Prior's poem,
48; and Walpole, 59–60; Walpole on
death of, 55; Zincke's gold box, 59. *See also*
Bulstrode; collecting; Portland Museum
Portland, Duke of (William Bentinck), 51,
53–55
Portlandia Grandiflora (Delany), 39–40, 81
Portland moth, 81
Portland Museum: and colonial botany, 63;
dissolution of, 60; proceeds from sale of,
65, 204n1; and women's intimacy, 64–65
Portland Rose, 81–83
Portland Vase, 1, 83–87
Portrait of the Artist as the Virgin of Guadalupe
(Yolanda Lopez), 182
Powers, Harriet, 189
Pratt Institute, 185
Prior, Matthew, 48

"Queen of the Bluestockings." *See* Montagu,
Elizabeth
queer sexuality: African-American, 189; Casid
on subversiveness of, 132; definition
of, 3; elegiac poetry and, 107, 132; and
"fairy spot" landscapes, 27; and Allyson
Mitchell's figures, 192; W. J. T. Mitchell
on, 10; overlap between friendship
and eroticism, 15–16; and politics,
193–94; and Sackville-West, 166. *See also*
homosexuality; lesbianism; sapphism
queer theory, 153, 200n57, 210n25

racism: and *The Dinner Party* (Chicago), 179;
in *The Land* (Sackville-West), 167–68;

portrayed in Kara Walker's work, 187–
89; and Seward, 188–89. *See also* Lewis,
Edmonia
Redouté, Pierre-Joseph, 40, 41
Reeve, Tapping, 132
Repton, Humphrey, 6, 32, 33, 65, 121
Richmond, Duchess of, 69
Ringgold, Faith, 189
Rivera, Diego, 172, 173
Robinson, Elizabeth. *See* Montagu, Elizabeth
Rogers, Pat, 204n1
Romanticism, 6, 32
Romney, George, 111
Root, Abiah, 161
Rosa, Salvator, 99
Rossetti, Dante Gabriel, 169
Rousham, 16
Rousseau, Jean-Jacques, 75

Sackville-West, Vita, 166–68
Salinas, Raquel, 182
sapphism, 15, 95. *See also* homosexuality;
lesbianism; queer sexuality
Sappho, 58, 95
Savile, John, 96
Schiebinger, Londa, 63
Schweitzer, Ivy, 14–15, 199n41
Scodel, Joshua, 212n16
Sedgwick, Eve Kosofsky, 4, 200n57
Self-Portrait Dedicated to Dr. Eloesser (Kahlo), 173
Self-Portrait "The Frame" (Kahlo), 173–74
Serena Reading (Romney), 111
Seward, Anna: childhood of, 95–96;
compared to Pierce, 2, 118; and Darwin,
96; and defense of *Flora Delanica*, 122–24;
depiction of Edgeworth in poetry,
105–6; discovery of Delany's work,
2; Faderman on, 95; and friendship
tradition, 15; and historical archive,
18–19; influence on early American
writers, 138–39; influence on Pierce,
124–25; as "inventress of the Epic
Elegy," 93, 107; and Ladies of Llangollen,
112–18; landscape arts of, 5; lesbian

landscape poetry of, 99–100; and Lichfield Minster Pool, 97, 98, 209n16; and Linnaean system of classification, 121–22; "Llangollen Vale," 114–16; and "The Loves of the Plants," 1, 121–22; and melancholia, 106–7; and monodic poetry, 107–9; portrait of, 94; and racism, 188–89; on Repton, 121; and *Serena Reading* (Romney), 111; on sister arts theory, 118–21; and Sneyd, 99–112; suitors of, 96; on superiority of poetry over other arts, 121; synaesthesia in poetry of, 105, 118–19; synaesthesia in work by, 99; and tradition of queer elegiac poetry, 107–10

Seward, Anna, works of: "The Anniversary," 100; "Elegy Written at the Sea-Side, and Addressed to Miss Honora Sneyd," 108–9; "Epistle to Miss Honora Sneyd . . . from the Grave of a Suicide," 99–100; "Epistle to Miss Honora Sneyd—Written, Sept. 1770," 109–10; "A Farewell to the Seat of Lady Eleanor Butler, and Miss Ponsonby, in Llangollen Vale, Denbighshire, 1802," 117–18; *Memoirs of the Life of Dr. Darwin,* 122; *Original Sonnets on Various Subjects, and Odes, Paraphrased from Horace,* 101; "Pastoral Ballad," 124–25; "Sonnet IV," 101; "Sonnet X," 102–3; "Sonnet XII," 103; "Sonnet XIX," 103–4; "Sonnet XXX," 104–5; "Sonnet XXXI," 105–6; "Sonnet XXXIII," 106; "Time Past," 100–101; "To Honora Sneyd, Whose Health Was Always Best in Winter," 101; "To the Right Honourable Lady Eleanor Butler, with the Same Present," 117

Seward, Thomas, 95

sexism, 179–80

Sex Lives of Daffodils, The (Corinne), 182

sexuality: and *Flora Delanica,* 38–43; and friendships, 124–25; and friendship tradition, 15–16, 199–200n42; and genres, 10; landscape arts as expression

of, 8; in late 18th-century America, 213n38; role in collecting, 62; and "Verses to Abigail Smith," 139–40

Shakespeare, William, 113, 144

Shannon, Laurie, 15

shellwork: of A la Ronde, 155–56; at Bulstrode grotto, 38, 68, 70–73; Delany's decorative, 73–74; erotic connotations of, 72–73. *See also* grottoes

Siddons, Sarah, 116

silhouette techniques, 187–88

Sissinghurst, 166

sister arts, 1; defined, 9, 12–13; *Flora Delanica* as example of, 42; and floral imagery, 172–73; grottoes, 69, 72–73; of Litchfield Female Academy students, 145–52; periodic recurrence of, 153; persistence of, 194; Portland Museum, 64; Seward on, 118–21; silhouette techniques, 187; synaesthesia at Bulstrode, 68; transatlantic reach of, 127; women's manuscript culture, 138; women's participation in, 9–11

Sister Arts: A History of Literary Pictorialism and English Poetry, The (Hagstrum), 9

Sketches of Universal History Compiled from Several Authors, for the Use of Schools (Pierce), 128

slavery, 143, 161, 163, 165, 188

Sloane, Hans, 45, 54, 60

Smart, John, 111

Smith, Abigail, 127–30, 142. *See also* Pierce, Sarah; "Verses to Abigail Smith"

Smith, Abigail Hubbard, 140

Smith, Elihu Hubbard: and abolition, 143; and *The Botanic Garden* (Darwin), 139; links to Seward and Pierce, 1; overview of life, 140; and Pierce, 127; and same-sex friendship, 140–42; transcriber of "Verses to Abigail Smith," 19, 128–30

Smith, Mary, 129

Smith, Mary Rozet, 169

Smith, Reuben, 140

Sneyd, Honora: and André, 107; death of, 106; Faderman on Seward's relationship

with, 95; first meeting with Seward, 96;
 portraits of, 111–12; Seward on marriage
 of, 93, 101–2. *See also* Seward, Anna
Solander, Daniel, 38, 63, 75
Solitude, 135
"Sonnet IV" (Seward), 101
"Sonnet X" (Seward), 102–3
"Sonnet XII" (Seward), 103
"Sonnet XIX" (Seward), 103–4
"Sonnet XXX" (Seward), 104–5
"Sonnet XXXI" (Seward), 105–6
"Sonnet XXXIII" (Seward), 106
So Rich a Tapestry (Hurley and Greenspan), 9
Sowing Empire (Casid), 132
Stabile, Susan, 12
Stanley, John, 71
Stanley, Lady, 25
Stewart, Susan, 63–64
Stieglitz, Alfred, 168–70
Stockton, Annis Boudinot, 135
Stockton, Richard, 135
Stourhead, x
Stowe, x, 110, 134
Strand, Paul, 170
Strand, Rebecca, 170–71
Strawberry Hill, 9
Surpassing the Love of Men (Faderman), 95,
 199n42
Swan, Claudia, 63
Swann, Marjorie, 61
Swan of Lichfield. *See* Seward, Anna
Swift, Jonathan, 30–31
Switzer, Stephen, 5, 6
synaesthesia: at Bulstrode, 68; defined, 13; in
 Seward's poetry, 99, 105, 118–19

Taylor, Mary Ross, 217n61
Tempest, The (Shakespeare), 144
Tenison, Margaret, 24
Teute, Frederika, 211n2
Thomas, Mickalene, 189
Throckmorton, Lady. *See* Collingwood,
 Catherine
Through the Flower (Chicago), 176

"Time Past" (Seward), 100–101
Todd, Janet, 199n42
Todd, Mabel Loomis, 161
"To Eliza Norris—at Fairfield" (Wright),
 211–12n3
"To Honora Sneyd, Whose Health Was
 Always Best in Winter" (Seward), 101
"To the Right Honourable Lady Eleanor Butler,
 with the Same Present" (Seward), 117
transgender identity, 219n97
Traub, Valerie, 15, 107
Trew, Christoph, 41
"Triumphs of Temper, The " (Hayley), 111
Turner, James, 16
Twickenham, 69–70, 135, 202n30

Unca Trans (Allyson Mitchell), 193–94, 219n97

Venus, 72, 85
Venus Temple/Mound, 34–35
Vernon, Anne, 54
"Verses to Abigail Smith" (Pierce): compared
 to Gray's "Elegy Written in a Country
 Churchyard," 132, 144; as Connecticut
 georgic, 127, 130–32; erotic imagery
 in, 139–40; gravestones in, 136–38;
 landscape in, 132–34; origins of, 130;
 and slavery, 143; Smith as transcriber
 of, 19, 128–30; and utopian vision of
 republic, 142–45; women's intimacy in,
 134, 136–38
Vertue, George, 74
Vickery, Amanda, 201n3, 201n5
Vindication of the Rights of Woman, A
 (Wollstonecraft), 145
Virgen de Guadalupe, 173–74, 180–82
von Frank, Albert, 143–44
Vyse, Cornet, 96

Walker, Alice, 186
Walker, Kara, 187–88
Walker, Susan, 85
Walpole, Horace: on death of Duchess of
 Portland, 55; and Duchess of Portland

LISA L. MOORE is associate professor of English and women's and gender studies at the University of Texas at Austin. She is author of *Dangerous Intimacies: Toward a Sapphic History of the British Novel* and coeditor of *Transatlantic Feminisms in the Age of Revolutions* and *Experiments in a Jazz Aesthetic: Art, Activism, Academia, and the Austin Project.*